Great
Memories!

Lou.

MEET THE BEATLES

MEET THE BEATLES

CULTURAL HISTORY OF THE BAND THAT SHOOK YOUTH, GENDER, AND THE WORLD

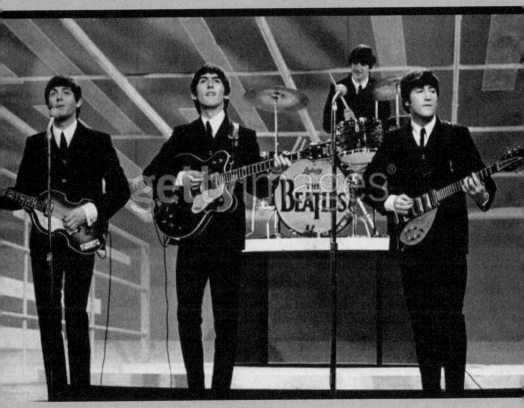

STEVEN D. STARK

HarperEntertainment / *An Imprint of* **HarperCollins***Publishers*

Grateful acknowledgment is made for permission or assistance in publishing material from the following:

The Playboy Interviews with John Lennon and Yoko Ono, conducted by David Sheff, edited by G. Barry Golson. Copyright © 1981 by Playboy.

The Beatles: An Oral History by David Pritchard and Alan Lysaght, published by Hyperion. Copyright © 1988 by David Pritchard and Alan Lysaght.

"Annus Mirabilus" from *Collected Poems* by Philip Larkin. Copyright © 1988, 2003 by the Estate of Philip Larkin. Reprinted by permission of Farrar, Straus and Giroux.

Excerpts from the letters of Stuart Sutcliffe reprinted by the kind permission of Pauline Sutcliffe.

HarperCollins books may be purchased for educational, business, or sales promotional use. For information please write: Special Markets Department, HarperCollins Publishers Inc., 10 East 53rd Street, New York, NY 10022.

FIRST EDITION

Designed by Gretchen Achilles

Printed on acid-free paper

Library of Congress Cataloging-in-Publication Data

Stark, Steven D.
 Meet the Beatles : a cultural history of the band that shook youth, gender, and the world / Steven D. Stark.
 p. cm.
 ISBN 0-06-000892-X (alk. paper)
 1. Beatles. 2. Rock musicians—England—Biography. 3. Rock music—Social aspects. I. Title.

ML421.B4S68 2005
782.42166'092'2—dc22
 [B] 2004059794

05 06 07 08 09 WBC/RRD 10 9 8 7 6 5 4 3 2 1

TO JAKE, HARRY, AND SARAH—MY FAB THREE!

CONTENTS

INTRODUCTION

WHY on earth would anyone need another book about the Beatles? Hundreds of volumes have been written about the group in a multitude of languages, describing everything from their musical scores (which they never wrote down because they could neither read nor write music) to a virtual hour-by-hour chronology of each Beatle's day. Their story has become our contemporary version of the Gospels, each disciple faithfully setting down what Saint John or Saint Paul said to him when it came time to write "She Loves You" or to visit the maharishi in India. As the British rock writer Charles Shaar Murray once put it, theirs is the greatest story "ever told and told and told and TOLD." And, unlike other pop phenomena, they seem, amazingly, to grow bigger by the year.

To a certain extent, almost all the books about the Beatles—even the so-called objective histories—are a form of fan literature: "Don't tell me what it means, just tell me again what happened," is the way a critic once put it. As such, these books always seem to me to miss the key elements of our modern version of the greatest story ever told. They tell the *what,* without ever really explaining the *why.* I decided to try to write a serious cultural history that focused on that *why.*

The Beatles were, of course, brilliant songwriters and innovative musicians. During their heyday, they sold more records than any entertainers ever, releasing around two hundred songs as a group in the eight years they remained together once they received a recording contract.

Yet looking mostly at their music—as most analysts do—provides an inadequate means to assess their impact. Their music was wonderful, but so was Beethoven's and even Irving Berlin's, and no one is going to annual Irving Berlin conventions or publishing biographies of him by the bucketfuls year after year. The Beatles became historical forces for reasons that transcended their songs.

Derek Taylor, their clever confidant and press officer, understood this well. "The Beatles are not a pop group," he once said. "They are an abstraction—a repository for many things." To understand this group, one has to grasp the larger cultural forces they triggered and came to represent that enabled them to make their mark.

That's what this book aims to do. If one had set out to predict the history of the second half of the twentieth century, one would never have surmised that four musicians—from Liverpool, England, of all places—would end up becoming the cynosure of the world's eyes and one of the century's major symbols of cultural transformation. What's more, it's never been clearly explained why their popularity and renown show few signs of diminishing in the first decade of a new century. More than forty years after they first hit the U.S. charts with "I Want to Hold Your Hand" and "She Loves You," anything connected to the Beatles continues to attract huge and adoring audiences—from compilations of their old hits, to auctions of their relics, to reminiscences by their friends and acquaintances. They are, said Taylor, "the longest-running saga since World War II."

To undertake this project, I ended up moving temporarily to England, near Merseyside, and I hope some of the many unexpected differences I found between the United States and the northwest of England have informed the book. A Beatles' cultural historian needs to understand two very different worlds: the one that produced them, and the American one that adopted them and, as the engine of international popular culture, remains the principal legatee of the group's existence despite their English origins. After all, it's one thing as an American to talk to old English friends and fans of the Fab Four; it's quite another to live every day steeped in the unique region and culture that shaped them.

As I researched their story, several themes emerged strongly that I

think are crucial to understanding both how and why the group was unique. First, if not always intentionally, the Beatles helped feminize the culture. "The feminine side of society was represented by them in some way," Yoko Ono once said, but that's understating the case. Elvis Presley may have started a revolution, but it wasn't primarily a gender revolution until the Beatles came along and helped remake the music—and then the culture—in their own image. With the prominence they accorded to women in their songs and lives and the way they spoke to millions of young teenage girls about new possibilities, the Beatles tapped into something much larger than themselves.

The Beatles were constantly drawn to strong women who, in turn, then shaped them. And, because of their background, the Beatles were able to identify far more strongly than their counterparts with the sensibility of their female audiences—which then allowed them to energize these female fans in a unique way.

To many, the hysteria known as Beatlemania, with its peculiar empowerment of young women, remains a significant event in the first stirrings of the gender revolution. Female fans had gone mad for Elvis, Frank Sinatra, Valentino, and even Franz Liszt in the past. But the world had seen nothing before—nor has it since—to rival the pandemonium that greeted the Fab Four everywhere they went.

"They were the great can opener of culture in the twentieth century," said Robin Richman, who reported on the era for *Life* magazine. "There was a wave of exuberance among girls they triggered that broke down the last restraints of the Victorian era."

The Beatles also challenged the definition that existed during their time of what it meant to be a man. This ultimately allowed them to help change the way men feel, the way men look, and the way men think about the way they look. Brian Epstein, their gay manager, influenced the group in many ways, but his most lasting contribution was to help design an image for the group that explored the fluidity of gender. It was a quest they had already begun on their own before they met him and which they continued even after his death in 1967.

"The Beatles set the tone for feminism," said University of Minnesota history professor Elaine Tyler May. "And that meant they recog-

nized in their own way that men have to change too in order to permit that revolution to happen."

After all, to many of their contemporaries, the Beatles initially looked and sounded like women. With their long hair, the "boys" were initially labeled as "girls"; their vocal signature in the early days was a high feminine falsetto "ooh" ("She Loves You"). Chuck Berry would never have sung a song as personal and as vulnerable as 1965's "You've Got to Hide Your Love Away." In fact, when George Martin, their record producer, first heard John and Paul sing "She Loves You," he exclaimed, "Well, you can't do the end of course . . . it's too like the Andrews Sisters!"

This focus on gender may have come naturally to the Beatles given their immersion in an English culture with a tradition from James I to Oscar Wilde and beyond of playing with the malleability of the concept. But it was very new to the rest of the world, particularly to Americans. Put another way: The Beach Boys, Bob Dylan, and James Brown were many things, but androgynous was not among them.

Second, the Beatles converged with their era in an almost unprecedented way. They were "of their time," said their producer George Martin, and that time, of course, was the 1960s. The late Beatle scholar Ian MacDonald may have been exaggerating a bit when he described the sixties as a "historical chasm between one way of life and another." Still, most would agree with analyst John Judis that the sixties have preoccupied modern America "almost as much as the Civil War preoccupied late-nineteenth-century America." The sixties, Judis wrote, have sparked debates about "the 'quality of life' and about . . . 'lifestyle' rather than simply about 'making a living.' The sixties unleashed conflicts within these new areas of concern—over affirmative action, abortion, homosexuality, drugs, rock lyrics, [and] air pollution," many of which still preoccupy us today.

During that decade, the Beatles came to embody the values of the counterculture in its challenge to "the Establishment." They certainly didn't invent that alternative worldview with its myriad of tributaries (a belief in altered forms of consciousness or a utopian universal love), which even today are such enormously contentious or attractive no-

tions, depending on one's point of view. Still, the group celebrated that alternative vision of possibility: They sang it and lived it for others.

Perhaps the most important aspect of the Beatles' attraction during that influential era was their collective synergy. They popularized the sanctity of "the group"—changing not only music but the counterculture at large, which came to emulate the collectivism they sang about and embodied. With the Beatles, the whole was always greater than the sum of the parts, which gave them a dazzling appeal to the millions who worshipped them.

Third, that semireligious allure of the Beatles was a key factor in allowing the group to endure. John Lennon was on to something in 1966 when he compared the group's popularity with that of Jesus. He was not alone at the time in noticing how the multitudes flocked to "witness" them or how sick children were brought to see the Beatles in the hope that the Fab Four might change their lives. Yet even John might be surprised at how it has all continued for four decades: With the subsequent talmudic study of their songs, the weaving of their story into legend, and the elevation of the Fab Four into a kind of sainthood, there is a way in which the Beatles have become our modern counterparts to the religious figures of the past. To their scores of followers, the Beatles were not only a group but something of a way of life.

Finally, the Beatles had a power over millions of people that was singular in history among artists. One critic in 1967 called the release of *Sgt. Pepper's Lonely Hearts Club Band* the closest Europe had been to unification since the Congress of Vienna in 1815, and most thought he could have included North America as well.

"Only Hitler ever duplicated their power over crowds," said Sid Bernstein, the promoter who helped set up some of their first concerts in America.

The Beatles "could have taken this roomful of kids and snapped them," said Ken Kesey after sitting through a concert.

That power was something new. Before, only popes, kings, and perhaps a few intellectuals could hope to wield such influence in their lifetimes. It all came about because the band had the good fortune to

emerge at a unique time when musicians could become forces for social change. Because of the post–World War II baby boom, the percentage of young people in the culture was near a historical high. In turn, youth had formed their own subculture, and at the heart of that rebellious enclave was rock and roll music. "For our generation," said the radical rocker John Sinclair, "music is the most vital force in most of our lives. Rock and roll is the great liberating force of our time."

A caveat: This book is not going to be an exhaustive nine-hundred-page account of which Beatle said what to whom on which day. Those works have their place, but if one is to evaluate the significance of the Beatles in the history of our times, centering the narrative around their day-to-day activities is not the best place to concentrate. Focusing only on the experiences or the music of the Fab Four will never explain why these pop artists, singularly, became the most celebrated and notorious figures of their age or why there's every chance no one may reach such heights again. Life to them, as John Lennon once described it, was often "a room and a car and a car and a room and a concert and we had cheese sandwiches sent up to the hotel room." As the Beatles became the focus of the world's eyes, they attained an unprecedented level of celebrity. That guaranteed them and their close associates a position from which they had very little contact with the outside world, and often put them in the worst position of all to evaluate what was happening and why. "People think the Beatles know what's going on," John Lennon said. "We don't. We're just doing it."

"We're constantly being asked all sorts of very profound questions," Paul McCartney said. "But we're not very profound people."

What's more, John, Paul, George, and Ringo were artists and entertainers, where a certain amount of illusion comes with the territory. "They were very much an *image* both on record and in concert," said Bob Wooler, the Cavern Club compere who helped steer them through their early days in Liverpool. Interviews with John Lennon, a journalist once warned, should be treated as "creative works of art," which is one reason why the loquacious Lennon often ended up contradicting himself from one colloquy to the next.

Compounding the problem, as the critic Louis Menand once noted,

is that it may be close to impossible to write an objective history of the Beatles after 1963 that is unclouded by the revisionism of the participants, whether intentional or not. There's a kind of Heisenberg principle at work here. Because of the group's unique kind of fame, those who knew the band tend to have an even stronger than usual stake in placing themselves at the center of the narrative.

To be sure, there's a process with any historical figure by which those associated with the figure color their memories through the lens of subsequent events. With the Beatles, however, this process was exponential. The group reached a level of celebrity and adoration never seen before or since in modern times (Marilyn Monroe would be the closest, not Elvis). "You couldn't talk to them without constantly realizing that they were world historical characters," said David Dalton, an American writer who hung around with the group in London in 1968 and 1969. Their aura was so blinding—they were just too famous and mythologized even then—that anyone around them formed impressions and recollections with the implicit awareness that these reminiscences would become instant fodder for the once and future gospel.

Even writers who tell the Beatles' story secondhand tend to find themselves pulled into a participatory role as expositors and interpreters of "the myth." That's why historical accounts of these years so often resemble something like the scriptures, or end up sounding utterly unenlightening. Writers look at the Beatles and tend to see themselves. As Menand put it, "Celebrities like the Beatles don't live in fishbowls; they are fishbowls."

I tried as much as I could to avoid these problems and frame the story in a somewhat new way. That isn't to say I haven't retraced their history too in the following pages. Nor does it mean that I didn't interview some of the principal sources or rely in many parts on the work of the many others who have come before me.

But I've tried to be different. Though it may be of interest to their disciples and fervent fans, understanding the essence of the Beatles doesn't depend on trying to reconstruct from all the subsequent tinted accounts who was standing where in the studio on a particular afternoon. I also tried to avoid delving into the titillating kind of gossip any

kind of Beatle historian encounters—except where I found it to be essential to understanding the phenomenon and its meaning. Like most rock stars, the Beatles had their fair share of wild times and women. So what else is new?

I tended to learn more about the whole phenomenon by stepping outside the bubble: reading teen magazines from the early days; listening to oral histories of Liverpool; and interviewing fan club presidents, student leaders, the girls who screamed at the concerts, and even the "Apple Scruffs"—the young women who hung outside the group's London headquarters for weeks at a time. I found a fair number of news accounts and interviews from the time that seem to have been ignored since. It also helped a lot just being in northern England, day after day, absorbing their history and culture while using some of the same shops and buses they must have used a long time ago.

But enough background. "Changing a lifestyle and the appearance of youth didn't just happen," John Lennon told the *National Observer* in 1973. "We set out to do it." Maybe that became true later, but in the beginning on Menlove Avenue or Forthlin Road in Liverpool, these four teenagers would never have articulated their quest in those terms at all. "We were just four relatively sane people in the middle of madness," George Harrison once said. And for all they had already accomplished in England by the end of 1963, if things had stopped there, they would be pretty much forgotten today. No, the madness really began in 1964, when these four young men set forth for the first time from England to America to try to conquer the world.

THE BRITISH ARE COMING!

IN the beginning there was the scream.

It was high-pitched, wailing, the sound of pigs being slaughtered, only louder. Some in England compared it to the air raid sirens that had been so prevalent during the war only two decades before. Oddly, it was both joyous and hysterical; it could be heard sometimes over a mile away. It was continuous, yet punctuated by crescendos. Its decibel level was so high that it broke the equipment measuring it, and the next day, some found their ears still continued to ring.

"I've never heard a sound so painful to the ear," one observer at the time said. "Loud and shrill. It was like standing next to a jet engine. It physically hurt."

Of course, years earlier there had been stories about the girls who shouted for Sinatra and then for Elvis. But this screaming was different—the beginning of a new era, an expression of cultural change.

"We screamed because it was a kick against anything old-fashioned," remembered Lynne Harris, a fan of the Beatles at the Cavern Club in Liverpool, where they were essentially the house band in the early sixties. "They represented what we could do with our lives."

"It seemed to me a definite line was being drawn," said Bob Dylan. "This was something that never happened before."

At first, the screams were triggered whenever the Beatles played their music, especially when they sang falsetto together and shook their long hair; the screaming was a kind of similar answer to the high tones

the girls were hearing. Soon, however, it grew to encompass anything connected to the group—their impending arrival at a hotel or airport, their appearance on a movie screen. Without it, at least initially, the group might well have been seen as just another flash in the pan. It became so much a part of the trademark of the Beatles that when the band produced its own *Anthology* history series in the 1990s, the episodes began with just the screams and everyone knew exactly what they were, what they were for, and what they referenced. Years later, Neil Aspinall, their confidant and roadie, would say of their tours, "It was just a permanent scream."

"You literally had to hold on to your seat," said Marcy Lanza, a fan at the time. "The noise was so loud that everything swayed and vibrated."

It drove some in the inner circle a bit crazy. "Shurrup!" John Lennon, all of twenty-three in 1964, would yell at the top of his lungs in response, but no one could hear him. George Harrison, then only twenty, was the first Beatle to begin to succumb to the pressure of the constant screaming mobs. "He was a dedicated musician, and he would spend his time in the dressing room tuning everyone's instruments," remembered Tony Barrow, their press agent. "And then they went on stage and no one could hear and it didn't matter what they did. His personality changed; he became a less tolerant person—snappish. He couldn't come to terms with it at all."

But that would come the following year. On February 7, 1964, George was still happy at the sight of more than a thousand screaming British fans at Heathrow Airport outside London to see the Beatles off on Pan Am Flight 101 for New York at 11:00 a.m. The screams were so loud that some in the Beatles' party initially mistook the sound for jet engines. Unbeknownst to the group, the band's arrival at the newly renamed Kennedy Airport eight hours later was already being announced nonstop on the airwaves to a shivering New York beginning to awaken to a gray day. "It is now six thirty a.m. Beatles time," the DJ on WMCA said. "They left London thirty minutes ago. They're out over the Atlantic Ocean, headed for New York. The temperature is thirty-two Beatle degrees."

The group was already the biggest entertainment phenomenon

Britain had ever known. The British knew all about the reaction the Beatles engendered in their listeners, which had started unexpectedly at a dance outside of Liverpool in Litherland at the end of 1960 and had eventually come to cover the whole of their island three years later. In the past year, the Beatles had sold more records in Britain than anyone ever, with four number 1 singles—"Please Please Me," "From Me to You," "She Loves You," and "I Want to Hold Your Hand"—and two hit albums. They had been the stars of their own thirteen-week series on BBC radio—*Pop Go the Beatles*—and in 1963 they had already toured their own country four times, playing to sellout, clamoring audiences everywhere.

In October 1963, the group had headlined on TV's *Val Parnell's Sunday Night at the London Palladium*—England's version of *The Ed Sullivan Show*—and the riotous fans outside had prompted one tabloid wag to label the new phenomenon "Beatlemania." Three weeks later, they were the stars of the prestigious Royal Command Performance in London, where John Lennon had delighted the upper-class audience and members of the royal family by announcing, "For our last number, I'd like to ask for your help. Would the people in the cheaper seats clap your hands? And the rest of you, if you'll just rattle your jewelry?" By the end of the year, they dominated their nation's airwaves, newspapers, and conversations. One British newspaper announced that the name of the Beatles was "engraved upon the heart of the nation."

But that was Great Britain, which in 1963 was in a different universe as far as the United States and the world entertainment market were concerned. And the Beatles knew it too. Rock and roll was virtually the exclusive province of American musicians, and no English rock act had ever come close to "making it" in the States. Cliff Richard, the UK's biggest pop star until the Beatles, was virtually unknown across the Atlantic, and only a few of his fellow countrymen had ever managed to climb to the top of the American charts.

As they sat on the plane that February morning, they all knew that the only member of the group who had been to America was George Harrison, who had visited his older married sister Louise in Illinois several months earlier. He had discovered that the hottest act in Britain

wasn't virtually unknown across the Atlantic in the summer of 1963; it was completely unknown.

"They don't know us," George had reported back to his mates after the trip. "It's going to be hard."

True, as they flew across the Atlantic that February, the group was currently on top of the charts in the U.S. with a huge hit, "I Want to Hold Your Hand." Yet there was still some evidence that the Beatles might be facing an insurmountable barrier. Three previous hit singles from the UK—"Please Please Me," "From Me to You," and "She Loves You"—had gone nowhere in the States in '63. The Beatles' British record company, EMI, owned the American label Capitol Records, which theoretically should have made any American release easier and more successful.

But Capitol stood up to its parent company and declined to release any of those three songs or the group's hit first British album. "We don't think the Beatles will do anything in this market," read a Capitol Records memo. That forced EMI to sell the rights cheaply to little-known companies with low advertising budgets, virtually guaranteeing failure. Not that fans were clamoring to hear the songs anyway: In the autumn of 1963, well-known New York DJ Murray the K had played "She Loves You" (finally released on the small Philadelphia-based Swan label) as part of an audience record-rating contest. It had placed third out of five songs, hardly the stuff of greatness.

In fact, the only American who had achieved any kind of success with a Beatle song was Del Shannon of "Runaway" fame, who had recorded a version of "From Me to You" which went to number 77 on the charts in July 1963.

Moreover, right before this first trip to the States, the band had spent three weeks in more diffident France, where few had screamed and the Beatles had received the kind of reaction that most French have given the English for the past thousand years. It had even become unclear at times who was headlining their shows in Paris—the group, folksinger Trini Lopez with "If I Had a Hammer" as his calling card, or French singer Sylvie Vartan. Three times in the middle of concerts their equipment broke down (George thought it was sabotage). Things got so

bad that their press agent, Brian Somerville, staged a fight backstage to give the press something to write about.

All this skepticism about the ability of an English group to cross over to America was well founded. First, there was hardly the global network of communications then that there is now. There was no MTV or CNN to spread the word and give the U.S. a taste of Britain's biggest phenomenon in decades. Even transatlantic telephone calls were oddities. Only a few U.S. broadcast and news organizations had bureaus abroad. Moreover, entertainment happenings were rarely considered front-page news in those days. The best the Beatles could hope to do in most American newspapers or magazines was to reach the inside pages.

Second, British youth bore little resemblance to their American counterparts. Despite a similar postwar baby boom and the beginnings of a youth culture, most young adults in Britain left school by fifteen or sixteen and went to work rather than completing high school and attending college. That, after all, had been the experience of all four Beatles, who never attended the equivalent of an American university for a day. English youth tended to identify with the working class, not the middle class; they were tightly bound and edgy, said one commentator, not cool. They also didn't define themselves nearly as much in terms of generational conflict as American teenagers did because there was much less age segregation in England, given that teens left school far earlier.

Once, when asked what made the Beatles different from other sixties icons, Ringo, said, "We don't hate our parents." British youth were only "junior versions of the men," said one analyst. "America had teenagers and everywhere else just had people," said John.

If the British had contributed next to nothing to the first ten years of the rock revolution, even as purchasers, it was also because they were light-years behind America as a consumer culture. It's hard to picture now but even in the 1950s a majority of the English still didn't have washing machines or refrigerators. In the early fifties, for example, the Beatles' home base of Liverpool still had horses in its streets, and when bananas arrived in the shops for the first time since before World War

II, which had broken out in 1939, there were lines around the block to purchase them. "We were hicksville," John Lennon said.

That meant their youth culture was also a lot different from America's. No one had Jan and Dean's wagon they could call a "Woody," because so few teens had cars, which meant the English didn't really date in the same way as American teens did. Mostly, they hung out in groups. Few could call "Beechwood 4-5789"—the title of an American hit—because most still didn't have private telephones. "When they left the cinema or turned off the gramophone," said one British historian referring to his nation's youth at the time, "there was nowhere for them to go." The sunny California world of the Beach Boys resembled the lifestyle of Saudi sheikhs far more than that of the average pallid Englishman.

It's true that English youth did listen to American rock and roll avidly, even if they didn't contribute to the recorded product and many of the lyrics went right past them. Overseas tours by Bill Haley and Eddie Cochran had attracted crowds of rampaging British teenagers in the fifties and early sixties. But the English often had to listen in clubs or on imported records, which were hard for many to find or afford. Few had transistor radios either, which had become a virtual requirement for many American teenagers. That made sense, since nearly all the music one could hear on British domestic radio came from the staid, state-run British Broadcasting Corporation (BBC), which didn't play rock and roll until the sixties and even then played only around ten hours a week of mainstream rock. There was no such thing as a DJ either. To hear a wide range of rock and roll in England over the radio, one had to be determined: Young fans such as Paul McCartney hooked up a radio with an antenna to pull in the static-filled sound of Radio Luxembourg from across the water, or on good nights, Radio Stuttgart from Germany. There were few independent companies to release rock and roll records, as there were in America; EMI and Decca controlled 75 percent of the British record market in 1959.

So the Beatles had reason to be concerned that their meteoric rise might be about to run into a ceiling. In a far more insular universe than today, they had no way of grasping the cultural earthquake that was taking shape on the opposite side of the Atlantic.

"Since America has always had everything, why should we be over there making money?" Paul asked record producer Phil Spector on the flight over, according to one account. The eccentric Spector had taken the Beatles flight rather than one with his own group, the Ronettes, which included his girlfriend and future wife. It was said he was terrified of flying and had convinced himself the odds were lower that something might happen to the Beatles' plane. "They've got their own groups," Paul continued in his lament about America. "What are we going to give them that they don't already have?"

A person in a position to answer Paul's question was Christina Berlin, a fifteen-year-old New Yorker who, several years later, would become best friends with a young New York photographer-to-be named Linda Eastman. Christina went to Kennedy Airport to greet the group that cold February morning, along with three thousand other screaming girls and 110 reporters. "At the airport, you could really feel that something important was happening," she said. "We had been bored, and you felt that this is the beginning of a youthquake. It felt like we were finally taking over the candy store."

"They're different," fifteen-year-old Elaine Collins told reporter Al Aronowitz of the *Saturday Evening Post* that February. "They're great because they're different!"

Looking out from the plane as it landed on the runway, the Beatles saw so much commotion they figured it couldn't possibly be directed at them. Then they heard the screams. It was the same as in England, only louder and more unrestrained. The group's initial reaction was that this was standard behavior for American teenagers. Then, as the screams got even louder and the police lines buckled, the Beatles began to realize what was happening. "On a scale of one to ten," Paul later said, "that was about a hundred in terms of the shock of it." Tom Wolfe, reporting for the *New York Herald Tribune,* described how "some of the girls tried to throw themselves over a retaining wall."

"So this is America," said Ringo. "They all seem out of their minds."

It had been a long time in the making. After all, as a fellow Englishman had once written, "What's past is prologue." Yet that aphorism applied not only to the group's own formidable and lengthy musical ap-

prenticeship in Liverpool and Hamburg. Though Brian Epstein, the Beatles' manager, had only visited the U.S. for the first time in early November to prepare the group's foray into the New World, he had been planning this trip in his mind ever since he had taken over the group two years earlier. Since then, he had been telling everyone that the Beatles would be "bigger than Elvis," not that anyone believed him. He took it to such lengths that he would have his friend Joe Flannery call him during meetings in Liverpool pretending to be Colonel Parker, Elvis's manager. Then Brian would turn to the person he was trying to impress and tell him he had Elvis's manager on the line. (It says something about the unworldliness of Liverpudlians that some actually fell for it.)

Yet the group's rise in the U.S. over about a two-month period leading up to their arrival in 1964—and their "entry into the modern mind," as writer Mikal Gilmore put it—was due to an extraordinary confluence of circumstances over which Epstein and the group had little control. It was an astounding occurrence. The Beatles had conquered England in a little over a year from their base in Liverpool. Despite their understandable concerns about how they might be received, they vanquished the U.S.—a country roughly five times the United Kingdom's population and far more diverse—in two months. The speed and depth of their American conquest remains unprecedented in the history of popular culture.

In his book on the sociology of epidemics, *The Tipping Point,* Malcolm Gladwell has described how a "social epidemic" reaches critical mass. It needs a susceptible population; a group of "carriers" who will spread the "bug" to the masses; and a quality that allows the "bug" (message) to stick. American Beatlemania had all those crucial elements: a series of attributes that the public couldn't get out of its head (the Beatles' Englishness, their look, their sensibility, their sound, and the reaction they provoked); a group of key organizers who would push the "epidemic" incessantly (radio DJs); and the age group most susceptible to crazes that exists—teenagers.

First, take the teenagers. The Beatles had the advantage of advancing on the New World when the number of those adolescents—their core market—was near a historical peak. Historian Steven Gillon has

called the post–World War II baby boom, when a new baby was born approximately every eight seconds, "the single greatest demographic event in American history."

Elvis had been born a bit early to capitalize on that baby boom. In contrast, the Beatles demographic timing was perfect: They arrived when they could grab as their primary audience everyone born between 1946 (now seventeen or eighteen) and 1954 (the ten-year-olds, who bought more pop records than one might think). The number of Americans aged eighteen to twenty-four increased by 50 percent between 1960 and 1970, from 16.5 million to 24.7 million.

Second, consider the band's memorable attributes—and there were so many that the Beatles seemed like creatures from another planet when they landed in early 1964 in what was still a terribly conformist U.S. society. For starters, rather than being a disability, the Beatles' Englishness was a great boost, since it gave them a pleasing novelty which made them distinctive. In cultural terms, England "hasn't been as influential to American affairs since 1775," *Billboard* pronounced, and it was meant as a great compliment.

Though it's often forgotten, a wave of Anglophilia had been sweeping the U.S. in the late 1950s and early '60s before the Beatles had ever set foot on American soil. There had been periods of such pro-English sentiment before in American history, courtesy of Henry James and the like. But the latest was especially strong because of its roots in popular culture. It had begun in earnest in the late fifties with the overwhelming popularity of *My Fair Lady,* which didn't close on Broadway until late 1962. Set in London and adapted from George Bernard Shaw's *Pygmalion,* the musical starred Brits Julie Andrews, Stanley Holloway, and Rex Harrison, a former student at Liverpool College.

Its success was followed by Lerner and Loewe's next musical, an adaptation of the King Arthur legend entitled *Camelot.* This musical wore its Anglophilia on its sleeve to such an extent that its title song even praised the English weather. *Camelot* not only starred Andrews and Welshman Richard Burton, but would later lend its name to descriptions of the whole Kennedy administration as it became mythologized in the weeks following the president's death less than three months before the Beatles arrived.

The success of a new musical on Broadway in January 1963 called *Oliver*—a hit from London based on the Charles Dickens novel *Oliver Twist*—further added to the pop culture Anglomania. (The cast of that musical, starring future member of the Monkees Davy Jones, would get second billing on the Beatles' first appearance on *The Ed Sullivan Show* on February 9, 1964.)

Meanwhile *Lawrence of Arabia,* starring Peter O'Toole as the dashing English hero, won the Academy Award for best film of 1962. The next year *Tom Jones,* an adaptation of the eighteenth-century Henry Fielding novel, starring Albert Finney, garnered the same award. The James Bond craze was also just getting started. Though hardly a member of the Beatle generation, Bond represented a new kind of urbane hero—a sharp break from the macho Gary Coopers and John Waynes who had once been the icons of American culture. President Kennedy himself had endorsed the Bond book craze when he told an interviewer he liked the spy novels. May 1963 saw the premiere of the first Bond movie, *Dr. No,* starring an unknown Scottish actor named Sean Connery as Bond.

On November 10, 1963, as the Anglophilia continued, NBC even aired a special based on the popular British satirical show *That Was the Week That Was,* starring young David Frost. It became a regularly scheduled series two months later.

In all this, the Beatles were also the unwitting heirs to earlier "British invasions." The late-nineteenth-century musicals of Gilbert and Sullivan had far more currency in American culture in the early sixties than now, so much so that when boomer favorite *Mad* magazine wanted to satirize President Kennedy, it depicted him and members of his administration singing songs to the tunes of Gilbert and Sullivan numbers. Many Americans could remember, too, when British film stars, beginning with Charlie Chaplin, had flocked to Hollywood—a trickle that became a stampede once silent movies went to talkies and an English accent was the order of the day. Joseph Epstein once wrote in *The American Scholar:*

> For an American boy growing up in the Middle West, World War
> II was fought at the movies. I fought it at the side of such

*gallants—and elegant— officers as Major Ronald Colman, Colo-
nel Douglas Fairbanks, Jr., Captain Noel Coward, Commander
Cary Grant, and Lieu (actually Lef)tenant Errol Flynn. Even in
American movies, the English officers always came off as the most
suave, most intelligent, most heroic of fighters.*

When the Beatles spoke with their thick Scouse accents, British lis-
teners immediately detected the regional dialect and thought of
downtrodden Liverpool. Americans, on the other hand, were un-
schooled in the intricacies of UK regional dialects and thought all En-
glishmen sounded the same. Thus they couldn't help but associate the
Beatles with suave British actors such as Sir Laurence Olivier and
David Niven.

Though they themselves would have been shocked to realize it, all
this meant that the Beatles came across to Americans as members of the
educated class. Given the English school system, which stressed literary
learning more than its American counterpart, there was at least a grain
of truth in the impression. Except for Ringo, the band members all knew
who Lewis Carroll, Dylan Thomas, Oscar Wilde, and John Keats were,
and scholars would later have no trouble locating some of the Beatles'
late-sixties romanticism in works by Wordsworth and Coleridge.
"That's what made the Beatles different," John once said, "the fact that
George, Paul, and John were grammar school boys." (That meant they
attended prestigious state schools for more accomplished students.)
Even at their press conference at Kennedy Airport, American reporters
were asking the Beatles questions they would never have asked Elvis or
Chuck Berry. "I watched amazed as 200 hard-boiled reporters who'd
come to destroy the Beatles ended up adoring them," wrote Dezo Hoff-
man, their photographer.

That first American appearance set the tone as the Beatles quickly
rattled off joke after joke in response to shouted press questions.

"What do you think of Beethoven?" demanded one reporter.

"Great," replied Ringo. "Especially his poems."

"Is there something you can sing?" shouted another.

"We need money first," said John.

"How many of you are bald so that you have to wear those wigs?" asked another.

"All of us," said Ringo, and John added, "And deaf and dumb too."

Because they were Englishmen, Americans were already inclined to perceive the Beatles as more articulate, theatrical, and intellectual than they were. Press repartees like this just proved it: Though their hairstyle was lowbrow, the Beatles came across from the beginning as highbrow. America's vast aspiring middle class could identify with the group, which meant that the transformations it would inspire would take a far different shape than the ones produced by inarticulate former truck driver Elvis Presley, a product of working-class America.

Their quick-witted erudition also made them seem like perennial students. Not surprisingly, the screaming mobs that followed them in the U.S. soon turned out to be not all that different from the groups of chanting protesters who would take over buildings later that same year in Berkeley as part of the Free Speech Movement, which marked the unofficial beginning of the campus activism of the sixties.

Coming from Liverpool—with its rough working class, its dearth of London high culture, and its distance both geographically and psychologically from the capital—the Beatles actually hailed from what many in Britain considered the least "English" part of England. Yet, ironically, that helped Americans accept them too, though no one focused on this at the time. As a seaport with a myriad of cultural influences from abroad, Liverpool was more like the U.S. than any other part of England. The Beatles' lack of deference, their straightforwardness, and even their sense of humor were closer in many ways to American styles than English ones. As the English journalist Godfrey Hodgson later put it, the Beatles grew up as the children of Irish immigrants in Liverpool with notions that teenage America soon found matched their own: middle-class virtue was a sham; authorities were there to be mocked; irreverence was the order of the day.

Then there was the Beatles' appearance—especially their long hair, which to many made them look like girls. "Their appeal was, from the start, visual almost as much as musical," Beatle analyst Mike Evans later wrote. "Their image was always unique."

Being a superstar who is instantly recognizable like Marilyn Monroe or Charlie Chaplin has its advantages. The hair gave the Beatles a similar benefit. "I think that was really one of the big things that broke us," Paul later said. "The hairdo more than the music originally." It wasn't so much the length—Elvis and James Dean had grown their hair fairly long too, a style which the Beatles copied early in their careers. Rather than slicking it back in fifties *Grease* style, however, the Beatles now all wore identical modified pageboys with no parts and long bangs.

England and Europe didn't pay as much attention: French and German students had been wearing their hair in a similar fashion for years. Moreover, to the English, a preoccupation with androgyny was par for the course in a culture where cross-dressing had been a regular part of pantomime and the music hall, not to mention Shakespeare. With single-sex education in most secondary schools (including almost all the ones the Beatles attended), boys and girls grew up learning in drama class how to impersonate the other sex.

Yet in America even the Beatles' mild gender-bending was a shocking revelation, an inversion not only of conventional style, but of the macho rebellion in the fifties of Elvis and Marlon Brando. America still shaped its conceptions of proper hair length and style on what the military proscribed. That often meant a crew cut, like the one the seven heroic Mercury astronauts wore.

They were "all getting house-trained for adulthood with their indisputable principle of life," Paul later said of American youth. "Short hair equals men, long hair equals women. Well we got rid of that small convention for them. And a few others too."

"The value of the early Beatles," one record reviewer wrote later, "was in the challenge they offered to a system of masculine values that seemed outmoded long before Germaine Greer fashioned a career from their denial."

The published reaction of one fan's father was typical: "There's not a man among them," he said.

Thus, when the American press first noticed the Beatles phenomenon from abroad—and the group didn't receive a tremendous first "notice," since it appeared in the back pages of the newsweeklies in short

articles and on TV broadcasts most didn't see—it wasn't the music that caught these journalists' attention. (That makes sense, since few had heard it on this side of the Atlantic.) Instead, it was the group's appearance and the reaction of those rampaging female mobs. "Beatlemania" was the title of *Newsweek*'s introduction to the band on page 104 in its November 18, 1963, issue. In its November 15 issue, *Time* magazine on page 64 remarked in an article titled "The New Madness" that "they look like shaggy Peter Pans. . . . The precise nature of their charm remains mysterious even to their manager." *Look* magazine called its piece "What the Beatles Have Done to Hair." Benny Goodman, the swing band hero of the previous generation, complained, "We were always busy playing the music; now they're busy growing their hair." Frank Sinatra's press agent concurred. They had, he said, "enough hair to hide two watermelons."

A report on the Beatles by Alexander Kendrick—first run on the CBS Morning News in the early hours of November 22, 1963, at about the same time Lee Harvey Oswald was heading to work at the Texas School Book Depository—was equally dismissive of the music. Cameras showed the screaming English mobs, and Kendrick intoned, "Wherever the Beatles go they are pursued by hordes of screaming swinging juveniles. . . . They symbolize the twentieth-century nonhero, as they make nonmusic, wear nonhaircuts, and give non-mersey."

In fact, Ed Sullivan knew nothing about their music when he signed them for his influential Sunday night show that would constitute their American breakthrough. He only became interested in booking them after his plane was delayed at London's Heathrow Airport on October 31, 1963, by screaming English fans who had come to see the group return from a short tour of Sweden. "I asked someone what was going on," Sullivan later remembered, "and he said, 'The Beatles!'" To which Sullivan replied, "Who the hell are the Beatles?" Still, the mob supplied much of the convincing he needed. "I made up my mind that this was the sort of hysteria that had characterized the Elvis Presley days," he said.

Yet even though the initial U.S. observers largely ignored it, Americans would soon find that the music of the Beatles was distinctive too. Epstein knew nothing of Sullivan's interest when he left for the States a

few days after the incident on the Heathrow runway. But he did have the demo of the group's upcoming single in his pocket. The Beatles knew their first records had gone nowhere in the States. So it would hardly be surprising if, in the fall of '63, they had approached the writing of the next single with an eye to trying to crack that formidable market. "I Want to Hold Your Hand" began in London in September 1963 on the piano, composed in the basement of the Wimpole Street house of Jane Asher, Paul's girlfriend. (Paul lived there on an upper floor for three years, following the group's move from Liverpool in 1963.) Like several of their early songs, it was a true Lennon-McCartney collaboration, though unlike most celebrated musical teams such as Gilbert and Sullivan or Rodgers and Hammerstein, one Beatle didn't write the lyrics and the other the music. Instead, both Paul and John contributed across the board, though soon this would translate into each writing his own songs and "submitting" them to the other for editing and improvement. (John's comments to Paul often sounded like the kind of thing a caustic schoolteacher would write to a pupil. On the margin to the lyric sheet on "Yellow Submarine," John later wrote, "Disgusting!! See me.")

Like all early Beatle songs, "I Want to Hold Your Hand" was catchy. In movies, there are countless talented actors, actresses, and directors, but the hardest thing to find is a good story. So it goes too in pop music with composers: There are great singers and players galore—many better than the Beatles ever were—but the hardest thing to find is good songs for them to sing. There weren't a great number of truly gifted songwriters in the first years of rock and roll, and of those, only a handful wrote material that they sang themselves. As the popularity of their songs over the years would attest, the Beatles' talent in both writing and singing their own work put them at the top of the class.

"It's hard to write a simple song," Alice Cooper once said. "The Beatles could do it better than anybody."

It helped the two songwriting Beatles (George's efforts would come later) that their songs had to be simple enough to be memorable. Since neither Lennon nor McCartney could read or write music, they had to create tunes they could remember well enough to convey to the other two members of the group later that afternoon or the next day. In future

years, no one would place "I Want to Hold Your Hand" in the Beatles' top 10 greatest tunes, or on any list of the greatest 100 rock songs of all time. But it was the record that altered everything in America.

Bob Dylan heard the 45 for the first time on the radio while riding in a car up the California coast in early January 1964. "He practically jumped out of the car," a friend said, according to writer David Hajdu. " 'Did you hear that?' Dylan exclaimed. 'Fuck! Man, that was fuckin' great! Oh man—fuck!' "

The novelist Joyce Maynard later wrote that when she first heard the record, "it seemed as if a new color had been invented."

Paul and John were "downstairs in the cellar playing on the piano at the same time," recalled Lennon about the composing session. "And we had 'Oh you-u-u . . . got that something . . .' And Paul hits the chord and I turn to him and say, 'That's *it*!' I said, 'Do that again!' In those days we really used to absolutely write like that—both playing into each other's noses."

Years later, John maintained that the song was "a beautiful melody." But it really wasn't. Critic Ian MacDonald pointed out more accurately much later that "I Want to Hold Your Hand" was a terrific record, but was not much of a song—which is why it was never effectively covered by anyone else. What it had was a catchy instrumental hook at the outset, followed by the characteristic well-crafted Lennon-McCartney musical hodgepodge of histrionics. "As a musician, all I can tell you is that all of their songs are full of great surprises—juxtapositions," said Ian Kimmet, a music producer.

"There's a uniqueness in their vocals and harmonies," observed Peter Curran, once a rock and roll musician and now a BBC commentator. "The songs look easy by design but they're actually quite hard to play; they twist the chords. You can see where the Stones get their chords from—Chuck Berry or someone else—but you can never tell with the Beatles."

"They were doing things nobody was doing," Dylan later remembered. "Their chords were outrageous, just outrageous, and their harmonies made it all valid."

This song was typical, from the unexpected rise on "I want to hold

your *hand*," to the odd harmonies in the bridge ("And when I touch you"), to the handclaps in the background. The "I can't hide" refrain—which Dylan mistakenly heard as "I get high," leading him to think the Beatles were already preaching a new gospel of drug use—came from a French record that Robert Freeman, a photographer, had recently played for John. ("There was one track where a musical phrase repeated, as if the record had stuck," Freeman recalled.) John then "borrowed" the technique. "We were the biggest nickers in town," Paul once said. "Plagiarists extraordinaire." Even the lyrical phrasing was given odd touches for effect, as in Paul singing, "Yeah you, *shay* that *sh*omething."

"The Beatles wrote and recorded for maximum impact," critic Jon Savage later wrote. "There were to be no gaps in the sound, no boring moments—something had to be going on all the time." It had been little more than a year since the Beatles had entered a studio on London's Abbey Road to record their first British track for influential producer George Martin. But that had largely transformed them from a performing band into a recording one. "We'd never properly heard what we sounded like until then," remembered Paul. "From then we were hooked on the recording drug." That awareness of themselves as a studio band was always in their minds when they composed their songs from then on.

The lyrics were a bit different too from what had come before in American rock and roll, where the words and phrasing often tended to the more stilted. "There's no reason why a pop song should distort everyday facts for the sake of fantasy," John once said. "It should reflect normal happening in everyday language." A lot of early Beatle lyrics sound like direct teenage conversations ("Pride can hurt you too—apologize to her!" they chanted in "She Loves You"), which the songs were, in a sense, since they were composed by John and Paul "talking" to each other at the piano.

In those days, Lennon and McCartney often wrote in the first and second person. "That was deliberate," remembered Tony Barrow, their press officer. "They told me, 'If we mention names like songs usually do, we'll attract all the Patricias and alienate all the Janes.' "

The song was also notable for what it lacked compared to its two

immediate Beatle predecessors on the English charts. There was none of John or Paul's falsetto "whoos" which had characterized "From Me to You" and "She Loves You." Perhaps they were worried about the marketability of this sound in America, after an acquaintance advised them that it made them resemble "a bunch of poofs."

Though it's seldom, if ever, mentioned, the Beatles' music resonated in Middle America that winter of '64 for another reason no one could really articulate at the time: It was terrific rock and roll without much of a hint of color, even though the Beatles covered more than their share of black artists. It wasn't intentional; it was just that the Beatles came from an environment where there were no black people to speak of, or at least ones whose sensibility had sparked—and was reflected in—rock and roll. One estimate in 1951 put the number of Asians and blacks in England, with a population of around 50 million, at around 140,000. There are stories that John's sheltered reaction when he first heard Little Richard had been, "I didn't know Negroes sang."

In total contrast to the Liverpudlians, Elvis had been mistaken for a black singer by much of his early audience. That's why a lot of the early conservative critique of rock and roll focused on the way the music encouraged racial integration. The critics had a point: Elvis had helped channel black culture into the mainstream. His social contribution, among others, was to help pluralize American culture. Rock and roll had provided a kind of musical sound track to the new civil rights struggle that had begun at Central High School in Little Rock in 1954. For example, the percentage of best-selling records by black artists went from 3 percent in 1954, the year of the *Brown v. Board of Education of Topeka* Supreme Court decision on school integration, to 29 percent in just three years.

The Beatles grew up in very different circumstances. "We never really saw black people in Liverpool," said Tony Carricker, John's friend in art school. "We knew there were blacks in America but we had no idea what it really meant. We didn't even know much at that time about the racial divide and all that Jim Crow stuff that was still going on."

The Beatles often talked about the influence of black artists such as Little Richard on their music; Ronnie Spector was struck when meeting

them how they "knew every Motown song ever put out." But it was a very odd, transmogrified kind of influence that was almost impossible to pick up when you heard them. It certainly wasn't the influence that groups such as the Rolling Stones or the Animals soon boasted of, with their adulation for old blues singers such as Muddy Waters. "There was no such thing, really, as the blues in Liverpool," said Carricker. "I'm sure John had no idea who Muddy Waters was."

This isn't to suggest that the Beatles had any kind of racist appeal. It's just that many Americans still had an implicit sense that rock music was, at bottom, "race music." The civil rights movement was the domestic story that had preoccupied the nation's attention for much of the decade before the Beatles arrived. In 1962 and 1963 that story had reached a new dimension with the struggles to integrate Birmingham, Alabama, and the University of Mississippi, plus the massive march on Washington in August 1963 that produced Dr. Martin Luther King's "I Have a Dream" speech.

If nothing else, the Beatles offered a temporary respite from all the tension. At the time of their arrival the entertainment-industry paper *Variety* conjectured that Beatlemania might be "a phenomenon closely linked to the current wave of racial rioting"; if so, it was a very different, white counterversion, which, of course, made it more acceptable. That helps explain why Albert Grossman, the onetime manager of Dylan and Peter, Paul, and Mary once drolly described the Beatles' greatest accomplishment as making it cool for anyone to be white. John Lennon agreed. "We were descendants of rock and roll," John once said. "We sort of intellectualized it for white folks."

It helped that unlike most of their American predecessors, the roots of the Beatles' music lay almost as much in the pop music of the 1920s and '30s as it did in early rock and roll—a remnant of the days when the black sound had often been less influential on the pop charts, especially in England. "I would quite like to have been a 1920s writer," Paul once said. Years later, he complained, "I always hate that my music's called 'rock' as though it's some inferior form"—a complaint one would never expect to hear from, say, Mick Jagger and the Rolling Stones or Eric Clapton, who worshipped at the feet of those blues greats.

Unlike Elvis, who grew up in the South on country and black music, the first tune George Harrison learned to play on guitar was the 1920s pop novelty hit "That Old Gang of Mine." Years later, when the Beatles were an accomplished rock act in Liverpool, their repertoire was striking in the way it included a number of pop standards or ballads more associated with old-time American performers such as Lawrence Welk and Guy Lombardo—"Sheik of Araby" or "A Taste of Honey." These numbers all fit in well with the American musical zeitgeist of 1964, in which accessible, hummable songs from award-winning musicals and movies were mainstays on the record charts.

Even the less pop-oriented John Lennon wasn't immune from the influence of this kind of music in the early days of the Beatles. When he wrote "Please Please Me," the group's first hit single in England, he began not with Chuck Berry or Little Richard in mind, but his memories of a Bing Crosby song his mother used to sing to him, "Please." "Do You Want to Know a Secret," another early Lennon and McCartney hit from their first album in 1963 (sung by George), had its roots in another song John's mother once sang from that period, "I'm Wishing," from Walt Disney's 1937 *Snow White and the Seven Dwarfs*.

Dick James, their music publisher, called "From Me to You" a "perfect Tin Pan Alley song." Without a hint of the more morose blues in their music and sensibility, the Beatles could devote themselves exclusively to making their audience feel good. No Heartbreak Hotels for these four.

All this help explains why blacks didn't participate in Beatlemania when the Beatles hit the New World—buying their records in far fewer numbers and staying away from the concerts. (It goes without saying that there wouldn't be much of a market for Beatle wigs in the black community.)

"I remember when they arrived," said Randall Kennedy, now a professor at Harvard Law School and a noted scholar of black culture and history. "We laughed at all the white people going crazy, though there was also a little resentment. We'd hear the Beatles do 'Twist and Shout' and we'd think 'What about the Isley Brothers version of 'Twist and

Shout?' It was yet another instance of white people finding they could only identify with other white people."

Besides, said Professor Kennedy, who was a fan nevertheless, there was no way you could dance to that "stuff" by the Beatles. "It wasn't soul music," he said.

There was another thing about the Beatles that bothered black people more than whites. "To the black community, the Beatles come across as young boys. Everything about them smacks of boyhood," wrote Larry Neal, a black poet and critic, a few years later. "In a world where a manly image is highly valued, there is no place for little boys."

In addition to seeming less threatening to white audiences than Elvis and many of rock's early pioneers, the Beatles appeared less intimidating for another reason—they didn't flaunt their sexuality. Their songs spoke innocently of hand-holding. "It was safer to love them" was how Ida S. Langsam, who was New York City area secretary of the official Beatles Fan Club, put it. The psychologist Joyce Brothers soon noted that that the band's effeminate characteristics were "exactly the mannerisms which very young female fans (in the age ten-to-fourteen group) appear to go wildest over."

"I remember when they first arrived," said Elaine Tyler May, now a history professor at the University of Minnesota but in high school in 1964. "Every girl wanted to be treated the way their songs indicated they would treat them. There was a sweetness and gentleness in their view of women and romance."

Thus, younger kids could also embrace the group without feeling they were joining some kind of cadre of juvenile delinquents, which had always been the implication as long as rock was associated with the James Deans of the world. It meant, too, that their parents could tolerate, if not like, the Beatles—an acceptance that was aided by the group's embrace of those inoffensive pop tunes such as "Till There Was You," a ballad from *The Music Man* that Paul sang on the band's first *Ed Sullivan* appearance.

It also aided their ascent that broadcast outlets were far more heterogeneous then than today: That helped expose the Beatles to a wide

audience. In 1964, American Top 40 pop radio stations tended to play a bit of everything: One could hear the Beatles, Patsy Cline, Frank Sinatra, and James Brown in the same half hour. Thus, soon after they hit it big on American shores, the Beatles' songs were being performed and recorded by everyone from the Boston Pops to Chet Atkins.

The Kennedy assassination on November 22, 1963, just after Epstein's visit to set up their trip, also helped create a climate that propelled the Beatles' rise. It did so, however, in unforeseen ways—primarily by creating a vacuum for another pop superstar (or set of them) to fill.

After rock and roll's striking debut in the mid-1950s, the music had entered a somewhat fallow period. Elvis went into the army; Chuck Berry was arrested for traveling across state lines for an "immoral" purpose; Jerry Lee Lewis married his thirteen-year-old cousin, which sent him into temporary exile; Little Richard found religion and swore off "the devil's music"; and Buddy Holly was killed in a plane crash. Into the void in the early sixties rushed bland white teen idols such as Paul Anka, Fabian, and Bobby Rydell, who were little more than younger versions of middle-aged pop crooners like Perry Como, host of a weekly television show, whose calling card was his utter blandness. ("Did you see Perry Como last night?" went the joke. "No, I fell asleep." "That's funny, so did he.") It was fitting that one of the big hits of 1963, "Dominique," was by a French nun. That void in American rock and roll in the early sixties was one of the things that allowed the Beatles to make such an impression with their music.

Yet, in an odd way, that same vacuum in the culture had also enabled President Kennedy to become the icon of the young—a kind of "New Elvis." His election in 1960 seemed to portend generational change: At forty-three, he was the youngest man elected to the presidency as he replaced the oldest one until then to hold the office. Kennedy went on to surround himself with advisers who were often even younger, including his brother Robert, the new attorney general and all of thirty-four. As the new president put it in his inaugural address, "The torch has been passed to a new generation of leadership."

It's hard to overstate—and sometimes to understand—how much the youth of the day identified with the first family's idealism and vigor (or "vigah," as JFK put it). It was a bond the president often emphasized himself, whether stressing physical fitness in the nation's schools or by creating the Peace Corps—labeled "Kennedy's Kiddie Corps" by the media. Within two years of his inauguration, around seven thousand volunteers had been dispatched to almost fifty countries, including many women who were given a chance to serve the nation in ways formerly open only to men. The president's rhetorical theme "to get America moving again" constantly played on an exalted sense of youth and dynamism. The young—and a not inconsiderable number of their elders—imitated John Kennedy's New England accent, his style, and the way his wife dressed.

Kennedy also created a cultural appetite for excitement, movement, and newness that both the press and the public seemingly could not get enough of. The mobs that followed him abroad weren't that different from those that soon assailed the Beatles. George Howe Colt later wrote in *Life* magazine:

> *We were spellbound by Kennedy. That summer [of '63] we could read his best-selling book about courageous men or watch a movie chronicling his own heroism on a PT boat in World War II. When he toured Europe in late June, we watched people there receive him as if he combined the best qualities of Elvis Presley and the pope. In West Berlin nearly 2 million people lined the streets, shouting "Ken-nah-dee"; women broke through police barriers to touch him; a thousand people fainted.*

When Kennedy was assassinated the nation took it hard, but surveys showed the young took it the hardest.

In those subsequent weeks of national depression, the Beatles made their appearance. Again, their Englishness helped them. They were fun and funny: It would have been inappropriate for anyone American to be as joyous as the Beatles were in the wake of such a tragedy. "Suddenly it

was a good flash," said Jerry Garcia of the Grateful Dead, describing the impact of the Beatles in the early days. "A happy flash. Post-Kennedy assassination. Like the first good news."

Without Kennedy, the culture was looking for someone else to, as he might have put it, pick up the torch for a nation now hooked on the glamour, thrill, and ferment of youth. "The Beatles filled an emptiness in our lives, something we all lacked in our hearts," said Robin Richman, a reporter for *Life* magazine. "We were starved and ready for them."

Thus the group and its manager caught the wave at precisely the right moment. That fall of 1963, at Epstein's urging, Capitol finally reversed its previous decisions and agreed to release "I Want to Hold Your Hand" with a large accompanying promotional campaign. George Martin had been lobbying EMI's affiliate for months; Capitol agreed to the reversal only after Eppie personally approached Alan Livington, the company president.

But the likeliest reason Capitol shifted course and began to embrace the Beatles to the extent it did was that Ed Sullivan had agreed to headline the group. There was no better way to sell a record than through television, and there was no better show to appear on than *The Ed Sullivan Show*. His influence on American culture was enormous; the show's televised rendition of old vaudeville was usually viewed by around 40 million Americans each week. Every Sunday night at eight o'clock, Sullivan put his version of the *Good Housekeeping* seal on everyone from Elvis and Bob Hope to Topio Gigio, the Italian puppet, and Itzhak Perlman, who appeared when he was thirteen years old.

This was in an era, long gone, when most families had only one television and there were only three broadcast outlets; anyone on *Sullivan* was performing for the masses—the young and old; black and white; rural and city dweller. After its debut in the fifties, rock music became a regular part of the show, sandwiched in between the introductions of celebrities from the audience, the tumblers, the comedians, the dance troupes, and the musical singers. The first night the Beatles appeared on *Sullivan,* they shared the stage not only with the cast of *Oliver* but also with Mitzi McCall and Charlie Brill, a comedy team, and Wells and the

Four Fays, a tumbling act who will forever remain an answer in trivia contests.

Signing up the Beatles was a leap of faith on Sullivan's part, albeit a cheap one. (He paid them less than half what he usually paid headliners and a pittance compared to what he had paid Elvis.) With the *Sullivan* appearances scheduled for February, Capitol set the release of "I Want to Hold Your Hand" for after the December holidays, often among the worst times of the year to premiere anything new because it's right after the biggest buying season of the year. The promotional campaign would focus on the group's odd name and their even odder hairstyle. Epstein, careful to limit the group's exposure, also scheduled three live concerts for that first tour—one in Washington and two at New York's Carnegie Hall.

In the weeks following the JFK assassination—even before the release of "I Want to Hold Your Hand" in the U.S.—the Beatles began to make their mark on America. With word of the *Sullivan* appearances leaking out and anxious for any kind of "good news," several American news organizations followed up on the early media reports that had highlighted the mobs and their hair. On December 10, Walter Cronkite showed a brief clip of the group on the *CBS Evening News* as he replayed the Kendrick piece that had originally run on the morning of the assassination.

"It was not a musical phenomenon to me," said Cronkite, who was also his broadcast's managing editor. "The phenomenon was a social one." *Billboard* first focused on them in a story on December 14. Meanwhile, a DJ in Washington, D.C., Carroll James, got a copy of the British version of "I Want to Hold Your Hand," which had already been released in the home country, and played it every night on his WWDC show to great audience response. A few other stations across the country followed. When Capitol heard that news, it scrapped the scheduled release date and issued it immediately.

On January 3, 1964, Jack Paar, the former host of NBC's popular late-night *The Tonight Show* and at the time the host of a weekly prime time show on Friday, played a tape of a Beatle performance in England,

six weeks earlier. Like so many other Americans in those early stages, he was far more mesmerized by the group's appearance and the uproar than by the music. He began by saying he was interested in "the sociological phenomenon."

"These guys have these crazy hairdos and when they wiggle their head and the hair goes, the girls go out of their minds," he said. "Does it bother you to realize that in a few years these girls will both raise children and drive cars?"

In New York, Ida Langsam was awakened by her mother. "My mom said, 'You have to see this thing from England.' I thought the music sounded good but I told her, 'The hair has got to go.' " With her friends, Ida began scouring the newsstands for news of the group and its impending visit. "The magazines didn't know what they were doing," she said. "They couldn't tell them apart. I thought I had a crush on John Lennon and it was really Paul McCartney because the magazine had mislabeled the picture."

Meanwhile American reporters began interviewing the Beatles during their appearances in Paris, where Epstein had booked them into an expensive suite at the George V to impress visitors. With word spreading about the early February *Sullivan* appearances that would bring the group to America, Capitol decided to take a chance and kick its campaign into a higher gear. It distributed 5 million "The Beatles Are Coming!" stickers; the accompanying promotional poster featured the slogan surrounded by four heads of hair. Capitol also ordered up thousands of wigs for its sales and promotion staff to wear. "Get those Beatle wigs around properly," a merchandising memo from Capitol read, "and you'll find you're helping to start the Beatle Hair-Do Craze that should be sweeping the country soon."

Capitol also cleverly (though not with the strictest journalistic integrity) released a tape of Beatle interviews with the recorded questions missing so any local radio DJ could play the tape and pretend to be questioning the group live. The publicity blitz also benefited from a pattern that had begun after the weekend of the Kennedy assassination—when the whole country had gathered around televisions to experience tragedy collectively—in which Americans seemed massively drawn to

any kind of diversionary home entertainment. Ratings were seldom higher across the board for *virtually anything*. For example, seven episodes of the TV sitcom *The Beverly Hillbillies* in the weeks following the JFK assassination became among the most widely watched half-hour shows in TV history.

In this environment, in a usually slow time of year, DJs all over the country pushed the Beatles and the record incessantly. Those radio DJs, of course, were the organizers with the medium to push "the bug." Teenagers had a special relationship with radio then that doesn't exist now; it was the essential medium in the rise of the postwar American rock and roll culture.

Television was a mainstream medium; teenagers constituted only about 10 percent of the viewing audience. Teens also tended to form an insular audience, preferring TV shows that no one else liked such as *American Bandstand*. Thus, television pitched them few offerings, and even when it did, teens often had to watch with their parents because many households still had only that one television set.

In contrast, local teen rock radio—a phenomenon that had arisen about a decade earlier—reached the youth of the nation alone in their bedrooms, where they weren't bothered by their parents, or via portable transistor radios, or through car radios heard while cruising Main Street in an Olds. To play the songs, many of these stations featured disc jockeys, the louder and more outrageous the better. These DJs became local personalities in their own right and attracted large local followings—Murray the K and Cousin Brucie in New York or the WPGC Good Guys in Washington, D.C.

Increasingly caught up in the growing fascination with the Fab Four, these DJs now competed with each other to see who could talk about the Beatles the most. "What sells records is radio," said one official of Capitol Records. "The Beatles got unbelievable radio play. There wasn't a single market in the country in which the air play wasn't simply stupendous." There was a way in which the Beatles gave the "fever" to everyone they touched, as millions now scrambled to get aboard. The DJs went wild, the reporters went crazy, and the screaming girls did too.

"It was like the O.J. Simpson of its time yet so much bigger," said

Christina Berlin. "It was pervasive. The discussions never stopped because there were four of them—who was the cutest, who was the toughest."

As they prepared for their trip that January, the Beatles obtained H-2 work permits that allowed them to come and play their music "so long as unemployed American citizens capable of performing this work cannot be found." And their record played incessantly. They soon learned that "I Want to Hold Your Hand" had gone to number 1 in the U.S. as it sold over 3 million copies, becoming the fastest-selling single in the history of recorded music.

"The Beatles were everywhere," said Robin Richman, "and they were drop dead cute. They hit like a tidal wave and they just got bigger and bigger."

"Excitement wasn't in the air; it *was* the air," was the way rock writer Greil Marcus later put it.

Any skepticism that had dogged the Beatles about Brian Epstein's wisdom in pushing the voyage dissipated as they heard the screams on the New York runway. The history of that American tour from February 7 to February 22, 1964, featuring their three appearances on *Ed Sullivan*, has become a part of pop culture folklore. There were the crowds of girls lining the streets and singing "We love you Beatles" outside their hotel windows (to the tune of a song from yet another recent musical, *Bye Bye Birdie*); the unexpected cleverness and cheeky humor they displayed at press conferences; the wave of music that ensued; and their meeting in Miami Beach with a brash young boxer named Cassius Clay, who two weeks later would upset Sonny Liston to win the heavyweight championship and then change his name to Muhammad Ali.

In today's media-segmented world, it is virtually impossible to perceive how pervasive the Beatles were during their first few days in America. "America gets madder, crazier, wilder about our Beatles every second," gushed the *London Evening Standard*. "Coast to coast yesterday the news was 'Beatle has bug.' George's 'strep' throat came first, Cuba, Cyprus, etc., came after." Someone estimated that at least one of the New York teen rock and roll stations played a Beatle song every four minutes. The University of Notre Dame radio station played "I Want to Hold

Your Hand" for an hour straight, at which point, according to *Billboard*, "students responded by storming the studio en masse." A *Billboard* headline said it all as the president visited New York at the same time: "LBJ Ignored As N.Y. Crowds Chase Beatles."

Their first *Ed Sullivan* appearance on February 9 attracted more than 70 million viewers—the largest audience for a nonnews event in the history of television until then—as well as fifty thousand requests for the 728 seats in the studio. The sixties as an era began that night: The Beatles were on stage for thirteen and a half minutes, singing and smiling their way in matching suits through a virtually unprecedented (at least for *Sullivan*) five songs—"All My Loving," "Till There Was You," "She Loves You," I Saw Her Standing There," and "I Want to Hold Your Hand"—though in George's case, the smiles may have been due to the amphetamines he had reportedly been given to get his strep-ridden body through the performance.

What struck many of the technicians at the show was how professional the group was. Unlike other acts, they rehearsed much of the afternoon and asked these technicians to play back the rehearsal and then adjust the sound so their instrumental accompaniment would be as loud as the lyrics. Epstein also asked Sullivan at the rehearsal for a copy of the host's introduction so he could check it, which prompted Sullivan to respond, "I would like you to get out of here." Still, Brian managed to plant a number of the questions at the press conferences. "I was fifteen and I was there because my father was a media executive," said Christina Berlin. "Brian asked me to ask, 'Do you like American girls?' "

Many adults, at least those in the media establishment, still didn't get it: Media reviews of the first *Sullivan* appearance tended to be awful. The *New York Post* described them as "asexual and homely"; the *New York Herald Tribune* dismissed them as "75 percent publicity, 20 percent haircut and 5 percent lilting lament." Other mainstream media outlets soon joined in the critical barrage, calling the band "the anti–barbershop quartet" and "an infestation."

Despite the grouchy reviews from grown-ups, however, those who saw the Beatles for those two weeks in February 1964 had their own glimpse of a new phenomenon. "If you told the tough guys they [the

Beatles] were better than Elvis, they beat you up," said one male New York teen who preferred the Beatles. So, like others, he talked about his new heroes "only to the girls."

"It was so much fun just to be part of something with so many other people your age," said Christina Berlin.

By April, the Beatles had the top five songs on the American charts and seven others in the top 100. The traditional equation in the American entertainment industry, which had seen TV and movie revenues higher than those for music, was on its way to being reversed. Meanwhile in Australia, the Beatles had the top six singles on the charts. The group now belonged to a fair part of the Western world, if only temporarily, since few expected them to last, including themselves. "They'll never see us again," said George on that first tour of America.

The Reverend Billy Graham agreed. "They're a passing phase," he said, "symptoms of the uncertainty of the times and the confusion about us."

Yet they were all wrong; it was only the beginning. The Beatles were able to keep the match lit for six more years—changing music and transforming the culture. How and why did they come to rule the world? The reasons had begun back in Liverpool, in England, a long time before.

LIVERPOOL: ROOTS AND REGRETS

T H E first thing we did," John Lennon once said, "was to proclaim our Liverpoolness to the world."

The northern English shipping city was the Beatles' anchor. Even though they moved south to London in 1963 never to return permanently, the boyhoods of all four under the "blue suburban skies" remained a major frame of reference throughout their career. As they came to broaden the subject matter of rock, they became like novelists, using autobiographical fragments of their past in songs such as "Penny Lane," "Strawberry Fields Forever," and "In My Life." Their attitudes to one another, to women, to style, to homosexuality, and to the idea that a group of equals was the best way to create music were all deeply shaped by their experiences as boys in Liverpool.

"Perhaps the greatest wonder of the Beatles and the greatest delight was that they actually came from Liverpool," their press officer and confidant Derek Taylor said. "That was the key to this thing. It was four Scouses [the common slang term for Liverpudlians] exploring inner space and finding just more and more Scouseness down there."

If America had been unimaginable to the Beatles before they arrived, the postwar Liverpool of over a million residents in which they grew up was even more incomprehensible to their American audience.

It wasn't even well understood by the inhabitants of London around two hundred miles to the south. "It *is* different," Derek Taylor once wrote. "It isn't England." Benjamin Disraeli had written a century earlier that northern and southern England were two nations "between whom there is no intercourse and no sympathy, two areas ignorant of each other's habits, thoughts and feelings, as if they were dwellers in different zones or inhabitants of different planets."

To Londoners, Liverpool seemed almost like the frontier—impertinent, emotional, and a lot less important than the capital city, which was considered the center of almost everything the establishment considered English. This sentiment contributed mightily to the sizable chip on northern shoulders that fueled a kind of antiestablishment attitude. Liverpool was a place, remarked one critic, that marked you for life and identified you as something of an outsider—a sensibility that was enhanced in a town populated by sailors, who have always tended to view themselves as outsiders as well.

"We were the ones that were looked down upon as animals by the southerners, the Londoners," John recalled. The rest of England told "Scouser" jokes the way Americans tell ethnic ones, as in:

Q: How does a Scouser make an omelet?
A: First, steal five eggs, then . . .

"Growing up, we didn't even see people from the south of England," said Rod Davis, John's schoolmate at Quarry Bank School and an original member of the Quarrymen, the band that eventually became the Beatles after numerous personnel changes. There was no hiding one's origins either, unless a Liverpudlian lost the distinctive, harsh accent that a scholar described as having a "built-in air of grievance." Early in his career, it was said Paul tried to fulfill one of his mother's abiding wishes and lose his accent, but he never did.

The city's residents had a reputation as irreverent, compulsive comedians: Liverpool was close enough to Lancaster to identify with movie and music hall comic great George Formby, and it had its own comic celebrities such as Ken Dodd. As one of the busiest seaports in the

world during its heyday, Liverpool was also more diverse than the rest of the United Kingdom, at least outside of London. It had the nation's first Chinatown and so many Welsh immigrants that in the nineteenth century it was the largest "Welsh" city in the world. During the famine of the 1840s, its population almost doubled, as close to four hundred thousand Catholic Irish emigrated across the Irish Sea, including the ancestors of John Lennon, Paul McCartney, and George Harrison. For decades, one area of the city even had an Irish nationalist for its representative in Parliament. Heathcliff of *Wuthering Heights,* the great outsider of Victorian literature, was, fittingly, Liverpool Irish.

At its sea-trading zenith, the port city had great wealth built substantially on the slave trade, which gave it a special affinity for the American South that would later translate into a love for its music. Daniel Defoe wrote in the early eighteenth century that "no town in England, except London, can equal Liverpool for the fineness of its streets and the beauty of its buildings." Herman Melville, too, had nice things to say about it a century later. In the early part of the twentieth century, the city had over ten theaters and the oldest repertory playhouse in the country; Sir Malcolm Sargeant and Sir Thomas Beecham conducted the Liverpool Philharmonic Orchestra. Even today, its Liver Building by the old port and its concert hall remain two of the finest examples of Victorian architecture in the country.

By the time all four Beatles were born in the early 1940s, however, the city was already marked for what would become a terrible decline. Airplanes had begun to take the place of ships in the network of transportation; John Lennon's and George Harrison's fathers, both seamen, eventually had to find other work. World War II devastated the city as well. Liverpool's strategic port status made it a major focus of Nazi bombers and the second leading target in Britain after London. In a single week in 1941, around a thousand people were killed; by early 1942 close to 70 percent of the homes in the city had been damaged. After it was all over, few had the money to rebuild many of the ruins, and Liverpool may have done the worst job on the continent to repair the war damage. "My play area was the rubble that were the remains of the zoo," said Brian Gresty, a schoolmate of John's at Quarry Bank School.

"About one-third of the downtown had been bombed," remembered Iain Taylor, a classmate of Paul's at the Liverpool Institute, his secondary school. "Ten years later, there was still a lot of broken glass around—we threw bricks at each other all the time. We thought of it as a kind of adventure playground."

The myth about the Beatles is that they were four hardscrabble working-class boys who made good. In fact, in Liverpool, three of the four (Ringo excepted) were considered relatively well off given the condition of many of their fellow Liverpudlians. They came from south Liverpool with its garden suburbs, which meant to their compatriots that they weren't "proles." Paul and George lived in state-subsidized housing, but at the time, there was little stigma attached to living in state-supported "council houses" and many upwardly mobile families did so.

Yet what passed for a cozy domestic life in England would have been considered abject poverty across the Atlantic. Life was drab: "We had no color, literally, because we couldn't get paint during or after the war," remembered Tony Carricker, a close friend of John's from art school. "We were in black and white—America was in color." Of the four, only John spent part of his early boyhood in a house with indoor toilets, which was hardly unusual because fewer than half of British households had them at that time. The routine diet was so poor that the average weight of working-class children actually increased during World War II simply because they were given one-third of a pint of milk a day and cod liver oil tablets by the government.

Lingering constraints from World War II created a daily life in the 1950s that contrasted sharply with the postwar affluence of the United States. (That's one reason that the English counterculture never developed much of a critique of consumerism and affluence like its American cousins did.) Because of strict postwartime restrictions that lasted until 1954, one needed a prescription to obtain orange juice. Even after the war, fresh eggs were often out of the question, so families ate powdered ones. In Liverpool, if there was word that a store would have cooking apples, the queue was known to start at 6 a.m. and reach a mile long; each customer was usually allowed only one.

In 1956, less than 10 percent of the country had refrigerators, but as

Iain Taylor remembered, "English houses were so cold that they were just like one walk-in refrigerator." Paul recalled freezing winters as a child and having chapped knees; George similarly remembered the only heat at night often being a hot-water bottle. Many families burned jam jars, old shoes, and potato peelings in the fireplace for warmth. (For the lucky, coal was delivered by a horse wagon accompanied by a guard to prevent people from stealing it during the delivery.) To get electricity or heat, many fed a meter: no coins, no "juice." The day meat rationing ended in July 1954, when John was thirteen and Paul twelve, crowds gathered on corners to sing "The Roast Beef of Old England."

Like many other seaports, Liverpool was a tough town and a city of bars (which in England meant pubs), sometimes four to an intersection. "There were a lot of really angry people around," Ringo remembered. Visiting there in 1964 for a book on England, Geoffrey Moorhouse observed that Liverpool was the only city in the country where one had a fair chance of getting mugged or could expect street fighting to break out at any minute. "The Mersey sound," wrote the *Daily Worker* later, "is the voice of 80,000 crumbling houses and 30,000 people on the dole."

Originally the innumerable Liverpool drinking establishments (extensive even for England, which likes its alcohol) served an economic function. They were informal business centers—the places where seamen, like the fathers of John and George and the future father-in-law of Ringo, often met to arrange work at the docks or passage on the next voyage. Sailors could disappear for months or years at sea with little or no planning. There was an old joke in Liverpool about a husband who went to buy cigarettes, only to return several years later. Pauline Lennon, the second wife of John's father, entitled one chapter of the biography of her husband "Married to the Sea," and the label could apply to hundreds of thousands of Liverpudlians who made their living, one way or the other, from the city's maritime position. Liverpool's seaport status set the tone for most of its citizens, even if they didn't work in the industry. It's no coincidence that when the Beatles later wrote a song of escape, it would be "Yellow Submarine"—a song of the man who went to sea. (Even today in Liverpool men still greet each other as "mate.")

Though it's seldom mentioned in analyses of the Beatles, Liverpool's

status as a major port had two major effects on male and female roles that affected the group. First, like other port areas, it fueled a booming gay subculture both in some of the city's pubs and, more important, on ships, where the repressive English laws against sodomy were rarely enforced. Brian Epstein, their future manager, was hardly the only gay man in Liverpool.

In fact, more than a few stewards on ships were said to be gay (or bisexual), and the crews often had elaborate ceremonies with feasts where men would cross-dress and "marry" one another. One steward who loved to direct such routines was Freddie Lennon, John's father. "There was little prejudice against the gays on the ships where they were well accepted," wrote his second wife in her biography of her husband.

What's more, the notion that a man can be both macho and effeminate is typical of port and sea existence, where, in the old phrase, "Ashore it's wine, women, and song—aboard it's rum, bum, and concertina." (The more modern version is "Nothing is queer once you've left the pier.") Though rarely discussed, especially in polite English company, gender bending is hardly unusual in a sea culture.

Liverpool's status as a seaport had another effect on gender relations: With the men often absent and the Irish influence strong because of the earlier migrations and the proximity to Dublin and Belfast, Liverpool domestic life had a matriarchal tone unusual for much of the rest of England. Often left home in charge while the men were at sea (or drunk), women ruled the roost. "Liverpool women are stronger than the men," observed Lynne Harris, who used to watch the Beatles at Liverpool's Cavern Club in the early sixties. "Especially the mothers. They had to be to support their families and one another. It's still true. My husband isn't from Liverpool and he's always asking me, 'Why do you have so many interesting women friends from Liverpool that have such boring husbands?' "

Painfully, however, in that culture of matriarchy, two of the Beatles lost their mothers at formative ages. This ended up shaping their outlook profoundly. Paul's mother died of cancer when he was fourteen. John was raised from the age of five by an aunt, and around a decade later, after his mother finally reappeared in his life on a frequent basis

when he was a teenager, she was struck by a car and killed. "I can't remember anything without a sadness so deep that it hardly becomes known to me," John wrote his close friend and bandmate Stuart Sutcliffe in 1961. As for Paul, when his mother died in October 1956, he went into his room and began strumming a guitar. A few weeks later, he had composed his first song, "I Lost My Little Girl." You don't need to be Sigmund Freud to see the connection.

Mary McCartney, Paul's mother, had kept her family together. A nurse and midwife, she had the family move numerous times during Paul's boyhood—always to a better home. (Though they didn't have an indoor toilet until the last home at 20 Forthlin Road, they usually had a phone because she was a midwife, and people needed to reach her.) She traveled to work on a bicycle in her uniform and hat, as the family couldn't afford a car. She was the major breadwinner in the family, which explains one of Paul's first comments after she died: "What are we going to do without her money?" When Paul went to Hamburg in the early sixties, the story around town was that he was now making more money than his dad. Father Jim McCartney held a variety of jobs, ranging from a cotton salesman to an inspector for the city cleaning department following around the sweepers.

Mary's childhood in Liverpool and Ireland hadn't been easy. Her own mother had died in childbirth in 1919 when Mary was nine, which might explain her later choice of career. As the story goes, she intensely disliked the woman her father remarried, so she moved out as a teenager to live with an aunt and continue to train to be a nurse. She remained unmarried throughout her twenties, which was hardly unusual in an England where there were 2 million more women than men because World War I had killed one eligible man in seven. In the 1930s, wrote one historian, old age was defined as anyone over thirty.

Mary met Paul's father in 1940, while visiting his sister, when an air raid forced everyone to remain in the house all night. Jim was thirty-seven and played in a dance band on the side. Later, he told Paul how it was important to play an instrument because it got one invited to the best parties. He was known as a man-about-town with a slight weakness for gambling; his family thought he had long since passed the age

of marriage. Nevertheless, the two wed in a Catholic ceremony less than a year later, and fourteen months after that James Paul was born on June 18, 1942. His brother Michael followed two years later.

It's been almost fifty years since Mary died, so memories have clouded over time. Paul has said he remembers her whistling a lot and one time insisting they move because he was getting too much dust on his face in the house. It's clear she ran a tight household, even though she was often working away from home. Both boys went to Sunday school and Paul was a model student. Because his mother was a nurse it was evidently expected that Paul would become a doctor, and had she lived, he might well have followed her wishes. By the age of eleven, the boys, whom their father described as inseparable, had done well enough on their entrance exams to attend the all-boys Liverpool Institute, considered by many the city's most prestigious grammar school. Paul was in the top part of his grade, winning prizes for such endeavors as an essay on the monarchy.

In the summer of 1956, Mary kept to herself the pains she was having in her chest, taking an antacid for relief. She left for the hospital in late October, only days before she died of breast cancer, asking the boys to throw out the flowers in vases around the house before they wilted away. Before the boys visited their mother at the hospital, Paul's aunt inspected them in their school uniforms to make sure their shirts were clean and their hair was well combed; they were apparently unaware how ill she was. Paul's father was so distraught after her death that the boys were taken to an aunt's house to stay. Paul later told Dot Rhone, his girlfriend for three years beginning in 1959, that while he remembered his father crying and how much that scared him, for his own part he couldn't stop laughing hysterically (a not unknown reaction to trauma).

Sociologist Lynn Davidman has written extensively about the devastating effects of a mother's death on a child. Children who lose their mothers tend to idealize them and adopt a romanticized view of women that they never fully discard. Yet at the same time, these children tend to have furious bouts of anger against women. They often suffer from recurring episodes of depression throughout their lives. They tend to divide their lives into "before and after." The experience is so painful and

profound that it often sets people on a different life course. It almost always means changed routines, the end of a protected childhood, and an irrational feeling of shame on a return to school and friends.

Paul seems to have fit the pattern. Though his numerous paternal aunts often tried to help out, he became something of a latchkey child. The boys helped with the cleaning and laundry, which had to be done in the kitchen sink. Even when Paul was playing the Cavern Club years later, friends remembered, his father would drop by the club to leave off a clean shirt so Paul could change out of his sweaty clothes, or a bag with a piece of meat or sausages in it with instructions on how Paul should cook it. This all had a profound impact on the young McCartney. Years later, the group's press officer, Tony Barrow, noticed "that the thing with Paul was that he always wanted women about him—to look after him. He didn't like the idea of fending for himself." It was something even his fans picked up. "He brought out the mother in me," said one.

After his mother died, Paul's father had bought him a trumpet. Instead, he took up the guitar in earnest and began writing his own songs. For the rest of his life, it would be striking how many of Paul's better lyrics recalled his "mother Mary" (as in "Let It Be") or referred to the experience of her dying (he elicits his thoughtless initial reaction, if only subconsciously, in "Yesterday"). Even the corny "Your Mother Should Know" has more meaning when viewed through the prism of Paul's past.

The more frequent way he dealt with his mother's death, he later said, was by putting a "shell" around himself. Throughout his career, he would become known for writing songs in the third person, which put emotional distance between the writer and his lyrics. He often used his music to create elaborate stories about other people—Eleanor Rigby or the Liverpool characters of "Penny Lane." Even in interviews, biographer Chris Salewicz complained, Paul's "agility as a communicator has been the paradoxical mastery of revealing nothing whatsoever of himself."

He rarely talked about his mother to friends, though Dot Rhone remembered how once he oddly looked up from a book featuring a picture of Jesus and remarked that it looked like his mother. From the time of Mary's death on, Paul's friends—especially his girlfriends—also noticed that he frequently seemed more interested in spending time with

their mothers than with them. Iris Caldwell, a Liverpool girlfriend when they were in their late teens, remembered how Paul would sit in a chair at her home and roll up his trousers so her mother could comb the hair on his legs. "Paul liked her because she was a real mum," she said, and long after they had broken up, Paul frequently dropped by to see Mrs. Caldwell with other girlfriends such as Jane Asher. He listened to the suggestions of these mothers, too. Mrs. Caldwell once complained to Paul that he lacked emotion. After writing "Yesterday," he phoned her long-distance to tell her he was about to perform a new song he had written. "You know that you said that I had no feelings?" he told her. "Watch the telly on Sunday and then tell me that I've got no feelings."

It also struck outsiders that Paul never seemed happier than when he could walk into a settled home and become part of a family. While the other three Beatles got their own flats in London in 1963, Paul instead moved in with his girlfriend's family, the Ashers. The off-duty policeman who was guarding the group in Miami during its first trip to America in 1964 was floored to find Paul hanging out with the guard's children. "He sat there reading with them—he was completely at home," the officer recalled. "The others were embarrassed, especially John—he couldn't stand that sort of thing." Even John's son Julian remembered that in the sixties, "Paul and I used to hang out quite a bit—more than Dad and I did. Maybe Paul was into kids a bit more at the time." It's not surprising that, years later, Paul's music with the Beatles and Wings— the band that included his wife, Linda, who also lost her mother as a teenager—often celebrated the joys of domesticity.

When his mother died, Paul's life in school changed too. Alan Durband, his adviser at the Liverpool Institute, sent a note to other teachers giving them the news. "He did go through a bit of a rough patch then," Durband told a journalist. "I think it shattered him a lot; maybe it made him turn to other things, like practicing his guitar and getting away from the school's environment, which was very academic." Paul's grades began to dip a bit. Soon, "he had a bit of a reputation for the way he dressed and acted," remembered Iain Taylor. "He was a real piss artist: I remember someone saying when he had him in class, 'We're going to

have some fun this year!' " He played the guitar day and night, and drew pictures of the instruments at school.

"What can I do?" Paul's father asked a neighbor. "The boys have lost their mother; they've got to have *something.*"

There was one other thing that followed in the wake of his mother's death. Nine months later, in the summer of 1957, Paul met John Lennon and his new bandmates, who called themselves the Quarrymen, at a summer fete in nearby Woolton. He joined up and they soon became a kind of surrogate family. Had Mary McCartney lived, it's highly unlikely she would have allowed him to become a Quarryman or, perhaps, that he would have needed to.

If Paul's childhood had been relatively stable until his mother's death, John Lennon's had been anything but. Though he hardly lacked for material possessions, John had had a horrific childhood, despite efforts by the group's publicity machine then—and some of his family since—to make the story sound more palatable. When the group released its "official" biographies for the press in 1963, John's read that his mother died before his fourteenth birthday. "After Mum died," it read, "I went to live with my Aunt Mimi." In a 1963 interview, he talked of his parents as if his family had been intact and "normal." He told a reporter: "My parents used to say to me years ago, 'You're not seriously thinking of making a career in that line.' I replied, 'No!' I was kidding them really because I didn't have any intention of doing anything else." When Hunter Davies penned his semiauthorized biography in the late sixties, John's aunt Mimi insisted he write that as a child "John was as happy as the day was long."

The truth was a good deal more complicated and far more painful. John said that, like everyone he knew, he was "born out of a bottle of whiskey on a Saturday night." His father, Alfred ("Alf" or "Freddie") was raised in an orphanage and at sixteen was about to go to sea from Liverpool when he met Julia Stanley, then only fourteen. She had long red hair, lived at home as the fourth of five girls, and, with a reputation for never being serious, had already been sacked from one job for her "pranks." Years later her daughter (and John's half sister), Julia Baird, said, "She took nothing seriously, except having a good time."

Julia saw Freddie on and off for years when he would come back on leave; her father apparently sought to break up the courtship by trying to arrange longer voyages for her beau, hoping she would meet someone else in the interim. When they finally got married, their honeymoon was a trip to the movies.

Whether John was conceived on the kitchen floor, as he maintained, will never be known. What is known, however, is that from the time of his birth until he was over three, Freddie was around for only about three months and missed his son's birth on October 9, 1940. John later described his childhood as one in which "men were just invisible," which gave him, as he put it, his "first feminist education."

Julia had a sister, Mimi, who was almost ten years older and childless. Married to George Smith, who was in the dairy business, Mimi was in many ways Julia's opposite in temperament. Yet almost from the beginning, there seemed to be a question about who should raise John. Years later Mimi told an interviewer that Julia used to say, "You're his real mother. All I did was give birth." Yet this all seemed somewhat out of character for Mimi because, as one of John's cousins, Stanley Parkes, recalled, "Mimi didn't want to have children; she couldn't be bothered with children. She would stand us for so long and then send us off to another aunt."

"I brought him up from a few weeks old until he was twenty-one," John's aunt said later, which contained some inaccuracies, as Mimi's recounting of the past often did. The truth is that John spent much of his first five years with his own mother. When he was little, his mother, bored with staying home and waiting for her seafaring husband, apparently began going out at night and leaving the toddler home alone. He was often terrified. "One night," John's assistant Fred Seaman quoted him as saying much later, "I saw a ghost just outside the window and screamed with terror until the neighbors came round to investigate."

John's art school friend Jonathan Hague recalled later that John "suffered an awful lot from loneliness. . . . If you were his friend he would beg you not to leave him and then go over with you exactly when you would be back." When John and Yoko became a couple John often insisted that she accompany him to the bathroom, so he wouldn't be

alone even there. It was a trait others, particularly women, often picked up immediately, even though it was in sharp contrast to the hard, humorous picture he usually displayed to the world. "At his core, John was a frightened man," said May Pang, who became his companion for a while in the seventies. Linda McCartney was similarly surprised the first time she met John. "He was totally lacking in confidence and very nervous," she said. Yet there was a way in which that trait helped shape John's cultural sensibility too. Years later, Anthony Fawcett, one of John's assistants, talked about John's particular sensitivity to the outside world, which, of course, helped make him especially receptive to the changing cultural currents of the sixties he would embody in his music.

When he was a young child, it was said, John's mother, Julia, picked up men—often visiting soldiers—and brought them back to the house. "Men were coming in and out of that house all the time—soldiers, civilians," Freddie's brother, Charlie, later told an interviewer (as there continued to be a pitched battle between both sides of the family as to who had neglected John the most). His mother "prostituted" herself, John once told Fred Seaman, "not for money but for silk stockings." To be fair, Julia's behavior was not especially unusual during wartime, when moral strictures tended to dissipate and when, it was said in Britain, foreign soldiers were "oversexed, overpaid, and over here."

"We were not really immoral," one homemaker remembered. "There was a war on." One survey in Birmingham found that one-third of all births there in 1944–45 had been to married women from liaisons with men other than their husbands. In the meantime, the roguish Freddie had been arrested for desertion on one of his voyages and later for stealing. Never the best of long-distance communicators (not that it was easy in those days), he lost touch with his family.

In the fall of 1944, when Freddie came home from an extended set of voyages, Julia was back living at her parents' house and told him she was pregnant by a Welsh soldier. The child was given up for adoption the following summer while Julia spent time in a Salvation Army home. A family member recounted that Mimi's reaction focused on four-year-old John. "You're not fit to have him," it's said she told Julia.

By the time Freddie came home again in March 1946, when John

was five and a half, Julia had taken up with a new boyfriend, John "Bobby" Dykins, a bartender. Again the facts are clouded here: According to one story later put forth by Mimi that doesn't ring particularly true, little John walked out of his mother's house by himself and moved in with his aunt, claiming he didn't like his new daddy. In any event, Freddie now apparently decided he wanted to look after John himself and decided to move with him to New Zealand. He took John to nearby Blackpool and made plans for the voyage.

Several weeks later, Julia and her boyfriend showed up. In a heartbreaking scene, John was confronted with the choice between living with his mother or his father. After a moment's hesitation, he ran to his mother and didn't see his father again for almost two decades. Interestingly, John blocked out any memory of the event until he was reminded about it by a writer twenty years later. "To this day," Fred Seaman quoted him as saying late in his life, "I hate having to make decisions. I get a headache when confronted with a choice." Within weeks after she brought John back to Liverpool, Julia found out she was expecting a child with her new boyfriend.

John was turned over to Mimi at this point. Some say Julia's new boyfriend didn't want John around. Others have said that Mimi went to the appropriate social service agencies and got them to persuade Julia to give John to her, though no formal legal steps seem to have been taken. "I don't want them to have him," a family member quoted Mimi as saying about Julia and her new boyfriend. "They're not married."

Whatever the reasons, five-year-old John went to live with his aunt and uncle George on Menlove Avenue in Woolton, and was told his mother had moved away. "Mama, don't go—Daddy come home," he sang plaintively in the song "Mother" on his first solo album in 1970. ("I used to say I wouldn't be singing 'She Loves You' when I was thirty but I didn't know I would be singing about my mother," he said.)

John's parents were never formally divorced, and Mimi apparently lived in constant fear that John's father would show up again and take away his son. John saw his mother Julia sporadically until he was a teenager and didn't discover for almost a decade that she was actually

living only a few miles away, or that he had, in the meantime, become a brother to two half sisters.

Aunt Mimi, who was over forty when she took John in, was considered "posh" by the other three Beatles; she was a buyer for Lewis's department store (which explained, in part, John's nice clothes) and even subscribed to the Book-of-the-Month Club. Paul was struck when he first visited their house at the large number of books and the typewriter they owned.

It's true Mimi had her hands full with John. Yet it's also the case that friends at the time don't remember her with much warmth. "She could be pretty nasty," said Dot Rhone, Paul's girlfriend for three years. "She was always after John."

"John never gave me the impression that he liked her—he always complained about the restrictions she put on him," said Thelma Pickles, a girlfriend in art college. Pauline Sutcliffe, the younger sister of artist-guitarist Stuart who was a Beatle for a brief spell, remembered, "She *looked* frightening to us kids. She had a strong jaw and wore a hat and was stern in appearance. . . . She was a forbidding figure, like the Wicked Witch from *The Wizard of Oz.*"

"The aunt dominated him more than a little bit," a neighbor once told a writer. "I won't say that it was hostile but it wasn't the easy, warm or loving relationship that I had with my aunts or my mom." Friends who remember John in early primary school recall a child who was already troubled—bullying the neighbors' kids on his bike, lighting bonfires in fields, and pinching "Dinky Toys" from the local store. He would steal money from the collection plate at Sunday school to buy bubble gum. "Running into John Lennon and his gang in Woolton on their bikes was not an enjoyable social encounter," remembered David Bennion, who lived nearby.

When at age eleven John entered the Quarry Bank School, with its strict rules and dress code, he was in trouble from the start. Unlike Paul or, say, Bob Dylan, who were decent academically, John was a miserable student and a rebel—though he typically needed a partner, or better yet a gang around him. Already he was displaying the odd charisma that

could persuade other boys to join him in his antics. "He always was up to some sort of mischief," said Bennion. "If you saw him, you'd expect trouble." To the parents of acquaintances, he was known as "that Lennon," as in "Keep away from *that Lennon.*"

"I did my best to disrupt every friend's home," he remembered. It didn't help matters at his house that close to two years after he entered Quarry Bank, Mimi's husband died, giving John another sudden absence to deal with and leaving Mimi alone to manage the rambunctious teenager.

John's close friends knew that even as a child, he wrote little fictional stories and drew cartoons he kept at home. Yoko later said that John began his habit of nonsense writing so that Aunt Mimi wouldn't be able to understand what he was putting into his journals. Long before he was known for his music, John's friends knew him for these works. And to his friends, he was one of the funniest fellows they had ever met. For religion class, John and his buddy Pete Shotton made a set of cardboard collars and distributed them to the class so that when the teacher walked in, they all looked like vicars.

At school, John could move teachers close to tears, scowling and slouching at his desk. At various times, according to numerous stories, he threw younger students over a wall into a neighboring girls school; stole money from a school fund-raiser; threw a blackboard eraser out a window; and played cards during a cricket match, which was evidently bad stuff at Quarry Bank. He cut out of a race in gym class, hid, and then mistimed his entrance so badly that they briefly put him on the team, thinking he was a track star. His report cards were dismal. "Hopeless. Rather a clown in class," read one. "Certainly on the road to failure," read another. "This boy is bound to fail," was the assessment in yet another.

"He just didn't give a damn," said Rod Davis, his schoolmate who joined the Quarrymen and later went on to Cambridge University. "It takes a considerable talent of a sort to pass no O levels [the equivalent of American final exams], but he did it." Despite his considerable artistic talent, John even flunked that final by drawing the wrong picture.

When Elvis Presley and the skiffle craze hit Britain in 1956 and 1957,

it wasn't that much of a stretch for John to assemble some members of his old bike-riding, now girl-chasing, gang to form a band they dubbed the Quarrymen after their school name. What undoubtedly helped push him in that direction as well was the reappearance of his mother, Julia, who had been living nearby all along with her boyfriend. "Her arrival in his life really messed him up," remembered a friend, Chris ("Nigel") Walley. John began visiting his mother, and at her urging, the band began practicing at her house. She became his first real fan.

Unlike Aunt Mimi, Julia loved popular music and had often sung to John as a child. When she heard Bill Haley and rock and roll, she danced around the house. She could play the banjo and soon learned to pick out some of Elvis's early songs. She taught the band old standards such as "Those Wedding Bells Are Breaking Up That Old Gang of Mine," and it was the banjo chords that Julia taught John which became his first lessons on the guitar. "She'd say to me—give me the banjo," said Rod Davis, who brought his to the practice sessions. "She was a slight figure, very encouraging, pretty. She didn't seem at all like a mother but more like an older sister." She even flirted with some of John's friends: When she first met John's best mate, Pete Shotton, he stuck out his hand, but she grabbed him around the waist and exclaimed, "Ooh what lovely slim hips you have."

John soon took to playing his aunt Mimi off her—spending the night at his mother's house if Mimi tried to discipline him and refusing to come back unless Mimi bought him something. It was all very confusing, so much so that, according to writer Johnny Black, John much later taped a recorded diary entry where he wrote about lying on a bed with his mother at that time, "wondering if I should do anything else."

Having lost his mother once, John lost her permanently when he was seventeen, less than a year after Paul joined his band. Julia died on July 15, 1958, when she was struck by a speeding off-duty policeman as she crossed the road near Mimi's house. Chris Walley happened to be walking by on his way to call on his friend when he witnessed her body flipped in the air. John subsequently didn't speak to his friend for over a year. "It was as if he blamed me," Walley said. "He went into a shell." Accounts are that at the funeral home John refused to look at his mother's

body and put his head on a relative's lap for the entire service. On his return to school (it was now art college—his Quarry Bank headmaster had pulled strings to get him admitted), he was so distraught, with tears rolling down his face, that one of the teachers suggested a friend take him out for a drink. Meanwhile his two half sisters were shipped off to relatives in Scotland for six weeks and were never told their mother had died, eventually figuring it out for themselves. Keeping track of the truth was a continual problem in this family.

In the aftermath, John became even more volatile, and so he remained, more or less, until he started taking drugs heavily in the mid-sixties. He was "like a dog with rabies," photographer Dezo Hoffman once said. "You never knew when he would jump and bite." Pauline Sutcliffe remembered, "John would rarely look you in the eye when he spoke." "He was always so brokenhearted," said Astrid Kirchherr, his friend from Hamburg in the early sixties. "The sadness never left him."

In the wake of his mother's death, the Quarrymen almost broke up. When they began to reassemble in mid-1959, John had a new girlfriend, Cynthia Powell. And he seemed to grow closer to Paul, who knew something of his anguish. Once, when asked why he and Paul got together, John said, "Well, we all want our mummies—I don't think there's any of us that don't—and he lost his mother, so did I." They now had an expression between themselves whenever someone got too serious or emotional: "Don't get real on me, man." Though the face Paul showed to the world was far brighter than John's, those who later knew them both well, like Derek Taylor, found they shared an anger against the world. Yet that anger was generalized: Without mothers—and in Lennon's case, a father too—to rail against, their music rarely contained as much of the adolescent rebellion against parental authority heard in so much of American rock (which also made their music more palatable to grown-ups).

It's hard not to see the psychological connections behind Paul's and John's tendency to look for strong women—some might say motherlike figures—to guide them at key points in their lives. The Beatle story would always remain unusual for the role played by these women: Astrid Kirchherr in Hamburg and Mona Best, Yoko Ono, and Linda

McCartney later. Interestingly, most were older—Yoko was more than six years older than John, unusual in a marriage at that time. Looking at the childhoods of both John and Paul, it is easier to understand why this was a group whose members eventually split up, in no small part because they wanted to devote more time to the women who surrounded them both personally and artistically.

When John began to write his own songs, his mother's influence was everywhere, and not simply because some of his initial compositions were based on songs she used to sing to him. "It's all very Freudian," he quipped later. He was one of the few rockers to devote a song to his mother by name—"Julia." In contrast to Paul, who reacted very differently to his mother's death, John wrote lyrics that oozed vulnerability and were obsessed with separation. "Rejection and betrayal were his experience of life," his onetime girlfriend Thelma Pickles said, and he brought that unique sensibility to rock music in both a literal sense ("I call your name, but you're not there") and metaphorically in much of what he wrote ("Ticket to Ride" and "You've Got to Hide Your Love Away"). As group biographer Hunter Davies noted early on, lost love was John's obsession in everything from "If I Fell" to "I'll Be Back."

"I've got a chip on my shoulder," he sang in "I'll Cry Instead." He once complained that traditional pop music "was about the sort of illusory romantic love that was basically nonexistent." In John's lyrics, Beatle chronicler Tim Riley wrote, "women seem to taunt him as much as they symbolize satisfaction."

The childhood of George Harrison, the last of the three original Beatles, was very different and far more stable. (Ringo didn't join the other three until much later, in mid-1962.) George was two and a half years younger than John—a lifetime at that age—and joined the Quarrymen in February 1958, when he had just turned fifteen. "I was so tiny—I only looked about ten years old," he remembered later.

George was originally a friend of Paul's. They had met on the bus to and from school, and they had even taken a hitchhiking holiday together, sleeping in the rough. The two practiced guitar together, so Paul knew how good his friend was and persuaded John to take him into the group.

George was the baby of his family and of the Beatles—a status he was never able to outgrow in the eyes of Paul and John, much to his later resentment. (In their early songwriting days, they often gave him the "baby brother" songs to sing such as "I'm Happy Just to Dance with You.") Both his parents were from families with seven siblings; George had two older brothers and a much older sister and a house full of his parents' friends throughout childhood. His father worked for a maritime company and later became a bus driver. His mother was a brassy, jovial woman who ran a dancing class with her husband and seemed to know half of Liverpool. "She was a mum to everyone," said her daughter, Louise, which at the time made her enormously appealing to Paul and John.

The death of Julia Lennon reportedly frightened George so much that he began having fears his own mother might be about to die. With his outrageous clothes and strong working-class accent, he irritated Aunt Mimi to no end, so George often took John to the Harrison house. George's mother was one of the only parents who seemed to like John and encouraged his talent and ambitions, even serving him whiskey occasionally when he visited. This hardly pleased Aunt Mimi. Several years later when the two matrons met at the Cavern Club where the Beatles were playing, George's mother remarked, "Aren't they great?" Mimi responded, "You thing. We'd all have had peaceful lives but for you encouraging them."

George's mother worried constantly about her son's prospects. Yet she was also extremely supportive. She bought George a guitar from money she saved from her house budget and became the group's "den mother" by letting them practice at her home after Julia died. Later, she went to almost fifty of their shows, according to Hunter Davies, and when the group hit it big, she would answer their fan mail. She sat up with George to try to hear the group's first records on Radio Luxembourg. When her son needed inspiration, he often retreated to his parents' house, where he wrote "While My Guitar Gently Weeps" for example. The assistance of his mother went so far that when George got stuck writing "Piggies" for the 1968 double album, *The Beatles,* she supplied him with a line. She also had an unusual fondness for Indian mu-

sic, as George would exhibit later, which she played around the house. (George also later remembered her singing songs by George Formby.)

George did well enough in school as a young boy that he got into the prestigious Liverpool Institute. That's where his academic proficiency ended. Arthur Evans, a teacher, remembered him as a "very quiet, introverted little boy, who would sit in the furthest corner and not even look up." He soon became known for his wild clothes—which included a yellow vest under his school blazer and the drainpipe pants of the teddy boys—as well as for his failing marks. (The name "Teddy" came from the Edwardian-style jackets many wore.) "I cannot tell you what his work is like," read one report, "because he has not done any." Schoolwork didn't interest him—all he wanted to do was play his guitar.

Music was not that unusual an avocation for a Liverpudlian, given the city's predilections and the new youth culture's preoccupation with rock and roll. But the way in which it became his and the other group members' obsession eventually marked this new band as something worth watching. However, it hardly happened overnight.

A COMMUNAL GANG OF ARTISTS

TWO things made the early Beatles distinctive and set the tone for the influential band they became. First, virtually from the start they defined themselves as a coherent whole, not as a collection of distinct individuals. The Quarrymen—the assemblage that eventually became the Beatles—"were a group of boys, a gang in the best sense, before they ever were a band," Pauline Sutcliffe, Stuart's sister, once wrote. That profoundly affected the way the group members related to one another and produced their music.

Second, primarily under John Lennon's influence, the Beatles thought of themselves almost from the beginning as artists. That meant they conceived of their work from the earliest stages as something serious, lasting, and with a far broader purpose than what pop music had traditionally entailed.

When they first got together, the boys were typical of the thousands of skiffle groups that formed across the UK in 1956 and 1957. "It was," wrote reporter David Ward years later, "simple you-can-do-it music, relying in its purest form on cheap guitars, tea-chest basses and washboard. Years before punk, it was the popular music anyone could play." These bands arose in the wake of the stunning success of Lonnie Donegan in January 1956, with his blues-country-hillbilly version of "Rock

Island Line," the old American folk song. In the beginning, besides John Lennon on guitar, the Quarrymen featured, on and off, a tea-chest standup bassist, other guitarists, a banjo player, and a drummer.

The proliferation of skiffle groups was a UK phenomenon, helped by the fact that Donegan was British but sounded American, which gave him street credibility with teens. The craze grew so quickly that guitar sales in Britain increased fivefold in 1956 over the year before.

In America, skiffle had little appeal. Yet the attraction of a skiffle band overseas was that almost anyone could afford the instruments and pick up the few notes necessary to join a group and start singing. Male group singing also has a much stronger tradition in England than in the States, as anyone who has heard the chants at soccer matches or a pub sing-along knows. "The English have always excelled at popular song," wrote Peter Ackroyd in *Albion*, a book on the English sensibility.

The skiffle craze in the fifties was also helped along by the BBC, which approved of this nonthreatening music far more than early rock and roll and created a radio show called the *Saturday Skiffle Club*. "It was like the hula hoop craze in America," Iain Taylor, Paul McCartney's Liverpool Institute classmate, remembered. "Everyone was twanging on something."

Skiffle found a particular home in Liverpool, which already had a popular musical heritage which reached across the Atlantic: A Liverpudlian, Lita Roza, had hit the charts with "How Much Is That Doggie in the Window" in 1953, and a local lad, Jack Brooks, had cowritten "That's Amore" around the same time. Moreover, country and western music—with its Celtic roots and fiddle playing—had always been more popular there than in the rest of Britain. (George Harrison's guitar playing owed more to melody-driven rockabilly star Carl Perkins than to the blues style that was a heavier influence on London rock artists.) That's one reason why early rock and roll was so embraced in Liverpool. With its roots in the American South, early rock sounded a lot like country: Bill Haley's band, the Comets, featured a pedal steel guitar and an accordion; the flip side of Elvis Presley's first single was a remake of an old Bill Monroe bluegrass tune, "Blue Moon of Kentucky."

A tough town, Liverpool was also known for its youth gangs. You

had to join one, Ringo once said, or you would be fair game for a beating. As odd as it sounds, in the wake of Donegan's success, many of these local gangs became bands, just as the gang warfare of the South Bronx would produce rap and break-dancing groups a generation later. "Instead of going around kicking people to death, they started to beat a drum to death," Allan Williams, the local entrepreneur who secured the Beatles some of their earliest bookings and played the role of their first real manager, once said.

John's group had its first unpaid gig at an outdoor street fair on May 24, 1957, when he was sixteen. Less than a month later, the group entered a television-sponsored talent contest but failed the audition, losing to an act with a midget on tea-chest bass.

By this time, many of the youth of Britain had already started to catch the rock and roll bug. There wasn't rock and roll radio like there was in America. But there were a few records (some imported, particularly in a port like Liverpool), jukeboxes, and youth clubs, which were enough to give the music a start given the burgeoning rebellious culture of the teddy boys. These English rebels preceded rock and roll, but once the new music appeared on the scene, they added it as a calling card in addition to their outrageous clothes. "Once I heard it and got into it, that was life, there was no other thing," remembered John Lennon in 1975. He soon grew ted-style sideburns, tightened his trousers, and got into disputes with his bandmates because he wanted to play this new music rather than skiffle.

When the film *Rock Around the Clock* (a low-budget quickie featuring Bill Haley and DJ Alan Freed) came to the UK in mid-1956, there were riots and dancing in the aisles of the theaters, though nothing happened in Liverpool, much to the disappointment of John. This film and the earlier *Blackboard Jungle* were instrumental in defining youth as a new antiauthoritarian subculture on both sides of the Atlantic (though *Blackboard Jungle* had little to do with rock and roll other than Haley's track that played over the opening credits).

Less than two months after that failed television audition for the Quarrymen, Paul rode his bicycle to the Woolton Parish Church fete. He was hoping to meet girls. Instead, through a friend, he met the Quar-

rymen, who were playing there, impressing them after the performance both because he knew how to tune a guitar and could remember the words to "Twenty Flight Rock," an Eddie Cochran song. (Throughout the years, it often fell to Paul to remember the words to songs John frequently forgot.) "He also looked like Elvis," John recalled. "I dug him." A few weeks later, John asked Paul to join his band, and though John remained something of the group's titular leader because he was older, it was more a partnership of equals than anything the Quarrymen had known before.

This focus on "the group"—evident from the Beatles' beginnings and rooted in Liverpool's unique culture—was different from what had been prevalent in most rock and roll until then. Fifties music tended to be dominated by solo figures such as Elvis, Jerry Lee Lewis, and Little Richard, as well as an occasional group with one principal male singer—the archetype for Buddy Holly and the Crickets or Bill Haley and the Comets.

The idea that a band should instead be a collection of brotherly colleagues who weren't really brothers (differentiating the model from the Everly Brothers or later the Beach Boys) wasn't invented by the Beatles. But they did eventually take it all to a new level.

"We were the only group that didn't feature that guy out front," John said.

That group ideal was, of course, a peculiarly adolescent aspiration—a mirror of the buddy relationships of young male teens. In England, these ties are particularly strong—forged not only in gangs but in all-boys schools and a culture that has always venerated these relationships, whether by inspiring the creation of the Boy Scouts or celebrating the affinity of Holmes and Watson. John asked many of his close friends to join the band in the early days whether they played an instrument or not. Friendship was enough.

Yet it wasn't only these forces that provided the model for a communal band of adolescents. If the island of Great Britain has traditionally been preoccupied with the sea in its arts—in everything from Anglo-Saxon poetry to the paintings of J. M. W. Turner—Liverpool was, of course, even more strongly influenced by that culture. Life in a band

was an odd imitation of life on a ship—at least belowdecks, where the hierarchy often disappeared. There, everyone became part of a close-knit team, functioning much like a family.

It was a situation that encouraged a unique model of male brother-hood, documented in sea novels such as Herman Melville's *Moby-Dick,* where Queequeg and Ishmael are "wedded" and Ishmael calls Quee-queg his "dear comrade and twin brother." Though America, *Moby-Dick* notwithstanding, lacked England's national sea culture, the romantic archetype of buddies together had resonance there, too. Life on the frontier had encouraged a similar kind of male bonding, featured in American fiction in the work of everyone from James Fenimore Cooper with his frontier hero, Natty Bumppo, to Ernest Hemingway.

This notion of an integrated collective "band" of colleagues was, surprisingly, a relatively new idea in music, and it eventually trans-formed both rock and the larger culture. Previously, the bandleader usually paid or employed the band and decided in a hierarchical way who should play what, and ultimately, who stayed and went. Ralph Gleason has written that there were some attempts in the heyday of American communitarianism in the Depression-era thirties to create what he called "co-op bands" but that "the whole attitude of the profes-sional musicians union and the attitude of the musicians themselves worked against the idea."

In contrast, this new model (also seen in different circumstances in rock's early days on some American street corners with doo-wop groups) was inclusive; the group leader was not necessarily the lead vo-calist, nor was he the musician with the greatest technical skill. Eventu-ally, of course, the Beatles dispensed with a leader altogether and the united sound that emerged from such a unit changed the sensibility of the music itself; the compositions that arose from such a unit were more cohesive and collaborative.

"It made us very tight; like a family almost," Paul said, "so we were able to read one another." Ray McFall, the owner of the Cavern, would remember that when he first heard the group in the early sixties, "they were as different from the normal group as chalk from cheese."

When the Beatles finally exploded in popularity years later, this sen-

sibility, in turn, became one of the lasting reflections of the collectivist sixties, as the number of hit singles by individuals dropped by more than 50 percent between the first half of the decade and the second, according to one study. Long after that era's communes had been converted into condominiums, bands would dominate rock music.

More important, by popularizing the sanctity of the group in a genre that became the heart and soul of a growing youth culture, the Liverpool model eventually helped encourage the whole notion of collectivism in the larger culture. It may seem old hat now, but the Beatles' example of working and living collaboratively proved extraordinarily powerful. As one critic put it, by being a true fellowship, bands like the Beatles helped inspire the creation of a far larger one. Their fans thought of themselves in that way too. "We were . . . a community, almost a family," was the way one screaming girl described the audience around her. Eventually, the whole counterculture thought the same way about more than just the Beatles. By the midsixties, collectivism was the order of the day, whether marching in the streets, joining communes, or passing joints around to create an instant sense of brother- and sisterhood.

Even the themes of the Beatles' songs eventually reflected this ethos: They were "more about camaraderie than conquest," wrote critic John Lahr. With the Beatles, the whole was always greater than the sum of the parts: As one of the group's later songs put it, "All Together Now."

"None of us would've made it alone," John once said, "because Paul wasn't quite strong enough, I didn't have enough girl appeal, George was too quiet, and Ringo was the drummer."

This new archetype also gave them a kind of dialectic, which ensured they never became boring to their audience. They became, in the description of some, a "four-headed monster," which suggested something almost out of Greek mythology. The Beatles, John stressed, were "a combination."

"We're all really the same person," Paul once said. "We're just four parts of the one."

Manager Brian Epstein was drawn to them, in part, for a similar reason. They "were different characters," he said, "but so obviously part of a whole."

Within that community of four, John and Paul were the acknowledged leaders—not that the public was generally aware of the extent to which they tended to run things. And the relations between those two were not always smooth. "It was not a love match," remembered Iain Taylor. "From the start, they were very, very competitive. It was kind of like two siblings." For example, once John found out that Paul was writing his own tunes, he soon started trying to do likewise. Years later, when John learned that Paul was getting married, he remarkably did the same thing—tying the knot less than two weeks after Paul's wedding.

"They were competitive over everything," photographer Harry Benson later wrote, "women, attention, toys."

Even their songwriting later proved to be competitive. Though the public thought of them as collaborators, John and Paul didn't collude in the typical style of others; each tended to write virtually complete songs and seek help from the other. Yet it was the extraordinary competition between them that helped spur them to greatness. This state of affairs constantly kept the group moving—unlike the contentious situation which could arise when one artist wrote the words and the other the music, which meant one was always waiting for the other to catch up. (Such was the case, for example, with Gilbert and Sullivan, who were often not on speaking terms.)

"They would bounce off each other," said Maggie McGivern, who got to know both John and Paul well later in the decade. "Their perceptions were different—Paul was softer and John sharper but they could change roles. They were so intertwined and so tight on so many different levels. There was a mutual admiration but it was always marked by who was going to give in first."

For both John and Paul, the close-knit structure of a band also offered a kind of supportive family—and indeed love—that they didn't have in their fractured homes without mothers. (Whereas John would turn to buddies in times of crisis, Paul's tendency over the years would often be to turn to family.) As Ray Connolly, a journalist who covered the group, once put it, the Beatles were something of a marriage of opposites with John as the errant father and Paul as the hardworking mother, keeping the family together. (The younger George later con-

formed to the family model as the truculent teenager, his nose frequently out of joint because he was treated by the other two as an "economy class Beatle.") Of the two "parents," John thought of himself more as a poet, Paul as a songwriter. John could easily be distracted; Paul could never stop working. When they wrote, John tended to start with lyrics, Paul with music. Paul was extremely confident, John far less so. John tended to be tough on the outside but a softie underneath; Paul struck many as exactly the opposite. Yet they were, Tony Barrow noted, "extraordinarily dependent on one another." Apart, they would never approach the art they created when they were together.

What also drew John and Paul together back in that summer of '57 was what they sensed in rock and roll. "When we first heard that music, we couldn't believe it was legal," said Tony Carricker, who shared John's love of the new music and discussed it with him all the time. "It was so subversive, so immediate, so visceral." There's a story, perhaps apocryphal, about an English principal who called a meeting of all the pupils in his school and announced, "I must speak to a boy named Elvis Presley because he has carved his name on every desk in the school!"

The new music was worlds apart from the pale soulless popular dreck of the time—Mario Lanza or Jo Stafford. As in America, the appeal of the music in Britain had less to do with its musicality or lyricism (after all, many of the lyrics reflected the unknowable American teen experience in school or with cars) than with its exhilarating attitude, sound, and beat. Its imprimatur was the electric guitar—raucous and unsubtle—an attack on all the musical seemliness that had come before. On both sides of the Atlantic, its emergence was a stunning cultural moment, as radical as when the talkies replaced silent movies.

Some of the Quarrymen wanted to remain a skiffle and acoustic band; Lonnie Donegan hated rock and roll and lamented, "Nothing makes me madder than to be bracketed with those rock 'n' roll boys." But Lennon and McCartney felt otherwise. It helped their argument that groups that played rock and roll suddenly had an easier time getting gigs, as youth clubs and dance halls now became the hangouts of choice for many English youth. Besides, because of changes in the English "hire purchase laws," it was now cheaper than before to buy an electric guitar on credit.

All this hardly meant the Quarrymen were immediately on the road to greatness; the group would spend the next three years toiling unappreciated in the basements and back rooms of Liverpool. Of the group's first appearance that August at a new club in a downtown Liverpool cellar called the Cavern (without Paul, who had yet to join the group and was away at scout camp), the club's owner later said, "I thought they were pretty useless, just a bunch of kids going through their apprenticeship, doing poor imitations of current pop—Buddy Holly and the like." During the next year, they averaged about a booking a month, practicing in between at each other's houses. Some of their public appearances were at contests, but the Quarrymen never won. "It was always the fat old lady with a pair of spoons who would beat us," said Paul. In local eyes, they were also disadvantaged by being seen by outsiders as snobs from Woolton on Liverpool's posher south side.

Friends were in and out of the group constantly for various reasons. Already the perfectionist, Paul tried to raise musical standards by repeatedly criticizing the group's drummer, Colin Hanton. Hanton soon tired of the harping, leaving the group with "lack of drummer" problems that persisted for years. "People who owned drum kits were far and few between," John remembered. "It was an expensive item. They [drummers] were usually idiots." The following winter Paul finally helped persuade John to let his younger friend from the Liverpool Institute, George Harrison, join the group because of his proficiency on guitar. Soon the new junior guitarist was known as the young ted who worshipped John and followed him everywhere.

The main influence on the future development of the Beatles during that fall of 1957, however, was occurring in, of all places, a school. That fall John had entered the Liverpool College of Art, a large, dirty building next door to the Liverpool Institute, where George and Paul were students.

In postwar Britain, art colleges were unique educational institutions. The usual path for most sixteen-year-old Britons was to leave school and get a job, with a tiny minority staying to finish their secondary schooling and prepare for a university education. That, for example, was what Paul was planning to do at the Liverpool Institute.

A small number of teens, however, went to art college. These weren't colleges in the American sense. Most decent-sized cities had one, and London had several. They had been started at the turn of the century by the Victorians as the British looked for ways to improve their international status in design. It was only in the 1950s, however, that these state-run institutions took on a new role and air. They became, in the words of George Melly, a British writer and singer, the refuge of "the bright but unacademic, the talented, the non-conformist, the lazy, the inventive, and the indecisive: all those who didn't know what they wanted but knew it wasn't a nine-till-five job."

"It had an aura of Beatniks, existentialism, and Paris," said Thelma Pickles, a student at the Liverpool College of Art and a girlfriend of John's. It was all very bohemian and experimental—encouraging self-learning—and it implicitly taught its graduates that to spend months or even years pursuing one's artistic dreams was the proper role for an artist. "Art college was where creative ability was seeded, including John's," said Jonathan Hague, a classmate.

Ordinary schools offered the traditional subjects and stressed memorization for final exams that determined one's entire grade. Art college, in contrast, offered rather free-form courses in design, life drawing, and lettering.

More important, it offered its students a vision of a kind of counterculture before there was one. Art students were bred to be outsiders. That was especially true in Liverpool's Eighth Section, which, outside of London's Soho, offered the closest English parallel to New York's hip Greenwich Village. It was home to the art college, coffeehouses, and pubs where the art students hung out—as well as an unbelievably messy flat that John shared with several friends for a time that was even written up in a Liverpool newspaper as "the Beatnik Horror." "Art college offered us that rare glimpse of an alternative life," said Tony Carricker. "It was a place to discuss books, ideas, alcohol, and sex."

The major unintended impact of art colleges throughout Britain was to create a breeding ground for British rock stars. Elvis had been a truck driver, but John Lennon, Pete Townshend, Eric Clapton, Jeff Beck, Jimmy Page, Ray Davies, and Keith Richards were all art college stu-

dents who tended to think of themselves as artists. This not only affected their approach to the music but their image as well. Because they all were trained as visual artists, their look was always important to them. (They could also experiment with that look at school, since art students didn't have to wear a uniform like other British students.)

Art college was also one of the few British educational institutions of the time that were co-ed. That led to an educational atmosphere less hierarchical and more collaborative than standard all-male British schools. It also gave John the rare chance to meet a large number of women who were untraditional, were considered his equals, and were cast in the role of friends rather than just sex objects. It's telling that the two women he later married considered themselves artists—albeit in different ways.

This is hardly to suggest that John and his art school acolytes became feminists overnight. "He was sexually quite mature for his age," said Carricker. He remembers John having a long list of girlfriends outside school, some of whom were there for sex and little else—a series of rendezvous John called colloquially "going for a five-mile run." When he'd meet up with girls from art school, he'd regale them with stories about his conquests, trying to make them blush.

John may have reveled in the artistic persona, but, as usual, formal classes didn't offer much of interest. He "was totally uninformed in every way," said one of his teachers. "John wouldn't have known a Dada from a donkey."

As at Quarry Bank School, he rarely followed instructions, preferring to spend his time sketching cartoons, some eventually finding their way into his book, *In His Own Write,* published in 1964 and described in a review then as "weird, off-beat and slightly sick." On the first day of a drawing composition class, while the other students did still lifes, John sketched a cartoon with a stone wall, a few weeds, and "weird creatures" jumping out of it.

"I thought, that's it—he'll be thrown out!" said Vi Upton, a fellow student.

"If he painted, he would paint the same scene every time," remem-

bered classmate Helen Anderson. "It was a dark scene in a nightclub, with a long-haired blond woman sitting on a stool."

"He was into music, girls, and art in that order with music way up," said Rod Murray, who shared that "beatnik" flat with him for a while. John, hands often in his pockets, stood out because he frequently cut classes and spent much of his time in a nearby coffee bar or at Ye Cracke, a local pub, nursing a cup of coffee or a beer as he smoked his "ciggies." Friends remember that many days they'd leave him in the morning and come back in the late afternoon and he was still sitting in the same place.

"For his time and place he was totally exceptional," said Carricker. "He was completely unbound by conventional restrictions. He made fun of everything."

As the clown, "he would say the most awful and cruel but funny things to people," remembered Rod Murray. "Like he'd go up to a man in a pub with one leg—remember this was still close to the war—and say loudly, 'I see you've only got one leg.'" "Jewboy" was another Lennon epithet.

He was the loudest in any group, frequently laughing hysterically, and he was always scrounging for money. "I was always very afraid of John," said classmate Ann Mason. "He had such an acute wit but it was like a searchlight going around. You would duck, hoping the searchlight wouldn't land on you."

"He was a terrible guy actually," a colleague once told the journalist Ray Coleman. "But I liked him." Some of his classmates remember that he seemed lonely and a bit sad, even when he was surrounded by friends. He also worried about how obnoxious he often could be. But, he confided to Jonathan Hague once, he couldn't stop himself from being cruel.

"John had a certain sadness," said Helen Anderson. "He couldn't do right for doing wrong."

"I think he was out of time," Cynthia Powell, his future wife and a fellow student, once said. "He didn't fit in. He had a cruel wit. He never fit in."

In the fall of 1958, in the aftermath of his mother's death, John's at-

titude and behavior worsened dramatically as he began drinking heavily. "When he drank," said Murray, "he was capable of anything," and he now drank all the time. He urinated down the elevator shaft at school and threatened many who crossed his path. Thelma finally had to confront him and tell him, "Don't blame me because your mother is dead."

"He was like a fellow who'd been born without brakes," remembered one of his instructors. That fall, the Quarrymen practically fell apart as he even lost interest in his music.

Following his mother's death, John soon started going out with Cynthia. Cyn was one of the quietest girls in the class, very gentle and neat. She was considered "posh," given that she lived across the Mersey River from Liverpool in Hoylake, on the peninsula known as the Wirral. She reminded one of her teachers of a librarian, and when she and John got together it floored nearly everyone. "What the hell does she see in him?" Helen Anderson asked a friend. Helen liked John because he was so funny but considered him a poor choice for a boyfriend. "He was quite a handful—I thought she was an idiot," said Ann Mason, another friend of Cynthia's.

Some of John's friends felt much the same way. "He always took the mickey out of her, saying 'Here comes Miss Prim' because she was always immaculate in pretty twin sets and pearls," said Thelma. "But it was obvious to me that he fancied her." To some, their relationship seemed a bit like John's with Paul—a marriage of opposites in which one principal thing the two seemed to have in common was that, like John, Cynthia had recently lost a parent, in this case her father. In fact, throughout his life John often sought out individuals who shared that attribute. For example, Thelma's father had abandoned her at a young age too, and much later, what drew him initially to Allen Klein, his choice for a manager after Brian Epstein died, was that Klein had spent part of his childhood in an orphanage. "It was the discovery of this shared experience that cemented our friendship into a relationship," said Thelma later. "I was impressed by how open he was about something that in those days was usually a hidden secret."

Cynthia had to endure a lot that year, John's second in art college. He was always broke and borrowing money from her. It was said that

Cyn's mother didn't like John, especially because Cynthia had been seriously seeing a boy with a "real job." John cheated on her regularly, as he did on all the girls. Cynthia later said, "I was frightened of John. He was so rough. He wouldn't give in. He just fought all the time." He hit her—a fact he later alluded to in the song "Getting Better" on *Sgt. Pepper*.

"All hell would break loose," she wrote in her autobiography. "I would be accused of not loving enough, of being unfaithful, of looking or talking to a member of the opposite sex for too long. John's jealousy and possessiveness were at times unbearable." To please him, she transformed the way she looked—wearing shorter skirts and fishnet tights so she would look like Brigitte Bardot (or the woman in the pictures he always painted). Yet it's clear she helped keep him together emotionally, nursing him back to some form of semistability.

She also began to accompany the band on gigs. "John seemed in need of affection, and depended on Cynthia," remembered Ken Brown, a student and bass player who played with them and helped them secure a few bookings. "She used to sit at the side of the stage, dressed usually in skirts and sweaters, never saying much."

By the next fall, in 1959, the Quarrymen were up and running again, practicing constantly at each other's houses and often meeting at lunch at the art college. John and Paul also kept trying to write songs, though at this point, Paul was ahead in this area. He already had the basis of a song about following the sun, and had worked out a number modeled on the Everly Brothers' country harmonies, called "Love Me Do."

Mostly at this point, however, the Quarrymen played the songs of others: Elvis, Little Richard (Paul's favorite), Chuck Berry (one of John's favorites), Gene Vincent, Carl Perkins, and especially Buddy Holly. "Holly was the role model," said Carricker. "His chords were simple and John could relate to him—he was white, wore glasses like he did, and he didn't have a lot of vocal strength." When the Quarrymen had gone into a makeshift tape studio in the back of a house in Liverpool a year before to record a demo for themselves, the song they chose was Holly's "That'll Be the Day," backed by a McCartney-Harrison original, "In Spite of All the Danger." The Holly song had special significance for John. "The very first tune I ever learned to play was 'That'll Be the Day,'"

he once said. "My mother taught me to play it on the banjo, sitting there with endless patience until I managed to work out all the chords."

In the fall of 1959, the Quarrymen got a break, scoring some regular paid gigs at a coffee club called the Casbah, located in the basement of the home of Mona Best, the wife of a local boxing promoter. Still, things were difficult. The Quarrymen entered another TV talent show in Manchester, thirty miles away, under the new name of Johnny and the Moondogs, but found they couldn't stay for the final round because they couldn't afford to miss the last train back to Liverpool. It was also getting increasingly hard to get anyone to hire the group given their frequent lack of a drummer. ("We don't need one—the rhythm's in our guitars," the boys said.) John, who still considered the group a kind of extension of his collection of student buddies, asked his art school friend Jonathan Hague to buy a set of drums to join now and learn the instrument later. "They were desperate to have anybody," Hague said.

Meanwhile, the group was gaining a reputation for never being serious. "Somebody would crack a joke," an acquaintance recalled, "and they wouldn't work for two hours." When they showed up for one gig, arranged by George's father, they got drunk between the two sets and could barely play for the second. They also seemed tremendously impressed with themselves—an opinion hardly shared by others. "John's answer to everything in Liverpool was, 'Oh God, we're better than them,'" said Carricker.

"They were aggressively anti," one observer later remembered. "They weren't sure what they were against but they were against it."

One factor that gave John renewed enthusiasm about the group as it headed into 1960 was the addition of a new member, Stuart Sutcliffe, a friend from art college. Like Hague and Tony Carricker before him, Sutcliffe was asked to become a member of the band without knowing much about music. "Get a bass, man, because then you could be in the band," John told him. "And it's not that hard, bass, you don't have to know lots of chords and stuff."

"He never practiced because John said he didn't have to," said Astrid Kirchherr, who soon met all of them in the fall of 1960 in Hamburg. "Of

course that would upset Paul. But John would say, 'He looks good and he's my best friend.' "

Stuart and John had met in 1957, John's first year of art college and Stuart's second. "They were on the same wavelength," Cynthia said, "but they were opposites." Stuart was quiet and very fragile looking, often pale as a sheet. He cut a figure as striking as John's at the art college but in a different way, as he dressed in tight jeans and bright shirts. "He had a very good image," remembered Carricker, and many considered him the most talented artist in the school.

Sutcliffe's mother, Millie, had been educated in a convent and trained as a missionary. She had met Stuart's father when he was married to someone else, and when they married, it was something of a scandal. Their families disowned them, and they eventually moved from Edinburgh to the Liverpool area. While Stuart's father ultimately took a job in the merchant marine that had him traveling for months at a time, his mother became a teacher and a local aide to future prime minister Harold Wilson. Because she was also frequently ill with asthma, Stuart and his two younger sisters often cared for themselves and for her. "Stuart was quite parental," remembered his younger sister Pauline, which would make him quite appealing to the parentless John Lennon.

Despite the fact that Stuart and Paul rarely got along, according to Dot Rhone, Paul's girlfriend, Sutcliffe soon became a kind of art director for the group. The first change he introduced was in the group's name. In the spring of 1960, the band became the Silver Beetles, which soon became simply the Beatles.

"Beatals" (as it was spelled at first) was, in part, a wordplay on "the beats"—the infamous New York and San Francisco beatniks such as the poet Allen Ginsberg and the novelist Jack Kerouac, who were young critics of American materialism and superficiality. These writers were the darlings of the art school crowd—and the name had the additional advantage of having an insect resemblance to the name of Buddy Holly's band, the Crickets.

When the British beat poet Royston Ellis came to Liverpool in the winter of 1960, he met the group when they tried to accompany him

during a reading. "They had a bohemian art school eccentricity," he remembered. Ellis used the occasion to teach them how to remove the Benzedrine from nasal inhalers to use it as a form of speed. It was a lesson the group absorbed quickly.

The Liverpool rock scene was extraordinarily fluid; anyone, it seemed, could become an entrepreneur or a musician. The group was now relying on Allan Williams, the owner of the local Jacaranda Club, as a kind of manager to help them get appearances. Williams later recalled the fights the band members had about whether they could afford to get jam for their toast, which cost one penny extra. Because they were drummerless—and not very polished to boot—he had trouble finding them work, so he hired them as occasional fill-ins and to paint the bathroom at the Jacaranda. "I thought the Beatles were a right load of layabouts," he said.

Ted "Kingsize" Taylor, a local musician, heard them early that year. "After two songs they had to leave the stage," he remembered. "They were just dreadful. They didn't have a clue as to what they were doing in a large hall. We liked Paul, but the others were just losers."

Not that the lack of acclaim fazed the group. "They had an air about them that seemed to say that if you didn't like them, they couldn't care less," one Liverpudlian remembered.

That spring of 1960, they got lucky. A London entrepreneur, Larry Parnes, was looking for groups to back pop singers. With an older fill-in drummer in tow (Tommy Moore), Parnes retained the Beatles to back minor singer Johnny Gentle on a nine-day tour of northwest Scotland. Paul, who was supposedly studying for exams that would make or break his academic career, convinced his father that the trip would be a good way to prepare. John told Gentle, "This is our big break. We've been waiting for this." Gentle, however, was not pleased. "I wondered what on earth Parnes had sent me," he later wrote. "They were the roughest looking bunch I had seen in my life."

Gentle had a better premonition of how the tour would go than his backup musicians did. The whole thing was a disaster, as the Beatles ran low on money during the tour and on at least one occasion reportedly ducked out of the hotel without paying the bill. Meanwhile Gentle

crashed the van, knocking out several of Moore's teeth. (When the local promoter found Moore in a hospital, he forced him back to the gig and sat him up on his drums.)

Soon the Beatles were back at the Jacaranda, playing for beans on toast and Coca-Cola. Later, during the summer of 1960, while Stuart worked part-time as a garbage man, Williams hired the four to back a stripper. They accomplished the mission by playing such tunes as "Moonglow."

Most other musicians would have quit. But beyond a drive and confidence that their friends still found misplaced, the Beatles had the singular advantage of being relatively well-off students who didn't have to work. Plus, they had somehow convinced themselves that they might be able to make music their careers.

Meanwhile, during the summer of 1960, Allan Williams received an offer to send a new Liverpool group to Hamburg, Germany, for a series of engagements (he had earlier sent a local group, Derry and the Seniors). Rock and roll was extremely popular in Hamburg, where there were many clubs, especially in the city's St. Pauli District, an area with one of Europe's wildest night scenes. American groups were too expensive, and the trip was usually too far for them anyway. Cheaper British imitators could fill the bill, and Liverpool already had a reputation as the home of a burgeoning rock and roll scene.

Many groups came to mind before the Beatles. All, however, had the disadvantage of either having to quit regular jobs to travel abroad, or of having significant gigs in the Liverpool area to give up. The Beatles had neither and were offered the German job—if they could find a drummer. It was a move that brought howls of protest from Howie Casey of Derry and the Seniors, who complained from Hamburg that such a "bum group" would ruin the chances in the future there for everyone.

Paul's friends were floored when he told them he was leaving school to go to Hamburg. "We told him there was no future in the music business—he was taking a huge risk," said Iain Taylor. "He didn't disagree." George's mother reluctantly agreed to let her seventeen-year-old go and baked him some scones for the voyage, which the boys would make by car via ferry.

Meanwhile, the Beatles desperately needed a drummer to qualify for the engagement. Paul, already the budding musical genius, was the member of the group who could handle every instrument, but he didn't want to switch from guitar, and besides, the request from Hamburg was apparently for a five-piece band. Frantic to find anyone to accompany them, they found a drummer at the Casbah, the basement coffee club where they had played sporadically. The owner, Mona Best, had recently purchased a drum kit for her son, Pete, who was eighteen, a year younger than John. "His mother was essentially buying him friends," said one observer, since drummers were always in demand. The four Beatles quickly gave him an audition. The fact that he passed was hardly surprising, since the group's choice was either to accept him or cancel the trip to Europe.

"From day one he wasn't on the same wavelength," said Dot Rhone. "But there wasn't anyone else."

In mid-August 1960, less than a week after Best's audition, the five Beatles—John, Paul, George, Stuart, and now Pete—left Liverpool in a minivan, accompanied by five other friends and relatives of Allan Williams. "I was . . . worried about Hamburg," Cynthia later told Hunter Davies, the Beatles' semiofficial biographer in the sixties. "I knew the Liverpool girls, but I didn't know anything about the situation in Hamburg. Anything could happen to them in Hamburg." As it turned out, almost anything did.

ASTRID, HAMBURG, AND THE GREAT TRANSFORMATION

HAMBURG was the place where the Beatles really began. Away from the familiarity of Liverpool for the first time, they drew on the German city's unique culture to create the foundations of a new sound, a new look, and a new identity. This was the place where the Beatles first re-created themselves, beginning a pattern in which the group would singularly remake itself often over the years. It was a trait that others soon noticed, and it added to both their allure and their ability to shape trends.

"That was the part of the Beatles which appealed to me the most," said one fan later. "Their constant changes gave you a blueprint to reinvent yourself as well."

The group's experiences in Hamburg also helped forge their synergy, as the adventure of living and playing in a new country bound the band together in a fashion similar to the way college unites roommates. "It was as though the Beatles had gone to Hamburg as an old banger and had come back to Liverpool as a Rolls-Royce," said Johnny Hutchinson, a Liverpool musician.

"I didn't grow up in Liverpool," John once said. "I grew up in Hamburg."

Though it's often forgotten, the Beatles were allowed to experiment

and evolve for a lengthy period outside the public eye. It took a long time for the world to acknowledge them. Of all the supergroups or acts in popular music history, the Beatles endured among the lengthiest apprenticeships and it served them well. By the time they came to America in 1964, they'd had close to a thousand performances of some sort. The circus atmosphere of Hamburg, particularly, would turn out to be ideal training for what the Beatles later had to withstand on the road, surrounded by thousands of screaming fans and reporters hurling questions. Being older than their fans wasn't a disadvantage either, as John later feared, because it gave them the maturity they needed to handle the extraordinary pressures of a new kind of fame.

Hamburg was also the venue where they met the first of several figures who, over the next two years, played key roles in their development. Astrid Kirchherr, a young German photographer who met the group that autumn shortly after their arrival, set the pattern for many of the women to whom the Beatles were drawn throughout their lives. Like Yoko Ono and Linda Eastman later, she was more comfortably middle class than the "boys" were and was a rebel against her background. Like Yoko, Cynthia, Linda, and Jane Asher, she considered herself an artist. Like Yoko and Linda, Astrid was also foreign and older than they were— born in 1938. In her case that meant she was old enough to remember the Nazis as a child. "We had to say 'Heil Hitler' when we got to school in the morning and it was the standard greeting when you met someone in the street," Astrid remembered. "It was like saying, 'How do you do?' "

When the Beatles left Liverpool in the summer of 1960, few beyond their immediate families and girlfriends saw much potential there. Astrid was among the first outsiders to believe in them, sensing something millions would see later. Their close involvement with her lasted not even two years, and even then it was sporadic. By the time it ended, however, the Beatles had a different image and conception of themselves.

First, Astrid helped change the way they presented themselves. At the time she met them, one musician remembered the group in mauve jackets and pointed shoes. They had slicked-back hair. Over about a year's time, these were gradually replaced by a more European, unisex style that was the forerunner of "the Beatle look." By the time they left

Hamburg, their demeanor was turning heads. "They had tremendous charisma as a unit," said one German observer. "They were unique."

Equally important, the Beatles refashioned a somewhat different sensibility for themselves. No longer Liverpool provincials—at least in their own eyes—the Beatles now considered themselves Continental artists, literate in a tradition that included Bertolt Brecht and Simone de Beauvoir. This cemented the impression they had already developed back in Liverpool that they were different—and several cuts above—the other rock musicians they met.

Astrid never set out consciously to change the group, as their new manager Brian Epstein would a little over a year later. This process was more subtle and evolutionary: Her own persona was so charismatic and appealing that over time the Beatles absorbed her style and that of her friends.

Like several of the students at John's art college back home, Astrid was interested in fashion design and was studying to be a photographer. She even had her own car, which few boys (and even fewer girls) in the Beatles' Liverpool circle did. She was sexy and exotic looking, in contrast to the sameness that dominated personal appearance back in England. She had a deep voice and a throaty laugh; wore short leather skirts, dark turtleneck sweaters, and fishnet stockings; and cut her blond hair very short—almost unisex style. She usually dressed in black and was fond of wearing large velvet capes. She was closer to Stuart, John, and George than she was to Paul and Pete, and like many of the people John chose to be his confidants, Astrid had recently lost a parent; her father had died several years earlier.

"She did look remarkable," remembered one of John's art teachers who saw her. "A beautiful creature and she had this leather suit unlike anything we'd seen before—not that anyone could afford such things in Liverpool."

Astrid hung out with a similarly styled Hamburg crowd that was called the "exis"—short for existentialists. They embraced modern music but disliked Bill Haley's image and weren't too keen on Elvis's either because they thought he had the wrong look (what was later described as too macho). They were part of a flourishing Bohemian art scene in

Hamburg, heavily influenced by France with its intellectual heroes such as Jean Paul Sartre and Jean Cocteau. "We didn't want to get our inspirations from the past because our past was the war, was Hitler, was uniforms, so we were searching for something new and fresh and creative," said Astrid.

The Beatles came to Hamburg five times to play for extended periods before the end of 1962. When they arrived for their first visit in August 1960 they were shocked to discover three things. First, they found to their surprise (as all Englishmen would for some time) that the supposed losers in the last war had recovered a lot better than the "winners." Like Liverpool, Hamburg had been hit by World War II bombing so intense it caused firestorms. But the city was thriving in a way that Liverpool never would again. "It was amazing—one hundred times richer than Liverpool," said Tony Tyler, an Englishman who met up with the Beatles on one of their Hamburg sojourns.

That added to what was still a lot of leftover hostility. "I can't really get talking to these German girls because I've still got a guilty conscience about the war," Stuart wrote home when he first got there. When he later overcame his guilt and brought Astrid back to Liverpool, the two didn't stay with Stuart's family, in part because his mother disliked Germans.

Their second surprise was that Hamburg's St. Pauli District, where they lived and performed, was something of the decadence capital of Europe. Hamburg had always had a reputation for wild sex and boundary crossing. Centuries before, part of the St. Pauli area had been cut off from the rest of Hamburg by a wall, and everything antiestablishment landed there, from religious and labor dissidents to prostitutes. Much later, novelist Stephen Spender had headed there in the wild days of the 1920s Weimar Republic, and in an unpublished work called "The Temple" had one of his characters say, "Germany's the only place for sex." Walking down the Grosse Freiheit in the Beatles' day one could find the whole shebang: whores, thieves, alcohol, drugs, transvestites, fights in the street, mud wrestling, as well as the ever-present blasts of rock and roll emanating from clubs. In Hamburg, there were, both literally and

figuratively, few boundaries, and the whole experience knocked any lingering Victorian sensibility out of the band.

"In Liverpool, everything shut down at eleven and the girls had to be home then," said Kingsize Taylor, a Liverpool musician who also played Hamburg. "In Hamburg, everything stayed open all night and no one cared if the girls came home the next morning."

To say that the five Beatles lived in a pigsty in Hamburg is only semiaccurate—many pigsties were tidier and more luxurious. Their first quarters were in a small room in the back of a movie theater. There was no heat, the five boys shared two sets of bunk beds, and they had to use the movie theater bathroom down the hall, meaning they never showered, at least there. Eventually, the jackets they wore on stage disintegrated from sweat. Their diet was often cornflakes and alcohol. Once a pile of vomit from overdrinking remained on the floor until it hardened. When they met Astrid, a major attraction was that her comfortable home had a place to wash up and that she cooked them kidney pie and chips, just like at home. In typical Beatle fashion, "all of the boys liked my mother," said Astrid.

The environment in Hamburg would have floored any schoolboy from Liverpool, even these five who were worldlier than most of their contemporaries. (George, after all, was still only seventeen.) Stuart wrote home complaining, "Hamburg has little quality, except the kind you would find on analysis of a test-tube of sewer water. It's nothing but a vast, amoral jungle."

The other four, however, felt somewhat differently about the new opportunities. There were later rumors of orgies and women who became pregnant; at least one paternity suit was filed and later settled. "Dolly birds"—an early form of groupies—followed them around; when the group was on stage female fans pointed at the Beatle they wanted and gave "the bending of the elbow of one arm across the wrist of the other in a sharp upward movement that suggests an erection," as Pete Best put it. Or they yelled, "Gazunka!" a suggestive phrase which needs no translation.

John seemed especially in his element. During their various trips to

free-for-all Hamburg, he became known for such antics as coming on stage one night dressed only in his underpants with a toilet seat around his head. Tyler remembered a card game when John picked up a bottle and cracked it over the head of a fellow card player.

Their third surprise was the engagements themselves. The Beatles were contracted to play for an exhausting four and a half hours every weekday night until 2 a.m., and six hours a night on weekends (Saturday nights until 3 a.m.), par for the course in Germany, where musicians tended to work longer hours than in Britain.

Paul was not the first to notice that their job was essentially to attract customers in from the street and sell drinks. The Beatles did so and made a reputation for themselves by creating a new persona—stomping all over the stage, throwing chairs, jumping into the audience, and yelling back and forth with the customers in an interactive display. The club manager ordered them to *"Mach schau,"* which means "Make a show," while the audience sent beer to the stage to get the Beatles through the night.

"Everybody saw that they were funny people," said Tony Sheridan, a popular singer who knew them in Hamburg. That's "what they were famous for, in Hamburg. Not their music so much." They were known locally as the *"beknakked* Beatles"—the crazy Beatles. The band was now engaged in a kind of popular performance art, hardly surprising in the country that was home to Brecht and cabaret. Of course, they were no strangers to similar traditions, hailing from a country where the roots of popular entertainment go back to the theater and music hall with their similar interaction between the performer and the audience.

The Benzedrine that Royston Ellis had introduced to them in Liverpool came in handy too. By the time the Beatles returned to Hamburg in the spring of 1961 for a second set of engagements, apparently all except for Pete Best were said to be regularly taking uppers, known euphemistically as "blue pills" or "prellies" (for Preludin). The prellies came in tubes, and they would ask each other, "Anyone traveling by tube tonight?"

Speed helped create early rock and roll: Jerry Lee Lewis and Gene Vincent were frequent users, according to Simon Napier-Bell, the one-

time pop manager who wrote about the phenomenon in his book *Black Vinyl White Powder*. Like many musicians, some of rock's pioneers apparently found it was the best way to adapt to the nocturnal lifestyle. The Beatles, of course, were in the same situation, if not more so, since they were also drinking constantly.

This first Beatle drug phase, which sped them up for several years, helped produce a hard-driving, accelerated rock and roll with a regular pounding drum beat that knocked the Germans out. "They made a lot of noise and passed on a drug-created excitement to the audience," said journalist Chris Hutchins, who heard them in Hamburg. The drugs also contributed heavily to the manic quality of the performances they staged and fueled their sense of themselves as "outlaws."

Despite their frenzied performances (or perhaps because of them), the Beatles were so zoned out during their Hamburg stays that when Hunter Davies interviewed them for his semiauthorized biography in the late sixties, no one could recall how many times they had visited there. "John," Davies wrote, "could remember almost nothing." Irritable from fatigue and hopped up on drugs, the Beatles also argued a fair amount during their Hamburg stays, even brawling at least once onstage. Stuart reportedly had fistfights with both George and Paul, who said something about Astrid. Meanwhile, according to Stuart's sister, Pauline, a drunken John even turned on Stuart one night.

Yet all these experiences in Hamburg might not have amounted to nearly as much had it not been for the influence of Astrid. She first visited the club where they were playing in the autumn of 1960, just weeks after their arrival, when her boyfriend Klaus Voorman convinced her to see this band he had discovered while wandering around the neighborhood several nights earlier. "It wasn't a place to go for a young girl," she told an interviewer. "It took me a couple of days to really make up my mind and agree to go there." Like so many in those early years, the first thing she noticed about the group was its aura and look, not how it sounded. "I was shivering all over the place," she said. "There was so much joy in their faces, the energy in their eyes, the fun you know."

She was especially struck by Stuart. He often turned his back to the audience—either to be cool or to hide the fact that he couldn't play his

bass well. (There are stories that the other Beatles sometimes disconnected his guitar from the amplifier.) He wore dark glasses and on this particular evening had a cigarette dangling from his mouth. "I just thought, 'God—this is not true!' No movement, nothing. Just this statue," she remembered.

After several nights at the club, Astrid's friends, who spoke better English than she did, struck up a conversation with the band. Astrid and her crowd were a Hamburg version of the students John and Stuart had known at art college, and the two crowds soon drew close.

In retrospect, it's easy to see what John and the others saw in her. Though intelligent, the Beatles were hardly sophisticated. Here, suddenly, was this exotic, beautiful, and understanding artist (with a car no less!) telling them how striking they were.

For her part, Astrid found them "the most charming and polite men I had ever met—so different from the Germans I knew."

"She [Astrid] was a catalyst," Tony Sheridan later said. "Her effect on everybody was such that it brought out the best in them, musically as well as personally." Stuart was particularly taken with her and they soon began a passionate relationship, even though she could speak little English.

Consistent with the wide-open mood in Hamburg that encouraged boundary crossing, Astrid's crowd affected an androgynous look and frequented gay bars. "There was a desire in certain quarters in Germany to subvert the overmasculinized German identity that these people felt had been the ruin of their society through Hitler," said Tony Waine, an English scholar of German culture. "Hamburg was at the center of all that."

"Recently I've become very popular both with girls and homosexuals, who tell me I'm the sweetest, most beautiful boy," Stuart wrote home. "When in Liverpool I would never have dreamt I could possibly speak to one without shuddering; as it is, I find the one or two I do speak to more interesting and entertaining than any others."

Stuart was the first Beatle to begin to adopt the unisex look of Astrid and her friends, which they said came from France. The androgynous style and close bond between Stuart and John even led to speculation

over the years that John and Stuart had a sexual relationship in Hamburg—a story that Stuart's sister, Pauline, believes, though it's denied by virtually everyone else who knew them, including Astrid. "They needed and loved one another but . . . there was nothing homosexual about it," Astrid said.

Astrid also spent a great deal of time photographing the group in shadowy half-light pictures. The Beatles were always drawn to photographers; Paul later married an accomplished one. In a world in which their look was so important to them, the Beatles understood from the beginning the importance of images. "I doubt whether anyone else has been photographed as much as the Beatles," wrote Sean O'Mahony, the publisher of the *Beatles Monthly Book,* a British magazine that later chronicled their activities by the month.

These first photo sessions with Astrid, staged at her instigation, captured the Beatles in a variety of poses wandering around Hamburg, often dressed in the black leather she wore and convinced them to adopt. They liked what they saw: When it came time for the group to design the album cover for one of their first LPs, *With the Beatles,* in late 1963 (released in the U.S. the following year in a slightly different form as *Meet the Beatles*), the picture looked similar in style to what she had shot three years before.

In the late fall of 1960, George was deported for being too young to work in a German nightclub late at night. Three of the others soon straggled back to England. Stuart, however, remained in Hamburg for several weeks with Astrid, to whom he was now engaged. That began the process that would see him leave the group to return to art studies with British artist Eduardo Paolozzi, who was teaching in Germany at the time. Stuart had far more traditional artistic talent than the others and had always viewed his musical experience with the group as a kind of sabbatical. Moreover, he was beginning to break down from the whole experience. "I am so happy that Stuart not play any more with the Beatles," Astrid wrote in a letter a few months later. "I think this has something to do with his nerves."

When the Beatles returned to Liverpool—somewhat shaken up by the way the whole experience had ended—Bob Wooler, a former railway

clerk and now a host at a club where he spun records, temporarily took them under his wing. He was slightly older, erudite, dapper, and a cut above most figures on the Liverpool music scene. As Billy Butler, who worked with him at the Cavern, put it, "He could make excitement come out of a leaflet—'Seven Great Hours, Seven Great Bands'"—and he would promote the Beatles by playing the "William Tell Overture" as they entered a performing area.

"Their attitude was more middle-class," said Wooler of the Beatles. "You always felt a bit elevated in their presence." He helped get them an end-of-the-year gig at Litherland Town Hall in greater Liverpool, where they were billed as "Direct from Germany," leading to confusion. "I ran into George on the bus to the gig because I wanted to hear this new German group," remembered Tony Bramwell. "George told me his group was playing. I hadn't known they were the same."

That appearance on December 27, 1960, is often considered the birth of the Beatle phenomenon in England; the story goes that the crowd went berserk upon hearing the new sound the Beatles had developed in Hamburg—more polished and much more grounded in driving rock.

"My God what a difference," Paul's brother Michael McCartney remembered about the group's new approach. "What a tightness. It had become unique, it had become their sound."

Something was clearly happening. By January 1961, the group had twenty local bookings; by February, over thirty. Through all their long nights of practice together, the Beatles had become Liverpool's version of the ultimate bar band. "Don't tell them they're fantastic," a local promoter said. "They'll want more money."

Harry Prytherch, a Liverpool musician, appeared with them on many bills. "When they came on I heard this huge noise," he remembered. "It was four guys with their backs to the audience and they would turn to the audience one by one. The girls just ran up from the back of the hall."

Old acquaintances couldn't believe it either. "The Beatles," said one. "Aren't they that group with that awful John Lennon who used to be at the art school?"

Yet despite their initial success in securing gigs when they returned from Hamburg, the Beatles were not in great shape as 1961 began. With Allan Williams now out of the picture, they had no one (other than Bob Wooler, who acted more as a friend) to represent them to ensure they got paid what they were worth. They also had no way to get to many engagements other than the public bus, and they were worried about their prospects of getting back into Germany because of the problems surrounding George's deportation.

They needed help. And over the next year, they would find it through two individuals whom no one would have predicted would be there for them.

THE PARENTAL OUTSIDERS: MONA AND BRIAN

THE Beatles returned from Hamburg transformed. Yet they still lacked direction and any sense of how they could convert their momentum into commercial and artistic success. It turned out to be two Liverpool outsiders—an ambitious woman and a troubled gay man—who would set them on the path to their promised land.

It was not happenstance that it was an unconventional woman and a gay man whom they drew in and to whom they were drawn. As self-defined outsiders, the Beatles tended to identify with other outsiders in their community. And once John and Paul lost their mothers, they almost always managed, one way or another, to find nurturing parental figures to help take care of them.

Mona Best was their drummer Pete's mother. She "threw us the lifeline," Pete later told an interviewer. For close to a year, using the experience she had gained helping her husband as a boxing promoter, Mona served as the Beatles' impromptu organizer and benefactor. She helped with the bookings; bought them a van; paid for equipment; got their performance fees raised; and, when they were faced with visa entry problems, wrote letters to help get them back to Hamburg in the spring of 1961. Mona took an intense interest in them at a time when few others in a position to help them would.

As difficult as it is to imagine today, Mona had set up the Casbah Club in the basement of her Liverpool home. On some nights, the club attracted hundreds of young people who sought out the bands and one of Liverpool's first espresso machines, and it is where the Beatles made some of their earliest appearances. She didn't do it for financial gain but in the hopes she could help launch Pete into the stratosphere of success. She also was looking for a challenge in a locale she found very stifling.

Like Astrid, Mona stood out in a crowd. "Mona reminded me of a film star," said Geoff Taggart, a local musician. Liverpudlians considered her brooding and exotic because of her jet black hair and "dark looks." They also thought of her as somewhat volatile. She was born in India, which was also Pete's birthplace. (That meant she had no local Scouse accent.) She had moved to Liverpool with her husband when Pete was four, but according to her son Roag, she didn't get along with her in-laws, who considered her pampered because of her more posh upbringing abroad. She was restless and bored, yet unlike many women at the time, she found unusual ways to channel her ambitions.

First, she decided to move, and when she found a large house she liked, she got the funds to pay for it by pawning some of her possessions and putting the money on a winning horse at the racetrack. Then she designed and opened her basement club, which the Beatles helped paint. She was known for giving raucous parties, and with her marriage on the rocks, the club and the Beatles became her focus.

"She doted on Pete," said Bob Wooler. "She desperately wanted them to get somewhere after Hamburg."

Mona had yet another connection to the Beatles. According to Roag Best in his book, *The Beatles: The True Beginnings,* sometime during this period, she began having an affair with their roadie and original acolyte, Neil Aspinall. A former student at the Liverpool Institute with Paul and George, Aspinall was studying to be an accountant when, as a lodger in the Best home, he met Mona, who was eighteen years older than he was. Aspinall heard about the band through Mona and Pete, and soon became their driver, road manager, and general Mr. Fixit. (It's a role that has evolved today into managing director of Apple in London.)

During the first ten months of 1961, the Beatles seemed to perform

nonstop. In April they made another lengthy trip to Hamburg, where they played for 503 hours over ninety-two nights, according to Beatle historian Mark Lewisohn. The rest of the time, they often took the van or the bus to play at local ballrooms around Liverpool.

They also became regulars at another venue—downtown Liverpool's Cavern Club, where they would make 292 appearances over the next two and a half years, playing at lunchtime and in the evenings. The Cavern was actually a cellar; Billy Butler called it an "air raid shelter with noise." Michael McCartney described the aroma as "rotten fruit, musty sweat, leaky toilets, and disinfectant." It cost a shilling to get in at lunch. After going downstairs and passing the toilet and coatroom, fans found the room divided into three parts with brick pillars in between. In the middle was a small stage two feet off the ground, which gave the Beatles about six feet of playing space. There were no curtains or rugs and only a couple of lightbulbs hanging from the ceiling. There were benches on the side, a few chairs in front, and in the back young women danced, mostly with each other. Bob Wooler, the compere, usually announced the acts; the coffee bar in the back served no alcohol.

The Cavern was a somewhat unusual venue for Liverpool. It was far more intimate than a ballroom. Moreover, it was downtown, which meant "office girls" could come during their lunch hour (and groups could get paid for playing then). The club was thus less likely to attract the toughs who would disrupt evening performances with their violence. That, in turn, made the Cavern palatable to a different class of patron and to far more women.

The post-Hamburg Beatles continued to strike Liverpudlians as different from anything they had seen or heard. The Beatles looked so scruffy that when George showed up for their first Cavern gig that year, the doorman refused to let him in. "That's the youngest tramp I've ever seen," he said.

"We had a dress code of sorts," said Ray McFall, who owned the Cavern, "and my first reaction was 'How the hell did they get in the club?'"

"It was so different from the run-of-the-mill groups at the time with

their suede-collared jackets and matching colors, all blues and yellows," said Liz Hughes, a Cavern regular.

Sometimes the Beatles wore collars and ties but no shirts, or cellophane bags around their shoes. Meanwhile, Pete Best often played the drums with one hand while smoking with the other. (Their amps were covered with cigarette burns.) Quiet "Bestie" was considered the fans' favorite, with looks far more conventional for the time. He was so popular, in fact, that Bob Wooler suggested they move his drums from the back to the front. "AIM—attitude, image, music—and in that order," Wooler once said to explain the group's appeal.

On the small Cavern stage, Paul played the PR man. He was more polite, while John tended to insult everyone, changing the lyrics to songs so that "A Taste of Honey" became "A Waste of Money" or Buddy Holly's lyrics became "All my life, I've been waiting, tonight there'll be no masturbating."

"John had a throwaway style that girls loved," Bob Wooler said. "It was a display of fuck-u-lence."

"Paul would play to the adults, or whatever, to make the group look good," Dot Rhone once told a reporter. "John would do the opposite to annoy them."

Stretching the approach they had perfected in Hamburg, the Beatles obliterated the distinction between performer and audience. These collaborative Beatles were far less hierarchical than most other Liverpool bands, who tended to play a rehearsed, prearranged set. In contrast, the Beatles sometimes ate and smoked on stage, and they engaged in a continual dialogue with audience members about which songs to play and who had come to hear them. They never stopped laughing. "We believe that one of the chief factors in the success of local groups such as the Beatles," wrote *Mersey Beat*, the local music paper at the time, "lies in the fact that they communicate with the audience, talk to their fans from the stage—and the youngsters feel, 'They are just like us!' "

The Beatles' approach not only endeared them to their fans. In many ways, the group got to know its audience as well as its audience got to know the group. That was extremely important to the Beatles and

it was a trait they tried to develop over time, since it gave them the antennae "to detect trends early," as the writer Allan Kozinn put it. Ian MacDonald later wrote, "There was, in truth, little of significance that happened in their time, however foolish or disreputable, which did not almost immediately find its way into the Beatles' life and work."

Their music was equally distinctive. "When they came on, it was like we all had an electric shock," said Irene Radclyffe, who used to go hear them often. "You couldn't not dance to it."

"The sound was such that it took you about twelve hours to recuperate," said one listener about Mersey music. "You know, when you came outside, you were talking to your mates, and all you could see was mouths moving up and down, because . . . you couldn't hear anything."

"They were raw," Liz Hughes told an interviewer. "Nobody had manipulated them or fashioned them in any way. It was completely raw and it was all their own—this one-two-three-four rock-and-roll beat."

The arrogance the group had displayed even before they went to Hamburg intensified. "They were always fun," said Dot Rhone, who said she was the subject of some of her boyfriend's earliest songs such as "Love of the Loved" and "P.S. I Love You." "But there was always an edge too. When I was around them I could never relax because you got the feeling you were never quite good or fast enough."

"At times," Bob Wooler said, "they reminded me of those well-to-do Chicago lads Leopold and Loeb who killed someone because they felt superior to him."

The Beatles later said they began writing songs so they could have something new that other bands couldn't steal. At this point in 1961, however, they had written only about a dozen numbers, and even these were rarely performed. Instead the Beatles played anything by others they or the crowd liked—and they seemed to like almost everything. One scholar later calculated that the Beatles covered a new song about every ten days between 1960 and 1962. "The Beatles," group chronicler Tim Riley later wrote, "elevated the idea of covering other people's songs into an act of self-definition."

They fretted often during 1961 about their failure to progress commercially. Bob Wooler once said that if someone hadn't brought the

group some promise of success by the beginning of 1962, they would have split up. John, who turned twenty-one in October 1961, worried especially that they were already too old to become rock and roll stars—one reason that he and Paul saw fit to pursue their parallel career as songwriters.

The first ten months of 1961 also saw two major changes in the group's sound and feel. First, with Stuart finally deciding to leave permanently, Paul, much to his initial disappointment, took over on bass when John and George refused to do so.

Yet Paul's move to a new instrument improved the group's sound and, eventually, its artistry. Throughout his career in the Beatles, Paul played the bass like a frustrated lead guitarist, thereby reinventing the role of the instrument in rock and roll. (This is very evident on *Sgt. Pepper*, for example, where Paul uses the bass in a more melodious style on songs such as "With a Little Help from My Friends" and "Lucy in the Sky with Diamonds.") Their sound also got thinner with one fewer lead guitar.

The second change, again influenced by Astrid, altered their look and resonated for years to come. The group didn't sit down one day and decide to take on a new image. But over time they started sporting a version of the now famous "Beatle haircut."

Stuart, of course, had been the first to cut his hair like Astrid's—growing it long in back with bangs in the front. It was called *pilzen kopf* in German—"mushroom head." When John and Paul visited Paris in the fall of 1961 they had their hair restyled in a similar fashion. Soon the two leads also began wearing black turtlenecks in the fashion of other French students. "Without grease," said Astrid, their hair "was very poetic." George followed but Pete was either unable or unwilling to do the same. (He had curlier hair.)

It was all in keeping with their background. The English have always been a bit nutty about hair. Even today, an American in the UK is often struck by what appears to be the highest ratio of hair salons to customers in the world. Hair styling is an expensive and elaborate ritual; it takes forever and the customer is plied with drinks and snacks. The status of the hairstyling industry in Britain helps explain why Ringo's goal

in the early days was to take his music earnings and open a chain of hair salons; Paul had a similar dream of helping his brother do the same.

Long hair was also something of a European tradition. Styles, after all, had begun to become shorter only at the dawn of the nineteenth century in imitation of Napoleon, who had something of a hair problem. (Ditto for Caesar, who lionized the laurel wreath worn on the head because it hid his baldness.) In contrast, Louis XIV, like most French kings, had grown his hair very long, and his courtiers wore similar-length wigs in imitation.

Hair had even taken on political connotations in English history: The short-haired "Roundheads" of the English Civil War in the mid-seventeenth century had defined themselves in contrast to the longhairs who supported the Crown. After that, thanks to the Romantic movement, it was mainly artists, like Oscar Wilde, who wore it longer.

Astrid said the Beatle style came from the way actor Jean Marais wore his hair in a Jean Cocteau film, *The Testament of Orpheus*. No longer in the group, Stuart even took the androgynous look several steps further by wearing Astrid's clothes—her leather jacket and velvet and suede suits. The look didn't always go over well when he returned to Liverpool for visits. "Got your mum's suit on then, Stu?" one of the Beatles said to him.

In the summer of 1961, John's art school classmate Bill Harry started *Mersey Beat,* a newspaper to cover the burgeoning music scene in Liverpool. He constantly gave his friend's group top billing, aided by Bob Wooler, who wrote a column for the paper. Wooler used his column that fall to describe the Beatles as "the stuff that screams are made of."

"Essentially a vocal act, hardly ever instrumental," he wrote, "they resurrected original style rock 'n' roll music." He concluded by saying, "I don't think anything like them will happen again."

Another columnist for *Mersey Beat* was Brian Epstein, the second unexpected figure to shape the Beatles career at this stage. Epstein was the son of the owner of North End Music Stores (NEMS) on Whitechapel Road, a shop said to have the largest selection of records in northern England. Epstein was older than all four Beatles (he was twenty-seven in 1961) and, befitting his status and education, he wrote

mostly about more traditional pop artists such as Anthony Newley. Brian was a world removed from the Liverpool background of all four Beatles. He had gone to private school and went frequently to the theater and the symphony. He was soft-spoken and well dressed; he had his nails done at the local barber's. He was as close to the posh establishment in the North—raised with a maid and a nanny—as a Jew could be in a country in which Christianity, after all, is the state religion.

Despite these trappings of success, however, Brian was as much an outsider as the Beatles saw themselves, if not more so. Like John, he was a difficult child from the beginning—"a square peg in a round hole" is the way a friend put it. He attended eight or nine schools—no one wanted to keep count—but he was always having to leave because he was unhappy or in trouble. He attributed his difficulties, in part, to anti-Semitism, but it was the obscene pictures he drew in class (much like those of John Lennon) that forced his withdrawal from Liverpool College, a secondary school.

Clearly there were problems at home. Once his parents went to a school play. "We'd sat through it all," his mother oddly recounted to group biographer Hunter Davies, "and the headmaster came up and asked us afterwards if we'd liked Brian. We hadn't realized which one he was. He was just so good we hadn't recognized him."

In his twenties, Brian drifted (like a butterfly, said one family friend), at one point seeking to become a dress designer, much to his family's horror. At another juncture, he decided he wanted to be an actor and he was good enough to get into the Royal Academy of Dramatic Art (RADA) in London at around the same time Peter O'Toole, Susannah York, and Albert Finney were there.

However, things didn't work out there either, or with his experience in the army in London for his compulsory national service. In both cases, the problem was his homosexuality, combined with an addiction to danger. "His demon was semen," Bob Wooler later said. In those days, when homosexuality was illegal and something still very much in the closet, it wasn't easy being gay even under the best of circumstances. And no one would describe Brian's history as the best of circumstances. Peter Brown later wrote that Brian cut short his RADA stint after he was

arrested in London for "importuning." Epstein had been semidiscreetly discharged from the army earlier, at a time when homosexual behavior could have brought a heavy jail sentence.

"Throughout his life, he was very, very ashamed of his homosexuality," his friend and *New Musical Express* journalist Chris Hutchins said. "He was frightened by it and terrified he would go to prison."

The illegality of gay activity, said Peter Brown, his friend and assistant at NEMS, "pervaded the whole life of a gay man. I can think of very few successful homosexual relationships in those days."

What made it worse for Brian was that he went in for what was called "the rough trade" and was frequently getting robbed or beaten up. It was said the Liverpool police had a file on him after someone tried to blackmail him. "The people he was attracted to were not the kind of people to settle down with," Brown later told an interviewer.

Back in Liverpool and apparently prone to frequent mood swings, Brian was put into the family business. They gave him the record department to run in a music store they owned on Charlotte Street; soon he was so successful they put him in a larger store on Whitechapel.

"I loved working there," said Roy Skeldon, a shop assistant. "Brian was always immaculately dressed, with cuff links and monogrammed shirts, and he always smelt perfumed." Tony Barrow remembered that Brian was the first man he ever met with varnished nails.

Music retailing became Brian's preoccupation: He set up a detailed filing system which noted how many times customers asked for certain records. Soon, he had developed an exquisite ear for what his customers wanted, which would pay off later in his dealings with a wide array of Liverpool groups and acts. "Way and above any record retailer, he was able to predict what the public might buy," Tony Barrow said.

How and why he first crossed the Beatles' path is still a subject of debate. According to Epstein's 1964 autobiography, *A Cellarful of Noise* (which John called "A Cellarful of Boys" to his face), a customer came in and asked for a copy of a record the Beatles had cut as a backing group for Tony Sheridan in Hamburg the spring before—a version of "My Bonnie." That led Brian to make inquiries, which led him to visit the Cavern to see the group live.

Bill Harry, however, disagrees that this was the principal factor. He said Epstein knew who the Beatles were, if only because stories about them surrounded Brian's own column in *Mersey Beat*. "He would quiz me," Harry said. "He saw something on his doorstep."

Whatever the reasons, on November 9, 1961, Epstein entered the Cavern in a suit and tie and was entranced by what he saw. "I was immediately struck by their music, their beat, and their sense of humor on stage and even afterwards when I met them I was struck again by their personal charm," he wrote later.

Others had a different opinion of what drew him to the Beatles. "There is no question in my mind that the Beatles happened because Brian fell in love with John," Nat Weiss, Brian's friend, was later quoted as saying to author Danny Fields. "I mean that was a motivating force for the whole thing." In later years, John, Pete Best, and John's old school friend Pete Shotton all spoke or wrote of polite requests by Brian to have sex with each of them. The two Petes just as politely turned him down; what John's response was would later become one of the mysteries of the group's history because John gave conflicting accounts in subsequent years.

Yet, of course, there was far more to Brian's interest in managing the group than possible sexual attraction. The Beatles offered him a kind of liberating acceptance. As the critic Jon Savage later wrote, "Epstein understood that freedom for the Beatles could be freedom for everyone, perhaps even himself, and, as they were called then, his kind." Yankel Feather, an artist who used to live in Liverpool, offered another, similar opinion. "I think he found it easier to create the Beatles than he did to reinvent himself," he told a reporter.

Most of Brian's family and friends took his interest in the group as yet another of his crazy ideas about what to do with his life. But the Beatles, with their wheels spinning, thought a professional manager would prove more fruitful than Mona. "To us he was the expert," John said. "I mean originally he had a shop. Anybody who's got a shop must be all right."

It's true Brian didn't have what would be considered proper credentials today; he had little financial expertise or inside knowledge of the

popular music scene outside of his work as a record retailer. But the Beatles were naive in this respect, since Liverpool had no professional managers in any real sense.

Unlike any of the Beatles or Mona, what Brian did have was a lot of money and an impressive car—a Zephyr Zodiac. Besides, he was Jewish, and some stereotypically figured that this must mean he knew something about business. If he failed, they could always throw him out—not that this was uppermost in their thoughts. When he came aboard, John could talk of little else than their good fortune in having such a figure join them.

There was no question that they would hire him, George Martin said later. "I mean, he was their only hope."

Even Mona, who some said entertained thoughts of formally managing the group herself, went along with the change in the hope that Brian could provide the outside boost to her son's career she couldn't. That didn't stop her, however, from often calling their new manager several times a day to question moves or make suggestions.

Being a novice actually turned out to be an advantage in some ways for Brian because it allowed him to reshape the role of manager as he went along. He soon became much more than simply a financial adviser to "the boys," as he called them.

First, Brian took on a kind of parental role for the group, as he nurtured them constantly and worked to smooth relations between them. His associates remember that he shielded them to the point that he wouldn't permit anyone to say anything in front of the Beatles that might upset them. He did their shopping and laundry, and provided them with their spending money. When John married Cynthia the next year, Brian gave the couple their party and virtually gave away both the bride and the groom. When George wanted to get married in 1965, he asked Brian's permission before he spoke to the bride's father. When Ringo got married the year before, Brian was the best man.

"I didn't think in terms of money, really," he said. To Brian "they became an obsession," Bob Wooler remembered. "They could do no wrong as far as he was concerned." Because Brian was single, he had no family life; he was on call for "the boys" twenty-four hours a day. That,

in turn, allowed them to concentrate on their music and songwriting, which is one principal reason they began to blossom in that area over the next year.

Second, like Astrid though far more intentionally, Brian also began refashioning the group's look and sense of itself. He had a flair for the visual and the dramatic. "He was an intuitive, theatrical guy," said John. "He presented us well."

He soon became their coach and artistic director—the new Stuart Sutcliffe. He made the foursome feel and look like stars, at least the way he envisioned stars, putting curtains on their stages and insisting on dressing rooms where possible. He gave them written instructions to play established sets and stop smoking, swearing, and eating onstage. (To the extent that the old improvisational Beatles survived into the later years, they did so in their press conferences and Christmas records for fans.) He told them to cut the ends of their guitar strings to look tidier. He kept the hairstyle they had developed in Europe but had it cut by his barber at Home Brothers, thereby neatening it. He brought a different sensibility to their performances—putting them in suits and eventually having them bow deeply from the waist after each song. Michael McCartney was struck by the fact that "Eppie" even insisted they wear the suits *on the radio*. (Unfortunately for him, the first ones he purchased weren't sweatproof, and the condensation in the Cavern ruined them.)

Brian even dictated what cigarettes the boys should smoke offstage; they had to switch to the Senior Service brand because Brian thought Woodbines were too working-class. He restricted their girlfriends from appearing at gigs on the grounds that it would alienate their base of female fans. He tried to buy back as many of the old pictures he could find of John in his underwear and the like so that embarrassing photos were no longer in circulation. Onstage, over time, the group became more unisex, a bit more cuddly, more mainstream, less rebellious, and less macho. "Brian could see what could happen with this band and he channeled it in exactly the right direction, which no one else has ever done, if you think about it," his assistant Alistair Taylor once said.

Third, Brian delivered for them from the start from a business an-

gle. Within a month or two of taking over, as Mark Lewisohn later related, Brian had obtained an audition with Decca Records, better deals and venues for the band's engagements, a BBC audition, and more money when they went back to Hamburg.

His musical instincts about the group were more off the mark, however. When Decca agreed to give the Beatles that audition (if only because Epstein's music store was a valuable customer up north), the group drove down to London on December 31, 1961, to record a dozen or so songs the next day. For some reason, Brian must have thought George had commercial appeal, since Harrison ended up singing an unusual number of leads for Decca. The selection was also eclectic, as if the Beatles were a kind of music hall act. The group sang three original compositions—"Like Dreamers Do," "Hello Little Girl," and "Love of the Loved"—but the assortment also included a number of novelty songs and old ballads—"The Sheik of Araby," "Besame Mucho," and "Till There Was You."

When, to their disappointment, Decca rejected the group, John blamed Brian, and their manager rarely had influence on their music again. Several years later, John responded to one of his suggestions in the recording studio by replying, "Brian, you look after your money and we'll look after our music."

After the Decca setback, Brian made the rounds in London, trying every record company he could. The Beatles often waited at Lime Street Station in Liverpool for their manager's return, which always brought disappointing news. All the companies were turning him down—Pye, HMV, and the rest—and none would even give the group another audition. "I didn't really blame the guy who turned them down so much," George Martin said later. "In fact, everybody turned them down, more or less, on the grounds that their material wasn't very good, I imagine."

Part of the problem was that Brian didn't have much to play for the record companies. Tony Barrow, a northerner then working in London as a freelance journalist and sleeve-note writer for Decca, heard the tape Brian had recorded at the Cavern and agreed with Martin's assessment. "The sounds were of the venue's exciting ambience but they gave little

evidence of the Beatles' quality of musicianship because their singing and playing were drowned out by screams. I remember a woman at the desk behind Brian as he played it, just rolling her eyes at me and pointing her thumb down."

Moreover, whatever charisma the Beatles transmitted didn't come across unless you saw them in person. Their look also seemed a bit weird, given the current image of the standard teen idol, who bore more than a passing resemblance to the greased-up Frankie Avalons then dominating the music scenes on both sides of the Atlantic.

The group seemed at a dead end, playing the same local venues over and over again. And the group's depression was further deepened by the death in Hamburg of their friend and former bandmate Stuart Sutcliffe during that spring of 1962. Stuart had been suffering from terrible headaches for months; he collapsed with a brain hemorrhage and died on the way to the hospital on April 10, the day before the Beatles arrived in Germany for their third of five engagements. His sister, Pauline, later wrote that John had caused the injury that resulted in Stuart's collapse in a fight almost a year before. There is little evidence to support this theory, however.

Throughout their lives, the Beatles had to deal with an unusual amount of death. After hearing the news, Astrid said John fell apart and spent hours with her. "He had a lot to say," she remembered, as he kept talking about the loss of his father and mother. "John had nobody."

Meanwhile the group seemed to be going nowhere. It's revealing that when Stuart died, the *Liverpool Echo,* a city paper, carried an article on his death under the headline "Probe into Mystery Death of City Student." "Stuart went to Germany 18 months ago with a Liverpool skiffle group for three months," the article read. The name of the group didn't even merit a mention.

A month later, Brian's efforts finally paid off. Several months before, a producer at EMI Parlophone, a small British label that was part of HMV, had indicated he might be willing to meet the Beatles in person. When George Martin, that producer, met again with Brian in May 1962,

he offered the group a possible recording opportunity sight unseen, for reasons that are still a bit unclear. A session was set for early June in London. Brian sent a telegram to the group overseas: "Congratulations boys. EMI request recording session. Please rehearse new material." The great adventure was about to take a new turn.

RESHUFFLING THE BAND WITH HUMOR

THE addition of Brian Epstein to the Beatles' "family" had begun to make them into a new force in popular culture. But it wasn't until the Beatles welcomed two people into the inner circle in the short space of four months in mid-1962 that they acquired the finishing touches that allowed them to begin to conquer the UK and reshape the culture. George Martin and Ringo Starr did many things for the Beatles, but their effect, over time, was to broaden the group's accessibility while also accentuating its compelling sense of humor and infectious sense of fun.

The Beatles had already displayed a knack for surrounding themselves with unusual people who could inspire and help them. Neither Martin nor Starr—the drummer the other three Beatles invited to join the band in the summer of 1962—was a conventional figure of the entertainment scene. Martin was not a renowned London producer and knew little about rock and roll. For his part, Starr was a decent drummer but hardly the best, even in Liverpool. Besides, with little schooling, he was clearly of a different class than the other three and was not conventionally attractive to boot.

Yet John, Paul, and George had the foresight to use both Martin and Starr to complete their picture. They knew rock and roll; Martin en-

abled them to move in other directions, eventually expanding the definition of their chosen genre. Selecting Ringo was an inspired act of genius. Think what the films *A Hard Day's Night* or *Help!* might have been like had Ringo not starred in them and one begins to appreciate what he meant to the group. "Yellow Submarine" and "With a Little Help from My Friends" would have been very different—and inferior—songs without everyman Ringo to sing them.

"There was some spirit that existed between the four Marx Brothers that wasn't there with the three of them," said comedian David Steinberg, referring to the improvements brought about by the introduction to that "family-gang" of Zeppo. A similar thing happened with the Beatles.

In fact, there was a way in which the Beatles resembled a kind of Marx Brothers comedy troupe; it was their sense of humor that commended them to many. "In their first film," wrote Cecil Wilson several years later of *A Hard Day's Night* in the *Daily Mail*, "they emerge as a comedy act who also happen to play and sing."

Humor, of course, has traditionally been of great importance to the English. "Our true patron saint is not St. George but Sir John Falstaff," wrote Hesketh Peterson in *The English Genius*. "We are the most civilized people in the world, the reason being that we are the most humorous people in the world." Englishman Charlie Chaplin was the most celebrated comedian of all time; fellow countryman Stan Laurel of Laurel and Hardy made his mark too. In contrast to their American cousins, English schoolchildren still grow up on a steady diet of literate humorists and satirists such as Edward Lear, Lewis Carroll, Gilbert and Sullivan, and, of course, Shakespeare. Indeed, nursery rhymes, with their roots in medieval and Elizabethan England, have a strange, compulsive humor to them. Even today, the cleverest schoolboys in England—at least to their peers—are usually the funniest boys.

"It comes, in part, from the class system," said Ray Connolly, a journalist. "Traditionally, the only way you could answer back to the upper classes without being insolent was by being funny."

Charlie Chaplin said something similar: "We must laugh at our helplessness or go insane."

William Hazlitt, the celebrated eighteenth-century essayist, called humor a "streak of light" which lightened his fellow countrymen's "natural gloom."

Though BBC radio avoided rock and roll in the fifties, it did feature a lot of comedy. Thus in postwar Great Britain, comedy helped form the mass consciousness of the Beatles' generation in much the same way as rock music did in America.

Nothing did more to shape that new comic sensibility than *The Goon Show;* what Elvis or Buddy Holly was to rock, *The Goon Show* was to comedy. "It was as unique in its own way as 'Long Tall Sally,'" said Tony Carricker, who would discuss the episodes with his mate John for hours.

Featuring Spike Milligan and Peter Sellers, the program ran on BBC radio from 1951 until 1960 and gave its listeners, many of them young, a weekly dose of anarchic, surrealistic insolence with three or four skits per half hour. Jonathan Miller, cocreator of the satirical cabaret *Beyond the Fringe,* later compared the program's influence to that of *Alice in Wonderland.* Though *The Goon Show* was quintessentially English, it had an American counterpart in *Mad* magazine; its style would be seen most clearly in the next generation on *Monty Python's Flying Circus.* The program combined an antiestablishment cheekiness with a dry literate sense of humor that poked fun at everything from the political establishment to the language. Like Joseph Heller's *Catch-22* in America, *The Goon Show* grew out of the experience of its creator-performers in the madness of war; unlike Heller, the English were also obsessed with lampooning the pomposity of the upper classes. "The Goons did an enormous amount to subvert the social order," said Miller. "After all, half *The Goon Show* is a send-up of British imperialism."

Listeners to the show were treated to the exploits of Professor Osric Pureheart, who was designing a lead violin for deaf people, or British hero Neddie Seagoon and Major Denis Bloodnok with his curry addiction. Sound effects might come from heavily edited donkey farts. There were routines such as this one:

MORIARTY: My socks keep coming down.
GRYTPYPE-THYNNE: Oh? Say "Ah."

MORIARTY: Ahhhh.
GRYTPYPE-THYNNE: Gad, you've got hoar-frost on the ankle.
MORIARTY: Is that dangerous?
GRYTPYPE-THYNNE: If it kills you, yes.

In the flurry of British comedy and satire that followed in the late fifties and early sixties came other similar efforts by comedy troupes— *Beyond the Fringe,* a wildly popular satirical review created by a group of Cambridge University undergraduates that included Miller, Peter Cook, and Dudley Moore, as well as BBC television's *That Was the Week That Was,* a satirical view of the news starring David Frost.

"We had the same timing as the Beatles and challenged the same conventions," Miller said. "In a way, you could say that the Beatles were satirical, or at least skeptical."

"We were the sons of *The Goon Show,*" John Lennon later said of the Beatles. "We were of an age. We were the extension of that rebellion in a way." The image of a collaborative group that wrote and performed its own material obviously appealed to the band. And many of the Beatles' later quips in press conferences could have come straight from the show.

Take a 1964 gathering with the press, as described by Beatle chronicler Keith Badman. A reporter begins by asking them rather pretentiously about their "false modal frame ending up as a plain diatonic":

JOHN: We're gonna see a doctor about that!
REPORTER: Who came up with the name Beatles and what does it really mean?
JOHN: It means Beatles, doesn't it? That's just a name, just like shoe.
PAUL: The shoes you see. We could have been called the Shoes for all you know. . . .
REPORTER: Who chooses your clothes?
JOHN: We choose our own. Who chooses yours?
REPORTER: My husband. Now tell me, are there any subjects you prefer not to discuss.
JOHN: Yes. Your husband.

REPORTER: Which do you consider is the greatest danger to your careers: Nuclear bombs or dandruff?

RINGO: Bombs. We've already got dandruff.

It wasn't just *The Goon Show* that formed the Beatles' sense of humor. Coming from Liverpool, where everyone considers him- or herself an amateur comedian, the Beatles were well schooled in the art of merriment. In the fifties, comedians from northern England such as Arthur Askey and Ken Dodd blanketed the radio waves and those vaudeville-like music halls still in operation. Liverpool comedians were known for playing the underdog, which, as self-defined outsiders, came naturally to them and appealed to the English fondness for humor that upset the class system. Yet twist that a little and you end up with the Beatles' kind of antiestablishment humor that the young found very appealing later in the sixties, as earlier comedians such as the Marx Brothers also enjoyed a renaissance.

"Humor is always a key to rebellious social movements because it weakens the establishment by making it appear ridiculous," said Michael Kazin, coauthor of *America Divided: The Civil War of the 1960s.* "This was especially true in the sixties, when part of the whole critique was that the establishment had become too straitlaced."

Getting the Beatles to laugh was never a problem. They deftly combined two types of humor endemic to the English: They were both verbally deft and masters of more basic standup humor like the comedy of George Formby. After all, Mona Best almost didn't hire them for her basement club because they could never stop clowning. In the early sixties, John's friends still thought that if he ended up on stage, he would be a comedian, not a musician. British journalist Maureen Cleave commented in a cable to her paper during their rapid rise to fame that "either they're employing the most marvelous concealed gag man or Bob Hope should sign them up right away."

Journalist Ray Connolly said later, "People forget how funny John was. He had you laughing all the time."

Back in Liverpool, Iris Caldwell remembered that Paul "was never serious. Always joking."

Being funny helped make them fun—also a key component in their

appeal. "We had fun, you know, we really had fun," George Harrison said later. It was a word the Beatles' friends used constantly to describe them in the beginning (though apart from one another they appeared far less jovial, as if joy could be experienced only as a collective trait).

"The thing about the boys is this great joy of being alive that they put across," said Alun Owen, a Welsh writer who traveled with the group in preparation for writing the screenplay to their first film, *A Hard Day's Night.*

"It was hard not to watch them every second—they were so alluring, entertaining, and fun," Joan Taylor, Derek Taylor's wife, said. "You could just not get enough of them."

It's a characteristic they passed on to their fans and friends. "Standing outside the Plaza screaming for them in New York," said Christina Berlin, "I don't think I've ever had so much fun in my life."

Rock had been many things in its first ten years of existence—rebellious, surly, and exciting. But it wasn't always that much fun. A product, in part, of the blues, it frequently OD'd under the weight of the *blue*ness of teenage angst. The patron saints of teen culture were the diffident Elvis and the persistently conflicted James Dean. Many of the genre's early songs dealt with teen anguish and lost love in its most forlorn forms: "Death rock"—in which one's lover perished in some grotesque tragedy like a car crash—was a whole category unto itself. To the extent that early rock tried to be joyful, it often ended up sounding trivial or goofy in songs such as "The Purple People Eater" or "Rama Lama Ding Dong."

In contrast, the Beatles delivered optimism and an elevated kind of fun by the bushel. Their songs didn't talk down to their audience, nor were they sappy, despite lyrics that spoke innocently of hand-holding and dancing. "Everybody loves them because they look so happy," Cleave later wrote, and they sounded just as happy as they looked. As others would point out, even when they later sang a song like "Misery," the Beatles couldn't help sounding not the least bit miserable.

That aura of fun remained at the core of the band's sensibility: In "She's Leaving Home" on *Sgt. Pepper,* the runaway teen leaves home to seek fun because it's the one thing that money cannot buy. In fact, the

Beatles' liberating kind of humor and fun became so contagious that it became a calling card not simply of the group but of the whole counterculture they helped promote several years later. The band's British acquaintance from Hamburg, Tony Tyler, subsequently described the sixties as "mostly driven by fun and the fun was driven by the music."

"Peace with Beatlespower is Funlove for Life!" read a sign at a 1967 festival in the U.S. "First and foremost: be happy, be creative, be optimistic in the face of everything," wrote Tom McGrath in a manifesto in the counterculture *International Times*. In his comprehensive survey of the Beatles' effect on the sixties, Beatle analyst Ian MacDonald called the "emphasis on informal and immediate fun . . . the hallmark of Swinging Britain during pop's peak years." The later renown of figures such as jokester yippies Abbie Hoffman and Jerry Rubin, as well as even comedian George Carlin, owed something to the success of the Beatles.

George Martin was candid in admitting that in the beginning the Beatles' music didn't impress him and his associates nearly as much as their humor and charm. "We've got to sign them for their wit," argued Parlophone tape and recording engineer Norman Smith after their first meeting in June.

Similarly, it was Martin's background in humor—as a producer of records with Goon Peter Sellers, Peter Ustinov, and the cast of *Beyond the Fringe*—that first commended him to the Beatles. Martin's taste was eclectic and aimed at what one writer would call "the distinctively British." (For example, Parlophone had supposedly cornered the market on Scottish dance music.)

Unlike other producers, Martin liked "running around and experimenting." He had produced a recording in which a saxophonist did "Three Blind Mice" in a number of styles, and he had recorded Ustinov as early as 1952 in such a way that the actor performed several parts with himself. Doing sound effects for comedy records—some of which eventually ended up on Beatle songs such as "Yellow Submarine"— seemed to thrill Martin more than the performers.

Martin had once played the piano in a dance band (George Martin and the Four Tune Tellers) and came across at first as clipped and upperclass; the Beatles called him "the Duke of Edinburgh" behind his back.

But the accent and demeanor came from elocution lessons and his work at the BBC; Martin later maintained, credibly, that his background wasn't that different from that of the Beatles. He had grown up in London in a two-bedroom flat without a bathroom or kitchen (his mother cooked on the stairs outside); he taught himself the piano, and received a scholarship to a Jesuit school. He wanted to write for films, and though he knew that pop acts were where the money was, he was a generation removed at age thirty-six in 1962 and had little interest in the likes of Elvis, Buddy Holly, or Little Richard. In fact, Martin turned down English pop star Tommy Steele, only to have him signed within days by competitor Decca.

However, Martin was interested—even if he wouldn't have articulated it in exactly these terms then—in changing the role of the record producer. In those days, Martin later told an interviewer, producers "didn't really shape events in the studio." Their job instead, he said, was "to recruit talent, put them in the studio, and give them an opportunity to be recorded, rather like a broadcast." Martin was far more intent on shaping sound, and he would get the opportunity to put his ideas to work with the Beatles.

Back in Liverpool, the band practiced alone at the Cavern for two days before traveling to London in early June 1962 to meet with Martin for their first rendezvous. After Martin took one glance at his new arrivals, a half hour late as usual, he left, assigning the session to one of his assistants accustomed to working with rock acts. The assistant brought Martin back only when he heard the Beatles perform "Love Me Do." According to accounts, Martin disliked the lyrics and wasn't that enthusiastic about the melody or their musicianship either. "That was the best of the stuff they had and I thought it pretty poor," he later said.

"Actually they were pretty bad," Norman Smith said. "But afterward they came into the control booth and we got to talking with them—and really *that* was fascinating."

As usual, the Beatles had a different opinion about their playing. "We thought it was good," said Pete Best.

There was general agreement at EMI about one thing. "He's useless, we've got to change this drummer," one of Martin's associates said to

him after hearing Pete Best play. Moreover, during the group's quick-witted conversations with the Parlophone recording hierarchy, Pete, typically, had rarely said a word.

For many groups that advice wouldn't have caused a permanent change in the group's composition. It was then standard practice throughout the recording industry to have anonymous studio musicians supplement the efforts of bands when recording. Besides, the Beatles were not ones to follow advice if it didn't fit with their own vision. In the coming months, for example, they would strongly reject Martin's suggestions about which songs to record for initial release.

The idea to dispense with Pete Best, however, took root because it jelled with what the other Beatles and Brian Epstein apparently were already thinking. Ever since "Bestie" had joined the group two years earlier at the last minute as the drummer they needed for their Hamburg gigs, he had never seemed to fit in with the other three. He was as quiet as they were loquacious.

"I found it very difficult to hold a conversation with Pete Best in those early days," Bill Harry later wrote, and Tony Sheridan, who knew the group well in Hamburg, remembered Best as "a loner, and in a group you can't be a loner." Best also looked and acted more like the surly pop stars of the era.

John, as usual, was more blunt: "He was a harmless guy but he was not quick," he said. "All of us had quick minds, but he never picked that up."

"He was slightly different from us, he wasn't quite as artsy as we were," said Paul.

Nor was Best's drumming the best, and as Bob Wooler always said, the Beatles were not a group to carry passengers. Thus months before George Martin and his associates gave their opinion about Best's drumming, the other three were already cutting him out of the collective process, neglecting, for example, to tell him that they had failed their January Decca audition until weeks afterward.

Friends also said Brian wanted Pete out because of his mother, Mona. Falling into the strong advocacy role she had filled before Brian took over as manager, she continued to call their manager repeatedly,

offering advice or complaining about bookings, fees, or the play given to her son. "That woman," Epstein told Bob Wooler, "is driving me crazy."

Photographer Harry Benson later wrote of a conversation he had with John a short time after Best had left the band. "One night at dinner Lennon mentioned why they had gotten rid of Best," wrote Benson. "He said it was because of Best's mother. Supposedly she was trying to take over the Beatles. Lennon said 'That's the truth. She was trying to run the Beatles her way.' "

Mona was also involved in a potential scandal. In late 1961, as described in such recent books as Roag Best's *The Beatles: The True Beginnings,* she had become pregnant, as her affair with the band's roadie and confidant Neil Aspinall continued despite her still being married to Johnny Best. (In fact, without the pregnancy, Mona might never have agreed to step aside and let Epstein take over the band the prior December.) She gave birth to a baby, Roag, in late July 1962, six weeks after the Beatles' first meeting with George Martin; the extra family responsibilities forced her to close down the Casbah Club.

The birth of the child must have presented Epstein with a problem: If the Beatles ever hit the big time, it might leak out that their drummer's mother had borne an illegitimate son by their road aide. In 1962, that would have been scandalous, and the prospects of acts have been scuppered on less. Besides, with the birth sidelining Mona temporarily, Epstein and the others had a chance to move against Pete.

On top of all this, the three other Beatles, as well as Epstein, sensed that something was still holding the group back from success. "What they needed in those days was someone that would fit in with their Liverpool humor," said Cynthia.

The replacement band member would be the only one consciously recruited for what he could do to complete the whole picture, from sound to look to sensibility. (In contrast, neither George nor Paul had been consulted when John had invited Stuart to join.) According to Bob Wooler, Michael McCartney once said that he almost replaced Pete, which suggests that Paul's original instinct, which would be repeated over the years whenever he or his bands needed other "partners," was to bring in a relative. There are stories that the band considered Johnny

Hutchinson of the Big Three, touted by many as the best drummer in Liverpool. But the Beatles were looking for much more than simply an improvement in their sound, and besides, Hutch was known as "a tough" and it was said John was a bit afraid of him.

Ringo Starr has been called the luckiest man in the history of entertainment—the musician who joined the Beatles after all their hard work and then immediately saw them skyrocket to fame. The truth is different. If the Beatles suddenly took off within months of Ringo's arrival and then stayed in the stratosphere, it's because Ringo had a lot to do with it.

He wasn't Brian Epstein's choice, at least initially. "Brian didn't want me," Ringo told Hunter Davies. "He thought I didn't have the personality. And why get a bad-looking cat when you got a good-looking one?" But the others felt differently, especially George Harrison, who knew what it took to be a complementary part of this unique whole. "In a way I felt a bit like an observer of the Beatles, even though I was with them," George once said. "Whereas John and Paul were the stars."

Though he grew up in Liverpool, Ringo's background was different from the other three, which is one reason that Brian was wary. For all of Paul's complaints about Pete, the last description anyone would apply to twenty-two-year-old Richard Starkey was "artsy." Because of various serious illnesses that kept him out of the classroom, Ringo attended school for only around five years. It was said he couldn't read until he was nine and still couldn't spell very well. (For an early press handout of the group, he wrote the word "anyone" as "enyone.") "John took the Latin and the painting," Ringo once explained.

He was three months older than John and grew up poor in a rough Liverpool neighborhood called the Dingle, where row upon row of small attached houses lined the streets and there were pubs on every corner. His parents split up when he was three (Ringo remembered thinking his father was an ogre), and like the others in the group, he grew up in a matriarchal household, though his mother remarried when he was almost thirteen. "Elsie was a real character," said Cilla Black, the Liverpool singer who was a friend of the Beatles, yet another "surrogate Mom . . . to me and to the other Beatles."

Before her remarriage, Ringo's mother was a barmaid and worked in a food shop to make ends meet in a house with no indoor toilet. The end of rationing made no difference to this family because they couldn't even afford basic staples such as butter. Ritchie, her only son, was a lonely child—frequently alone for months at a time in a hospital with appendicitis or pleurisy; in those days, parents were often not allowed to visit their sick children because it was considered too upsetting for the youngsters. One account put the number of operations he had as a child in double figures. "I wish I had brothers and sisters," he said. "There's nobody to talk to when it's raining." At night when Ritchie was home, he would occasionally sing "Nobody's Child" to his mother and she would quietly weep. When Ringo recorded his first solo album in 1970, he chose to sing a series of ballads from the thirties and forties that his mother loved.

His initial ambition was to be a tramp because they had to walk everywhere, like he already did. At various times, he worked as a railroad messenger, as an apprentice engineer, and for two weeks in the bar on a ferryboat. He once considered immigrating to America, and even went so far as to contact the Houston Chamber of Commerce. (He liked Texas from cowboy movies.) When the skiffle craze hit, he was typical of the thousands of Liverpool boys who joined a band; the only thing that made his story somewhat atypical was that he played the drums, courtesy of his stepfather, who bought him a set. By 1959, Ritchie was the drummer in a group—Rory Storm and the Hurricanes—which, like the Beatles, soon moved into rock and roll. Unlike the other three Beatles, however, Ritchie adopted a stage name, as did all the members of his band—par for the course in those days. (The name Ringo came from a Western, enhanced by the number of rings he wore on his fingers.) Many in Liverpool considered Rory Storm and the Hurricanes better than the Beatles, partly because of Rory's wild stage outfits and antics, and they often played on the same bills as the Beatles. They were even in Hamburg in the fall of 1960 when the Beatles were there (the Hurricanes were actually paid more), and Ringo occasionally filled in on drums for Pete Best.

Opinion about Starr's drumming would always cover the spectrum. "Whenever I hear another drummer, I know I'm no good," he said on

one occasion, and when he once won an award for his musicianship from *Melody Maker,* John allegedly quipped, "He isn't even the best drummer in the Beatles."

"We always gave Ringo direction—on every single number," Paul later said. When Ringo joined the group for the first time in the studio in September, George Martin even saw fit to replace him with a studio drummer, forcing Ringo, in humiliated fashion, to play the tambourine on one version of "Love Me Do."

On the other hand, Beatle chronicler Tim Riley has called Ringo the Beatles' "most underrated musician." "Playing without Ringo is like driving a car on three wheels," George Harrison once said, and when the three surviving Beatles reunited in the midnineties to record "Free as a Bird," the song began with the drums and it was instantly recognizable as the work of Ringo—simple yet solid and distinctive. "I play with emotion and feeling and that's what rock is," he said. Like all of the Beatles, his musicianship would evolve, and after that first session in September 1962, Martin never again called for him to be replaced in the studio.

Yet the truth is that the Beatles weren't looking for the world's greatest musician as their drummer. They already had two intensely creative, tightly wound leads—and wannabe George too—and the last thing they needed was another star. What they required, first, was someone who could fit in and be another brother in the family, so to speak. In a world where band members have to live together twenty-four hours a day on the road, compatibility is essential. "You have to realize what it's like to be a musician and this was always true of them," John's assistant in the late sixties, Dan Richter, said. "You're always moving in the dead of night, you're either on stage, traveling, or in a hotel—you're completely isolated from the world."

Still, it took a while for even easygoing, laid-back Ringo to fit into this close-knit group. According to photographer Dezo Hoffman, Ringo wasn't officially in the group until after the American tour in 1964. "I didn't feel I really belonged until after the first two years," Ringo said. "It was just them—the Beatles—and me, the new drummer." But once he became established as a member of the band, he made it easier for all of

them to get along with one another. "He would be the catalyst," George Martin said later. "His opinions counted. If John was doing something a bit dubious and Ringo would say, 'That's crap, John,' John would take it out. He wouldn't get angry, he would accept it."

Moreover, for a group of people who hated to be alone, Ringo was essential. On the road he often roomed with Paul. Yet John's friend Jonathan Hague also remembered that whenever he ran into John over the years, Ringo was almost always there too. When the group finally stopped touring in 1966, and John went off to be in the movie *How I Won the War*, it was Ringo who flew to visit him in Spain when Lennon got lonely.

Beyond that, Ringo added an essential element of ordinariness to the group, which ended up greatly bolstering its appeal. This collection of striking-looking arty students didn't need another unique figure; what it lacked was the common man. Ringo was the only one of the four who could dance. In 1968, the others went to India to visit the Maharishi Mahesh Yogi because they were searching for the meaning of life. Ringo, in contrast, was impressed with the guru because he always seemed to be laughing, and Starr left India, not because he was disillusioned, but because he didn't like the food.

In further contrast to the other three, Ringo was smaller and less attractive; his Scouse accent was stronger, and it's no coincidence that in the Beatles' films, he was portrayed as the funny, needy, lovable loser—a kind of variant of Chaplin's Tramp. He was the heart to their head—the only member of the group who could have been a character in a Dickens novel. His presence in the group made them all more accessible.

He also seemed happy in an uncomplicated way, which often appealed to children and adults as much as to rebellious adolescents. He was, wrote one profiler, "the most evenly happy Beatle." He helped smooth the group's ascent in the U.S. in 1964, and it was his membership in the band which made it easier, for better or worse, for the Beatles to be converted into cartoon characters for television and the psychedelic movie, *Yellow Submarine*.

Victor Spinetti, who appeared with the group in both *Help!* and *A*

Hard Day's Night, once described the differences among the four to interviewers Alan Lysaght and David Pritchard:

> *I was at a hotel in Salzburg while we were filming* Help! *and I had the flu. We were all staying in the same hotel and I was lying in bed. Each of the Beatles visited me separately, and the way they visited me when I had the flu is what they are really like.*
>
> *There was a knock on the door. Paul McCartney opened it, looked around and asked, "Is it catching?" I said "Yeah," and he closed the door. George Harrison walked in and said, "I've come to plump your pillow because whenever you're ill people come to plump your pillows." . . .*
>
> *John Lennon walked in and said [in a German accent], "You are in zee state of Austria. You are going to be experimented on by zee doctors and your skin will be made into lampshades. Heil Hitler!" Then he walked out. Ringo walked in, didn't say anything, sat on the side of the bed, picked up the room service menu, looked at it, and said, "Once upon a time there were three bears, Mommy bear, Daddy bear, and Baby bear. . . ."*

The other three left it to Brian to inform Pete in August 1962 that he was being thrown overboard. Brian and George Martin had to field the angry calls from Mona. Despite her resentment, she apparently remained somewhat friendly with the three original band members over the years—even lending her father's medals from India to John to wear on his *Sgt. Pepper* uniform. Pete, however, never spoke with any of them again. (In protest, Neil at first refused to set up Ringo's drum kit.)

Getting rid of a band member didn't seem to exact any toll on the exacting Paul; George had also been militating for a change, though there are suggestions he now feared that with Best gone, he might be next.

Normally, however, such a move would have been more difficult for John, who, understandably, had trouble with anything resembling abandonment. (According to Brian, John also liked Pete more than George and Paul did.) But John had less to do with the whole Pete inci-

dent than he might have because his mind was on other matters. That summer, he learned that his girlfriend, Cynthia Powell, was pregnant, and given the mores of the time, they were married soon after getting the news. John's aunt Mimi was so upset that she refused to attend the impromptu wedding held at the Mount Pleasant Register office in Liverpool four days after Ringo first officially played with the group. Paul was the best man, and the small guest list included Brian, George Harrison, and Cynthia's brother and wife. (Cyn's mother missed the wedding because she was living in Canada, working as a nanny for her cousin. Had she not left the country months earlier, Cynthia wouldn't have been without parental supervision and thus wouldn't have been able to get together with John nearly as much and may well not have gotten pregnant.)

The wedding "reception" was held at a nearby café, where they ordered roast chicken. That night, John headed to Chester to play with the other three Beatles. "He was not in a good mood," Harry Prytherch, a Liverpool musician, remembered. "He was so angry they had to walk him off stage." Brian wanted to keep the marriage a secret, afraid that if it leaked out it would hurt the group's growing popularity with their young female fans. Ringo himself learned of the wedding only weeks later. "I saw them many times at the Cavern after that," said Lynne Harris, a fan, "and I had absolutely no idea that John was married."

Cynthia's pregnancy was, obviously, not an auspicious start to a marriage; to many observers, the other three Beatles would often treat her better than John did. Marriage, John later said, "was like walking about with odd socks on or your fly open." Without the baby, Cynthia later complained, John "would just have gone off with the Beatles forever"—which is pretty much what he did anyway.

By most accounts, John was an awful husband and father at this point. "How can you talk about peace and love and have a family in bits and pieces—no communication, adultery, divorce?" his son Julian (named after Julia) asked decades later. His half brother Sean, John's son with Yoko, born in 1975, didn't disagree about their father. "He was a macho pig in a lot of ways," he once said, "a huge asshole."

Part of the problem was the group itself. "His love was the Beatles,"

Cynthia said. The Beatles were already "married"—to each other. "Whoever was around the Beatles had to be just totally supportive of them," she complained.

Even without the group, however, anyone in a relationship with John would have had her hands full. Women who met both him and Paul often found Paul charming and romantic, at least on the surface; John they often found far less so, until he met Yoko. "Paul would never treat a girl like shit," said Thelma Pickles, who knew them both well from back in Liverpool. "But John was no respecter of good manners; being courteous was beyond him."

To those who knew him, John's treatment of Cynthia continued to conform more or less to the pattern. He cheated on her. Consistent with the attitudes of the era, he didn't want Cynthia to work or continue her artistic pursuits, and she would ask their friend Bill Harry if there was any field of art he could think of that John wouldn't object to her pursuing. When she tried to obtain a nanny, John refused to hire the woman. And when Julian was born in the spring of 1963, John didn't visit the baby or his wife for several days after the birth.

That typified the relationship. "We never had much to say to each other," John recalled. Several years later, when he was asked by a reporter about "the pill," John answered, "I wish they'd had it a few years ago." No one at this point would ever have predicted that a group with John Lennon would eventually influence opinions about women or family life for the better, or that he was capable of writing lyrics that women would find empowering.

After the marriage in August 1962, the pregnant Cyn moved in with Aunt Mimi on Menlove Avenue. John's aunt hardly welcomed her with open arms. Boarders were sharing the house. One acquaintance remembered Cynthia telling him that her hands became raw from all the dishes she had to wash. "When Cyn had her baby," another friend remembered, "Mimi didn't even get out of bed to see her off."

Meanwhile, less than a month after the wedding, the Beatles went back to the studio in London to begin recording in earnest for Parlophone with George Martin. The revolution was about to begin.

FIRST RUMBLINGS OF A GENDER REVOLUTION

It was the Beatles' persistent and resolute connection to their female followers that became the foundation of their influence and popularity. Yet they couldn't have done it without the vision they were able to communicate to these fans through records. From virtually their first day in the studio until they broke up, the Beatles used the power of the recording process in new ways that allowed them, in turn, to speak to their audiences more powerfully than musical artists ever had done before.

For that reason, among others, the Beatles marked a dividing line in the history of music and popular culture—though no one knew that on the afternoon of September 4, 1962, when they entered Abbey Road Studios to record their first single, having met George Martin three months earlier. Certainly records, and even music, are not as important cultural forces today as they were a generation or two ago, so it is sometimes difficult to appreciate what the Beatles accomplished and what they meant to the millions who followed them.

"I'm sure this will be difficult for people hundreds of years from now to comprehend . . . but for a time in the late 1960s, a lot of people really believed that some kind of revolution was imminent, and that the music let you feel what it was going to be like," Robert Walser, chairman

of the Musicology Department at the University of California at Los Angeles, once told a writer. "There was this energy, sense of empowerment, sense of community coming from the music. In no other historical period had that happened with music."

Without that music—and more important, the records that delivered it—the sixties would obviously have been very different. Music seemed to be everywhere in that era—in the parks, at demonstrations, blaring constantly in college dorms or in the car.

Music is, of course, an art form that has been around since the dawn of history; Plato gave it a central role in his utopia. Before the rise of radio and records, however, it had come to the listener in the mediated form of a public or personal performance. Songwriters had their songs interpreted by others; even Beethoven was at the mercy of the orchestras or quartets that played his compositions. Audiences were also circumscribed by the number who could attend a performance at any single time.

Once radio and records arrived in the early decades of the twentieth century, however, everything changed. Electricity brought the actual performances of artists directly into the home on a regular basis. Able writers had the potential to perform their own work (though many still don't). The possible audience for a formal performance went from a few thousand at best to millions. Formally performed music also became more pervasive—from something that the average individual might encounter a few times a year in a concert hall or a church to something enveloping one's existence in homes, shops, or cars.

Moreover, the importance of the performance was replaced by the importance of the recording. This was especially true of rock and roll, which was one of the first forms of music to develop in the postwar period, when the rules had changed. It owed its existence to the electrification of the culture—from the radio and phonograph to the amplifiers that suddenly allowed three instruments to constitute a band. "Due to its success in establishing records as a true medium for music," rock writers Michael Lydon and Ellen Mandel wrote, "rock 'n' roll . . . won an audience larger and more spontaneously responsive than any other music now commands." The rise of rock set the stage for a musician (or

group of them) to become the originator of a new kind of personal "globalization" and to use song to wield a power over millions that no artists had known before.

Of course there were accomplished and popular musicians before the Beatles, and there were better ones, too. Bach and Beethoven, however, had been born centuries too soon. (Roll over Beethoven!) As Tim Riley and others have noted, the Beatles were the first artists really to capitalize on the notion that they could mold themselves not simply as songwriters, where others were left to interpret their work for them, but as *record creators*. What was important to them was not simply the song but the precise way it was presented on vinyl in its full complexity—the voices, the sound, and the exact instrumentals in the background.

"I'm a record fan," John said.

"Recording was always the thing," Paul agreed.

This approach enabled them to reach their congregation in far more immediate ways than others had done. There was an intimacy involved in this new form of communication—a sense that artists were talking to their audience in a new, direct way.

This would prove true especially with teenagers, who as usual had adapted to a new technology the fastest. Teens could buy a record, bring it home, and play it over and over again in their bedrooms on portable machines. At the same time, listeners could turn on the radio and know that similar teenagers all over the world were doing the same thing.

George Martin didn't share the Beatles' interest in rock, at least at first. But he did share their preoccupation with record production. To be sure, most of the group's innovations in the studio came later. In the England of 1962, there wasn't that much experimentation to be done: Studios were still primitive and almost everything was recorded in two-channel mono sound, which meant that it wasn't possible to add much to the original performance without degrading the recording. Even so, the Beatles tried. "They brought in loads and loads of records from Liverpool to show us what sounds they wanted," said Norman Smith of Parlophone. "They were so aware of what was going on in America, where they most definitely were ahead of us in pop production."

That September afternoon in 1962, the Beatles entered through

Abbey Road's "tradesmen's entrance." They rehearsed six songs. Though Martin would later become as experimental as the foursome, it was his view at this point, invoking the common practice of the time, that the Beatles should do what other acts traditionally did with their first single. That meant recording a song written by a professional songwriter, in this case "How Do You Do It?" by Mitch Murray, later made into a hit by the Beatles' fellow Liverpudlians Gerry and the Pacemakers.

The Beatles, as usual, had other ideas. "We just don't want this kind of song, we don't want to go out with that kind of reputation," Paul remembered saying. "It's a different thing we're going for, it's something new." Though they loved doing cover versions live, the Beatles wanted to record for the charts something they had written themselves.

At that time, the Beatles' stage act still included very few of their own songs. Though some reports at the time claimed they had written scores of songs, Paul subsequently said they had finished only about twenty when they first entered the recording studio. In fact, on the Beatles' first two English albums, almost half the songs were covers of others' material. In these early sessions to find a first song to record, the Beatles even rehearsed an old forties pop standard rerecorded by the Coasters, "Besame Mucho," with an eye to possible release.

Despite their lack of songwriting success so far, however, the Beatles considered it essential that they write their own material for record release. Part of the rationale was economic: Songwriters were known to have longer and more lucrative careers than pop stars. According to some in Liverpool, Paul, at least, foresaw a career for himself, if nowhere else, on Denmark Street, London's version of Tin Pan Alley.

More important, the Beatles wanted to shape their own future. They quite consciously considered themselves artists—a breed apart—and they sensed that only if they wrote their own material could they create a unique identity where the character of the records reflected the character of the performers. Their insistence on this in the recording context—as opposed to their live performances—underscored their recognition of the singular power of records. (In contrast, Elvis wasn't a songwriter and became dependent on the recording powers-that-be, which severely limited his career.) Though others such as Buddy Holly

and the Beach Boys had already done something similar (or were in the process of doing so), this determination would change the course of rock music when others followed it—allowing rock to become more of an art form and to reflect the real concerns of youth and the musicians who represented them.

Martin finally gave in and agreed to let them release Paul's "Love Me Do" as their first single, with McCartney's "P.S. I Love You" as the flip side. On its release, the record didn't immediately strike the reviewers much differently than it had originally struck Martin, who didn't think much of it. England's *Record Mirror* gave "Love Me Do" three bells out of five, saying "the strangely named group are fairly restrained in their approach and indulge in some off-beat combinations of vocal chords." Liverpool's *Mersey Beat,* which tended to hype anything the Beatles did, said that "although 'Love Me Do' is rather monotonous, it is the type of record which grows on you."

Yet there were some who heard something new and exciting in "Love Me Do"—allowing the record, with some help from the group's Liverpool fans, to rise to number 17 on the British charts, enough to warrant a second release later in the fall. "It was so different in its simplicity," said Irene Radclyffe, a fan from the Cavern. "Its words spoke to you."

"There was a quality of spontaneity there that was very different from the polished sound of American records," remembered Simon Frith, who became one of Britain's leading rock writers. That gave the record a realism and authenticity that even today comes through.

With "Love Me Do," the Beatles could hear themselves as recording artists for the first time, and it raised a new set of issues for them. " 'Love Me Do' wasn't as big a hit as they'd hoped for," said Alan Smith, a Merseyside journalist.

"I suppose we were a bit overconfident about our chances once the rest of the world had a chance of hearing us on radio or something. So we sulked a bit," said George Harrison.

Brian blamed the disappointing sales on the efforts of the group's song publisher and went looking for a new one. Martin offered another explanation that was closer to the mark. "Love Me Do" had been written

as a song long before the Beatles had ever thought of themselves as a recording band. "They weren't thinking in terms of records" then, he said.

John also had a particular reason for feeling uncomfortable about this first release—both sides had been authored by Paul. Now that the Beatles had become a recording band, he was in danger of letting internal control of the group slip to someone else if he didn't start writing more songs. Moreover, in the wake of "Love Me Do," the Beatles still had their old problem: If they couldn't develop another song better than "How Do You Do It?" Martin would again insist they record that as their next single. John's response was to come up with "Please Please Me." From then on he blossomed as a songwriter: For the next three years, virtually all the A sides on the group's singles either belonged to John, or were among the few real collaborations he and Paul ever did. Paul, still thinking of that career on Denmark Street, was somewhat more active in the early days authoring A sides such as "World Without Love" and "Nobody I Know" for other groups in the Epstein stable or friends such as Peter and Gordon.

In its original form, "Please Please Me" was much slower than the released version. When Paul and John first recited the words to Iris Caldwell and her mother back in Liverpool, the women burst out laughing. At first, George Martin didn't like it much either, but he was a better editor than McCartney at this point. He suggested both a new introduction and a new ending, and speeding up the song. They also added a harmonica at the beginning, just like in "Love Me Do."

By the time they had finished reworking "Please Please Me" at the end of November 1962, the Beatles had created a hit, and everyone who heard the song knew it. "It knocked me out," said Martin.

When a reviewer for the *New Musical Express* first heard the song he wrote, "I can't think of any other group currently recording in this style."

He was right. Like many of John's songs, "Please Please Me" was written in the first person and indirectly reflected the neediness its author frequently felt. Like much of John's work, the song was not terribly singable. "Basically a realist," Beatle analyst Ian MacDonald wrote later,

John "instinctively kept his melodies close to the rhythms and cadences of speech." As with almost all early Beatle songs, it was the vocals and utterly uncommon harmonies that stood out far more than the rather simple instrumentation.

Yet the most defining characteristic of the record was the way it made the listener feel. On vinyl as in person, the Beatles "had that quality that makes you feel good when you are with them and diminished when they leave," George Martin said.

Eager to follow up on the success of that record, which hit number 1 on several British pop charts, Martin pulled the Beatles into the studio on February 11, 1963, to record an album. Having caught the Beatles at the Cavern Club, he wanted to re-create the excitement of their live shows in the studio. (He even began the album with a "one, two, three, four"—a count typically associated with stage shows—as the Beatles launched into "I Saw Her Standing There.") The album contained fourteen songs—the four from their first two singles and ten new numbers. Of the latter ten, six were covers of other artists' material; three were primarily written by John ("Misery," "There's a Place," and "Do You Want to Know a Secret"), and only one by Paul ("I Saw Her Standing There").

"I Saw Her Standing There" was typical in the sense that the group was searching early on for songs to which their female audience could relate. That was also key in their rise to fame. One of the Beatles' defining attributes as they gained notoriety throughout Great Britain and then America was the way they triggered such an emotional response in their female fans. To paraphrase rock writer Jim Miller, the Beatles' first great contribution to cultural history was Beatlemania itself.

Part of the reason for that was what and how they sang. More than any other male or group of them on either side of the Atlantic, the Beatles covered a number of songs by the American "girl groups" of the early sixties, incorporating these prominently into their act and putting five onto their first two British albums: "Boys" and "Baby It's You" (originally done by the Shirelles), "Chains" (the Cookies), "Devil in Her Heart" (the Donays), and "Please Mr. Postman" (the Marvelettes).

When she met the Beatles in 1963, Ronnie Spector of the Ronettes

was struck by how the foursome all knew the American girl group songs. When describing the group's sound to *Mersey Beat* that year, George Martin told readers that the Beatles "sound like a male Shirelles." In fact, many years later, George Harrison was still so influenced by the girl groups that he was successfully sued for plagiarism for lifting the tune of the Chiffons' "He's So Fine" for his "My Sweet Lord."

In 1962 and '63, girl groups were a feminized island in a musical genre often dominated by men and their outlook. That male domination had roots in the genre's origins: The blues, which provided the roots and backbeat of rock and roll, was preoccupied with "women trouble." It was usually sung by men and frequently depicted females as instruments of the devil, if not worse. A lot of white rock and roll in the early days reflected this rancorous attitude: Even the young Carole King, a songsmith on New York's West Side, cowrote songs titled "He Hit Me (It Felt Like a Kiss)" and "Please Hurt Me."

In turn, most of early rock and roll's performers were men; the rock and roll life appealed far more to them than to women. Electric guitars were the computer games of their day; mastering their intricacies by sitting in a room eight hours a day appealed more to males. The lifestyle of living on the road, eating junk food, and traveling far from friends and family was usually more attractive to men than to women. Certainly the more men were attracted to rock and roll, the more it attracted other men in a kind of continual bonding, as it had in Liverpool.

What this meant, conversely, was that femininity—or at least feminine attributes—often came to be defined as the enemy of teenage rock rebellion. Like the heroes of a Jack Kerouac novel, rock's balladeers were frequently "on the road"; over the years they were "The Wanderer," "Born to Run," driving their "Little Deuce Coupe" or "little GTO," as they left their women back home in a trail of dust.

This isn't to suggest that all of rock and roll's early heroes or followers were macho men or that the rock and roll culture was the musical equivalent of football practice. Women were essential to the early culture of rock in the more reactive but crucial role of consumers. They bought the records, controlled the dancing, posted the pinups, and or-

ganized the fan clubs. They also generally responded to—and demanded—a romantic sensibility in the music that men rarely did.

Part of Elvis's appeal had been that he managed to walk the tightrope between these two extremes. He was both rebellious and sentimental, the good boy and the bad one. Though few mentioned it at the time, his style and lyrics hinted at a more open and softer image than the traditional macho man. (Think of "Love Me Tender," "Teddy Bear," or "Are You Lonesome Tonight," originally recorded by Al Jolson.) There was also a hint of androgyny in his eroticism. He sang of male vulnerability and displayed a strong sense of visual style with the red shirt, black pants, and two-tone shoes.

Yet John, Paul, George, and Ringo took it all several steps further. As observers noted then—and sometimes lamented—the Beatles had no machismo; they didn't flaunt their male sexuality, unlike "Elvis the Pelvis," who was too phallic and groin-centered to be a gender revolutionary. The Beatles had the advantage—though no one described it as such—of being oblivious of the blues tradition in a Liverpool musical scene grounded in skiffle, the music hall, rockabilly, and country music.

This made them very different from most male rock and roll artists in America. And it gave them a special affinity for the girl groups. Like their own sound, girl group music stressed vocals, not instrumentation, and the voices were higher—like those of the Beatles. The songs emphasized a kind of bonding that appealed to the Beatles—the chorus often answering the lead singer with advice ("You should hear what they say about you," answered by "Cheat-cheat" in "Baby It's You"). Despite a few songs of yearning, the overall mood of the music was also anything but morose: Rock writer Greil Marcus later described the girl group sound as the music of "celebration—of simple joy."

From these songs, the budding Liverpool songwriters learned to speak from a female point of view. Moreover, as rock writers such as Jacqueline Warwick and Tim Riley later pointed out, by covering the girl group songs the Beatles sent a subtle message to their audience that they felt the same way as the teenage girls listening at home—turning "female dependence into male vulnerability." Performing these songs also gave the Beatles, said another critic, a kind of "cuddly androgyny." (The

Beatles switched the gender pronouns when they sang "Devil in Her Heart" and "Baby It's You." But they never did so on "Boys," which left John, and later Ringo, professing their love for other males.)

With their third UK single in April 1963, "From Me to You" (and the flip side "Thank You Girl"), the Beatles issued two songs they considered direct messages of appreciation to their female fans—itself an unusual gesture. "A lot of the girls who wrote us fan letters would take it ["Thank You Girl"] as a genuine thank-you," Paul said.

"It's hard to underestimate how electrifying that must have been," said Zoe Williams, now a columnist for London's *Guardian*. "Remember that when this was going on, the whole cult of the teenager was embryonic. It was amazing that someone could speak to you. Of course, now we have whole industries and a culture designed to speak to women and youth—they're pandered to all the time. But then, it must have been like being abroad and suddenly hearing someone speaking your language."

Yet it was "She Loves You" that August—the group's fourth British single and their first monster hit—that really reinforced this new feminine-based sensibility. Though John and Paul wrote it together, it was Paul's idea to put it in the third person rather than the first. (John usually preferred to sing about his personal experiences: "I've never enjoyed writing third-person songs," he said later.) In this case, Paul's suggestion worked: The Beatles took the oldest lyrical phrase in the book ("I love you") and gave it a twist. By distancing the pronoun, the song spoke directly to the sensibilities of a female audience as the lyrics turned their disdain not on the female, as male rock traditionally had done, but on the boy who is mistreating his girl, telling him to apologize for a change.

Even the construction of the song originally resembled a girl group number—the "Yeah, yeah, yeah" answering the singer as a rather undistinguished duet between Paul and John; at least one early observer heard this acoustic version and didn't think much of it. But George Martin worked on it with them, adding the drum roll in the beginning and putting the chorus first. The Beatles also took one of the most used pop chord progressions in rock and roll and bent it slightly so that it yielded something truly fresh.

When the song appeared at the end of the summer of 1963, it sold more copies than any record in British history. "There was an open-ended generosity in the words," wrote their press adviser Derek Taylor later, "spelled out with Liverpudlian directness and warmth." What's more, the high "Whoo" in the song before the chorus—borrowed from the Isley Brothers' "Twist and Shout," a staple of their live show and first album—usually sent live female audiences shrieking.

The song was also sung by John and Paul together, and as one interpreter later noted, "the strong bonds between the makers of this music have a great deal to do with its emotional strength and effectiveness."

"I liked the way they sang together," said fan Irene Radclyffe. "And I liked the way their lyrics reached out to you. It was a double whammy."

Over time, of course, the Beatles evolved almost as much lyrically as they did musically. Yet their unusual-for-rock respect for women rarely wavered. Women were addressed as "my friend"—egalitarian in itself. For both Lennon and McCartney, women were usually not the door-mats or superidealized figures of other rock lyrics—the Mary Lous or the Venuses in blue jeans. Instead they were often fully formed characters—nurses, meter maids, or older single women cleaning up in churches after weddings. Some, of course, were mothers, which itself revealed a certain sensitivity to female sensibilities.

John, especially, became known for writing songs in which he assumed the role that women had traditionally taken up in rock and roll ballads, further cementing an emotional tie to their female following. He was forever being stood up (as in "Ticket to Ride" or "No Reply"), or letting his lover know that he would be there waiting for her endlessly ("All I've Got to Do"), or expressing fear of getting hurt again ("If I Fell" or "Don't Let Me Down"). If John wasn't a girl, he certainly seemed to think like one, at least part of the time.

This isn't to say the Beatles didn't write their share of traditional romantic ballads, albeit beautiful ones, or even that they didn't adopt rock's traditional attitude to women on songs such as "Run for Your Life," "She's a Woman," and "Another Girl." But more often their background, the loss of their mothers, and their love for one another allowed

them to transcend stereotypes and write songs that girls and women could take as liberating in ways that hadn't been true in rock's past.

In addition to their music, the Beatles' image, orchestrated by their manager, Brian Epstein, increased their appeal to female audiences. The first thing he did, of course—as did George Martin—was to second their decision to refuse to conform to existing musical practice by making one of the four the leader. This helped the Beatles later on to help change how men thought of themselves and how the larger culture thought of masculinity. Academics such as Deborah Tannen and Carol Gilligan have described the different leadership styles of men and women. Men tend to lead by creating hierarchies with strict lines of authority, typically with one person in charge. Women more often create collaborative structures, or "webs," in which people are more connected and the goal is consensus.

Thus, when they eventually hit it big, the Beatles not only sounded and looked more feminine because of their style and their hair; they were more feminine in their group dynamic. For most of their existence, decisions were always made collectively. That kind of democracy, as one critic noted, entailed an enormous tolerance for one another's foibles—a philosophy that eventually attached itself to the counterculture with a vengeance.

Brian did make some major changes, however. He put the band in matching, somewhat unisex, collarless suits with velvet collars. In photo sessions they now often wore boxy short jackets and dark sweaters. Along with their heeled boots and hair, their clothes now tended to gloss over, rather than emphasize, any traditionally masculine elements of male appearance such as broad shoulders.

Adopting the traditional pose of women, the Beatles were now there to be ogled as well as listened to—which added to their allure among the young female fans who began to trail them everywhere. "I never felt people came to hear our show—I felt they came to see us," said Ringo later. These girls were now staring at four musicians who, in an odd way, were reflections of themselves—a phenomenon that would be repeated in the future by androgynous stars such as David Bowie and Michael Jackson.

Though the Beatles went further than their contemporaries in appearing so feminine, this tradition, too, was deeply embedded in English culture. In Elizabethan times, "mumming" (a practice in which each sex dressed up as the other) was popular during the holiday season. Because the theater was all male in that era, Shakespeare's plays were first performed by all-male casts. All these traditions were passed into the music hall and beyond; as scholar Marjorie Garber has written, British detective fiction seems obsessed with cross-dressing as a means to catch villains. It was an Englishman at the turn of the last century, J. M. Barrie, who created the perpetually boyish and androgynous Peter Pan—whom one scholar later called the first of the preteen heroes and who was played in the Broadway version by a woman.

Other British icons, literary and otherwise, also embodied this trend. One commentator has written of how, in the Middle Ages, "the gilded youth of Normandy and Norman England began to wear long garments like women which hindered walking or acting of any kind; they copied the walk and mien of women." Oscar Wilde needs no introduction to modern audiences, and Lawrence of Arabia's appeal, some have speculated, had as much to do with his ambiguous dress and the fact that he hung out with men as with any of his exploits.

All this emphasis on androgyny was accompanied by a more relaxed attitude toward homosexuality among the English compared to their American—and even Continental—counterparts. After all, it is the French who call homosexuality "*le vice Anglais.*" "There's more terror of that hint of queerness—of homosexuality—here than in England, where long hair is more accepted," Paul once said of America.

Certainly there had been strict criminal laws in the UK forbidding gay sex for centuries until they were changed in 1967; Brian Epstein became ensnared by them. Yet it was common knowledge among the English that some of their rulers were gay or bisexual—a state of affairs that would never have gone over well in, say, Peoria. When James I took the crown in the early seventeenth century, there was a common saying, "Elizabeth was King, now James is Queen." There had always been widespread gossip about Edward II, Richard II, and William III, who were all commonly said to favor the company of men. Reinforcing these atti-

tudes were the practices in traditional English boarding schools, where boys were closeted with each other and their teachers for long periods of time and casual homosexuality was said to be rampant.

The Beatles were products of all this, and it struck many who met them throughout their career. "To see the Beatles is to confront a gallery of eminent women of the nineteenth century," Murray Kempton, the celebrated columnist of the *New York Post*, once wrote. "Women of character, of course, who got themselves criticized as masculine."

John "appeared much more delicate and gentle than the solidly tough macho image he projected on stage," wrote Pauline Lennon when she first met him in the midsixties. Paul was alluring in a different kind of way, though still reminiscent of the way people tend to describe girls, not boys. "He was very very attractive," said Thelma Pickles, who was friends with both him and John in Liverpool. "He was very very pretty, very beautiful, and very courteous."

There was another factor affecting the Beatles' refashioned sensibility. Whether or not one subscribes to the theory that what attracted gay managers to the rock world was that it gave them the chance to hang around with "the boys," it is true that a fair number of the major management figures in early UK pop were gay, according to Simon Napier-Bell. Epstein eventually brought several gay friends into the management entourage surrounding the Beatles. (When Tony Barrow went to work for the Beatles, John asked him why he was coming to work for Brian if he wasn't either Jewish or gay.) "The history of rock is based on homosexuality," a British entrepreneur once said. "That's how rock emerged in England. I don't think it would have started without it."

The gayness of the UK rock world undoubtedly helped Brian make the contacts that would smooth the group's ascent through the pop world. Yet it also affected the Beatles' style and outlook. "Gays were different," the Who's Pete Townshend once said approvingly. "They didn't behave like other adults; they were scornful of conventional behavior; they mixed more easily with young people, and seemed to understand them." A rebellious alliance, of sorts, was being formed—a fact that George Melly noted in 1970 when he took an initial look back at the gay origins of the British rock culture. "Their belief in the self-sufficiency of

the chic, the 'amusing,' the new; the love of glitter and danger; the belief in hard work at the service of sensation; these are now acceptable within a heterosexual context," he wrote.

"In London at the time, there was a great honoring of the homosexual side of life," said Marianne Faithfull. "It was just in the air everywhere."

These gay English promoters, said Simon Napier-Bell, also had a real sense of what teenage girls liked—the boys "they fancied themselves." The notion that gays or bisexuals tend to understand the culture of women better than other men was not unprecedented in English cultural life either. Oscar Wilde was one of the principal architects of contemporary "girl culture," establishing the first modern "women's magazine" in London in the late nineteenth century, as he changed the name of the *Lady's World* periodical to the *Woman's World*.

Along with the music, the new image of the Beatles started to have a galvanizing effect. By early 1963, Thelma Pickles began to notice how girls were now following the four to cars and then refusing to move. The crowds in the theaters and concert halls grew so loud and impassioned that Brian began to insist that the group appear on raised stages to protect them. At one show, said an observer, "all you could see were the heads of girls, and a nurse standing at the end of each row waiting to help those who fainted."

"I could understand the girls screaming," said Pickles. "The Beatles were hugely attractive, quite raw, and unobtainable. Besides, you couldn't dance at these concerts in theaters so you had to do something—how else could you get rid of all that energy and desire?"

Of course, female fans had shrieked for stars in the past who were dramatically different from the men in their lives, thus offering a liberating vision of new possibilities. Elaine Showalter has written that these episodes often came in eras portending or containing great conflict over sex and gender roles. A century before, an observer had described how the women of Europe frequently surrounded long-haired classical composer Franz Liszt, "as peasant boys on country roads flock around a traveler while his horses are being harnessed." Liszt's gloves were frequently stolen and torn to pieces; women used to treasure his discarded cigar butts.

More recently, women had screamed and swooned for other men who displayed an androgynous quality—the closest thing to a powerful woman, as one critic put it. They yelled for silent-screen star Rudolph Valentino, who dressed as "the sheik" in the twenties, as headlines proclaimed, "10,000 Girls Mob World's Greatest Kisser" and fans overran his dressing tent on film sets. ("He does not look like your husband," wrote one fanzine. "He is not in the least like your brother.") And they turned out en masse for Frank Sinatra, who in the beginning was attacked by critics for his softness because he didn't go to war and sang songs intended to be sung by women. Then, of course, there had been the commotion for Elvis.

But no one could remember anything quite like the tumultuous reception female fans gave the Beatles. In truth, no one has seen it since. At concerts during 1963, it became increasingly difficult to hear anything the group sang or played, as the shrieks came in swells. Barbara Ehrenreich, Elizabeth Hess, and Gloria Jacobs later wrote about the scenes of chaos and described them as key moments in the history of the women's movement—the "first mass outbursts of the sixties to feature women" and "the first and most dramatic uprising of *women's* sexual revolution."

"The women's movement didn't just happen," said Marcy Lanza, an early American devotee of the band. "It was an awareness that came over you—that you could be your own person. For many of us, that began with the Beatles. They told us we could do anything."

Others identified the screaming as a mark of mass power that ultimately translated into the death knell for the last remnants of the Victorian era. Of course, if the final vestiges of that bygone era were finally disappearing, the Beatles were also heralding a new age for Britain. The origins of that, too, had been brewing for some time.

ENGRAVED UPON THE HEART OF ITS NATION

IN 1963 the Beatles rode a wave of cultural change in England that had been building up since the end of World War II. Though the cracks in that nation's class system—along with the collapse of the empire—alarmed many Englishmen, they also helped trigger a sense that a new age had arrived in which many of the old rules were open to question. The Beatles embodied this new spirit, and virtually the whole country embraced them because of it.

"The Beatles were the first to give confidence to the youth of England," said Richard Lester, their director for *A Hard Day's Night* and *Help!* "They sent the class thing sky-high."

It bolstered their ascent too that across the board, the British media—television, radio, and the print press—fell for the Beatles as assuredly as did all the screaming girls who followed them constantly.

The Beatles emerged with Great Britain on the verge of a social revolution they would soon inherit and symbolize. It was, one analyst later wrote, the "beginning of the end of the age of deference."

Politically at least, the Great Britain of 1963 was the same as it had been in the 1950s. The Conservatives still held power after twelve years. Prime Minister Harold Macmillan, an old Tory, presided over a terribly aristocratic government.

Yet even he could sense some changes. "You've never had it so good" had been his campaign slogan in the late fifties, and while there was still no comparison between the wealth of the UK and that of the U.S., he had a point. For the first time in a long time, many British families had a little extra money to spend and their children felt freer to spend it. Record sales began to rise even before the Beatles hit the national scene—from 9 million pounds in 1955 to 14 million in 1957 and 22 million in 1963.

The growing wealth of the country and a postwar baby boom similar to the one in the States were part of the story. Yet there were other factors too that would trigger a transformation in British society. In the eighteen years since World War II the United Kingdom had lost its vast empire, from India to Africa, as its colonial possessions sought independence. That experience profoundly shook the country, causing many to question its conventions. "Great Britain has lost an empire and not yet found a role," said former American secretary of state Dean Acheson.

With the collapse of the empire came the decision to end conscription into national service (the UK's equivalent of the American draft), which was another liberating factor for Britain's youth. "Conscription killed a lot of imaginations," said Tony Carricker, John's art college friend. "You suddenly had a lot of freedom when it was eliminated."

Later, when they hit it big, a reporter asked the group, "If there had been National Service in England, would the Beatles have existed?"

"No," answered Ringo. "Cuz we would have been in the army!"

The Beatles would become the first representatives of a fresh new generation to emerge in a Britain that now, officially, would be untouched by war, unlike its predecessors. "We finally had a generation of men who wouldn't be killed," said Virginia Ironside, who became a young London columnist. "There was a way in which we all wanted to celebrate this."

The young rejoiced by challenging the old order. None of the old conventions defined British society more than its class system and the correlative unquestioning adherence to restraint and authority. "Authority was everything," humorist Peter Cook later remembered. "You disobeyed any form of it, from a schoolmaster to a doctor, at your peril. You didn't even think about it."

Yet even the class system was beginning to melt, if only a little. The process had begun two decades earlier during the war, when classes mixed frequently in the military and in communal bomb shelters. It continued with the 1944 Education Act (England's version of America's GI Bill), which expanded educational access and made university education free. The continuation of conscription after the war for a while—with its mixing of classes—and the establishment of cradle-to-grave free health care with the creation of the National Health Service were other factors in democratizing the nation.

As Britain slowly began to open up, popular culture reflected the new state of affairs first. This was hardly surprising, since pop culture has traditionally been a democratizing force—its trends dictated by those at the bottom, not the top. "It was a working-class revolution," said Virginia Ironside, and it was also a revolution that tended to emanate more than usual from outside London, in the North. The North "promised a new vitality, sweeping the dead wood from the boardrooms and replacing hidebound administrators with ambitious young go-getters," wrote historian Raphael Samuel. "The Northern voice . . . was a classless one."

Meanwhile popular British "kitchen sink films" of the late fifties and early sixties such as *Billy Liar, The Loneliness of the Long Distance Runner,* and *This Sporting Life* focused sympathetically on the working class. Movie stars such as Tom Courtenay, Albert Finney, and, a bit later, Sean Connery and Michael Caine reflected the new mood.

"For the first time in British history, the young working class stood up for themselves and said, 'We are here, this is our society and we are not going away,'" said Caine.

"You could find a bold, spirited, and, crucially, *employed* generation of young people," wrote author Shawn Levy. "They'd invented themselves as living works of art in a way no Britons had since Oscar Wilde."

Fashion began changing too. In England, clothes had often been the battering ram of social protest, as with the teddy boys a decade earlier. "Never forget that clothes are the things in England that make your heart beat!" Malcolm McLaren, the former manager of the Sex Pistols, told Jon Savage. "There's a constant attempt to step out of that class

structure of the two-piece suit." English trendsetters soon started shipping their own fashion revolution to the world. "Vidal Sassoon exported his haircuts, Mary Quant exported the miniskirt, David Bailey was already traveling the world for *Vogue*," said Andrew Loog Oldham, who did some PR work for the group before leaving to manage the Rolling Stones.

Around the same time, as Levy and historian Richard Weight have written, sex was becoming a new part of the public discourse, wiping away those last remnants of the Victorian age. It was a remarkable change in a nation that, even at the end of 1960, had made a jury decide whether D. H. Lawrence's *Lady Chatterley's Lover*, written more than thirty years earlier, was obscene. (The verdict of no came despite the judge's instruction, "Is it a book that you would even wish your wife or servants to read?") The key move in the sexual liberalization of the nation came when the National Health Service made the pill more available in Britain in the early sixties, helping to spark a sharp change in sexual mores that was beginning to occur all over the Western world. As the poet Philip Larkin later wrote:

Sexual intercourse began
In nineteen sixty-three (which was rather late for me)
Between the end of the Chatterley *ban*
And the Beatles' first LP.

By 1965, things had changed so much that it was permissible for Kenneth Tynan to say the word "fuck" on the BBC.

Then there was England's Watergate: the Profumo Affair, the sensational sex and spy scandal that broke in the winter of '63 and seemed, as historian Weight put it, "to implicate the entire British ruling elite." The affair involved the liaison of a cabinet officer with a call girl who had also been involved with a Soviet naval attaché. The security of Britain was hardly at stake, but the scandal mesmerized the nation, as it seemed to symbolize the corruption and double standards of a ruling elite. Within a year after it broke, a key witness had committed suicide, a cabinet member had resigned, and Prime Minister Macmillan had been forced

to step down. A year after that, paralleling the Beatles' rise, the left-leaning Labour Party ruled England for the first time in over a decade.

The Beatles were not responsible for any of these developments. But what they were able to do brilliantly was embody and give voice to the new mood: They played Joshua to old England's Jericho. The rise of the Beatles, wrote one commentator, was the "biggest explosion in history short of war for Britain."

"They represented hope, optimism, lack of pretension, that anyone can do it, whatever their background," said Derek Taylor.

By 1964, even the Labour Party sounded Beatle-esque in its manifesto, "Let's GO with Labour for the New Britain." Someone reported a van driving through neighborhoods announcing, "Yeah, yeah, yeah! Vote for Labour!" The night before the election, Brian Epstein sent Labour Party head Harold Wilson a telegram that read, "Hope your group is as much a success as mine."

In 1963 the Beatles—the foremost of England's new "living works of art"—played close to a concert every day. They toured Britain four times and then played Sweden in October and Ireland in November. During this period they also performed their last gig at Liverpool's Cavern Club in August and did a series of engagements at British seaside resorts during the summer. On many of these early tours the pattern was roughly the same: The Beatles began the tour as a subsidiary act to better-known artists such as Roy Orbison, but within a few days they had become the star attraction, with mobs of screaming girls trailing them everywhere.

Their rise caught almost everyone by surprise. Vic Lewis, an impresario who would later work with the group, met the foursome backstage that spring when they were touring with Orbison. "Christ, Orbison draws a lot of people," Lewis said when he saw the crowds gathering outside the theater. Then he discovered virtually all the fans were there to see the Beatles.

As for the group itself, Paul asked a friend, Geoff Taggart, to take a picture of him with Orbison, so he'd have a memento of the time the Beatles toured with a famous star. "With the possible exception of George Harrison, who was very sharp about money and these things,

they had no idea yet what was happening," said Tony Barrow, their press agent.

The growing devotion of the fans was a grassroots phenomenon. Without a considerable boost from England's media, however, it might well have taken a very different form. "In their characters, collective and individual, the Beatles were perfect McLuhanites," wrote Ian MacDonald. That meant, in part, that they had the distinct advantage of being favorites of all three major media then dominating their nation.

Take television. It "kick-started their stardom on both sides of the Atlantic," said Tony Barrow. Even the launch of "Please Please Me" in early 1963 was helped immeasurably by the Beatles' first national television appearance on *Thank Your Lucky Stars,* England's top-rated pop TV show.

With television finally beginning to penetrate the vast majority of English homes, the Beatles were among the nation's first TV phenomena—which was hardly surprising, since their appeal was always visual as well as musical. The Beatles were made for TV: Between 1959 and 1965, the group appeared on more than thirty TV shows in the UK, an extraordinary number for the era. They were terribly fashion conscious: Paul, said his friend Barry Miles, always knew where the creases in the back of his pants were. Yet they looked striking on stage for reasons that went beyond their clothes and hair. They held their guitars noticeably higher than most guitarists did. Since Paul played left-handed and John and George right-handed, when two approached the microphone together, it tended to create a choreographed symmetrical picture with the guitars gracefully to either side rather than poking one another.

The Beatles also received an unplanned boost from an unusual source: the weather. The winter of 1962–63 was one of the coldest in Britain's history. Zoo animals were endangered and soccer matches across the island were canceled. "There was nothing to do but stay in and watch television," remembered Andrew Loog Oldham. Driven indoors, the public kept tripping across the images and sound of the Beatles (though, as was the case everywhere, few could tell the four apart in the beginning).

Then there was radio. In the United Kingdom, BBC radio is still far more of a mass medium than anything on radio in the U.S.; it primarily features regularly scheduled shows broadcast nationwide, rather than programming consisting of local disc jockeys just spinning records. Despite its aversion to rock music, BBC radio was infatuated with the Beatles even before they were famous. In 1963 alone, the Beatles were on British national radio around forty times live, and they were even given their own show for thirteen weeks, commanding audiences of millions.

The group had several factors working for it other than their songs and charm. Reporter Ray Connolly pointed out that as a government-sponsored network, the BBC was under a contractual obligation to feature new live recordings. George Martin called in chits, and Brian too worked tirelessly on their behalf. The BBC had regional studios in Manchester keen to get a share of the national audience and show their counterparts to the south that there was something happening outside of London. The group's active Liverpool fan base also lobbied heavily for them. All came together to create a groundswell.

Finally came the print press. As one writer later put it, the "press loved the Beatles and the Beatles loved the press." But it took until the summer of '63 for the national print press really to begin to notice the band. Until then, most of London's Fleet Street ignored the Beatles (as they disregarded almost all pop music), except for Maureen Cleave of the *London Evening Standard,* who, according to fellow journalist Ray Connolly, went up to Liverpool early in the year at the suggestion of a friend who had told her how funny the Beatles were.

Once the print press noticed the screaming girls trailing this group of singing quipsters, however, it couldn't leave the Beatles alone. To paraphrase English author Michael Bracewell, to the press, the crowd that came to see the band was at least as interesting as the band itself. Not for the last time, the Beatles "turned everything into events," said John. "Rock Boys Flee Screaming Mob As Teenagers Go Wild," read one headline. "Girl Bites Steward at Leeds Dance," read another. According to Connolly, between October 1963 and the end of the year, at least one major British daily ran a front-page story on the Beatles every day as the papers looked to report something more upbeat than the constant bad

news emanating from continual government scandals. "You have to be a real sour square not to love the nutty, noisy, happy, handsome Beatles," read an editorial in the *Daily Mirror,* the paper which coined the term "Beatlemania" that fall. Given the rush of press reports, even the few American correspondents posted in London began noticing the scenes of chaos.

The love affair with the Beatles went both ways: No act in the history of entertainment ever seemed to give as many press conferences or interviews. For all their complaints about the intrusions of fame, the Beatles loved reporters, in contrast to, say, Elvis, whose manager restricted journalistic access to his star.

According to Yoko Ono, John used to say, "Journalists are very intelligent people." But there was more to the mutual affection than that. At one time John had expressed a desire to be a journalist, and the band shared some traits with the reporting profession such as writing quickly on deadline. (In the next year, "A Hard Day's Night" would be written in an hour; "Help!" in 45 minutes.) "I like three-minute records," John said, "like adverts," which in turn were a lot like the abbreviated stories one might read in the papers.

With the press highlighting everything the Beatles did in that fall of 1963, they were the talk of the nation. Their rise seemed to symbolize the notion that the class system was eroding and that anyone could make it in the new Britain and anything could happen. "Their success," wrote critic John Lahr later, "was as exciting as their songs."

"Security is the only thing I want," said Paul. "Money to do nothing with, money to have in case you wanted to do something." For his part, he was so exhilarated about what was happening that he practiced his autograph constantly and, according to one account, snuck into crowds in a disguise to listen to what the girls were saying about him and his colleagues. Meanwhile, according to their old Liverpool friend Bob Wooler, John had gone "from rage to riches."

When the group appeared live on television from the London Palladium on October 13, 1963, they drew an audience of more than a fifth of the nation. When they did the prestigious Royal Command Performance a month later before an audience that included the Queen

Mother ("You're dealing with *class*," Brian told them), they were seen through the recorded highlights by around a third of the nation. By December, close to as many stayed home simply to watch the Beatles as panelists on *Juke Box Jury*.

Adding to the frenzy was the release in late November of the Beatles' second album, *With the Beatles*, which, was issued in the U.S. in slightly different form several months later as *Meet the Beatles*. Once again, it was the striking appearance of the Beatles—this time on the cover of the album—which startled their fans initially. In 1963 few considered pop record sleeves as anything more than an opportunity to include a nice publicity shot. Yet George Harrison had complained that the cover of their first album in England, *Please Please Me*, which contained just such an ordinary photograph, was "crap." (The Beatles had dressed in traditional coats and ties and posed smiling.) So they set out to change that paradigm as well.

The Beatles approached Robert Freeman to take a picture, impressed by what he had done when asked to shoot jazz musician John Coltrane for a similar purpose. *With the Beatles* featured a cover photograph of the heads of the unsmiling Beatles half in shadow, dressed in turtleneck sweaters, much in the artsy style of the pictures Astrid had shot in Hamburg several years earlier. In America, Elvis laughed that the picture reminded him of the movie *Children of the Damned*, and the shot was considered so radical because the Beatles weren't smiling that George Martin had to get special permission from EMI to run it. Yet as with their insistence a year earlier that they had to record their own material for singles, the decision by the Beatles to feature such a different kind of photo implicitly reinforced their image as performers intent on moving in new artistic directions.

Satisfied that fall that Great Britain had finally fallen head over heels for his boys, Brian turned his attention to other worlds, sending the Beatles to Sweden and Ireland with plans to tour France and Australia in the coming year. He also set his sights on America, where no British rock act had ever been successful.

"Somehow it didn't seem right that they might make it in America;

it was hard to accept," said Frank Sellors, a Liverpool musician. "It seemed like a complete impossibility."

Fueling the skepticism about their prospects overseas was the fact that the group's first few singles had gone nowhere across the Atlantic. Even John was heard to say, "It's been fun but it won't last long." Yet even though Brian had never even been to the New World before traveling there in November to plan the Beatles' first foray, he had a sense that there was something universal in their appeal. He told photographer David Bailey, "The Beatles are famous because they are good; but they are a cult because they are lucky. . . . It is simply a kind of mass pathology; they have this extraordinary ability to satisfy a certain hunger in the country. England needs them, so does most of the world. Their happening is as organic as an earthquake."

At the end of the year, the group launched its assault on the United States with the release of "I Want to Hold Your Hand." Within two months, America had fallen even faster than Britain had, and a new cultural era had begun.

HERE, THERE, AND EVERYWHERE IN 1964

EVEN the Beatles had speculated that they might not last much past their initial invasion of America. But they underestimated their appeal, their power, and their remarkable ability to grow. The Beatles were more than simply a musical band with a new sound that could spawn thousands of imitators. Instead, they were a cultural force—a communal band of equals—and they represented a foreign nation whose "swinging" styles American teens now idolized. They also continued to speak to girls and women in new and empowering ways through both their music and their very public lifestyle.

Defying the common trajectory of celebrity, the more famous the Beatles became, the more interesting they got. While mass celebrity has tended to ossify most pop culture figures, it nourished the Beatles. Their music got better as they took more chances. They continued to reinvent themselves.

"We were always pushing ahead: '*louder, further, longer, more, different,*'" said Paul about their music, but it applied to virtually every other aspect of the group as well.

For the better part of three years following that first visit to America in 1964 the rampaging mobs of admirers who followed the group everywhere forced them to become captives of their notoriety. "Prison-

ers with room service" is what author Philip Norman called them. Followed through print, film, records, and television by millions who had made the Beatles the latest in a series of pop culture icons—only more so—their every move was the subject of scrutiny. At each appearance, the pop of flashbulbs was constant and the foursome were constantly surrounded by scores of policemen to protect them from their rioting, adoring fans. When John and George went on a "secret" vacation to Hawaii, their private beach was invaded by the press and fans. Even the Duke of Edinburgh got caught up in the madness. Quoted as saying that the Beatles "were on the wane," he was forced by the media furor to backtrack the next day when a press spokesman "clarified" the statement by claiming Prince Philip had actually said, "The Beatles are away at the moment."

This kind of unimaginable fame had already begun to destroy Elvis, who was on his way to becoming a reclusive freak by the time the Beatles exploded on the scene. If they were, even now, turning out differently and less damaged, they had each other to thank. "It took four of us to enable us to do it," John once told an interviewer. "We couldn't have done it alone and kept that up." The obscene pressure drove them even closer to one another and reinforced for them, in their isolation, their feeling of being outsiders, so important to their sensibility.

"I never did have many friends," said John. "The Beatles were my friends." Later he told biographer Hunter Davies how "I have to see the others to see myself."

"No one else had gone through what they had, no one else understood," George Martin wrote. "They seemed to find a tremendous inspiration from each other's presence. There was a kind of love between the four of them, some feeling that gave them strength. It was a case of the whole being stronger than the sum of its parts. Although the world had accepted them with open arms, it could also, in many ways, be their enemy."

Eventually, that sensibility did become the calling card of the youth culture in its struggle with what was called "the establishment," really meaning adults. "In a group," Pete Townshend of the Who once said, "you learn the art of compromise, you learn the art of diplomacy. I think most of all you learn the art of caring about other people's opinions."

"I absolutely did believe—as millions of others did—that the friendship the Beatles had for each other was a lifesaver for all of us," said their aide Derek Taylor. "I believed that if these people were happy with each other and could get together and could be seen about the place, no matter what else was going on, life was worth living."

Allen Ginsberg, the poet, even saw in the group's sense of itself an implicit endorsement of gay rights. They were "giving an example to youth around the world that guys can be friends," he said.

As for the group itself, Ringo talked of the kind of "mental telepathy" that developed, so that "you knew when someone else was going to do something, and we'd all do it together without anyone saying anything." When Roger McGuinn (then known as "Jim") of the Byrds met them, he was struck that George Harrison always answered personal questions with "we"—"like the Beatles were a gestalt or something. It was as if they had combined minds."

It was four "guys who really loved each other," said Ringo. "It was pretty sensational." Even when they didn't have to, members of the group tended to vacation together and dress in similar styles. When in London, they'd often ride to the studio together, and after recording they'd often hit the clubs together too. On the road, they clearly could afford separate bedrooms but they would still often team up in twos. John, forever lonely unless surrounded by his "gang," wanted them all to live together a few miles apart in the London countryside and was somewhat taken aback when Paul refused, preferring to remain in London. On the few days they were apart during these years, they would frequently call each other on the phone like homesick children. Eleanor Bron, who appeared with them in *Help!* was struck by how, always, "they had a lot to talk about with each other."

"If one experiences something, the others all have to know about it," said George's girlfriend and future wife Pattie Boyd. "Even just a mood, they have to rush off and tell each other about it. They have crazes, just like you have crazes at school. When a craze hits the rest of them, the whole house has to be overturned until George gets what they've got. But it keeps them all happy."

Though the Beatles often said how much they craved contact with

the rest of the world now that they were famous and isolated, Mary Wilson of the Supremes complained that when outsiders met the group, it often felt like "we had interrupted something." Michael Lindsay-Hogg, the film director, worked with both the Beatles and the Rolling Stones. He told Bill De Young in *Goldmine*:

> They were very different from the Rolling Stones. The Stones were more accessible—like if you'd give Mick and Keith an idea, you'd bat the idea around together. Whereas with the Beatles, if you gave them an idea or a concept, it was kind of like throwing a piece of meat into the bear pit. They'd paw it over and chuck it around between themselves, and they'd exclude you. They'd do it in a four-way tangle. And then they'd come back to you after a while with their opinion.

There was a way in which after some time, the Beatles' isolation became self-imposed—the better to preserve their own integrity. When the group appeared on a Radio Luxembourg series at the end of 1964, they made virtually all their dedications to old friends back in Liverpool—Pete Shotton, Chris Walley, and Ivan Vaughan, the boy who had introduced Paul to John back in Woolton. In 1968, group biographer Hunter Davies was struck by the fact that the group still had pretty much the same inner circle as in 1962. "John didn't really change when he hit it big," said art school chum Jonathan Hague, who used to visit him. "And he would say to me, 'I knew you before and I know you're not here for what you can get but you knew me when there was nobody and that means more to me than all the rest put together.'"

Perhaps the most remarkable things about this period is that alone for the most part with each other, there was still a way in which the group managed to remain interesting and plugged in to the collective unconscious of their times. "They always seemed to be reinventing the sixties for the rest of us," said Tony Tyler, their acquaintance from Hamburg.

Nineteen sixty-four was the year when the Beatles seemed to be everywhere. That summer, they toured the U.S. and Canada, doing

thirty-two shows in thirty-four days, traveling an average of over 500 miles a day by plane to cover over 22,000 miles. That fall they went back to the UK, with fifty-four shows in twenty-five cities in thirty-two days. Before, after, and in between these trips they hit France, Denmark, Sweden, Holland, and Hong Kong. When they went to Australia in June of 1964, they were greeted by crowds of 250,000 in Melbourne and 300,000 in Adelaide. Even the making of *A Hard Day's Night* in March and April was torturous, as in one week the Beatles had to travel 2,500 miles by train, filming scenes. This was globalization on a new scale.

Nineteen sixty-four was also the year in which Beatlemania became a part of American life. Throughout the year there were constant announcements that the "next Beatles" had arrived: the Dave Clark Five, the Rolling Stones, even Herman's Hermits. But, if anything, the Beatles phenomenon grew: Each single and album was heavily anticipated for what the Beatles would do next, since they were known, in Paul's words, for "trying to get a new sound on every single thing that we did."

As writer Anthony De Curtis put it, they were the "essence of what a fad is." An unprecedented wave of products, particularly in the U.S., bore the group's imprint—dolls, bubble gum cards, magazines, sweatshirts, buttons, coloring books, jewelry, harmonicas, drinking glasses, talcum powder, pens, licorice, and stamps, to name only a few. (Forty years later, a set of four Beatles fourteen-inch promotional Bobb'n Head Nodders which went for a few dollars in 1964 listed for $7,350.) Hotels in which the group had stayed cut up the sheets on which they had slept (or so it was said) and sold the small strips. Scores of teen magazines such as *16* could talk of little else, and in England, the group had an entire magazine devoted to its activities: *Beatles Monthly Book.* "From *Beatles Monthly*," wrote one fan, "we knew their favorite colors (Paul's, black), their favorite foods (George's, lamb chops and peas), and the lengths of their inside leg. . . . According to the magazine, Paul's girlfriend would have to have 'a fine facial structure.'" They each received thousands of fan letters. A majority of those to John, said a relative who read them, were from girls asking him for advice on emotional problems. "They assumed that as a writer of love songs he had all the answers," she said.

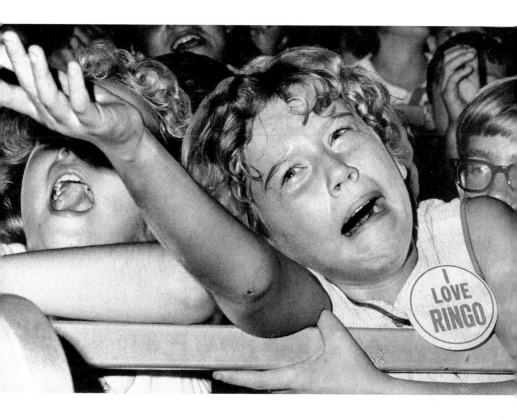

The screams that greeted the Beatles everywhere were later identified as a key moment in the history of the women's movement. "The way you lost yourself in the crowd," said one female fan. "There was something about the Beatles that went way beyond the Beatles."

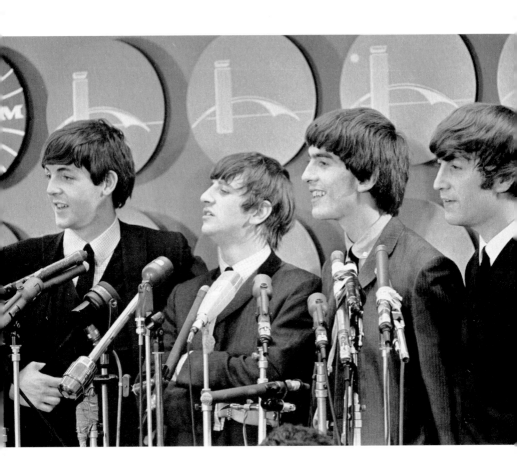

The Beatles' arrival in New York in February 1964 was their "entry into the modern mind," according to one critic. Their unexpected humor, unusual appearance, and upbeat music helped them to conquer America faster than any other cultural phenomenon in history.

AP/WIDE WORLD PHOTOS

ABOVE The war-devastated Liverpool in which the Beatles grew up was a far cry from the abundance of postwar America. In the 1940s and '50s, Merseyside children like the four Beatles treated the unreconstructed bomb sites as playgrounds. COURTESY OF NATIONAL MUSEUMS LIVERPOOL (MERSEYSIDE MARITIME MUSEUM)

LEFT In postwar Britain, comedy shaped the consciousness of the Beatles' generation in much the same way as rock music did in America. No group influenced the Beatles more than the Goons, the zany stars of BBC radio. POPPERFOTO/RETROFILE.COM

British art colleges offered their students a vision of a counterculture before there was one. This is John's section in 1957; he's standing at the upper left. COURTESY OF VIOLET AHMED

The Beatles' hair and unisex appearance may have seemed strange to Americans in 1964 but both had their roots in many places—ranging from the look of Oscar Wilde in the late nineteenth century (LEFT, AP/WIDE WORLD PHOTOS) to that of their friend Astrid Kirchherr in Hamburg, shown here in the early 1960s with boyfriend and band member Stuart Sutcliffe (BELOW, JURGEN VOLLMER/STARFILE).

ABOVE The early Beatles, including drummer Pete Best standing at the right. In those days, "the boys" were known as much for their clowning as their music. JULIET WILSON ASSOC./SIPA

LEFT In the early 1960s, the Beatles often played midday shows at the dank Cavern Club in Liverpool, attracting "office girls" on their lunch break and a more respectable crowd, as they did here. DEZO HOFFMAN/

REX FEATURES

Both John and Paul, who lost their mothers in their youth, always looked for parentlike figures to help take care of them. Their manager, Brian Epstein—shown here in 1967, shortly before he died—not only helped develop an image for the band that girls found irresistible, but looked after everything from their earnings to their laundry. DAVID MAGNUS/REX FEATURES

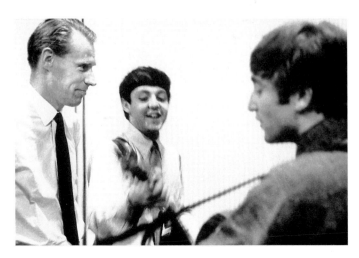

The Beatles called the aristocratic-looking George Martin the Duke of Edinburgh behind his back, but as their studio producer he helped them use the power of records in a new way that cemented the unique tie they had with their fans.

TERRY O'NEILL/REX FEATURES

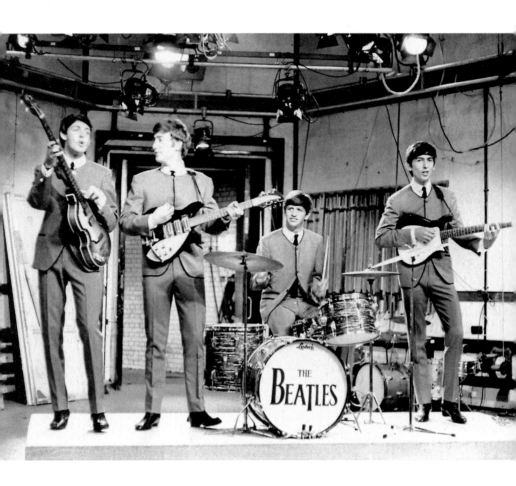

ABOVE The band in their famous collarless suits, circa 1963. Along with their heeled boots and long hair, the Beatles' clothes at that time tended to gloss over any traditionally masculine elements of male appearance, adding to their androgynous appeal. UNIVERSAL PHOTO/SIPA

FACING PAGE The Beatles were able to bridge the two very different countercultures on either side of the Atlantic. Whereas the "swinging London" scene centered on style, as this group of fab Londoners demonstrates (TOP, EVENING STANDARD/GETTY IMAGES), the rebellion of American youth was much more political, like this protest during the Berkeley Free Speech Movement in 1964 (BOTTOM, ENFIELD/SIPA).

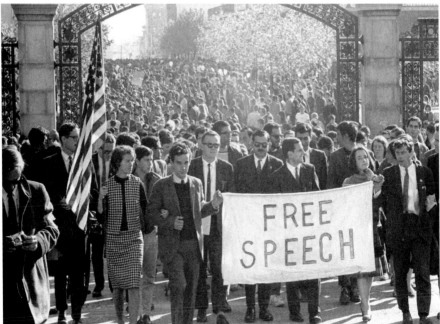

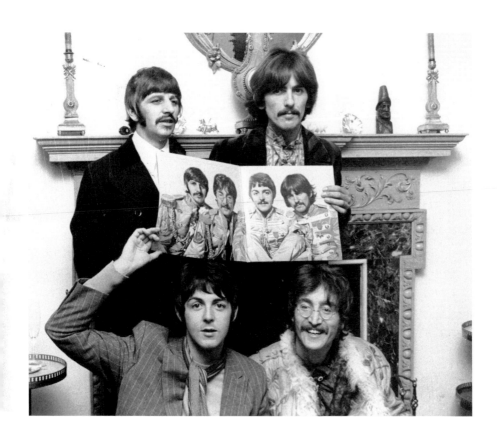

ABOVE In 1967, a record album had the power to move the world. The release of *Sgt. Pepper* that year unified the counterculture and crowned the Beatles as the leaders of that alternative movement in America and around the globe. JOHN PRATT/KEYSTONE/GETTY IMAGES

FACING PAGE Two very different types of protests. One important cultural battle the Beatles inspired was over the issue of hair. Young people—like the protesting group of Norwalk, Connecticut, high schoolers (TOP, BETTMANN/CORBIS)—were inspired by the Beatles to view long hair as a symbol of freedom and part of the struggle for civil rights. On the other hand, conservatives were outraged by John Lennon's comment that the group was "more popular than Jesus" and picketed the Beatles' concerts, including their final appearance in America (BELOW, AP/WIDE WORLD PHOTOS).

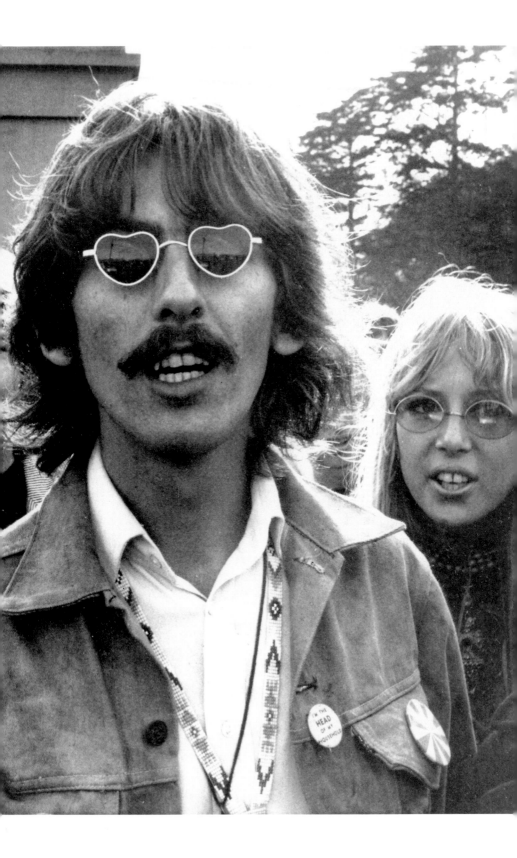

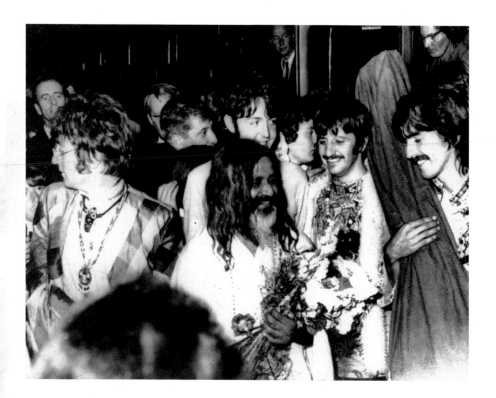

ABOVE The Beatles' involvement with Maharishi Mahesh Yogi had a major impact on both their outlook and influence on the counterculture. It temporarily ended their infatuation with drugs—changing their music—and it popularized the allure of India, tapping a number of strands that made alternative and mystical forms of consciousness one of the culture's preoccupations. AP/WIDE WORLD PHOTOS

FACING PAGE The first Beatle to sense a disconnect between the band and where the culture was heading was George Harrison. In 1967, with his wife, Pattie, he toured Haight-Ashbury and was shocked by all the panhandling and disarray he saw. He later compared it to the Bowery. AP/WIDE WORLD PHOTOS

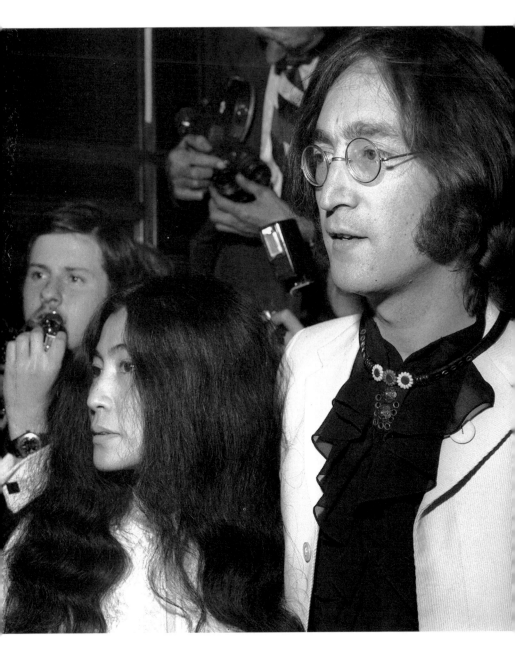

The Beatles were always drawn to strong women. Moreover, throughout their career, they preached that love was a form of salvation. Thus it was no surprise that when John and Yoko got together in 1968, everything changed. HARRY MYERS/REX FEATURES

John and Paul were always extremely competitive; within months after John had paired up with Yoko, Paul found his own soul mate in Linda. From then on, these women tended to spur their partners in opposite directions, acting almost like lawyers in an ongoing dispute.

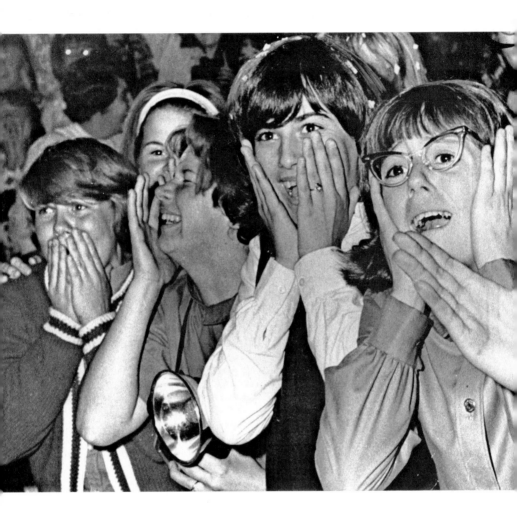

"They gave me such a feeling of happiness," said one Beatle fan much later. "They captured me as a girl and I'm trapped forever. They put a spell on me that has never been broken." KEVIN COLE/REX FEATURES

Meanwhile the crowds became larger and rowdier as girls pulled in their friends and younger sisters. The scene in Cincinnati at the end of August, as described by a local paper, was typical:

Some sobbed, clutching their hands to their mouths. Others waved their hands above their heads and screamed at the top of their lungs. Some jumped up and down on their seats.

The estimated 115-degree temperature melted bouffant hairdos as well as inhibitions. Well-groomed girls who had hoped, without really hoping, that they would attract the eye of a Beatle began to look like Brillo pads.

A priest turned around in the crowd, looked at a reporter and said with tears in his eyes, "I don't believe it. Just look at them— at their faces."

In New Orleans, two hundred fans at a concert collapsed in the heat. Concerts in Cleveland and Kansas City had to be stopped in the middle to calm the crowd. In Australia, a woman threw her disabled six-year-old at Paul, who was riding in an open truck. When Paul handed the child back the woman wept. "He's better. Oh, he's better!" she exclaimed.

In the *New York Times Magazine*, David Dempsey attempted to explain what another reporter at the paper described that summer as "the psychological phenomenon." "Whether dancing or merely listening and jumping," he wrote, "those taking part are working off the inner tensions that bedevil a mixed-up psyche."

When those women describe it all now, there is more than a hint of the rumblings of a revolution.

"I tasted something," said Marcy Lanza, a New York fan. "I was totally going outside of myself—it was total freedom. Once you tasted it, you had to have more. The way you lost yourself in the crowd—there was something about the Beatles that went way beyond the Beatles."

Others, like historian Susan Douglas, later saw the tumult as the beginning of the counterculture of the young. "They made kids part of history," wrote author Joyce Maynard. "Their appearance gave us our first sense of youth as power."

"The Beatles," wrote another fan later, "made fun of authority, made it all seem absurd, even laughable. It was a new kind of power." Journalist Tom Wolfe wrote how the "last semblance of adult control over music vanished at that point."

In 1964, the Beatles had an unprecedented six number 1's on America's *Billboard* charts ("I Want to Hold Your Hand," "She Loves You," "Can't Buy Me Love," "Love Me Do," "A Hard Day's Night," and "I Feel Fine") and a seventh song Paul wrote for Peter and Gordon ("World Without Love"). In early 1964, one estimate had them selling 60 percent of all American singles. Between January and October, they placed 28 different songs on *Billboard*'s Top 100, and around a half dozen more compositions they had written that were recorded by other artists were also on the charts.

Among other things, their success demonstrated how clued into the mainstream the Beatles were. It was part of the group's genius that they could be both cutting-edge and traditional at the same time. There's a tendency to think of rock and roll as always innovative, but the artists with whom the Beatles shared the number 1 spot during 1964 included Louis Armstrong with "Hello Dolly," Dean Martin with "Everybody Loves Somebody," and Bobby Vinton with "Mr. Lonely." The second-biggest-selling British singles artists of the decade were Herman's Hermits, who appealed to the preteens for whom the Beatles soon become too grown up. Revolutionary artists make history, but they usually sacrifice their popularity to do it. Dylan, for example, was a key figure in the pop culture of the sixties, but he never had a number 1 record; his influence was primarily on the intellectual elite and other musicians, not the masses.

The Beatles were the exception to the rule. They were leaders, but their role in popular culture, as a critic put it, was often to travel "only a few miles behind" in the mainstream, "consolidating gains and making acceptable new ideas."

The foursome helped change rock and roll dramatically but not overnight. It took, really, until the summer of 1965 for the first wave of the so-called British invasion to reach American shores as six British acts other than the Beatles hit number 1 that year. (In 1964, only the Animals with "House of the Rising Sun" and Manfred Mann with "Do Wah

Diddy Diddy" hit number 1 in the U.S., and significantly, both did so singing songs written by Americans.) Ironically, the girl groups who had so influenced the band—and who still had about a quarter of the number 1 hits in 1964—essentially collapsed in popularity beginning the next year in the wake of the male-dominated British invasion. Only Motown's Supremes were truly able to withstand the trend.

With the rise of the Beatles, 1964 also saw the lowest percentage of records on the hit charts by black artists since rock and roll had hit the scene in the midfifties. The Beatles were unintentionally whitening rock and roll—all the more so because at least some of the British groups that followed in their wake found success by rerecording old hits by black artists (like Herman's Hermits with "Silhouettes").

As for America's leading white group, the Beach Boys, the rise of the Beatles posed a direct challenge. "When I hear really fabulous material by other groups," the group's leader, Brian Wilson, told a reporter, "I feel as small as the dot over the 'i' in nit." Thanks to the Beatles' domination of the charts, the Beach Boys' "Fun Fun Fun" never reached the top spot, much to Wilson's disappointment. When "I Get Around" finally became the surfing group's first number 1 and their only hit to reach that position during 1964, it became the first single by a group of American men to reach that coveted spot in eight months.

Pop music soon became, in critic Michael Bracewell's words, "the principal cultural currency of Englishness" in America, as imitation became the sincerest form of flattery. There was an English act for every kind of taste: Petula Clark for Mom and Dad, Herman's Hermits and Freddy and the Dreamers for little sis, the Dave Clark Five for those who preferred a mediocre clone of the Fab Four, and, of course, the Rolling Stones, whose calling card quickly became that they seemed more rebellious than the Beatles. ("Would You Let Your Daughter Marry a Rolling Stone?" queried one infamous English headline.) Teens often defined themselves by whether they preferred the Beatles or the Stones. "The Stones were too rough," said Ida Langsam, echoing the views of many teenage fans. "They weren't pretty. Their fans were scruffier, dirtier, nastier, and more obnoxious." Parents generally couldn't stand them either, which, of course, added to their appeal for many. "The Rolling Stones

searched for the worst inside themselves and found it," wrote Simon Napier-Bell. Or, as Tom Wolfe put it, "the Beatles want to hold your hand but the Stones want to burn your town."

There were hits for groups on the Beatle model such as the Zombies, the Kinks, Wayne Fontana and the Mindbenders, the Who, Gerry and the Pacemakers, Billy J Kramer and the Dakotas, the Searchers, and the Hollies. A British look or sound was such a ticket to success that a group of boys from San Antonio renamed their band the Sir Douglas Quintet and had a hit; for a while the Turtles fictitiously billed themselves as "the Turtles from England" and tried to fool promoters by ordering tea with milk instead of coffee. The Strangeloves—three American songwriters in real life—pretended to be a trio of Australian sheepherders named Miles, Niles, and Giles. The Knickerbockers had a hit with "Lies" because it sounded a lot like the Beatles. Even Lorne Greene, the grandfatherly star of television's *Bonanza,* hit the top spot with an old-fashioned narrative song about a cowboy that owed a lot of its success simply to the fact that he named the hero "Ringo."

Other than obliquely boosting the Beatles, all these groups were indirectly selling Britishness. As the rock writer Lester Bangs put it, "the British Invasion was more important as an event, as a *mood,* than as music."

"For a few crazed years at the height of a crazed decade, being English was the coolest—pardon, fabbest—thing anyone could be," wrote Jane and Michael Stern in their book, *Sixties People.* "Thanks to the Beatles, being English came to mean being zany and hyperkinetic, dressing in madcap clothes, and being wildly rich and famous."

Meanwhile the Anglomania that had been sweeping American pop culture for several years continued. In 1964, the first of the Pink Panther series starring Peter Sellers arrived on American screens. The James Bond movies continued, spawning a television copy, *The Man from U.N.C.L.E.,* which, while thoroughly American, paid homage to its heirs over the ocean by having the spy agency's director, played by Leo G. Carroll, be an Englishman. The movie version of *My Fair Lady* won the Academy Award for Best Picture for 1964; an adaptation of Robert Bolt's tribute to Sir Thomas More, *A Man for All Seasons,* won the award

two years later. In between, the U.S. fell all over itself celebrating the four hundredth anniversary of the birth of William Shakespeare, as *Life* and the *Saturday Review* came out with special issues to commemorate the event. The movie *Mary Poppins* even sold Anglophilia to the under-eight set.

Some even saw in the British invasion that followed the Beatles a different focus on sexuality—a fast-paced, audacious emphasis on seduction borrowed from the world of James Bond that the film series featuring Austin Powers lampooned decades later. Formerly staid London now became known as "Swinging London"—a wild collection, at least in the media snapshot, of hip clothing stores, miniskirted young "dollies," and long-haired rock stars. Fashion models such as Jean Shrimpton and the fashion photographers who shot them such as David Bailey became the preeminent stars of the scene. It's no coincidence that many British pop stars (including George—though not John and Paul) married models. A "youthquake" had grabbed the fashion world. By April of 1966, *Time* magazine labeled London "the city of the decade"—a place that was a "dazzling blur," "pulsing," "spinning," "buzzing."

Nothing did more to popularize the Beatles' new version of Britishness and collective harmony in that initial year of world conquest than the release in July 1964 of their first film, *A Hard Day's Night*. (Even its premiere in Poland caused scores to miss classes in the schools.) The project signaled another step in the Beatles' evolution as a different kind of cultural force. By combining the power of two media in a new way, the Beatles continued their transformation, in critic Jon Savage's words, from a musical group into a way of life.

Beginning with *Blackboard Jungle* in the midfifties, films had played a role in popularizing the rock culture and in defining teenagers as a new class. Elvis, of course, had forsaken his role as a rock pioneer to try to make it in Hollywood. Yet, for the most part, his films were forgettable, as were a long series of uninspired flicks that featured rock and roll such as *Don't Knock the Rock* and *Beach Party*. For the most part, these movies took the new class of teenagers that rock had helped define and pandered to it shamelessly with flimsy plots of teens flirting with one another and crashing slumber parties.

In the beginning, some evidently intended the Beatles' cinematic venture to be little different. The group had been offered a script called "The Yellow Teddy Bears" (the name speaks for itself) that was rejected because, as Paul later related, the director wanted to write all the songs himself. "There was no question of doing a cheapo rip-off like the typical pop musicals of the time," Paul said. "We were determined to hold out for something better."

Yet originally, even *A Hard Day's Night* was put into production only to allow the film company, United Artists, to release a film sound track. (Capitol had forgotten to include film sound tracks in its contract, so someone was bound to fill the void.) The movie was shot quickly and cheaply, in black and white, since, as director Richard Lester put it, "the music department of United Artists felt the Beatles probably wouldn't last the summer." At the time the contracts were signed for the film in 1963, America wasn't even in the picture yet; otherwise, as John Robertson and Patrick Humphries later wrote, the film certainly would have been made in color.

But, as usual, Brian Epstein and his band had the determination, or at least the luck, to attract yet more compatriots willing to assist them in blazing another new path. The Beatles immediately took to Lester, an American—as they had eighteen months earlier to George Martin—because of his similar association with the Goons. (Lester had done a five-minute cult classic with Goon Spike Milligan called "Running, Jumping, Standing Still.")

That sensibility infected the film too, much to the Beatles' benefit. "We want to put over their non-conformist, slightly anarchist characters," said Walter Shenson, the producer, also an American. "We want to present their almost Goon-like quality." It was Shenson, for example, who thought Lester and the Beatles were a good match and brought them together, thereby guaranteeing a cinematic product that would be well understood in the New World. Shenson also suggested that the film open with the Beatles being chased by their fans so that any members of the audience who weren't familiar with the group (not that there were many by the time it appeared) would immediately understand their immense popularity.

The Beatles were already distinct in popular culture in using so many different avenues to get their message across—records, radio, television, photos, Christmas records for their fans, even all the souvenir trinkets that were produced with the Beatles' imprint on them. There were exceptions: No one would maintain that all those lunchboxes with the group's pictures on them presented a consistent portrait. Still, as much as possible, the group wanted to make each venture fit with its overall message. That may have made the Beatles control freaks of a sort, but it's why, as Tony Barrow explained, when a favored photographer would publish pictures without their permission, they'd eliminate his access.

Walt Disney had fashioned an entertainment imprint for children through various media—"an image in the public mind," he called it—and the Beatles were doing something similar. This made their influence far greater than that of other comparable figures in popular culture and helps explain what the group thought it was doing when it later attempted to use its Apple business to venture into fashion and other endeavors. It also helps explain why the Beatles became pioneers in using combinations of those media—short films that acted out their songs, for example—that became the forerunners of MTV. As author Bob Neaverson and others pointed out, *A Hard Day's Night* was a kind of early rock video, exemplified by scenes like the one when the band escapes and runs feverishly around a field as "Can't Buy Me Love" plays for little reason related to the plot.

Deciding to make the film about Beatlemania (one of the original working titles) was the key to the whole thing. Shenson, Lester, and Alun Owen, the Welsh screenwriter from near Liverpool, quickly realized that the Beatles' closeted life amid the chaos of Beatlemania was so unprecedented that it should be the subject of the film. (The movie was shot mostly in low-ceilinged locales—trains, cars, or rooms—to reinforce the impression that the Beatles were prisoners of their fame.) "Their life is far more fantastic than anything I could dream up," said Owen, who traveled with the group to get a sense of who they were and how they spoke.

Necessity was surely the mother of invention here: The foursome ei-

ther refused to or couldn't learn lines, which explains why, throughout the movie, they almost always spoke in improvised or short staccato sentences. Afraid of mistakes, Lester always shot with two cameras to make sure he'd have something he could use. "The more we could give them situations that were familiar to them . . . the better the odds they would be able to carry it off moderately well," said Lester.

"There was a scene in the film," Lester told another interviewer, "where they are interviewed by the press. . . . I simply gave one-line questions to the people playing the reporters and the Beatles ad-libbed their answers."

The film presented a fictitious version of a few days in the Beatles' lives. The four were given no love interests—consistent with Brian's belief that showing specific girlfriends would diminish the foursome's popularity. (When the Maysles brothers shot a documentary of the group's first trip to America in 1964, they were asked to keep Cynthia and any girlfriends out of the movie.) The character of Paul's grandfather, who sows trouble in the film while traveling with the group, was fictional.

Yet the fictions seemed to end there. Other rock films had presented contrived, romantic plots—Elvis as a Western hero or Hawaiian crooner. In contrast, by playing themselves in *A Hard Day's Night*, the Beatles were able to define their essence for their audiences far more completely than they could in songs or press conferences. This was particularly true for audiences outside of Britain, which hadn't been able to sample the Beatles through the ever-present BBC appearances. As Tony Barrow pointed out, this fictional pseudodocumentary assumed the role of an actual historical record for millions, and it altered the image of pop music and its artists around the world. The film was considered so realistic that an unknown word Owen adopted into the script— "grotty"—began to be used so often it entered the language. Not for nothing did John originally want to call the movie "Authenticity."

By taking the public behind the scenes—even into a Beatles' bathtub—the film helped establish a kind of intimacy between the performer and the audience. (That's one reason why American female audiences tended to scream throughout the film, making it difficult for

anyone to hear.) To be sure, the Beatles didn't invent this trend. In the past, *Life* magazine had helped bring celebrities "up close and personal." Programmers had already discovered that because it comes into living rooms and bedrooms, the still fairly new medium of television favored a similar style of personal disclosure that was popularized on interview shows such as Edward R. Murrow's *Person to Person,* filmed in the homes of the stars.

But *A Hard Day's Night* was a far longer and more intimate dose of reality programming. What's more, the Beatles seemed much more willing to reveal themselves to their audience than celebrities had before. From then on, said Simon Napier-Bell in another context, "the artist whose next record was going to sell as well as his last was likely to be an artist who'd made his life into an ongoing media saga in which the public could participate. To be 'heard of' had become just as important as 'being heard.'"

This made the group pioneers in helping to establish yet another cultural paradigm. The Beatles were becoming more than just musicians or entertainers with a set of products or performances to leave with the public. Seemingly always on call, they now embodied the notion that who you are is inseparable from what you are. Soon, as historian David Steigerwald has written, the concept of the "artist as star" had emerged in a number of areas—in painting with Andy Warhol and in literature with Norman Mailer, who made himself central to his book on the Vietnam protest movement, *Armies of the Night.*

A Hard Day's Night also helped the Beatles bolster their artistic credentials. Adults and college students had taken notice of rock and roll before—it was hard to ignore it—but for most serious student activists and intellectuals at the time, rock music was considered too mainstream and trivial to be relevant. This had become especially true in the late fifties, when, after its initial striking debut, rock and roll had entered its fallow period. While British students tended to gravitate to jazz, American college students swarmed to folk music, which, with its frequent allusions to alleviating injustice and poverty, contained a strong political element that matched the moment.

The Beatles' initial ascent in America had been marked by wide-

spread skepticism in more intellectual quarters. "Whenever the first strains of 'I Want to Hold Your Hand' begin to twitch my stirrup bones," wrote future *Rolling Stone* writer Michael Lydon in the *Yale Daily News* in early 1964, "I send out silent screams for help to Chuck Berry, Elvis, Carl Perkins, Little Richard, the Orlons, the Impressions, Martha and the Vandellas, Major Lance, the Drifters, and those other greats who have long defended the American way of rock." He called the Beatles "English synthetics," and in his outrage, he was not alone.

A Hard Day's Night began to change all that. The group's wit and sensibility on screen were enhanced by Lester's use of both New Wave and grainy kitchen-sink techniques, and even bits of surrealism. Thus began a process that would merge teen culture—whose ethos of rebellion was essentially grounded in pop junk, or so thought serious intellectuals—with Bohemian culture, which had always intended to make a far more serious and artistic critique of society. At the same time, other artists such as Roy Lichtenstein were attempting similar pop-art mergers in their field.

"I think the movie had more impact on me and everybody I knew than their music did," Jerry Garcia of the Grateful Dead said. "Their early music that is. . . . It [the movie] was satisfying on a whole lot of different levels, for people who were already Bohemian or beatniks."

Jann Wenner, the founder of *Rolling Stone,* later described seeing the movie and the fun the Beatles embodied as "the moment that changed my life."

By that fall, the influence already showed. When student protesters at the University of California at Berkeley took over an administration building in support of the Free Speech Movement, they sang the usual folk ballads that were prevalent during the influential civil rights movement in the South—"We Shall Overcome" or Bob Dylan's "Blowin' in the Wind." But for the first time anyone could remember, the protesters sitting inside the seized building also sang a song from rock: "It'll Be a Long Hard Fight," sung to the tune of "A Hard Day's Night." The Beatles were crossing into new territory.

When older critics saw the Beatles in *A Hard Day's Night,* they were similarly floored. In contrast to the often negative knee-jerk reaction to

the group's appearances on *The Ed Sullivan Show* several months earlier, the American press now fell all over itself praising the Beatles. "The film with those incredible chaps, The Beatles, is a whale of a comedy," wrote the *New York Times.* "It really is an egghead picture, lightly scrambled, a triumph of the Beatles and the bald," wrote the *New York Herald Tribune.* The *New York Journal-American* was not alone in comparing the film to the work of the Marx Brothers. Andrew Sarris in the *Village Voice* called the movie "the Citizen Kane of jukebox musicals."

It helped, too, that the songs accompanying the film and what followed on their next two albums in America (as Britain and the U.S. continued to release slightly different LPs) were their best yet. Most of the songs were written by John, as he continued to dominate the group's output. It began with the title track: Since the film had already been named, the Beatles had to write a song with the same phrase—not an easy task for almost anyone but them. Yet like the film, the song "A Hard Day's Night" was less "teeny boppish" than what had come before. With its interlude of "when I get home to you" and talk of "a hard day's night," it was clearly a song about someone with a job—older than the traditional subject of teen anthems who could be found surfing or driving around high school.

The song also began with what became one of the most celebrated chords in rock music. "We knew it would open both the film and the sound track LP, so we wanted a particularly strong and effective beginning," said George Martin. During the group's first visit to the U.S. in February 1964, George Harrison had been given a new twelve-string Rickenbacker guitar, and he took to it immediately. This guitar had seldom been used in rock and roll before, and it gave the Beatles' music— and then much of rock as others followed in their path—a slightly new instrumental sound. When Roger McGuinn of the Byrds, for example, heard the Beatles, he got the guitar for himself, thereby initiating the Byrds' unique style.

A Hard Day's Night brought other musical changes. Besides writing all their own material, the Beatles used the piano more than they had previously, which led eventually to more songs composed in the tradition of classical pop, where the music is more melodic than the rhythmic sound of the guitar.

In other songs on *A Hard Day's Night* and the albums soon to follow ("Any Time at All," "I'll Cry Instead," "I'll Be Back") John was far more honest and darker than he had been before about revealing the possessiveness, rage, and fear of abandonment he felt whenever he was in a relationship. Though largely unnoticed at the time, that too was the beginning of a dividing line in rock and roll. Thanks in part to the influence of Bob Dylan, to whom the Beatles were now listening, John had discovered, he told an interviewer later, that he "could be the subject of his own songs." Even the far more guarded Paul was becoming increasingly confessional in songs such as "Things We Said Today." As other pop artists opened up their own lives to scrutiny, this confessional style had an enormous influence. As rock academic Simon Frith later noted, this fashion contributed to the growing notion that the private lives of artists—and ultimately everyone—were public property, further blurring the line between personal and public that the Beatles had implicitly challenged in *A Hard Day's Night.* They were, in critic Milton Okun's words, using their songs to present "private emotional experience as group material."

An increased public focus on the Beatles' fashionable girlfriends also helped cement their appeal at this time, particularly with their female followers. This, too, was largely new in the pop world because stars, including the early Beatles, had traditionally either portrayed themselves as perpetually single (and available) or presented their families in posed, formalized portraits. In contrast, the Beatles broke with Brian's edict to keep their other halves hidden from the public. The group had officially admitted John's marriage before leaving for America in early '64, and on the Beatles' initial *Ed Sullivan* appearance, CBS even told America that John was hitched with the celebrated caption under his picture on the screen "SORRY GIRLS, HE'S MARRIED." As to Paul, "there was a considerable difference of opinion [in the inner circle] over the Jane Asher situation," Brian Somerville, the group's press officer, was quoted as saying about Paul's decision to let his relationship with the young British actress be known to the press. "Brian made a terrible fuss about it, saying that it would offend the fans. But, in effect, Paul just told him to mind his own business."

In America, the girlfriends and wife received an enormous amount of attention as they were presented, in the words of one observer, "not so much as competition but as someone to emulate." Deviating from the usual pattern, Beatle fans soon knew a lot from the fan magazines about Cynthia, Jane, and model and actress Pattie Boyd, whom George had met on the set of *A Hard Day's Night*. Both Pattie and Jane had their own careers, providing, perhaps, something of a role model. Their behavior, too, was ultramodern, not that the press at the time publicized the fact. Pattie, for example, went away with George on vacation a short time after she had met him.

Pattie even had a column in the U.S. teen magazine *16* (virtually all subscribers were, in fact, younger). As the gospel of swinging London went international, the Beatle girlfriends were hailed as part of the new royalty. "In the pages of *16* magazine," recalled one fan, "we learned how to iron our hair to make it as straight as Pattie Boyd's or Jane Asher's."

In particular, Asher's liaison with Paul added to the favorable publicity surrounding the group. As one of England's leading child actresses, Jane Asher was almost as well known in their homeland as he was—the youngest actress at the time ever to play Wendy in *Peter Pan* in the West End. By the time she left school at fifteen, she had made eight films, acted in four plays, and appeared on television almost a dozen times. Her father was a prominent physician who was known for his work on the newly discovered Munchausen syndrome; Jane's mother, who was a distant relative of T. S. Eliot, taught music at a prominent London music school, where one of her pupils had been George Martin. The family lived in a huge house in the upscale district of Marylebone in London, which, as one observer noted, they treated like their own home town. "They seemed to know everyone and to have been everywhere but they were very nice with it," wrote Paul's friend Barry Miles.

It was the perfect place for Paul, who moved in shortly after he started going out with Jane, who was then only seventeen. "It was such a nice household instead of a cold flat in Mayfair," said Paul. "Margaret Asher cooked—I liked the family." He lived in the attic in what had been the maid's room—an odd choice for a pop star, though not for Paul, who craved the companionship of a family. Once again, his friends

noted, he seemed to be having a relationship with his girlfriend's household as much as with the girlfriend. Meanwhile, Jane's brother, Peter, became one of Paul's best friends and continued to be the beneficiary of some of Paul's best hit songs for his pop duo, Peter and Gordon.

Paul used the Ashers as a base to introduce himself to the life of London and break out of the relative isolation surrounding the other three Beatles. Already he was carving out a different role for himself in the group, "educating himself in the arts," as he put it, while meeting such luminaries as Harold Pinter, Andy Warhol, and David Hockney. There was a cost to the Asher family: The pressure of the fans constantly waiting outside and telephoning the house became so great for Jane's father that he moved out for a short time. But "Paul could never be without a girlfriend," said his aide and friend Tony Bramwell. "He never had any bachelorhood ever."

Paul and Jane had met at a party at the flat of journalist Chris Hutchins in early 1963. Jane came over after she had seen the Beatles in her role as a onetime teen celebrity journalist, writing about the group for *Radio Times*. "John was in a bad mood because he thought there were too many people there and not enough booze," remembered Hutchins. Lennon's response was to go up to Jane and crudely ask how girls masturbate. When she became upset, Paul started comforting her and smoothing things over—which was often his role with John. Soon thereafter Paul and Jane were an item.

"Paul would have been awestruck with Jane," said Maggie McGivern, Paul's girlfriend later in the decade. "We all knew who she was." The inner circle had divided feelings about her; the Liverpudlians in "the mob" tended to be suspicious of any upper-class Londoner. She seemed to feel, said John's friend Pete Shotton, that "she was cut from finer cloth than the other Beatle women." Tony Barrow liked her, though he did describe her as the "perfect partner at the time for Paul, who was a social climber." Chris Hutchins agreed. "Paul was a snob," he said. "Just like Mick Jagger."

But most saw nothing but bliss down the road. "She was calm and gentle, very well-spoken, with red hair and freckles," remembered Thelma Pickles. "She was posh but not snobbish at all." To the nation,

they were the perfect young couple, which, if nothing else, must have displeased John Lennon.

Where Jane and Paul differed was in her desire to be independent because of her career. According to those around them, Paul and Jane quarreled often about her work as an actress, which took her away from him for months. This was consistent with the way other Beatles saw their partners' roles. Reflecting the attitudes of that time, George wanted Pattie to give up her modeling career and John still wanted Cynthia at home with Julian, doing no art.

"I don't want to be part of a gang," Jane told one journalist.

In fact, Jane tended to rebel against any suggestion that she should be defined as simply Paul's girlfriend. When an American fan approached her when she was on tour with the Royal Shakespeare Company in the U.S. to show her a photo spread of herself with Paul that purported to feature "the Jane Asher look," Jane closed the magazine and refused to look at it. "What's the Jane Asher look?" she asked caustically.

She also was distinctly unimpressed with the trappings of fame. The mobs bothered her too. Journalist Don Short remembered being caught in a mob chasing the Beatles and almost being run over by Jane in her car as he tried to catch up with Paul, followed, of course, by the hordes of adoring fans.

When Jane came to Paris to see the group in January 1964, Paul wanted her to stay at the hotel with him and the group. She wanted to tour Paris. "It's so silly of me to stay at the hotel," she said. "It's just that he's so insecure. For instance, he keeps saying he's not interested in the future but he must be because he says it so often. The trouble is, he wants the fans' adulation and mine too. He's so selfish; it's his biggest fault. He can't see that my feelings for him are real and the fans' are fantasy."

Because of this, Jane and Paul often "fought like cats and dogs," said Tony Barrow. Yet those fights were frequently what drove Paul to write some of his best songs. John—the tough guy on the exterior—was often at his songwriting best when exploring his vulnerability and softness. In contrast, Paul, the good boy on the outside who seemed polite to everyone and the least rebellious Beatle, often did his finest work when he could explore his feelings of anger. Over the next two years, in songs

such as "I'm Looking Through You" and "We Can Work It Out," Paul stepped out of his usual self-assured character to write about his feelings in his relationship with Jane.

Paul's attitudes to women as displayed in his lyrics were complicated. He was a hopeless romantic ("And I Love Her"), but once reality tended to intrude into any relationship, his feelings often turned to anger and self-pity. (In "The Night Before" he was already feeling sorry for himself one morning later.) Despite his reputation as "the cute Beatle," there was a residual hostility to women that ran through his songs, as he announced "you won't see me." He tended to self-absorption: In "What You're Doing," he typically asked not "What's wrong?" but what his lover was doing to *him*. In contrast, John often saw rejection or abandonment as matters of profound sadness, not anger.

Yet Paul and John softened the edges on one another. And their lyrics often belied their images: If anyone was taken aback by the cynical view of women exhibited in Paul's lyrics, it could be discounted because Paul looked so boyish and friendly. Similarly John's more hardened, roguish image could be softened considerably by listening to his lyrics, which revealed an open, vulnerable side very different from the public image.

There were other signs of changes in the Beatles' output in 1964. Paul's "Can't Buy Me Love" marked the end of the brief period when John and Paul had fully collaborated in writing their hit singles. Now their musical relationship became more competitive as each, by and large, wrote his own songs and waited to see who would get the A side on the next single. For the next year, despite the success of "Can't Buy Me Love," it would continue to be John.

By the end of 1964, the Beatles could say they were dominating the world of entertainment more than any performers in history. Yet they were thoroughly exhausted, a fact that the astute could see in their new album, released in the UK that fall as *Beatles for Sale.* (This album was released in different parts in the U.S. as both *Beatles '65* and *Beatles VI.*)

"They were rather war weary during *Beatles for Sale,*" said George Martin. John's songs were more downbeat than before and had more of a country western feel ("I Don't Want to Spoil the Party"), a style which,

as critic Allan Kozinn later pointed out, John associated with sadness. The Beatles even looked oddly bummed out on a cover photograph, shot by Robert Freeman, which was never released in the U.S.

There was a slip in standards, too, as the group added six covers of others' songs (like "Mr. Moonlight") because they had run out of their own. For a group always intent on maintaining its excellence, it was a painful lapse in professionalism, and they knew it.

Yet worse, though the fans worshipped their lifestyle, the Beatles could seemingly look forward to only more of the same in 1965: more hit singles, another two albums, another film, and another tour of the U.S., Europe, and Britain, which meant more of their isolated life in hotel rooms. "How often do you think we enjoyed a show when we were touring?" John said later. "Perhaps one show in thirty. It was a nightmare. It's like being a child and performing for your parents all the time," an odd comment for someone who, after all, was something of an orphan.

Two other things, however, had entered the equation that would alter the group's schedule, its music, and ultimately its outlook as well. Great cultural changes were afoot. The Beatles had met Bob Dylan. And, thanks to him, they had discovered marijuana.

HAIR, DRUGS, AND ROCK AND ROLL

THREE major attributes helped define the emerging youth culture of the midsixties. Two of these—the maturing sensibility of rock music and the move to personal freedom symbolized by long hair—wouldn't have happened without the Beatles. The third—the ubiquitous use of drugs—the Beatles wouldn't have happened without. Because the Beatles were so associated with these three developments, when a backlash began to develop against them and what they represented, there was a backlash against the Beatles.

The Beatles, said George Martin, "were more brilliant than they realized and it would have happened without drugs." But he was wrong: Though few at the time knew the extent of their drug use, drugs had fueled the Beatles almost from the beginning and refashioned the group even before those same substances, with the band's implicit endorsement, remade the wider youth culture. In fact, when the *Beatles Monthly Book*, their unofficial fan magazine, published its last issue in December 1969, the publisher stepped away from the magazine's usually rapturous tone to blast the group for the way it had encouraged drug use among the young.

"Marijuana started to find its way into everything we did," said Paul. "It colored our perception and we started to realize there weren't as many barriers as we thought."

Soon it would do the same for millions. More than any other factor, drugs provided the foundation for the sixties counterculture. "In many ways, the counterculture was about altered states of consciousness, which really meant drugs," said Robin Richman, who reported on the era for *Life* magazine. "That led to a number of the changes in the sixties."

Drugs provided the backdrop for the era, even for those who chose not to take them. The influence of marijuana and psychedelics was everywhere. The drug-inspired emphasis on those "altered states of consciousness" helped fuel the interest in alternative forms of religion. The way drugs heightened sensation and helped loosen the bounds of morality were factors in stoking the sexual revolution.

Alcohol—the drug of choice of previous generations—was the source of pub fights and lonely idylls on bar stools, while tending to make imbibers more aggressive and raucous. In contrast, marijuana and the more popular psychedelic drugs of the sixties tended to reduce aggression, helping to cement the notion of peace as a key element in the growing counterculture.

"Drugs helped bring it all about," said Maggie McGivern, Paul's girlfriend later in the decade. "But bloody hell, it worked."

In their use of drugs, the Beatles were hardly alone in the music community. Drugs have been an important engine of popular music, producing changes in style based on the drug of choice at the moment.

In a way, it is possible to tell the story of the group's music through the drugs they were on at various times. The Beatles had begun in Liverpool and Hamburg as an alcohol- and amphetamine-driven band, and that didn't change during their first year of world fame. "They were always drinking," remembered photographer Harry Benson, with the usual drinks of choice being Scotch and Coke or Scotch and lemonade. To keep going, the band members were also on Dexedrine or Preludin, colloquially called "Purple Hearts," also popular among college students who need to stay up all night studying. George remembered that when they flew from England to Hong Kong in mid-1964 the Preludins and alcohol made a long trip seem like it had taken ten minutes.

"They were all on Purple Hearts in the early sixties," said journalist Chris Hutchins, who hung out with the group. "Those drugs make you

more promiscuous, more creative, more excited—you want to do more, talk more." That sense of acceleration, of course, had found its way into much of the Beatles' early music even if observers didn't know its well-spring. (The Beatles seemed to play "Roll Over Beethoven" twice as fast as Chuck Berry did.)

One associate who shared the group's predilection for uppers was manager Brian Epstein. "I discovered far more about amphetamines around Eppie than I ever learned around John Lennon," Hutchins said. "Eppie was constantly hopped up. We would go out to eat at the finest fish restaurant in London and he'd order a bottle of the best wine and the first thing he'd do is swallow pills. 'Here's five for you and five for me,' he'd say. Then he'd never touch his food."

Many of their compatriots were doing the same thing. "It should have been called 'Speeding London,' " said Harry Shapiro, author of a history of drugs and popular music. Andy Warhol described a similar phenomenon across the Atlantic. "I could never finally figure out if more things happened in the sixties because there was more awake time for them to happen (since so many people were on amphetamine) or if people started taking amphetamine because there were so many things to do that they needed to have more awake time to do them in," he said. "It was probably both."

Like so much else in the Beatles story, there is disagreement about when the Beatles were first introduced to marijuana. What is clear, however, is that toking up with influential older rival Bob Dylan in New York on their '64 summer tour of the U.S. launched the group into marijuana nirvana. Passing around a joint, the group put wet towels under the door of their New York hotel room, hoping to conceal the smell.

From that point on, though their fans didn't know it at first, all four Beatles were consistently stoned on marijuana—and soon on more— for much of the rest of their existence. "We believed in cannabis as a way of life," said Derek Taylor.

Marijuana had been in vogue among jazz musicians for decades and the Beats had endorsed its properties as well. But its widespread popularity in the 1960s greatly expanded its influence. In the words of one record executive, marijuana "worked wonders in the music indus-

try. . . . It gave musicians that sense of heightened awareness and produced classic hits."

What made music in the sixties unique, of course, is that the use of illicit drugs soon became so widespread that it was assumed (often correctly) that the audience was on the same drugs as the musicians. Much of the music of the period was produced with this thought in mind (which is why so much of it is unlistenable today).

"Over time there had been a gradual disengagement of young people from the adult culture," said Erich Goode, a sociology professor who has written frequently about the history of drug use. "That youth culture was more adventurous, risk-taking, and antiestablishment. The use of marijuana fit in with all of those things and had the advantage of being fun to use too. Once it started in earnest, it spread like wildfire."

Soon virtually everyone seemed to be smoking grass even though it was illegal—at concerts, political rallies, parties, and at home, helping to create the sense of a persecuted rebellious community that was essential to the zeitgeist of the youth culture. Landon Jones later wrote that if the popularity of this sacrament could be reflected in the number of words it added to the English language, there was little that could match the popularity of pot or grass, reefer, hash, dope, Mary Jane, J's, or weed which could cause one to be zoned out, stoned, down, turned on, or zonked.

"For a counterculture beginning to question the hectic aggressiveness of the culture at large, marijuana was the perfect antidote: It made the user more introspective and passive," said Keith Stroup, an attorney and founder of the National Organization for the Reform of Marijuana Laws.

It was also a good fit for the Beatles. Even before they had discovered the drug, the adjectives people often used to describe the group were "happy" and "nonthreatening"—adjectives similar to the ones frequently invoked to describe the drug's effect on users. The Rolling Stones and marijuana never quite seemed to fit together; grass and the Beatles were a match made in heaven.

At first marijuana probably changed John—who once said, "I've always needed a drug to survive"—more than the others.

"John knew he had a problem when he drank," said Dan Richter, his aide and friend in the late sixties. "People who have trouble controlling their emotions and have repressed feelings often turn to drugs. As did John."

It worked. Marianne Faithfull said that when he stopped drinking he became much less aggressive.

By the beginning of 1965, John later admitted, he was smoking marijuana for breakfast, and George and Ringo were no strangers to the drug either. Paul, though he would avoid acid for the most part, was also no slouch in the marijuana department. One member of the inner circle later recalled that when Paul first got together with his future wife, Linda Eastman, one of her trademarks was that she traveled around with virtually the biggest bag of marijuana anyone had ever seen.

The first effects of the Beatles' new use of grass had already become apparent to insiders by the end of 1964, when their annual Christmas message to their fans was marked by chronic giggling. Their dope smoking revealed itself even more during the filming of their second movie, *Help!*, shot early in 1965. The Beatles were often so high during the filming that it was hard to get work done. One day in May, director Lester tried to film a short scene outside Buckingham Palace more than twenty times and finally had to quit. "They would break up and giggle and whack each other with their elbows," said one American reporter on the scene. "The Beatles were just too high to continue shooting."

By mid-1965, the drug use was affecting their music. The changes "really began when Bob Dylan gave marijuana to the Beatles and the Beatles' music changed, there's no doubt about it," said Derek Taylor.

After that first meeting, Dylan became more like the Beatles and the Beatles more like him. Within a year, Dylan had "gone electric" at the Newport Folk Festival and on his albums—trading in his folk sound for the more cutting edge of the electric guitar and entering the higher reaches of the rock charts for the first time with "Like a Rolling Stone."

The Beatles were similarly transformed. "I've never been so excited about meeting any other musician before," John had said prior to that initial encounter. Up until that point, the lyrics of Beatles songs had not been particularly sophisticated. That was in sharp contrast to folk music

and the work of Dylan, who had said that "the words are just as important as the music; there would be no music without the words."

When Dylan moved into rock, he brought other folkies along as well, like the Lovin' Spoonful and the Mamas and the Papas. Yet he didn't have the mass popularity the Beatles enjoyed. When the Beatles' music became more intellectual and socially responsive, it affected *everybody*. "The Beatles came along and that was pretty much it," said Darby Slick of the Great Society band in San Francisco. "Folk music just went instantly into the dumper."

By 1965, Americans were already familiar with the notion that youth were on the march, inspired by the moral clarity of the civil rights movement. Student protesters seemed to be everywhere—as Freedom Riders in the South in 1961, as volunteers at Freedom Summer in the same region in 1964, and later that same year at Berkeley as part of the Free Speech Movement. Though rock had always been associated with rebellion, folk music was, of course, the traditional music of political protest. When folk and rock began to converge—thanks in large part to both the Beatles and Dylan—rock began to acquire much of the edge and relevance that folk had carried in American culture, even if the lyrics of the newer genre weren't nearly as pointedly political as those of folk music had been. (Reflecting the change, rock and roll now tended to be described a bit more seriously as just "rock.")

This meant, too, that rock music could become more intellectual. Because of their background the Beatles had always possessed artistic aspirations unusual for rock musicians. "Before the Beatles, rock had a lot of id but not much ego," said Neal Gabler, a cultural historian. "Around this time the Beatles did something terribly unusual and difficult: They took the serious artistic questions usually asked in high culture and brought them into popular culture."

From mid-1965 on, the trend in rock toward articulating a broader dissatisfaction with society was obvious. Besides Dylan's "Like a Rolling Stone," the charts soon included folklike protest songs like Barry McGuire's "Eve of Destruction" ("You're old enough to kill, but not for voting!"), Donovan's "Catch the Wind," and Simon and Garfunkel's "The Sounds of Silence." In the words of writer Jacob Weisberg, a genre

which began as "a moan about parental authority" was now on its way "to a questioning of institutional and governmental power." While rock and roll had traditionally reflected its teen buyers in a preoccupation with relationships and sex, that too was shifting. Within a few years, one scholar would find the percentage of the genre's songs not dealing with love and courtship in some form up to about a third from close to zero.

Soon, there was a widespread belief, naive in retrospect but understandably powerful, that the sheer energy and generational impetus of rock could transform the world. Later in the decade the San Francisco journalist Ralph Gleason wrote, "I am convinced that rock 'n' roll in its total manifestations will cause one [a government] to fall," and millions believed him. "Out of it will come the programs. Out of it will come the plans," he wrote.

"It was a political statement," said Joe Boyd, cofounder of the UFO rock club in London, "to get stoned and listen to somebody improvise on an Indian modal scale for twenty minutes with an electric group playing around him."

"Pop music is the beginning," said Donovan. "Fashion will change, architecture, eating, everything because we want it a certain way and we're going to do it."

That unshakable commitment to personal freedom as enunciated by Donovan would soon be at the core of the embryonic counterculture in its struggle with "the establishment." By 1966, the mood had spread virtually worldwide. A dispute in Communist East Germany over whether youth should be allowed to listen to the Beatles and other rock groups was creating, according to the *New York Times,* "the greatest internal turmoil in East Germany since the Berlin Wall was erected." The authorities finally gave up: "East Germany Commies Surrender to Beatles," read the headline in *Variety.* "Battle Was Lost Anyway."

"The Beatles would cultivate a generation of freedom-loving people throughout this country that covers one-sixth of the Earth," wrote Mikhail Safonov years later about the band's effect in the Soviet Union. "Without that love of freedom, the fall of totalitarianism would have been impossible, however bankrupt economically the communist regime may have been."

Yet the first important battle in many places wasn't over music. Beauty may be only skin deep, but how one looked began to take on major cultural and political significance. The Beatles directly inspired this struggle. Though conflicts over hair length may seem trivial today, at the time they took on the cast and language of other fights for individual freedom.

"Yes my hair is long and I haven't shaved in days," sang a folksinger at a Berkeley demonstration. "But I'm fighting for my freedom while clean-cut kids look the other way."

"The issue of hair," said fan Marcy Lanza, "was viewed in the context of the civil rights movement. To us, it was about the same issue— freedom."

Up until this point, the main focus of the group's cultural impact had been on girls—the instigators of Beatlemania. Now it switched to the other sex as the cultural prospects of liberation began to tempt boys as well.

For a long time, of course, long hair on boys was simply called a "Beatle haircut." Only the year before, in 1964, the group's hair had been shorter and, though nontraditional, still considered by many to be more strange than threatening. As their locks steadily grew longer, however— and with it the hair of practically every member of a white rock band— the message changed and millions followed. The length of hair on men now became the preeminent symbol of whether one was part of the youth revolt or not. The rebellion was easy to accomplish: All you had to do was stop going to the barber.

"Hair," read *Amy Vanderbilt's Book of Etiquette*, "because it is so obvious, easy, and cheap to manipulate and color, has always been a frontline symbol of teenage rebellion."

The first signs of generational warfare within families, schools, and communities now often centered on hair length; many of the cases litigating the extent to which authorities could force boys to cut it reached the federal courts. In fact, long hair soon came to represent a multitude of utopian possibilities, so much so that when the creators of a musical several years later wanted to describe the whole sensibility of the new age they simply entitled it *Hair*.

Because they were older, there wasn't much authorities could do about college students, who in the wake of the Berkeley Free Speech Movement in 1964 began organizing across the country to get rid of campus hair and dress codes and—while they were at it—parietal hours dictating when the other sex could visit dorm rooms. The real struggle was with younger teens in high schools, where the example of the college protests trickled down. "Big Sprout-Out of Male Mop Tops" read the headline of a story in *Life* magazine in the summer of '65 that related how teenage boys across the country were refusing to toe the line in school and get their hair cut. One analyst complained that "a Beatle-type hair style can be as frightening a symbol as a switchblade." As Grace Palladino has documented in her book, *Teenagers,* the issue was covered intensely by the media—especially the youth press in publications such as America's *Senior Scholastic* and *Seventeen.* These were hardly radical organs, but as style arbiters, some of these magazines picked up the cry that youth should be able to fashion their hair and dress any way they wanted.

Soon rigid, gender-bound modes of appearance and behavior began to break down among the young. "Are You a Boy or Are You a Girl?" sang the Barbarians. Not only was hair getting longer, but men (the Beatles included) began to wear beads, necklaces, and bright, embroidered clothes made of unusual fabric. Literary critic Leslie Fiedler commented on how the new rising spirit of collectivism was essentially a feminine notion—a revolt against the competitive male individualism that dominated American culture.

Meanwhile the Beatles' second movie was released in the summer of '65. Even without the drug factor, the film was not destined to be the artistic success that *A Hard Day's Night* had been. Originally *Help!* was going to be something of a sequel to the first film (Lester wanted to call it *Beatles 2*), with a plot concerning a man (Ringo) who wakes up one day, decides he can't stand the pressures of fame, and hires a hit man to kill himself. Then he changes his mind and tries to find the hit man to call it off. That idea had some possibilities with its connection to the way the Beatles were feeling about the constrictions of celebrityhood.

Unfortunately, Lester discovered that a film with a similar story line was already in production.

Stuck for a plot, Lester settled on a James Bond–type spoof—a kind of cinematic comic book that Lester said was exploring the "correlation between pop music, pop art, and a pop movie." At another moment, Lester told reporters, "You'll find nothing new about *Help!* There's not one bit of insight into a social phenomenon of our times."

Nevertheless, like its predecessor, the film continued the Beatles' conversation with their fans, giving their audience something to go see again and again in the summer of '65. (A new Saturday morning Beatle cartoon series in the U.S., licensed without their artistic control, extended the dialogue to the under-ten set beginning that September.) And with the release of the *Help!* LP that summer, the Beatles continued their move in a new folk-oriented Dylanesque direction. The lyrics became sharper and more autobiographical—a trend that had accelerated when journalist Maureen Cleave of London's *Evening Standard* had told John he should start writing songs with more than just one-syllable words. (It was also Cleave who had suggested a change in "A Hard Day's Night," after Lennon had originally written, "When I get home to you, I find my tiredness is through.")

On *Help!* the Beatles also developed a gentler, more acoustic sound on songs such as "You've Got to Hide Your Love Away" and "Yesterday." It became more difficult to dance to their songs because of the slower tempo. (John had written "Help!" as an even slower tune, but to his eternal displeasure, producer George Martin made him speed it up to have more commercial appeal.)

Thanks in large part to Martin, who brought a classical sensibility to rock music, the Beatles also began using outside musicians—a flutist on "You've Got to Hide Your Love Away" and a string quartet on "Yesterday." In fact, while today's critics tend to see the early link between Dylan and the Beatles mostly in John's autobiographical songs, at the time it tended to be Paul's "Yesterday" that struck critics as Dylanesque because it involved a singer accompanied only by a guitar (plus the classical musicians suggested by Martin).

"Paul goes it alone on a Dylan-styled piece of material," wrote *Billboard* in its review.

"Yesterday"—perhaps the Beatles' best-known tune—was a shock in rock at the time. It remains one of the most popular songs ever written, covered by other artists over 2,500 times. Yet there's evidence that its singularity was a point of contention among the Beatles. It was the first time the Beatles had released a song that didn't feature the entire group. Moreover, until then John had been controlling much of the group's output and he appeared to resent Paul's success with a song that appealed to adults as much as to young rockers. "What a load of bloody crap!" John said when he heard the tune, to which George added within hearing distance, Paul "thinks he's Beethoven."

It could hardly have pleased lead guitarist George either that on "Ticket to Ride," released as a single in the spring of '65, Paul took over Harrison's guitar duties, presumably because he thought he could do it better. Within a few months, a studio producer said, "The clash between John and Paul was becoming obvious. Also, George was having to put up with a lot from Paul. . . . As far as Paul was concerned, George could do no right." Meanwhile John was reportedly miffed that Martin, presumably at Paul's instigation, had asked Brian Epstein if McCartney could get sole or primary credit for "Yesterday," rather than the usual "Lennon-McCartney" notation. Epstein said no. (McCartney would obsess over this for decades, and forty years later he was still fighting with Yoko Ono over who should get primary credit for the song.) None of these spats were apparent to the public at the time.

What didn't change on "Help!" was John's attitude to women. On "You're Gonna Lose That Girl" he repeated the unusual-for-rock theme from "She Loves You" that those who treat women badly deserve to lose their affection. And on "Ticket to Ride," he sung of passively sitting by while his woman deserted him yet again, repeating the preoccupation that had plagued him since childhood.

Meanwhile the Beatles continued to tour. They hit France, Italy, and Spain that summer of '65, where, to their surprise, their shows didn't sell out even though Paul tried to introduce the songs in the native language of the country they were visiting. In December, they did nine con-

certs in their homeland. In between, in August, they headed to the U.S. and Canada again, where they did sixteen shows in ten venues (plus *The Ed Sullivan Show*) in eighteen days.

What was more striking than the pace of this 1965 return tour was its scope. The Beatles began appearing in large stadiums, opening the tour before almost fifty-six thousand fans at Shea Stadium in New York. This was the beginning of "stadium rock," and apparently the size of the screaming mobs began to alarm the Beatles. That show, Ringo remembered, made John "crazy."

Mick Jagger, who loved attention and was in the crowd, had a similar reaction. "It's frightening!" he said.

When the Beatles came off the road late that summer of '65, they tentatively decided that they had to stop touring soon, though no one could yet envision an alternative. From September 1965 until the following May the Beatles rarely played a live show. Capturing the difference in their style between the touring period and the new one to come—which eventually encompassed everything from their music, to the drugs they were on, to their sensibility—Tony Barrow called the periods the "Old and New Testament eras."

The transformation marked yet another dividing line. Though the Beatles had toyed with the concept of moving away from live performances ever since they had first entered a recording studio three years earlier, the group now began creating music to be heard only on record rather than in performance. "Coming into the studio was a refuge for them," said George Martin, and the group began staying past midnight, working on their records. "It was a time and place when nobody could get at them."

The Beatles also began to think of each album as a presentation in itself, like a film or a novel; within two years, LP sales, thanks to their example, eclipsed sales of singles for the first time.

"When I first started in the music business," said George Martin, "the ultimate aim for everybody was to try and re-create, on record, a live performance as accurately as possible. But then, we realized that we could do something other than that. In other words, the film doesn't just re-create the stage play. So, without being too pompous, we decided

to go into another kind of art form, where we are devising something that couldn't be done any other way."

With Martin's help, the Beatles now began fashioning yet another new paradigm. Critic Paul Saltzman later called the Beatles "the first poets of technological culture." In the words of one scholar, "the quest for the illusion of reality, of bringing into the living room the sensation of being in a concert hall, was replaced with a new sonic world which could not actually exist, a pseudo-reality created in synthetic space." This new "pseudo-reality" also fit in well with the ethos of the emerging drug culture, which also aimed at exploring alternative visions of reality.

It took almost two years for the Beatles to perfect the model. The first transitional product of their new efforts was *Rubber Soul,* released in December 1965. "*Rubber Soul,* for me, is the beginning of my adult life," said Paul at the time. Not everyone loved this "adulthood": It was an album, wrote one commentator, that for the first time in the group's career "erred on the side of pretension rather than simplicity."

"Without a shadow of a doubt the Beatles' sound has matured," wrote the critic for the influential *New Musical Express* in reviewing *Rubber Soul.* "But unfortunately it also seems to have become a little subdued."

As with *Help!* earlier in the year, the Dylan- and marijuana-influenced tempo stayed slower as the words became more meaningful and more personal. ("*Rubber Soul* was the pot album," John later said.) The group introduced new instruments and sounds: a sitar on "Norwegian Wood (This Bird Has Flown)" and a guitar played to sound like a Greek bouzouki on "Girl." Romances were no longer boy meets girl and falls in love. At times, Paul and John told unconventional stories, as in "Norwegian Wood" about an illicit affair gone astray, or "Girl," about a woman whose attitudes puzzle her lover, or "Drive My Car," a song they described as a comic short story. The "she" of earlier songs was now occasionally given a real name, as in "Michelle."

All this continued to be in contrast to what was going on elsewhere in rock. Though rock music was gradually becoming more political, it wasn't becoming feminized; in fact often the opposite. At around the same time the Beatles were recording *Rubber Soul,* the

Rolling Stones were singing about not being able to get any satisfaction; Mick Jagger would soon be putting women under his thumb in hits that poured out "a psychotic flood of abuse against women," according to one author.

Dylan, the other patron saint of the new music, was scarcely a feminist either, though admittedly the relationships described in his songs were hardly the simple romances of traditional rock. "Dylan had contested many aspects of the dominant culture," analyst Paul Hodson later wrote, "but not its preferred styles of masculinity."

As some later noted, *Rubber Soul* was also striking—though few noticed this at the time—for the way in which Paul began to emerge as an engine of the group's product. His confidence appeared to be growing now that he was writing more—one reason that the songs on *Rubber Soul* were often more melody driven. As the Beatles began to do more work in the studio, Paul also started to take on a closer working role with George Martin, since the other three had less patience for the complexities of instrumentation and recording technique.

At around this time, John and George moved on to LSD, with Ringo slightly behind, creating another fissure with Paul. "They quite literally used to eat it like candy," said Pete Shotton of George and John. (Though acid wasn't for Paul—he probably took it fewer than a half dozen times—by the next year or so, he later admitted, he was into cocaine.)

The effect of their drug use on the culture, said one critic, was to clean up the image of psychedelics, making them more acceptable to their millions of followers. By the next year, Timothy Leary said, "I consider them [the Beatles] the four evangelists in the psychedelic movement."

The new drugs had different effects on each Beatle. For John, LSD stimulated the production of some of his most creative songs over the short term. Yet John's overuse of the drug—he once estimated he tripped more than a thousand times—eventually impaired his creative influence over the direction of the band. With John continually tripping, Paul started taking over more of the group's musical responsibilities. Though their work was still collective by anyone's description, Paul soon began writing a majority of the group's songs, which some speculate may have pushed John to escape by taking even more acid.

"In a way, like psychiatry, acid could undo a lot—it was *so* powerful you could just *see*," said George. "But I think we didn't really realize the extent to which John was screwed up."

"I can't disclose specifics, but in general I'll tell you this. LSD is the most devastating thing for mental health that ever existed," Arthur Janov, John's therapist in the late sixties and early seventies, told a reporter. "To this day, we see people who've been on LSD, and they have a different brain-wave pattern, as if their defenses are totally broken down. It stays."

For George, acid was the impetus that sent him hurtling on a voyage of inquiry into Indian culture and music that eventually had a profound effect on all four Beatles. "It was like opening the door, really, and before that you didn't even know there was a door," he said. It wasn't a change everyone welcomed. Tony King, a friend, told Steve Turner, the English rock writer, "When I first met George in 1963, he was Mr. Fun, Mr. Stay Out All Night. Then all of a sudden he found LSD and Indian religion and he became very serious. Things went from rather jolly weekends where we'd have steak and kidney pie and sit around giggling to these rather serious weekends where everyone walked around blissed out and talked about the meaning of the universe."

For the Beatles as a whole "it was only when LSD arrived, bringing an 'alternative' outlook for which inner freedom was more important than material success, that the pieces fell into place and the group's new direction became clear," wrote Ian MacDonald later.

The single "Paperback Writer" and its flip side, "Rain," released in the late spring of 1966, continued the evolution of the New Testament Beatles as the songs landed in an America now preoccupied by LSD. In 1966, the drug was made illegal by Congress, and three powers in the magazine world—*Life, Newsweek,* and the *Saturday Evening Post*—all devoted major stories to it. Influenced by John's "Nowhere Man," the group's first song not to deal with relationships in any form, Paul's "Paperback Writer" was both his first song to deviate from rock's fundamental obsession with romance and one of his new ministories, this one about a man trying to write a novel. While virtually all of the group's prior songs had been about relationships in some form before these singles, from now on fewer than one third would be. In fact, at this point

John stopped writing traditional romantic songs altogether for two years, leaving that department solely to Paul.

The flip side of "Paperback Writer," John's "Rain," was, in critic Allan Kozinn's words, one of John's new songs that were primarily an "expression of attitude." The subject matter of the song revisited an old English preoccupation with the island's dank, dark conditions, much like the paintings of Turner.

As much as the lyrics, "Rain" forecast the sound of the new Beatles. As Mark Lewisohn later put it, "Rain" was "full of all the latest technological advancements: limiters, compressors, jangle boxes, Leslie speakers, ADT, tapes played backwards, machines deliberately running faster or slower than usual, and vari-speed vocals." John said he came up with the idea of an ending that played earlier parts of the song backward when he came home stoned one night and accidentally played a recording from the studio topsy-turvy.

The new style caught their public unawares. "They have, to put it bluntly, goofed," wrote the critic for London's *Sunday Mirror* when reviewing the new single.

In fact, as observers later noted, half the fourteen songs on the next album, *Revolver*, were drug songs of one form or another—not that this was apparent to most of the Beatles' public at the time. Paul's "Got to Get You into My Life," for example, was one of the best rocking love songs he ever wrote but it was evidently intended, at least in part, as a tribute to the power of drugs, not Jane Asher. He may have meant "Good Day Sunshine" to be nothing more than a paean to "being alive," but "knowing" hippies heard the lyrics and thought it, too, was about drugs.

Yet however one described the songs on *Revolver*, released in August 1966, they formed one of the most outstanding albums in the history of popular music. It was an album created by *artists*, with a panoply of styles and instrumentation unheard of in previous popular rock and roll. As critic Russell Reising later wrote, *Revolver* was the first album for the group that featured a song where the Beatles themselves played no instruments ("Eleanor Rigby"); the first song adapted from a literary source ("Tomorrow Never Knows"); the first to open with a composi-

tion by George ("Taxman"); and the first to feature a song in Indian style ("Love You To"). Thanks to the magic of the studio, the music and voices were continually accelerated or slowed; tape loops were spliced together to create strange sounds, and even Ringo joined in, putting a large woolen sweater inside his drum to distort its sound. "It seems now," wrote Richard Goldstein presciently in the *Village Voice* at the time, "that we will view this album in retrospect as a key work in the development of rock 'n' roll into an artistic pursuit." That "development," in turn, inspired the whole genre of rock to continue to evolve into something representing far more than simply adolescent rebellion. For better or worse, rock and roll and its countercultural disciples would now take themselves very seriously.

In keeping with this new approach, Paul's six songs on the album were several steps beyond anything he had written before—though far more traditional in a classical sense than John's. On "For No One," the principal instruments featured were a French horn and a piano; no other Beatles appeared except Ringo. "Good Day Sunshine"—a kind of music hall number—featured no lead guitar work. Neither did "Eleanor Rigby," another compelling Paul ministry, this one about an older unmarried woman, sung to the accompaniment of a string quartet arranged by George Martin. "Jane Asher had turned him on to Vivaldi," said John.

As for George Harrison, he had three songs on the album—more than he had produced for an LP so far. Without a collaborator, it had taken him longer to come into his own as a writer, and here, as in his songs over the past eighteen months, much of his work tended to reflect a rather sour attitude to love. As others have noted, Harrison's early "love songs" tended to be tinged with suspicion and defensiveness—"If I Needed Someone" (but, of course, I probably don't), or "You Like Me Too Much" (which is mostly your problem, not mine). It was only when he began writing his own Indian-type music, beginning with "Love You To" on this album, that his tone changed.

John's five new songs on the album mostly celebrated the joys of escape—namely, sleeping or taking drugs. Though venerated by critics since, they were generally less accessible and not greeted at the time with

the same kind of enthusiasm as Paul's compositions. (A British magazine poll of favorite *Revolver* tracks taken soon after the album's release found that fans placed only one of John's songs in the top five.) The first song John had written for the album, "Tomorrow Never Knows," began with the words from Timothy Leary's *The Psychedelic Experience,* which John would read while tripping. He asked George Martin to arrange the song as if four thousand monks were singing it perched on a mountain. With its use of strange percussion, backward tape loops, and John's voice run through a loudspeaker, it was among the most experimental tracks rock had yet seen.

There was another emerging theme on this album. It was a characteristic of acid that, in Jon Savage's words, it could make "you see the world anew, just like a child" and "cause another return to childhood." Maybe that's what Cynthia Lennon meant when she said that acid made John like a little boy again, escaping "from the imprisonment which fame had entailed."

There was a way in which the Beatles had often reminded observers of the very young. "They are like children in many ways," George Martin told Hunter Davies. "They love anything magical." In the words of another onlooker, they acted out the process of never growing up and their spirit of fun emphasized that connection. Writing later about their early look and sensibility, the novelist Alison Lurie described them as Christopher Robinesque, with their emphasis on the "childish impulses of noisy play and free impulse release." Their androgyny also reinforced memories of the time of life when the differences between boys and girls are often less pronounced and even blurred.

There is, in fact, an English tradition going back to the pastoralism of Wordsworth of worshipping childhood and creating adultless utopias full of Peter Pans, hobbits, or Alice in Wonderlands. It was an impulse that informed a growing revolution in style in Britain. "I saw no reason why childhood shouldn't last forever," said fashion designer Mary Quant in describing one of the notions that distinguished her work, characterized by big flowers and short, unshaped dresses.

"We've all of us grown up in a way that hasn't turned into a manly way," Paul said. "It's a childish way."

Whatever the causes, John now began writing about when he was a boy on songs such as "She Said She Said" and the upcoming "Strawberry Fields Forever," named after the orphanage near his home in Liverpool. On "Paperback Writer," the group sang "Frere Jacques" as the backing to the lead vocal. Since one member of the group always influenced the others, it was a notion that soon infatuated all the Beatles, whose new psychedelic world in song came to represent a kind of childhood Eden—an enchanting utopia for children where a new consciousness ruled. Given their influence, this emerging sensibility soon became part of the larger psychedelic counterculture, which, in one writer's words, now took "being childlike as a sign of mental health." A French writer called the new mood the "triumph of babydom over thought."

The song that best embodied this new mood on *Revolver* was "Yellow Submarine," with the lead sung by Ringo in his "everyman" role. Written by Paul, the family man who loved kids, the recording featured "magical" side effects like the sound of the ocean and included a brass band—a summer memory from the Beatles' childhoods in Britain, where bands play in parks constantly. It was easily singable, a trait evidenced by the fact that the Beatles brought a number of their friends into the studio to join the chorus. Its theme was, again, the joys of collectivism. With its colorful imagery of a magic kingdom to which reborn children could escape—like the stories in so much children's literature—it even became the source of a feature-length cartoon movie.

Soon this seemingly juvenile song had become much more. Within months of the song's release, protesters at Berkeley—now militating against the Vietnam War—were singing the song together. Michael Rossman, a Free Speech activist, wrote in a leaflet:

The Yellow Submarine was first proposed by the Beatles, who taught us a new style of song. It was launched by hip pacifists in a New York harbor, and then led a peace parade of 10,000 down a New York street. Last night we celebrated the growing fusion of head, heart and hands; of hippies and activists; and our joy and confidence in our ability to care for and take care of ourselves and

what is ours. And so we made a resolution which broke into song;
and we adopt for today this unexpected symbol of our trust in our
future, and of our longing for a place fit for us all to live in.

Derek Taylor said something similar: "It's really like a kind of ark where, at least that's how I saw it, a Yellow Submarine is a symbol for some kind of vessel which would take us all to safety, but be that as it may, the message in that thing is that good can prevail over evil."

After *Revolver*—which took an almost unprecedented (for then) three months to record—the Beatles needed a rest. Instead, they were forced to hit the road in the summer of '66 for what would be the final time. Over three months, after playing one last UK concert, they headed to Germany, Japan, the Philippines, and lastly the U.S.

This tour confirmed their previous tentative decision to stop touring. They were unable to perform any of *Revolver*'s complicated songs in concert, or at least chose not to do so. For a group that prided itself on its professionalism, they were awful. Even Paul forgot the words to songs and John often played the wrong chords. They returned to Hamburg for their first time since their early days (the threat of paternity suits had kept them out until then, according to Brian's advisers), and saw Astrid for the first time in several years. "I felt sorry for them," she later wrote. "They had missed their youth in some way. I could see that in their eyes."

In Tokyo, the Beatles were scheduled to play at the Budokan arena for five shows in three days, and because it was considered something of a religious war shrine, there were numerous complaints. To head off trouble, the Japanese ordered thirty-five thousand police to protect the tour and there were three thousand policemen inside the concert hall. Meanwhile, the Beatles played on a raised stage, so anyone who broke through the numerous police blockades couldn't get at them.

At the next stop in Manila, in a celebrated incident, the Beatles failed to attend a party given by Imelda Marcos, the wife of the president. The result was that they were prevented from leaving the country until they had posted a tax bond. Their security force was withdrawn, leaving the four to run for their plane carrying their own luggage and

equipment while fans attacked them. The authorities made their plane sit on the runway for hours. George, in particular, was afraid they might be busted.

But America, which had always greeted them with open arms, provided the real surprise at the end of that summer. In the year since they had last traveled there, the group had changed a lot as their drug use had moved them somewhat out of the middle American mainstream. But the country had changed too. In 1965, it had still been possible for most adults to view the Beatle-inspired youth movement and any unrest it engendered as something akin to the benign rambunctiousness always displayed by youngsters. With music and hair now becoming more radical political statements, however, that was no longer true.

Moreover, the Beatles were arriving in the middle of a summer of racial unrest as riots engulfed a number of American cities including Chicago, New York, and Cleveland. "America is not too settled at the moment," said Derek Taylor at the time. "There is much violence and the sun is burning out of the hard sky." With the Vietnam War escalating, antiwar rallies had also moved off the campuses and into the streets, becoming more militant. In response, Lewis Hershey, the director of the selective service system, had announced that any student who illegally protested the draft could lose his deferment and be sent to war.

With generational and political battle lines hardening, a cultural backlash had developed that would foreshadow a major electoral backlash two years later, particularly in more conservative areas like the South. It was hard not to see that many had no use for the political evolution rock music was taking. In the spring of 1966, "The Ballad of the Green Berets"—as prowar a song as anyone could imagine—hit number 1 in America, and both Nancy and Frank Sinatra ("These Boots Are Made for Walking" and "Strangers in the Night" respectively) retook the top of the rock charts with pop that could have been hits five years earlier. Meanwhile the Beatles' new, more subtle songs and image had little appeal for younger teenyboppers, who were about to go over en masse to groups such as the Monkees, a domesticated made-for-television version of the Fab Four, who premiered with their own show on NBC television that fall.

The Beatles were thus prime targets in the culture battles when they arrived in the U.S. in August. Matters got worse when, on the eve of their visit, the teen magazine *Datebook* published a Maureen Cleave interview with John Lennon from earlier in the year in which he had said the Beatles were now "more popular than Jesus." Few had noticed in largely irreligious England—in part because it was probably true—and, in fact, Lennon's remarks would hardly have been out of place in a *Time* magazine cover piece several months earlier that had asked the far more radical question "Is God Dead?"

But in the more religious American South, Lennon's remarks ignited an uproar. Preachers and law enforcement officers in the region had been railing for years about the pernicious effects of rock and roll. When native son Elvis and his southern cohorts had been leading the musical charge, however, it had been impossible to mount much of a counteroffensive. The Beatles, of course, were a different story. In response to the Lennon interview, there were radio station–sponsored bonfires throughout the region, burning Beatles records. The Ku Klux Klan and others picketed their concerts. A Pennsylvania state senator called for their concert to be canceled in his home state. When the group arrived in August 1966 for its first U.S. show in smoldering Chicago—where at about the same time Martin Luther King Jr. was stoned by a hostile crowd while leading a march—Lennon was forced to apologize for his remarks, which was about the worst agony he could imagine.

Meanwhile the Beatles' new outlook was rubbing a lot of people the wrong way. In England it had been reported that the crowds to greet them were dwindling, and when the Beach Boys beat them out in a *New Musical Express* poll as to the best group of 1966, Don Short of the *Daily Mirror* wrote, "The decline and fall of the Beatles became official last night."

The group clashed with Capitol, its American label, as the company forced the band to change the cover of the album *Yesterday and Today* from an unsettling picture showing the foursome strewn with butchered meat and doll's heads into something more conventional. The backlash was also exacerbated by John—anxious to recover his "real self" after his apology—who now announced his support for those

protesting the Vietnam War. Paul, too, was having to defend remarks that "America is a lousy country where anyone who's black is called a nigger." What the group didn't realize—in fact no one did at the time— was that by being so vehemently attacked by "the establishment," the Beatles were solidifying their position as leaders of the counterculture.

Because of the drop in their popularity, most venues on the tour didn't sell out. This time, Shea Stadium didn't fill. In Seattle, half the tickets for an afternoon show in a fifteen-thousand-seat indoor arena went unsold.

Worse, the anger in the culture seemed to permeate the crowds that came to see them. Beatles fans had always been somewhat unruly, but this was a scary change in tone. In Cleveland, 2,500 fans invaded the field, stopping the concert. In Memphis, the group was hit by rotten fruit and the concert was delayed because of a bomb threat. In Los Angeles, there were continual clashes between fans and police both during and after the concert with dozens of injuries. In New York, two girls threatened to jump from the twenty-second floor of a hotel unless they could see the group.

As George Harrison put it, the world had used the Beatles as an excuse to go mad and then blamed the group.

Death threats followed. The Beatles had eschewed U.S. ticker tape parades because of memories of the JFK assassination, which had also prompted the unofficial guideline that the Beatles try to avoid appearing in front of an open window inside a hotel. Now they were frightened much of the time. Louise Harrison visited her brother in a hotel on the tour. "I remember looking at George as he stepped onto the fire escape," she said. "He turned and looked at me, and I always sort of got the impression that it was like the look that would be in the eye of a deer that was looking into the barrel of a gun." When a firecracker went off during their Memphis appearance, they looked around at each other to see who had gotten shot. Even Paul, the leading advocate for touring, was so upset that he began occasionally vomiting out of fear before performances. By the day of their last concert in San Francisco in late August, the group knew its touring days were over. "So now it's all over," George

announced triumphantly when it was over. "I can stop pretending to be a Beatle now, people!"

For the first time in almost a decade, each Beatle decided to go his own way for several months. In September, George went to India with Pattie to study Indian culture and music, and there he also met a self-styled guru who called himself the Maharishi Mahesh Yogi. Paul went to Africa and then stayed in London, where his "self-education" in the burgeoning London underground continued and he wrote the score for a film, *The Family Way*. John went to Spain, where, with his hair cut to resounding publicity, he began filming *How I Won the War*, directed by Richard Lester. Ringo mostly hung out at home.

There was no formal announcement that touring had ended. But with members of the group scattering and refusing to announce the dates of future tours, the English press establishment concluded (with the American press following) that the group was slipping and probably breaking up for good. After all, the expected route for popular musicians at that time was to record songs quickly and then hit the road to publicize them.

"*Beatlemania* is at an end," wrote the *London Sunday Times*. "Beatles May Not Appear as Group Again," read the headline of the *Daily Telegraph*. "At the Crossroads," wrote the *Daily Mirror*, "the Sad Dilemma of Four Very Talented Lads." Brian Epstein had continually to issue statements denying that the Beatles were a thing of the past.

Though they badly needed the rest, it was hardest on John, who without his mates seemed lost. "You seem to need them even more than they need you," his wife, Cynthia, told him. John had recounted to his friend Pete Shotton earlier that year that he had fallen to his knees one night and begged God to help him. "God, Jesus, or whoever the fuck you are—*wherever* you are—will you please, just once, just *tell* me what the hell I'm supposed to be doing?" He had said something similar to Maureen Cleave. "You see there's something else I'm going to do, something I must do," he said, "only I don't know what it is."

By the end of November, the foursome reunited in London. Apparently the synchronicity still existed: All four Beatles were now sporting

similarly styled shorter haircuts. "We cannot stay in the same rut. We have got to move forward," Paul told a reporter, as if everything they had done so far counted for very little. They now began the demanding work that six months later would produce the album that would transform everything again: *Sgt. Pepper's Lonely Hearts Club Band*.

SGT. PEPPER'S COSMIC COUNTERCULTURE

IT'S impossible to imagine today how a simple record could galvanize millions. Yet *Sgt. Pepper's Lonely Hearts Club Band*, released in early June 1967 at the dawn of the "Summer of Love," did just that. Its release was an incredible social phenomenon. The sound, the format, the message, and the timing of that LP came together to crystallize the emergence of a counterculture and crown the Beatles as the leaders of that alternative movement in America and around the world.

"I think the signal event of that period was the release of the Beatles' *Sgt. Pepper's Lonely Hearts Club Band*," said comedian Robin Williams later. "With that one album, it was clear that something absolutely new was happening with young people."

The idea of a counterculture defies one all-encompassing definition. It was not an organized movement, like a political party, where everyone went in the same direction simultaneously. Nor was it a doctrine with a defined ideology. Instead it was a fluid set of assumptions and beliefs about the world, all joined under the general umbrella of redefining what the norms of a society should be. In turn, it dictated the lifestyles and political culture for a large minority of the young in the late sixties.

"A utopian exhilaration swept across the student universe," wrote

Paul Berman later. "Almost everyone in my own circle of friends and classmates was caught up in it. . . . Partly it was a belief, hard to remember today, that a superior new society was already coming into existence. And it was the belief that we ourselves—the teenage revolutionaries, freaks, hippies and students—stood at the heart of a new society."

It was a product of a multitude of influences: antiauthoritarianism from Henry David Thoreau to the Marx Brothers; the beat movement; Eastern religious philosophy; Western romanticism; and the American tradition of radical utopianism. In an odd congruence, it seemed essentially American, yet as Louis Menand later noted, much of it was imported from abroad.

Above all, the counterculture was the creation of the young. It challenged the older generation on a number of issues—religion (a fascination with mysticism and Far Eastern faiths), clothing (more casual, colorful, revealing, with comfortable garments for both sexes), living patterns (a transitory communalism), sex ("free love"), the meaning of work and success (antimaterialism and a rebuffing of impersonal corporate institutions), and, of course, through music, drugs, and politics.

The Beatles had already been instrumental in making the leaders of rock music the deities of a youth culture for whom conventional politics and politicians were being discredited. But the *Sgt. Pepper* album took it all to a new level. As a critic later put it, politics and art were now more closely linked than at any time in recent history.

The figureheads and products of media other than music didn't offer much of an alternative for leadership. The 1960s, of course, had no computers, video, or Internet to compete for the attention of the public. Commercial television, with only a few channels and no cable or specialized networks, was geared by necessity to a mainstream audience with its mainstream values. For example, the biggest television show of the Summer of Love in the U.S. was the final episode of *The Fugitive,* in which Richard Kimble tracked down the one-armed man; the three top-rated series of the year were the cowboy saga *Bonanza, The Red Skelton Show,* and *The Andy Griffith Show*—three programs about as far removed from the counterculture as imaginable.

Because the three television networks didn't want to alienate anyone

in their audiences, they followed well-worn formulas even when shows were aimed specifically at teenagers. *Hullabaloo* and *Shindig* weren't really much different from Dean Martin's and Ed Sullivan's weekly musical variety programs. Portrayals of teen life typically ran to the ultracute *Patty Duke Show* and *Gidget*.

Hollywood was similarly out of touch with the youth culture. Movies weren't as influential in those days—the audiences were smaller and the large screen didn't generate the media buzz it does today. Even when such films as *Bonnie and Clyde* and *The Graduate* held out the promise of tapping into the sentiments of alienation fueling the youth culture, they could be experienced only occasionally through a special trip to a theater.

Though there were writers associated with the counterculture such as Herman Hesse and Kurt Vonnegut, the conservative Harold Bloom later lamented that "not a single book of lasting importance was produced in or around the movement." Even if one disagrees with Bloom's harsh assessment, books were not central to the counterculture and its lifestyle. They are meant to be read alone—not collectively—and it was very difficult to read, or better yet, "experience" a book while one was stoned.

Yet music via records was another matter. In today's era of MP3s, when CDs are on their way to obsolescence thanks to Internet downloading, the idea that an album could galvanize an entire culture seems implausible. But things were different then. Since the midfifties, of course, rock had been the medium of the young, with legions of radio stations to feed them. The advantage of a recording—unlike a movie—was that it could be taken home and played repeatedly, shared communally as well as treasured privately.

If a movement were to travel internationally, records were the most portable form of communication that existed in 1967 other than the written word. It was consistent with the values of the time, too, that music's appeal was antirational, or at least extrarational; media analyst Mark Crispin Miller has called music the "least cerebral of arts." The counterculture was a movement dedicated to overthrowing conventional society's overreliance on reason. That music was, in the words of

critic J. Bottum, "a thin rather than a thick art form" and a genre that eschewed "the explanatory arts" was all to the good as far as the young were concerned.

Besides, drugs enhanced the auditory experience. If the counterculture were to have titular leaders, it made sense to have them come from the rebellious world of rock and roll.

"At no time in American history has youth possessed the strength it possesses now," Ralph Gleason wrote in *Rolling Stone* in 1968. "Trained by music and linked by music, it has the power for good to change the world."

Sgt. Pepper's Lonely Hearts Club Band seemed to fulfill all that promise. Critic Robert Christgau has pointed out that with the passage of almost a year since the Beatles' last album—the longest the group had ever gone between LPs—*Sgt. Pepper* "was awaited in much the same spirit as installments of Dickens must have been a century ago."

The album did not disappoint. "When *Pepper* came out that June," said Robin Richman, "people immediately bought the album, smoked dope, danced to it, and memorized it. It just exploded what had been building up. It was like Christ coming into Jerusalem. They were the gurus, the shamans, the spiritual guides, and this was the text."

"The *Sgt. Pepper* album . . . compresses the evolutionary development of musicology and much of the history of Eastern and Western sound in a new tympanic complexity," said Timothy Leary, illustrating Richman's point. He called the Beatles the "Divine Messiahs."

Critic Langdon Winner wrote:

In every city in Europe and America the stereo systems and the radio played, "What would you think if I sang out of tune . . . Woke up, got out of bed . . . looked much older, and the bag across her shoulder . . . in the sky with diamonds, Lucy in the . . ." and everyone listened. At the time I happened to be driving across country on Interstate 80. In each city where I stopped for gas or food—Laramie, Ogallala, Moline, South Bend—the melodies wafted in from some far-off transistor radio or portable hi-fi. It was the most amazing thing I've ever heard. For a brief while the

irreparably fragmented consciousness of the West was unified, at least in the minds of the young.

"The effect of something like the *Sgt. Pepper* album on me and other activists, organizers, and counterculture people around the world was one of incredible impact—like starting a fire in a fireworks factory," said Abbie Hoffman, the Yippie political firebrand.

Sgt. Pepper's historic impact was the combination of a number of factors. It came out just as the counterculture was gaining wide influence. It had the extraordinary fame and reputation of the Beatles behind it. Its striking experimental innovations—a different type of cover, sound, and approach—represented a kind of *Ulysses* for the new age, though unlike Joyce's novel, which few ever read, everyone listened to *Pepper*, which meant everyone could discuss it. A few songs approached greatness, such as "A Day in the Life"—a quasi-rock symphony with imagery that was compared to that of the great poets. *Sgt. Pepper* validated for the counterculture that it was a serious and important movement engaged in the process of irrevocably changing history.

"We always felt we were talking about Sgt. Pepper as if he were really some sort of mythical band leader for *all* hippies," said Steve Gaskin, himself a hippie at the time. "We were really talking about worldwide transformation—and we weren't just talking about music but about everything."

Ironically, *Sgt. Pepper* was also the album the literary and intellectual establishment embraced; it was hard to find a critic who didn't declare it to be something of a masterpiece. The *New York Review of Books* wrote that it created "a new and golden renaissance of song." *Newsweek* compared the Fab Four to T. S. Eliot. Kenneth Tynan went further, calling the album "a decisive moment in the history of Western civilization." While one might think that this widespread acclaim from the establishment would turn the counterculture against the Beatles, it had the effect, instead, of legitimizing the youth culture in its own eyes.

The album also merged the countercultures on both sides of the Atlantic. On paper *Sgt. Pepper* and America were not a match made in heaven. The album's theatrical tone was "peculiarly English," said

George Martin. Unlike Americans—who tend to head to the frontier when they seek freedom—the album reflected instead the propensity of those living on a crowded island to escape into the past in a wave of nostalgia. On *Sgt. Pepper* the Beatles evoked an old English world of fairgrounds ("Being for the Benefit of Mr. Kite") and Victorian bands playing in the park (the title tune and reprise).

Moreover, the new LP deeply reflected its creators' immersion in an English experimental scene that had no real counterpart across the Atlantic. For starters, the London counterculture was far more absorbed in the latest intellectual and artistic currents than anything that existed in the U.S., where people drew a sharp distinction between the democracy of popular culture and the elitism of high culture. Throughout 1965 and 1966, Paul had immersed himself in London in the experimental musical work of Stockhausen, the films of Antonioni, and the works of countless other progressive artists whose influences were all seen on the album. As one analyst put it, if the American counterculture was hedonistic, England's was earnest—an understandable development, since many of its founders hailed from art college, where they had learned to take themselves and their work very seriously.

The British counterculture also tended to be far less political than its American counterpart. Though British youth obviously knew about Vietnam and many strongly opposed the war, it was a far less pressing issue for them because their nation wasn't fighting and they faced no draft. The civil rights movement that had helped define the American youth movement didn't exist there either. If the youth of America were beginning to turn against President Lyndon Johnson in droves ("Hey hey, LBJ, how many kids did you kill today?"), the youth of England still tended to admire Harold Wilson, the nation's first Labour Party prime minister in almost two decades and the youngest prime minister of the century until then.

To paraphrase author Charles Shaar Murray, in the sixties Americans had politics as the root of their rebellion; the British had style. Though it is obviously trivializing important changes to say, as Dylan did, that the sixties were ultimately about clothes, it is true that the British were ahead on that score. (The hippies—and then American cul-

ture at large—eventually copied them to a certain extent.) The emphasis on clothes and style also allowed the English to pursue their preoccupation with androgyny, as stores like London's Granny Takes a Trip, which opened in 1965, sold clothes for men and women together. Other London clothing stores, such as I Was Lord Kitchener's Valet, sold old clothes and military uniforms and provided the Beatles with some of the imagery that would surround *Sgt. Pepper*.

When Grace Slick of the Jefferson Airplane met Donovan in 1967, that difference in look was what struck her first. "He was dressed in this long, East Indian–looking arrangement and was throwing flowers into the crowd," she said. "And we're going, 'Oh Lord in heaven.' Because we were kind of scruffy, most of us. We'd get up onstage to play and we didn't even bother to dress up very much."

Differences between the two countries also played out in where and with whom cultural experimentation was popular. America was the home of the democratic "happening," which celebrated communitarianism. In contrast, the leaders of the less egalitarian London scene concentrated themselves in hip shops and private clubs, where the beautiful people gathered in smaller, more exclusive venues such as the Scotch at St. James, the Speakeasy, and the Ad Lib. "It was like a men's smoking club," said John, "a very good scene."

This typically English world was embraced by Paul far more than by the other three Beatles. He was a regular at the Ad Lib; he was at the launch parties for new ventures like the London underground paper, the *International Times*, where he came in the costume of an Arab; and he helped get the Indica bookshop and gallery started, which became a gathering place for some of London's new hip young. (It was at the bookstore that John purchased the book that gave him the opening lines of "Tomorrow Never Knows," and it was at the gallery that he met his future wife, Yoko Ono.) In this atmosphere, a struggling experimental artist from America like Yoko could find a much more receptive audience for her work than she ever found in the United States.

London's counterculture scene also had a strikingly different attitude to money than its American counterpart. American counterculturalists— perhaps because they took the nation's abundance for granted—often

made antimaterialism a key part of their ethos as they set up food co-ops, shared property, and advised their fellow citizens, in Abbie Hoffman's words, to "steal this book." In contrast, the English never stopped celebrating the acquisition of wealth because, if nothing else, it upset a class system where inheritance had previously been almost the sole avenue to riches. "To have money was the 'Revolution,' " wrote Jon Savage. "To make it was a public service and if you were young, heroic."

Until *Sgt. Pepper,* much of the young London elite tended to look to the Rolling Stones as their icons more than the Beatles because the Stones seemed more rebellious. Even John Lennon considered Mick Jagger something of the leader of the London scene. After all, the Beatles had received MBEs in 1965 from that ultimate pillar of the establishment, the Queen. In contrast, in February 1967, Mick Jagger and Keith Richards were busted at a party where the police found Jagger's girlfriend, Marianne Faithfull, naked, wrapped only in a rug. (George Harrison had been there too but apparently the cops waited until he'd left to bust the house; the Beatles were still considered too much of a national treasure and untouchable.) To their aficionados, the Stones played "rock" while the Beatles performed "pop." "We saw no connection between us and the Beatles," said the Stones' Keith Richards about their early days. "We were playing blues; they were writing pop songs dressed in suits." Besides, it was the Stones who had the major connections to the celebrity models and pop stars who reigned over the London scene. (Mick was, at various times, linked with Jean Shrimpton and Marianne Faithfull, and a few of the Stones with model and actress Anita Pallenberg.)

It helped, too, that the Stones were from London, not the north, and that they (or at least Mick) seemed more preoccupied with the goings-on of the upper classes than the Beatles ever did. As critic Robert Christgau later suggested, the songs of the Stones were often bitter attacks on the hypocrisy and decay of Britain's gentry. While the Beatles evoked the sentimental romanticism of Liverpool's Penny Lane in their songs, Jagger's antiromantic Stones were far more obsessed with the adventures of the rich young women of Knightsbridge in songs such as "Play with Fire" and "Stupid Girl."

The attitude of Virginia Ironside, hired as a young columnist by the

Daily Mail, was typical. "Like a lot of my friends, I had reservations about the Beatles in those little suits and cute mop tops," she said. "They weren't really revolutionary enough. The Stones were much more interesting and much more honest."

The Stones had millions of followers across the ocean too, but Americans generally weren't nearly as critical of the Beatles as hip Londoners were. In contrast to their exalted place in the hierarchy of Swinging London, the Stones were rarely considered the equals of the Beatles in America; they certainly had too much of an edge to be the band of the moment during San Francisco's Summer of Love. It's no coincidence the Stones did what many consider to be their worst work when, in 1967, they briefly tried to discard all their negative energy and become utopian hippies like the Beatles on *Their Satanic Majesties Request.*

"Those were very interesting times and psychedelia was an interesting movement, and the Beatles did it really well—I have to say, to be fair, better than the Stones, I'm afraid," remembered Marianne Faithfull.

Sgt. Pepper showed why, as it bridged the gap between the two countercultures. Though influenced heavily by experimental artists virtually no one in America knew, *Sgt. Pepper* still fit the mood of American hippies, who, like all optimistic U.S. pioneers, wanted to create yet another new world.

In the guise of an album, *Sgt. Pepper* created its own utopia and populated that alternative world with a number of ideas and images that were in vogue—or soon would be—in the growing counterculture. One critic called the album "a new machine—one that grinds out mystics and Outsiders." In his book *The Making of a Counterculture,* Theodore Roszak would soon identify a number of elements of the new movement: the generation gap that fueled it; the emphasis on alternative forms of consciousness, often from the East; the glorification of drug taking; the stress on personal liberation; and the elevation of feeling, fun, and childlike play over the serious rationalism that was a part of so much of Western society.

The Beatles seemed to address all these elements. Songs such as "She's Leaving Home" dealt with the generation gap. *Sgt. Pepper* was an album made by people on drugs ("I get high with a little help from my

friends"), to be listened to on drugs (how else to fathom "A Day in the Life" or the bizarre fairground music of "Mr. Kite"?), and there were a number of references to psychedelics throughout the album, culminating with the coda Paul wrote (but John sang) for "A Day in the Life": "I'd love to turn you on."

"Now there was an album that proved to the masses what musicians had believed for years," said John Phillips of the Mamas and the Papas. "That music and drugs worked wonders."

The influence of the East came through on George's one song, recorded only with him and numerous Indian musicians, "Within You Without You." (That said, it was the least popular song on the album, and EMI chose it to lead off the album's second side so fans so inclined could "put their pick up down on the second track and skip it completely.")

As one critic noted, all the songs on *Sgt. Pepper* were in the present tense. (Berry Gordy of Motown had long urged his writers to do the same, the better to make the songs appealing to a generation focused on the "here and now.") Like children, the Beatles staged a kind of performance as party—a happening!—and they all wore costumes for the cover to celebrate. They even grew mustaches to change their appearance. The Beatles' infectious sense of fun now became a kind of call to arms.

"That's what the whole sixties flower power thing was about: 'Go away, you bunch of boring people,'" said George Harrison. Not for nothing, did critic Richard Goldstein call the group "the clown gurus of the sixties."

Most important, the theme of communalism—exemplified by the crowded cover shot and tunes such as "With a Little Help from My Friends"—gave the album the unifying message it needed to be embraced by the counterculture. On the album and the immediate follow-up single, "All You Need Is Love," the Beatles' former emphasis on individual romantic love transformed itself into a philosophy based on universalistic love. (There were no traditional love songs on *Sgt. Pepper*.) That was "the idea that imbued that whole age," said the Airplane's Paul Kantner.

"I think individual love is just a little of universal love," said George Harrison.

"We need more love in the world," said Paul. "It's a period in history that needs love." This focus on love was quickly conflated with peace, which appealed to the more politically focused youth in the U.S. protesting the Vietnam War.

Rock's first widely heralded concept album contained twelve songs (plus a reprise) and took around seven hundred hours to record. There was virtually no separation between songs—instead of a three to four-second gap of silence, each song flowed into the next. The words to each song were printed on the back cover of the LP. The record included, at various points, pipe organs, animal sounds, tapes of orchestras played backward, a symphonic crescendo that lasted almost a minute, the sound of combs on toilet paper, and an ultrahigh frequency audible only to dogs.

The album also announced a change of the guard in the Beatles, though few noted that at the time. It's true that John wrote the main parts, if not all, of four songs and made key contributions to several others. But *Sgt. Pepper* was, almost from beginning to end, Paul's conception. As the Beatles scholar Peter Doggett later wrote, it was Paul's genius that he could take avant-garde ideas (like the orchestral crescendos in "A Day in the Life") and package them so they would be accepted by everyday listeners. By and large, the album reflected his enormous range of musical styles and what Ian MacDonald called his "emotional populism" ("we'd love to take you home")—a powerful idea in egalitarian America.

The idea of making the album the workings of an imaginary group called Sgt. Pepper's Lonely Hearts Club Band had also come from Paul, though the conceit lasted only a few songs and in the intricate cover and cutouts that came enclosed as a package with the album. Though the concept had its origins in an important goal—Paul wanted to re-create the atmosphere of a concert now that the band was no longer touring—it was not a notion that particularly pleased some of the others. "Paul was going on about this idea of some fictitious band," said George Harrison. "That side of it didn't interest me, other than the title song and the album cover."

In addition, Paul took over a lot of the work of recording *Sgt. Pep-*

per. He spent days trying to get a single sound right on a track as they labored, for example, to get not just the combs and toilet tissue to hum during the end of "Lovely Rita," but the right *strength* of toilet tissue and the *proper* combs. As Paul and George Martin—who had always been interested in creating experimental music and shaped this album more than any other—obsessed over details, Ringo and George Harrison grew bored.

"We were virtually reduced to being a session group on our own album," Ringo later complained, though at least he learned how to play chess while waiting to be called to play. At this point, Paul's leadership didn't seem to bother John, who said he was happier than he'd ever been in the studio.

Yet as Paul increasingly took over, something began happening to the group dynamic. Paul Kantner later said that once acid hit the scene, it was harder for groups to coordinate their activity. These drugs "were not conducive to playing in the group activity of a band," he noted. Because they were no longer together on the road, it was also harder for the Beatles to feel close in the studio, where they rarely played as a unit.

As with so much else the Beatles produced, there was a large visual element to the hoopla surrounding *Sgt. Pepper,* adding to its allure. There was talk that the Beatles had originally planned to do a film around each song, but they abandoned the idea after doing two experimental MTV-like promotional films around the back-to-childhood Liverpool songs on the preceding single, "Penny Lane" and "Strawberry Fields." (They were forced to act out scenes to the song because of a legal ban in England against miming words to a record.)

After that idea was scrapped, the foursome settled on the construction of a cover to herald the new album and new age. They did so despite the opposition of their record label, which feared lawsuits and forced them to try to get the consent of those pictured. (Brian Epstein wanted them just to forget the whole thing and release the album in a plain brown paper bag.)

With pop artist Peter Blake working on the design, the Beatles wore old British military uniforms for the cover shot, behind a collection of objects, like John's television set, and plants that fans took to be mari-

juana. They were surrounded by pictures and cutouts of dozens of their heroes, friends, and other pop icons—an eclectic collection of the best and the brightest idolized by the counterculture. Each Beatle was supposed to contribute suggestions for inclusion but Ringo didn't make any and George reportedly asked mostly for Indian gurus. John was turned down in his request to include Jesus, Hitler, and Gandhi. (To spite the record company, Hitler was actually put on the album but placed behind the Beatles where you can't see him.) When the cast of visible photos was finally assembled, there were over sixty figures "joining" the Beatles, including philosophers like Karl Marx and Carl Jung; English variety stars (Tommy Handley); as well as others like the Beatles who had similarly experimented with drugs (Aldous Huxley and William Burroughs). There were entertainment world icons such as Tom Mix, Marilyn Monroe, W. C. Fields, and Marlon Brando, and writers such as H. G. Wells and Lewis Carroll. Boxer Sonny Liston was there, as were four wax figures of the moptop Beatles of three years earlier. There were only three other rock stars pictured: Dion, Dylan, and their friend who had died in Hamburg, Stuart Sutcliffe. For audiences, identifying all the figures on the cover and decoding why the Beatles had put them there was yet another drug-fueled quest that could go on for months.

When it was all said and done, Paul had succeeded in his goal of having the group—and the genre of music they played—accepted as serious art. Rock songs in general began to get longer and more complex. Albums, not singles, became the calling cards of the musical counterculture. A new medium—FM radio—arose in the United States to play these longer songs. (The Doors released two versions of "Light My Fire"—a long one for FM radio and a shorter version for AM.) Teen purchases of albums passed those by adults for the first time in history. Listening became more important than dancing in the rock world because there was no way anyone could dance to the songs of *Sgt. Pepper* and its progeny. The British, particularly, sensing themselves as progressive artists, picked up on the trends on *Sgt. Pepper* and other fresh works to fashion a new kind of psychedelic music in which guitarists like Eric Clapton with Cream jammed for hours like jazz musicians.

Yet there were dissenters, even then. Richard Goldstein declared at the time that in many places *Pepper*'s special effects were "fraudulent"; Bob Dylan commented, "I didn't like it at all. . . . I thought it was a very indulgent album." Later, author Tim Riley similarly complained that much of the album was "texture for the sake of texture."

Others deplored the album's aftereffects. As *Rolling Stone*'s Jon Landau later pointed out, if rock was now more thoughtful—and to be viewed more thoughtfully—it also acquired a tendency to become too self-conscious and divorced from the mainstream. Moreover, if the Beatles had always sounded more white than a lot of other rock artists—that, after all, had been part of their initial American appeal in 1964—this new psychedelic music washed out virtually all of rock and roll's black roots. *Sgt. Pepper* was not a big happening in the black community, and there were, in fact, few black hippies, even if Jimi Hendrix incorporated the title tune into his act within a week of the album's release.

Yet few paid much attention to the handful of critics then. In mid-June, shortly after the album's release, Monterey, California, held its international pop festival, which featured, among others, the Jefferson Airplane, the Who, Ravi Shankar, Simon and Garfunkel, and the Mamas and the Papas. Jimi Hendrix made his American debut and stole the show, thanks in part to Paul, who lobbied to include him. Helping to organize the festival was the Beatles' old friend Derek Taylor, and the program even featured a drawing from the group and a note from London, "Peace to Monterey from Sgt. Pepper's Lonely Hearts Club Band." "The *Sgt. Pepper* buttons," wrote Ralph Gleason in the *San Francisco Chronicle*, "set the theme."

That festival, wrote Michael Lydon in an unpublished dispatch for *Newsweek* at the time, "demonstrated the continuing influence of the Beatles. Dozens of the other Monterey performers owe their being there to the Beatles. John Phillips was a folk singer until he heard the Beatles. 'They were not so much a musical influence as an influence because they showed that intelligent people could work in rock and make their intelligence show,' " he said.

Three days later, Paul confirmed to a British television interviewer what many knew and millions of others suspected: that the group had

been experimenting with LSD. The interview caused, understandably, an uproar among the press and fans—which was exacerbated in Britain by the fact that the BBC banned the playing of "A Day in the Life" on the grounds that it was a drug song. Billy Graham said he would pray for Paul. "My heart goes out to him," he said. "He has reached the top of his profession and now he is searching for the true purpose of life."

Paul's "revelation" surprised the other three, exposing a few more tensions in the group dynamic. After all, Paul had taken acid far less frequently than the others. "I could have done without it myself," said Ringo of his mate's interview.

Less than ten days later, the Beatles became the ultimate global embodiment of that Summer of Love. They gathered a select group of friends in Abbey Road Studios in London to record a song for a live worldwide broadcast that had been arranged by networks around the globe to celebrate the unity of a world interconnected by new communication satellites. Brian Epstein had asked the boys to write something "stirring but simple." Press aide Tony Barrow remembers that Paul said, "I think each of us should have a go and see how we get on and see how it shapes up." According to their associate Tony Bramwell, Paul came up with "Your Mother Should Know," a kind of diminished version of "When I'm 64" that eventually showed up on *Magical Mystery Tour.*

In contrast, John caught the mood perfectly and won the internal competition by writing "All You Need Is Love." George Martin composed an opening that repeated the bars of "Le Marseillaise" to achieve maximum international effect. For the performance, the group all wore hippie clothes, complete with flowers and beads, and Jane Asher helped compile the guest list, which included Mick Jagger and Keith Moon of the Who. Brian called his friend Nat Weiss in New York. "All you need is love, love is all you need," he said. "Call Capitol—that's the next single."

The visual effect on TV was stunning. Surrounded by their disciples, sitting on the floor at their feet as confetti rained down in the studio, the Beatles performed the song for an unprecedented audience of hundreds of millions around the world. An orchestra in black tie played in the background as friends carried around signs saying "All You Need Is Love" in several languages. It was the visual and musical embodiment

of the communal message the Beatles had been preaching. Pop music, said Derek Taylor later, never had a finer moment.

As the song shot to number 1 in a matter of days the Beatles talked of moving to an island with their wives, girlfriends, and recording engineers to create a new kind of hippie utopia. (Their trip to Greece to look for just such a refuge was marred when someone forgot the drugs and John made the memorable remark "What good's the bloody Parthenon without LSD!")

"The idea," said George, "was to show that we, by . . . having all these experiences, had realized there was a greater thing to be got out of life—and what's the point of having that on your own? You want all your friends and everybody else to do it too."

The Beatles—now among the most famous people in the history of the planet and the acknowledged leaders of a vast counterculture—were on top of the world. They would not stay there for long.

OUT OF SYNC

BY the fall of 1967 the culture had begun to shift again. The Beatles had always been notable for their ability to reinvent themselves, but these were profound alterations to which, over time, they were either unable or unwilling to conform. Over the next three years, changes in their own inner circle and events in an increasingly divided outside world began to leave the Beatles out of sync with both the counterculture and each other.

Cultural changes that used to take years seemed to occur within days. "That year did take about fifty years," said George Harrison, referring to 1967. By that October in San Francisco, the flower children had already staged a "Death of Hippie" funeral procession. The hippies had expired, according to one report, "from media overexposure, the misuse of drugs, the spreading of venereal disease, and the swelling ranks of 'plastic' part-time hippies." Later that month, "Stop the Draft" week turned violent, as in nearby Oakland the police attacked a crowd of demonstrators.

It was a taste of things to come. *Rolling Stone* magazine later called the period from November 1967 until October 1970 "the age of paranoia." By the time it was over, the world knew all about the Charles Manson killings, the murder at the Altamont music festival, the death of student protesters at Jackson State and Kent State, and the riots at the Chicago convention. Two of the leading political figures of the era had been assassinated; even artist Andy Warhol had been shot. Hard drugs

had begun to take their toll, and use of the word "revolution" had become extremely common as young protesters took to the streets across the world. In such an environment, it was not out of place for rock groups to sing of street-fighting men or being forced up against the wall.

With their gentle optimism and continued focus on how love could save the world, the Beatles were increasingly out of tune with these changes in the counterculture and its "war" with the culture at large. Despite the emergence of *Sgt. Pepper* as the focal point of the counterculture, the Beatles, especially Paul, had never seemed interested in fomenting a violent generational conflict.

Put another way, when one thinks of the history of 1964–67, the Beatles are an integral part of the story; they provide the sound track for the era and the inspiration for millions of followers. One gets the sense that if the Beatles had never come to America, made *A Hard Day's Night,* or released *Sgt. Pepper,* history would have been very different.

From late 1967 to 1970, however, in the era of the Weathermen, assassinations, and polarization, the Beatles saw their impact on their times diminish. If the group had never gone to India, formed Apple, or released *Abbey Road* during those years, little of significance in the outside world would have changed.

In this period the Beatles came under increased criticism from the Left, especially in Britain, for not being political and revolutionary enough. This allowed many on the London scene to revert to their traditional charge that the Stones were more authentic than the Beatles. Alan Beckett in the *New Left Review* argued that the Beatles had "a dangerous tendency towards denial that anything is difficult in relationships." In contrast, he wrote, the Stones had mounted "a completely justifiable and welcome attack on the amorous cliches of popular music." In another piece, Richard Merton argued that the Stones' celebration of sexism was actually an implied critique. "The Stones strike for realism in contrast to the Beatles' fantasies," wrote the American rock critic Jon Landau on another occasion.

In fact, with their sensibilities more in sync with the troubled times, this was the one period in which the Stones produced music which has lasted as well—if not better—than that of the Beatles.

Even authorities in the Soviet Union joined in the criticism. A newspaper published by the ministry of culture charged the Beatles with going respectable, while holding up Bob Dylan as a figure who had remained authentic.

Ironically, this absence of direct political content in their music—which seemed rather quaint in the late sixties—allowed the Beatles to stand the test of time. Few of their songs explicitly referenced the events of the day, giving them a timelessness that eluded their contemporaries.

Equally important, the rage and disillusionment of the era—so prevalent on the records of artists such as the Doors and the Jefferson Airplane—were almost absent in the Beatles' work. Not present either were the rambling jams of groups such as Ten Years After that had trouble lasting beyond the era that produced them. What ultimately proved appealing and lasting about the counterculture was its optimism and emphasis on the aspirational value of communalism—traits the Beatles embodied to a T.

Of course, at the time, no one could know what would last and what wouldn't. One of the principal things that defined the Beatles in this period was a jumbled series of attempts to find "the next big thing" that would both give them a new focus and redefine the counterculture in ways more consistent with their positive vision. What linked three very different enterprises over the next two and a half years—*Magical Mystery Tour*, the trip to India to study under the maharishi, and the creation of Apple—was that they represented the Beatles' attempts to do this, even if all three failed to varying degrees.

The first Beatle who seemed to sense a disconnect between the group's outlook and where the culture was heading was George Harrison. He was already the most disillusioned with being a Beatle, given his continued junior status in the band—a carryover from when he had joined the group almost a decade before as its youngest member. "Of the four of them George had the hardest time," said Harry Benson, a photographer who was with them frequently in the early days. "Ringo knew he was lucky to be there. George had talent but was left out of the loop so to speak."

In August, George made a pilgrimage to the Haight-Ashbury dis-

trict of San Francisco, the epicenter of the counterculture, to mingle with his followers. He was shocked by what he saw and compared it to the Bowery. "There were these people just sitting around the pavement begging," he said, though it didn't help that he was on LSD at the time. George resolved to give up drugs, and the other three announced a similar intention. Whatever their aim, they hardly stuck to the pledge, though they did curtail their intake at times, particularly during the maharishi episode to come.

Yet there was a lot more to the Beatles' confused steps in new directions over the next year than that. The first internal event to unsettle the group came with the death of their manager, Brian Epstein, in late August 1967, less than two months after the release of "All You Need Is Love." Obviously the Beatles owed a lot of their early success to Brian's perseverance and ability. Over the years, however, as the group's renown grew, his influence diminished. Brian took care of them in a parental way, yet like any parent, he found his lads outgrowing the nest as they got older. "I can't get them to do anything," he lamented to Tony Barrow. Now that the group was no longer touring, he had much less to do. "What am I going to do now?" Brian asked a friend. "Shall I go back to school and learn something new?"

Worse, Brian's contract with the Beatles was due to expire in the early fall of 1967. It has remained a subject of endless debate what the Beatles planned to do about him. It's well documented that Brian was terribly inexperienced—as they all were—in the new world of global business the Beatles had helped create, and he botched numerous opportunities to make more money for the group through better recording and merchandising deals. The group, especially Paul, complained to him and others constantly about his shortcomings, and there were stories that the Beatles had made inquiries about manager Allen Klein, an American, who was now helping the Rolling Stones get more lucrative recording contracts.

"I went over to Paul's house around this time," remembered singer Julie Felix, who dated Paul briefly. "I got the impression he really didn't like Brian Epstein. There comes a time in all artists' careers when they discover that their agent is making more than they are.

"Plus," she added, "it seemed to me that Paul didn't approve of Brian Epstein's lifestyle."

The concern wasn't that Brian was gay, though there were still persistent problems with his propensity for picking up "rough" men and then becoming a victim of robbery or assault. Far more troubling was the fact that as the pressure increased in London, Brian began taking more and more drugs. He also began gambling more, losing, according to one report, an average of thousands of pounds a week.

"Brian would tell me, 'I'm not as unhappy as people think I am,' " said his close American friend Nat Weiss. "But he was manic-depressive. His mood would change like the weather—zoom!—happy and then unhappy."

"Near the end, it was impossible to take his word for anything," said Tony Barrow. "He'd say, 'Yes, go ahead,' and then a short time later, he'd yell, 'What have you done? Why didn't you ask me?' He became less and less accessible."

"His appearance changed," said Geoffrey Ellis, a friend and associate in Epstein's musical business. "He was more puffy eyed. He couldn't concentrate. He was impossible about showing up for meetings."

Brian sent the four Beatles—especially Paul—constant gifts and cards. Yet "they weren't there for him like he was there for them," said Joanne Peterson, his assistant. At best, it seemed the most he could hope for with a new contract was a diminished role.

Yet whatever the Beatles planned to do, they all vastly underestimated the value of having an honest and dedicated manager in a field where those qualities are often in scant supply. "Just to have someone they trusted to be honest in charge of their business meant they never had to think about it," said Ray Connolly, who covered the group in their later years for the *London Evening Standard*. "Once he was gone, all that changed."

The Beatles also fell victim to what would later be called "the Michael Jordan syndrome." Jordan, of course, was probably the greatest basketball player of all time. But when he tried to transfer his genius to the baseball field, he found that he couldn't hit a simple curveball.

Similarly the Beatles were unparalleled as recording artists and

songwriters. But as they discovered over the next three years, that hardly meant they could make movies, run a giant corporation, or manage their own financial affairs as well as experts in those fields. "As businessmen," quipped one pundit later, "the Beatles were great musicians." Turning their attention to other endeavors also meant, of course, that they had less time to devote to their music.

"I don't know how much money I've got," said John around that time. "I did ask the accountant once how much it came to. I wrote it down on a bit of paper. But I've lost the bit of paper."

Their manager's troubles were there for all to see. In the fall of 1966, Brian attempted suicide and ended up in a mental hospital. When he got out, he was soon back on his pills. When Nat Weiss saw his friend in the U.S. at that time, he tried to throw a bottle of Brian's pills out of the window to stop his drug taking, but Brian told him, "I know what I'm doing." Friends later reported that Epstein subsequently threatened suicide on at least two other occasions and the following May was back in the hospital.

Three months later, on August 27, 1967, Epstein was found dead in his bed at home in London. A subsequent inquest ruled that his death was accidental from taking too many pills (there was apparently no suicide note); later there would be speculation that he had been killed in some kind of bizarre plot or by a person he had picked up.

The sad truth, however, is that no one seemed terribly surprised. Except, of course, for the Beatles, who heard the news in Wales, where they had gone for the weekend to hear the gospel as preached by a new guru they had met only days before—Maharishi Mahesh Yogi.

"They were totally bewildered when he died," said Maggie Mc-Givern, a girlfriend of Paul's. " 'Where do we go now? What do we do now?' they said. Their eyes had been wide shut. It was the beginning of the end."

"I knew that we were in trouble then," said John.

"It was like a child losing a parent," said Joanne Peterson. "When he was alive the Beatles had known they could always go home if something went wrong."

Of the four, only Paul seemed to exude confidence. "I don't think I

was too worried about the prospect of going ahead without Brian," he said later.

Perhaps he should have been. Within a short time, the Beatles learned that without Brian, they couldn't even get along with one another.

"It's overlooked a lot," singer Marianne Faithfull said much later, "but the sort of person who can interpret one person to another or interpret somebody to the rest of the world is more important than we know."

Each of the Beatles attempted to fill the managerial and emotional vacuum in a different way. Faced with yet another death by a parental-type figure, John seemed the most lost. "When I saw John a few days after the funeral," said Nat Weiss, "he didn't seem to be himself. He was going on and on about the maharishi and how he had told them that Brian wasn't really dead, but had simply moved on to a higher place." The maharishi had also told them, "He was taking care of you. He was protecting you. He was like your father. I will be your father now." It was a promise that John, for understandable reasons, took to heart.

In fact, John was so lost that he began looking for all the father figures he could find. In the aftermath of Brian's death, he apparently did a complete about-face and finally agreed to have a serious meeting with his own father for the first time in over two decades. When the Beatles had become famous, John's errant father, now a common laborer, had been tracked down by the press and popped out of nowhere to tell his story and to try to cash in on his son's fame, even releasing a single. Brian brushed him aside. Now John began meeting with him again, and soon he had moved with his new wife into John's house outside London for a spell.

In the wake of Brian's death, George Harrison urged further involvement with the Maharishi Mahesh Yogi, and lobbied for the group to make a pilgrimage to India. Paul, in turn, moved to organize the group around another activity, one he had been planning since earlier in the year—a new film they would produce and direct themselves. He called a meeting at his house less than a week after Brian's death. "If the others clear off to India . . . I think there's a very real danger that we'll never come back together again as a working group," he told Tony Barrow.

The film that Paul persuaded the others to do that September was another of his "concept" projects. In his travels through the London cultural underground, Paul had been very interested in the work of experimental filmmakers, at one point making his own amateur film about dirt. *Magical Mystery Tour* was considered yet another way to reach the public now that the band was no longer touring. The idea was that they would tour the country in a psychedelic bus, a cross between the Merry Pranksters and Liverpudlians on a holiday. Friends remembered how Paul, when he had met Allen Ginsberg, had told the poet stories of how the beats in San Francisco reminded him of how everyone acted in Liverpool. To him, combining the two was a story idea that couldn't go wrong. If it worked out, wrote Mal Evans, their assistant and confidant, "it is pretty certain they will make their next full-length cinema film in the same way."

On the bus the band members were to be joined by a group of odd actors such as a fat lady, a group of dwarfs, a comedy poet, and their old friend Victor Spinetti from their previous films. The film had no formal script or plot; it would be about whatever the group spontaneously encountered. Each Beatle was asked to contribute scenes—as John did about a crazed waiter who keeps shoveling spaghetti onto the plate of an overweight woman.

"It went off totally unprepared and half-cocked," said Richard Lester, their old director, who was not involved with this project. Though Paul was the nominal director, without Brian, there was no one to organize the venture. One night on their travels Paul and Neil Aspinall reportedly spent hours deciding who should stay in what room because the fat ladies and dwarfs didn't want to share quarters.

Once the short excursion was done, the Beatles did their own editing. Though all four came by the cutting room from time to time, it was mostly Paul who ran this part of the project as well, spending the better part of three months during the fall finishing it. When the experimental film was released on the day after Christmas (British Boxing Day) on the traditional BBC—in black and white though it had been shot in color—the Beatles were floored to learn almost no one could understand it and even fewer liked it. It was their first critical failure and the

first example of the Jordan syndrome. They were bewildered, to say the least.

"It's like, you know, we make a record album and all the songs don't necessarily have to fit in with each other, you know. They're just a selection of songs," a slightly bewildered Paul said. "But when you go to make a film, I don't know, you seem to have to have a thread to pull it all together."

Reviewers called it "blatant rubbish" and a "witless home movie." "*Magical Mystery Tour* Baffles Viewers," read one headline. Paul called a reporter the next morning. "We goofed, I suppose," he said. Later he told another scribe, "The mistake was that too many people were looking for a plot when there wasn't one." The film wasn't even formally released at the time in the United States, showing up later in selected art houses or on college campuses.

The album that was released a month before the film received a far better reception. "The Beatles are at it again," wrote Nick Logan in the *New Musical Express*, "stretching pop music to its limits on beautiful sound canvases." In truth, however, even though the album was a cut above what almost any other group could put together, it was a pale imitation of its predecessor—a *Sgt. Pepper Lite*. It had only six new tracks and one, "Flying," was a mediocre instrumental. The title track, "Magical Mystery Tour," was a less spirited imitation of the *Sgt. Pepper* opening. As the American Beatles scholar Walter Everett later noted, "Your Mother Should Know" was twenties and thirties pastiche done less well than "When I'm 64." The album had John's brilliant "I Am the Walrus" and Paul's "Fool on the Hill," but two or three good songs do not make an LP.

As for the packaging, the *Magical Mystery Tour* album sleeve featured multiple pictures of the Beatles in costume à la *Pepper*. It painfully highlighted that only months before, the Beatles had been there and done that, only more professionally and creatively.

Not that this soured the band in its fans' eyes. The group's single that fall, "Hello, Goodbye" (which was not in the film), went straight to the top of the charts. For all its catchiness, however—and Paul could write the catchiest of tunes—the lyrics were insipid, with a constant

repetition of "Hello" and "Goodbye." It was said that John despised the song, though only a few years earlier the two had still possessed enough of a collaboration that he probably would have forced his partner to improve it rather than resigning himself to its release.

" 'Hello, Goodbye' beat out 'I am the Walrus,' " he later told *Rolling Stone* publisher Jann Wenner, discussing which song became the A side of the single. "Can you believe that? I began to submerge." That plunge was illustrated early the next year with the release of Paul's "Lady Madonna" (side A) and George's "The Inner Light" (side B)—the first Beatle single to feature two original songs with virtually no connection to John. "Lady Madonna" was also notable, among other things, for being yet another unusual-in-rock tribute by the Beatles to motherhood, still an abiding preoccupation of both Paul and John.

By that time in the winter of 1968, the Beatles were in India, studying and meditating with the maharishi. The impetus for that excursion came from George. With John "submerged," it was the first time George had led the group, supported strongly by his wife, Pattie, who had been instrumental in introducing him to Transcendental Meditation, a kind of spiritual relaxation technique derived from Indian culture and religion.

While growing up in Liverpool, George's mother had been besotted with much that was Indian—the food, the music, even the clothing and furnishings. Her son brought a similar preoccupation to the Beatles. For two years he talked of little else and wrote all his songs in an Indian style. "When I saw George that summer of '67 on the West Coast," remembered Nat Weiss, "he just went on for hours discoursing about Indian philosophy."

After learning to play the sitar for *Rubber Soul,* Harrison had gone with Pattie to India, where he studied under one of the virtuosos of the instrument, Ravi Shankar. He helped get Shankar booked at the Monterey Festival in June 1967, thereby exposing the Eastern musician's work to a broader audience. When George tried to sell the Beatles on the maharishi, Paul was said to be skeptical but John was willing, as always, to try anything. (Ringo was happy, as usual, to go along for the ride.) "John and George found themselves as one when it came to discovering the mysteries of life," said John's wife, Cynthia.

The English, of course, have traditionally been far more fixated on India, their former colony, than Americans are. Back then, counterculture Americans frequently celebrated Native American culture as part of their "back to the basics" ethos—passing around "peace pipes," reading Carlos Castaneda's accounts of taking mescaline with the natives of Mexico, or celebrating pantheism. In contrast, the English tended to look to India for similar sentiments and experiences. After all, their island had a much higher proportion of Indian immigrants, and the food and bright clothing styles (worn by both sexes) of the subcontinent were more familiar there than across the Atlantic. In fact, many of the early pioneers who had introduced Hinduism to the U.S. reading public twenty years before the Beatles appeared had been English expatriates such as Aldous Huxley and Christopher Isherwood.

George was neither the first nor the only musician to bring the sensibility of India into rock music and the counterculture. But as a member of the world's most famous band, he was the great popularizer. The allure of India—primarily through an interest in its religions—tapped a number of strands in a counterculture that made alternative and mystical forms of consciousness one of its principal preoccupations. The appeal of India's alternative religions was not simply that they were not part of established Western thinking or that some promised through their practice yet another kind of a "high." They also fit the antiacademic tenor of the times as they offered an alternative interpretation of the meaning of life.

When the other three Beatles met the maharishi at a London lecture in August 1967 at the plush Park Lane Hilton, he was said to be almost fifty and was thought to be something of a popularizer himself. He taught an easy style of meditation purported to bring a deep form of "bliss" and relaxation to the practitioner. It wasn't until he hooked himself up with the Beatles, however, that his Transcendental Meditation became one of the principal means by which the connection to Indian thought entered the mainstream in the UK and America.

"You have created a magic air through your names," the maharishi told them when they first met him in London. "You have now got to use that magic influence on the generation who look up to you. You have a

big responsibility." The *Daily Express* reported that the Beatles, "all twid-dling red flowers, nodded agreement."

The group's pilgrimage the following February to Rishikesh, India, to study with the maharishi received enormous publicity—though the Beatles were somewhat protected from the press at the guru's headquar-ters, a kind of upscale Indian version of a holiday camp or resort. Along with their wives, girlfriends, and various members of the entourage, the Beatles spent their days meditating (often holding contests to see who could go for the longest); attending lectures (some of which became the subjects of future songs such as Paul's "Mother Nature's Son"); and lounging around. John used the sessions with the maharishi as a kind of pseudopsychoanalysis, asking the guru, for example, about the brass bands he heard playing in his head. They were required to become veg-etarians while they were there, and all subsequently tried to stick to the diet, with varying degrees of success.

Like other attendees at the retreat during their stay (who included actress Mia Farrow; her sister; Donovan; and Beach Boy Mike Love), the Beatles were supposed to disdain the trappings of everyday life in India. Their ordeal, however, was made easier by the fact that they were fol-lowed around constantly by houseboys and even a masseuse. The ma-harishi also had his own helicopter and took them for rides.

The time at the retreat did allow the band members to decompress and spend time together in a way that hadn't been possible since they had been on the road almost two years earlier. The result was the most prolific period of songwriting they had experienced since they had first burst on the scene in 1963 and 1964. Off heavy drugs and unable to sleep at night (as he would write in "I'm So Tired"), John whiled away the hours writing new numbers. George and Paul did much the same. Away from George Martin and the tricks of the studio, the result was the production of a large body of simpler songs, written for guitar (basically the only instrument they had with them), that were a far cry from what they had been producing on their last three albums.

The forced togetherness didn't last long. The first to fall away were Ringo and his wife, Maureen, who stayed less than two weeks and had sneaked in scores of cans of baked beans and eggs to get them through

the tribulation of having to subsist on Indian food. Paul and Jane were next, having stayed about a month. While Paul put up a good front, it was said he was bored. Moreover, the reports were that Jane was increasingly disillusioned and missed London.

That left George and John, along with their wives and a few remaining members of the entourage. John's mood wasn't improved by the fact that he now had fewer buffers between himself and Cynthia. She had gone to India hoping to restore their closeness but others at the camp noticed how John constantly claimed he needed to be alone to meditate. "He and Cyn were in the process of splitting up," said one observer. "There was no question about that." Meanwhile, John and George were left pondering what was left of the group's unity now that half the membership had escaped back to Britain. George later complained bitterly that Paul, Jane, and Cynthia had never had any idea what the maharishi was all about.

As John later pointed out, for all his productivity, much of the work he produced in India was dark—"I'm So Tired" or "Yer Blues," with its "Yes I'm lonely, wanna die." "He went so deeply within himself through meditation that he separated himself from everything," said Cynthia.

In mid-March, one of John's friends in the entourage, "Magic Alex" Mardas, told him that he suspected the holy guru was privately putting the moves on some of the women. George was skeptical of the charge but John used the excuse to storm out of the camp and back to England.

The unfulfilled promise of enlightenment from the flawed maharishi left him shattered, and he reacted as if he had lost yet another parent. "I always expect too much," he later said. "I was always expecting my mother and I never got her, that's what it is." When it came time for him to write about the experience, the maharishi was, fittingly, depicted as a woman in "Sexy Sadie" (it's the same number of syllables)—though the original words John was persuaded to cut were said to be "You little twat, Who the fuck do you think you are, Oh you cunt."

There was one other thing John did on his return to England. He was "spiritually adrift once more," his friend Pete Shotton recalled, and his "instinctive response was to return with a vengeance to his former drug habits."

"He went from Transcendental Meditation to heroin," Mike Love later told rock writer Mike Paytress. "He definitely had some issues."

The whole experience seemed to have the opposite effect on George. For the first time in two years he began writing more traditional rock songs that were far better than anything he had done before.

"George calmed out after Rishikesh," said reporter Don Short. "He made one strike into adulthood."

Back in London, the Beatles put on their public faces. "The course did us a great deal of good," said John. Yet now, they faced more than the task of simply making an album of all the songs they had written in India. Before they had left, they had announced their intention to move beyond the music business to bring the communitarian principles of the counterculture to various corporate and business endeavors. To facilitate the grand scheme, they set up Apple—a New Age umbrella corporation before anyone had even coined the phrase "New Age." Within a year, Apple encompassed a clothing store, a record label, and a film company, as well as virtually all the business affairs of the Beatles. The group's vision was grandiose: The foursome talked at various times of even starting an alternative school.

The initial idea was not the craziest of notions. The idea of an umbrella corporation had actually started as a tax-avoidance ploy, in a nation where tax rates were almost confiscatory, as George had complained two years earlier on "Taxman."

Moreover, the counterculture was well on its way to establishing a number of viable commercial enterprises. The alternative press was humming, as was the alternative London fashion scene; food co-ops were beginning to blossom everywhere. Several years later, John Lombardi wrote in Rolling Stone's "The Age of Paranoia" that " 'hip capitalism' does not always have to be a pejorative, and there is room for many kinds of communally run organizations—business, political, artistic." The Beatles' idealistic venture fit in with their notion that businesses could be run in entirely new ways—community based rather than hierarchical, socialistic rather than profit oriented.

"It's a business concerning records, films, and electronics, and, as a

sideline, manufacturing or whatever," said John, describing Apple. "We want to set up a system whereby people who just want to make a film about anything don't have to go on their knees in somebody's office."

"The concept *will* spread," said Paul. "It *will* be fantastic."

It would be, wrote one cultural historian later, a "financial Pepperland."

Yet as businessmen, the Beatles were still musicians. The band thought it could do anything but "the only thing we could do successfully was write songs, make records, and be Beatles," said George.

Paul's naïveté was typical. "We started off coming to Apple with great theories like, when you come into business . . . you don't need to answer the telephones every minute," he said. "But in fact you do a bit. You need to at least have someone there to answer the phones. We were disillusioned about that for a bit." Another problem was that the whole concept for Apple came mostly from Paul, according to Peter Brown, head of the company. That meant that it soon became a source of conflict between him and John.

As the Beatles returned to England from India they also found the outer world slipping further away from their utopian grasp. While they were away, English youth had shown they were becoming increasingly politicized; a protest march near the American embassy in the winter of 1968 turned into a violent confrontation with the police. (The incident inspired Mick Jagger to write "Street Fighting Man.") The student revolt seemed to be going worldwide as protests in Prague were followed in May by demonstrations and strikes in France, which soon found itself in an uproar as students led a revolt against the government. Though the Beatles were later to be credited with inspiring the embattled youth of Eastern Europe through the liberating message of their music, at the time many thought that events were beginning to pass them by.

Meanwhile, John was in increasingly dire straits and there was no one around who would tell him so. In May, on a multitude of drugs as usual, he called an emergency board meeting of Apple and the other three Beatles. When they gathered, he announced, "I've something very

important to tell you all. I am . . . Jesus Christ come back again. This is my thing." No one contradicted him.

On that night of May 19, with his wife Cynthia out of town, John decided to invite over a somewhat older married Japanese artist friend in whom he had shown a professional interest. Once again, a woman was about to be instrumental in shaping the band's destiny.

LOVE IS ALL YOU NEED

THE Beatles always had a distinctive relationship with women. They spoke to female listeners and fans in a special way, eliciting a special response, and, at the same time, they were influenced by a number of strong women throughout their lives. It is not surprising, then, that once John found Yoko and Paul found Linda, everything changed.

In retrospect, the importance of Yoko to John and Linda to Paul made sense for a group that had proclaimed how love was a form of salvation. Yet at the time, few saw it that way, which is a major reason why the emergence of these women caused such a stir.

What's more, the addition of these women to the entourage added a new dimension of rebellion to the Beatles. In the argot of the sixties, the counterculture was all about "sex, drugs, and rock and roll." The Beatles, of course, had ruled over the world of rock, and their identification with drugs was clear—even if the average fan had no idea of the prodigious amount of their intake.

Their relationship to the sexual side of the revolution had always been more ambiguous, however. One of the key elements of the new ethic of the sixties counterculture—and one of the more threatening initially to the older generation and the more conventional culture at large—was its emphasis on a free expression of sexuality. In the zeitgeist of the counterculture, at least as men saw it, open sex with a large number of partners was a way of expressing distaste for the restrictions of a

repressive society, proclaiming one's liberation, and promoting the universal "love" around which that community revolved. It was even a way to oppose the war in Vietnam; after all, the slogan was "Make love, not war." Even those who might not have endorsed that motto absorbed the new values quickly: In early 1968, the *New York Times* was already highlighting the growing practice of unmarried couples living together.

Previously, the Beatles' public image had been tied to a rebellion against strict gender roles. But it had not been linked explicitly to sexuality in the way that the Rolling Stones and a lot of other rock stars were. When Brian Epstein refashioned the image of the Beatles in the early days to make them more cuddly—the better to package them to the public—it was the sexual side of their rebellion he curbed the most. The Beatles were never closely associated with the sexual antics of Swinging London. The press that covered them played along—never publicizing a life on the road which, in the great tradition of rock, often resembled an orgy.

Until 1968, the Beatles did little in public to spoil this pristine portrait. Their songs had rarely, if ever, been overtly sexual; they wanted to "hold your hand" rather than "spend the night together." Moreover, when they hit it big on both sides of the Atlantic, John was already married (happily, so the public was told); George and Ringo were soon to be; and Paul was the steady boyfriend of one of England's more celebrated young actresses. A more traditional group of lads one was unlikely to find, or so people thought.

When John left Cynthia for Yoko Ono in 1968, he blew the whole constructed image apart. Though there was undoubtedly resentment and prejudice against Yoko because of her personality, race, and eventual role in breaking the group apart, she was also enormously controversial because for the first time her presence forced the public to confront the Beatles as sexually in tune with those other changes in society. ("When we weren't in the studio," Lennon later said of his early relationship with Ono, "we were in bed.") Yoko has attributed her notoriety in England before she became linked with John, in part, to the fact that some of her most celebrated work was about sex, such as her

infamous London underground movie, *Bottoms,* featuring 365 close-ups of people's rear ends. (To the British, at least, that's sex.)

It wasn't long after the two got together that John posed nude with Yoko on one of the duo's album covers (*Two Virgins*)—shocking to even the other three members of the group, especially Paul. The Beatles' music got raunchier too on songs such as "Why Don't We Do It in the Road" and "Come Together." Undoubtedly influenced by John's behavior—the usual pattern with these competitive two—Paul soon broke off his relationship with Jane Asher (or had it broken off for him) in the summer of 1968. A short time later he found his own soul mate.

Although the marriages of both John and Paul later became venerated symbols of respectability, when John first appeared publicly with Yoko in June 1968, while he was still married to Cynthia, it was considered, at least in England, among the most controversial things a Beatle had ever done. (Yoko, too, was married at the time.) "Where's your wife?" London reporters yelled at him when the two were seen in public together. This was, after all, an era when it was still considered unacceptable for the presidential nominee of a major political party in the U.S. to have been divorced. (It had helped quash Nelson Rockefeller's Republican presidential candidacy in 1964.)

In the end, it was hardly surprising that members of a band that had preached that love is all you need would end up abandoning each other for that love when they found it. Yet that's not the way people saw it at the time. Many considered it unfathomable the way John, and later Paul, seemed to turn themselves over completely to these new women. It's true John and Paul were seriously conflicted about their choices, but that conflict was one of the things that made their story so compelling.

Later, of course, all these developments contributed to the renown and permanence of the Beatles when the partnerships of both John with Yoko and Paul with Linda were hailed as early models of gender equality. In this the Beatles were again out of sync—only this time by being too far ahead of the culture. As things changed gradually over the next few decades, the Beatles grew in stature as well. After all, they had been there on this issue long before almost anyone else.

The Beatles' special connection to women took forms other than these individual relationships, expanding even to their affinity with their female followers. From the very start, these fans perceived a special bond. "We were all very protective of the Beatles from nonfans and they, in turn, were very protective of us," said Ida Langsam. Once touring ended in the midsixties, that special relationship took on an unusual form: A small group of teenage girls (and a boy or two)—not runaways but devoted tagalongs—followed them everywhere with the group's acquiescence and protected them from the outside world.

The Apple Scruffs—later immortalized in a song George did for his first solo album and by Paul in "She Came In Through the Bathroom Window" on *Abbey Road*—were unique in the world of rock. They were, said producer Phil Spector, "the most faithful fans in the music business." Lots of rock groups had fan clubs on the one hand and groupies on the other who followed the band and "serviced" them sexually. A few select groups even had adoring mobs like the Beatles did, even if the girls didn't scream for the others quite as much as they screamed for the Beatles.

But the group of fifteen or twenty Scruffs was unique, and so was the Beatles' connection to them. They defied easy description: For the most part, they were a tight collection of teenage girls who spent all their time outside work or on vacations trailing the group around. The Scruffs gathered outside the Beatles' homes in the morning, followed them to Apple headquarters and the studio, and waited all hours of the night for them to emerge. They had their own newsletter. Each had a special connection to one Beatle (Sue, for example, was known as "Sue-John"), and the band knew many of them and greeted them by name as they left home or the studio. The relationship was nurturing and protective on both sides—more older brotherly than parental or sexual. They walked Paul's dog for him and were invited to Apple Christmas parties. When John and Yoko went to court on drug possession charges, the Scruffs were in the gallery. For the last two and a half years of the group's existence, the Scruffs were one of the major ways these isolated band members kept in touch with "real people" in the world.

Thus when Paul decided to get married in early 1969, he felt he had to go outside the gates of his home in St. Johns Wood and offer an explanation to the Scruffs. "We were very upset," said Diane Hamblyn. In big-brother style "Paul came out and told us, 'Someday you'll want to get married too and have kids and you'll understand.'" When George's marriage to Pattie began to crumble early in the seventies, he too talked to one of the Scruffs about it. Alan Clayson, one of George's biographers, wrote: "Through daily contact with the Scruffs, George's presumptions about fans had altered. No longer a screaming mass as amorphous as frogspawn: 'Their part in the play is equally as important as ours.' If in the mood and Savile Row was quiet, he'd reserve a little attention for Scruffs he knew by name, asking after their families, noticing whether they had a haircut, and bringing them up to date with progress on Abbey Road."

It all illustrated how the Beatles—in contrast to other rock bands— were able to maintain a special connection to women. All four Beatles may have shared some attitudes to women that were consistent with the mores of their era, but at the same time they were also able to convey something very different.

To the public, however, it was the relationships of John with Yoko, and then Paul with Linda, that drew the attention in 1968. These relationships hardly evolved overnight, though it may have seemed that way at the time to the outside world. Virtually unknown in the U.S. except to avant-garde art aficionados, experimental artist Yoko Ono was already fairly well known on the London scene at the time she and John formed a romantic link. She had arrived in London from New York in September 1966 for the "Destruction in Art Symposium." At that gathering, she made an immediate impact as she performed, among other things, her line piece (draw a line and erase it) and her cut piece, in which members of the audience were invited to chop off her clothes while she sat impassively onstage. At the symposium she also smashed a vase—a performance not unlike what Pete Townshend of the Who was doing with his guitar on stage. Like most of Yoko's work, these pieces, in the words of one of her exhibition catalogs, focused on the idea "of the unfinished" and on eliminating barriers between artists and audiences.

"From what we had heard, we thought Yoko was breaking new ground," said Anthony Fawcett. "The arts, fashion, and music overlapped at that time and Yoko fit right in." The *Financial Times* called her performance art "uplifting," and within months she was being described by another English paper the "high priestess of the happening," as she appeared regularly at exhibitions, concerts, and rock gatherings.

It was a status that had eluded her for her entire life to that point. She was already thirty-three in 1966—seven years older than John and far from a baby boomer. She had grown up in a Japan ravaged by war, which would explain much of her later preoccupation with peace. (She had survived the 1945 fire raids on Tokyo in her family bunker.) Her family was upper-class, with thirty servants before the war, and by Western standards both parents were terribly strict and distant. "I always seemed to be very weak," Yoko once remembered. "I just wasn't able to stand up to my mother and before I did anything at all I used to ask permission." It's been written that she first met her father, a banker, when she was two or three and they had temporarily moved to the U.S. for his work. (She supposedly used to have to make an appointment at his job to see him.) After the war, the family standard of living was diminished, at least for a while, but her father was allowed to keep his job.

"It's interesting," she later said of her relationship with John, "because we come from such totally different backgrounds." But they had one thing in common. "My anger stems from a very early age," she said, which might explain some of her later songs such as "What a Bastard the World Is" and "I Felt Like Smashing My Face in a Clear Glass Window."

She returned to America from Japan in 1953 to attend college at Sarah Lawrence in Bronxville, New York, in part because she thought it might bring her closer to her father, who was now back working in the U.S. Classmates, like feminist pioneer Kate Millett, remembered her as "fearless," though her own memory, she later said, was that she felt like a misfit. By 1956 she obviously felt strong enough to stand up to her family, because she left school without graduating to marry a young Japanese pianist whom her family despised, determined to become an avant-garde artist. She was soon living in New York City and undertak-

ing her performance art before tiny audiences in people's homes and small auditoriums.

Later Arthur Danto, a philosopher and art critic, would write that Yoko was "one of the most original artists of the last half-century." She became known as a major figure in a number of movements that emerged primarily in Manhattan in the late fifties—conceptual art, minimalism, fluxus, and performance art. Her specialty was doing inchoate pieces in a variety of forms that directly involved the audience in some way—what she would call "instructional art." For example, she presented a blank canvas and invited the audience to paint, or asked participants to listen to the sound of boiling water evaporating. Viewers were requested to put together a broken cup with glue and thread. The experimental artist John Cage stretched her across a piano. In her book *Grapefruit*, published in the early sixties, she instructed the reader, "Carry a bag of peas. Leave a pea wherever you go," and "Smoke everything you can. Including your pubic hair." She also envisioned filming every second of a person's life, an idea that foreshadowed the plot of *The Truman Show*, or even *Big Brother* almost 40 years later.

"She was as much a star in her world as John was in his," said Dan Richter, who met her in the midsixties and later became an assistant to both her and John. "But it was a very small world."

If the Beatles had spent years as musical apprentices hoping to make it big, Yoko wandered in the desert far longer. From New York to Japan and back to New York, she traveled in search of recognition over a ten-year period that began in 1956. She went through a marriage, a divorce, a remarriage, and an apparent suicide attempt in Japan, where the reaction to her work was not as positive as she had hoped. She endured almost a decade of living in New York lofts where she could barely afford the rent and heat. Her second husband, an American, was, in the description of many, something of an unsavory character who spent most of his time trying to get his wife better known while she worked, among other things, as a waitress in a macrobiotic restaurant. Robin Richman at *Life* magazine remembered Yoko constantly coming by the magazine's offices, bringing in her contact sheets and seeking publicity. Jerry Hop-

kins, who wrote her unauthorized biography, later described her as "whimsical, sometimes pretentious but always determined."

"I think I have done as much work as Stockhausen or John Cage, but I was mainly an artist's artist before I met John," she later said. She would blame sexism for her lack of fame. "I wasn't even in that game; I was a woman," she said. "A woman is basically thought of as, I don't know, ornaments."

The positive reaction to her work in London must have been a revelation. Before John and she were ever an item, she was collecting "more column inches than the rest of the artistic community combined," wrote Peter Doggett.

In October 1966, she appeared at London's Roundhouse at the celebration launching the underground paper the *International Times*. The following month, she had her own exhibition entitled "Unfinished Paintings and Objects" at the Indica, the gallery associated with the bookstore linked to Peter Asher and Paul McCartney. The exhibition featured objects that were clear or white, like a chess set or a transparent stand that held an apple for participants to bite.

It was at a preview for this exhibition in the fall of 1966 that she first met John. He had just returned from Spain, where he had been filming *How I Won the War,* and was soon to head into the studio with his mates to begin work on *Sgt. Pepper.* John Dunbar, a friend and part owner of the gallery, told him, "This girl, she strips naked in a bag," which was a rather misguided explanation of one of Yoko's performance art pieces. John later said he was expecting an orgy. On seeing Lennon, Dunbar told Yoko, "Go and say hello to the millionaire." For an ambitious artist, a Beatle could be the patron of all patrons, and in fact Yoko had already been trying to contact Paul in the hopes of getting him to donate some musical scores to John Cage's collection.

The story of Yoko and John's first meeting has been retold so often that it has become a part of Beatles mythology—though it's often not mentioned that John had apparently been up for several days tripping on acid by the time he arrived at the Indica. He took a bite of the exhibited apple on the stand. Yoko gave him a card that said, "Breathe." John went to a part of the exhibit that contained a hammer, a nail, a board,

and a sign that read, "Hammer a nail in." Yoko said it would cost him five shillings, and John replied that if he pretended to hammer, could he pay an imaginary five shillings?

John was intrigued by Yoko's art, but, contrary to the myth that developed, it did not appear to outsiders to be love at first sight. For a time, Yoko apparently seemed to see John more as a commercial possibility than a romantic one. Over the next eighteen months, she wrote and called him often, especially when he was in India in early 1968. ("I am a cloud. Watch for me in the sky," read one message.) He helped sponsor her "13 Days Do-It-Yourself Dance Festival" and in October 1967 her "Half a Wind" exhibit at the Lisson Gallery (featuring half a chair, half a hat, etc.)—where she reportedly upset him by revealing to the public what was supposed to be his anonymous financial support. Meanwhile, her career in London continued to flourish as she seemed to be a one-woman publicity factory, gaining headlines for *Bottoms* and for covering the lions in Trafalgar Square in white cloth.

Sometime in this period, John began visiting Yoko in her flat, discussing art and maybe more. Yet few around them saw any possibility that the two would become romantically involved on any kind of permanent basis. John's buddy Pete Shotton later said he viewed Yoko as just "the latest addition to John's collection of human oddities." Tony Bramwell said that their relationship surprised him because Yoko hardly resembled John's previous ideal of a woman: Brigitte Bardot.

His friends were also surprised because even though John and Cynthia seemed to have little in common anymore, they did not expect him to act so decisively to end the relationship. What they didn't know was the circumstances under which Cynthia was discarded: After John and Yoko spent the night together at his home in May 1968, Yoko simply moved in. When Cynthia came home from a trip about a week later, she found John with Yoko having breakfast.

"Facing me was John sitting relaxed in his sitting gown," she subsequently wrote. "With her back to me and equally as relaxed and at home was Yoko. The only response I received was, 'Oh hi,' from both parties."

Subsequently, John and the people around him had a number of explanations for what was going on. Meeting Yoko clearly lifted John out

of the funk which he had developed since the group had stopped touring in August 1966. "She's made me into a whole person," was the way he put it.

"You might say that Yoko brought John back to life," said Pete Shotton.

Yoko was also very intelligent, an artist, and far more worldly than John was. "John never grew out of being an art student," said Peter Brown, who was now running Apple following the death of Brian Epstein.

Jonathan Hague, his old friend from art college, agreed. "I confronted him after he left Cynthia and I asked him, 'Why Yoko?' And he said, 'Cynthia is a housewife. But Yoko's an artist and I'm an artist and she feeds me ideas and that's so important to me.'"

"Yoko was very intelligent," said Ray Connolly, who knew both John and Yoko well from covering them as a journalist. "John hadn't gone to university and probably felt that he had missed something. He thought it was more exciting to be an avant-garde artist than a rock and roller though he now wanted to be both. She opened up a side of him that had been dormant and he was thrilled."

It was John who had once said that "avant-garde" is French for "bullshit." But Yoko's work struck him differently. Her art had a sense of humor John could appreciate. And its collective theme—tearing down the walls between artist and audience—obviously appealed to someone for whom collectivism in any number of forms had been one of the major threads in his own work.

Moreover, John always had trouble working alone. With Paul now beginning to dominate the Beatles, Yoko offered him a new and more satisfying collaboration. Once he and Yoko got together that May, they were rarely apart as long as the Beatles remained a functioning foursome. Reporters soon found to their frustration that they couldn't interview one without the other—which helps explain why Yoko began receiving such bad press. "She always had a comment to make," said Don Short. "What she wanted to do was explain her art." In their first year together, said Derek Taylor, John and Yoko spent as much time together as most couples do in a half century.

John, of course, had always been drawn to strong women. His long-

lasting relationships with women were complex. On the one hand, he desperately wanted a nurturing mother figure; after their relationship started, he began calling the older Yoko "Mother." (Beatles scholar Walter Everett later noted that Yoko's singing role on the upcoming "White Album" was to play "mommy," as when she sang the mother role on "The Continuing Story of Bungalow Bill.") Meanwhile John began composing songs, such as "Julia," in which he interposed memories of his mother with Yoko. (In "Julia," he referred to his mother as "ocean child," a translation of Yoko's name.)

"It's like having a mother and everything," he said to an interviewer, describing his relationship with Yoko. "I can afford to relax. I could never relax before."

"She made John kinder," said George Melly.

On the other hand, John also sought a personality strong enough to balance, if not dominate, his own. This was especially true now that Brian Epstein was gone and the maharishi had proven to be a disappointment. Only Yoko could tell John teasingly but critically, for example, that she considered him clean-cut. "She always pushed him," said Paul. "Which he liked—nobody had ever pushed him before."

Actually, Paul had pushed him too, but it said something important about both John and (later) Paul that they were able to see women as capable of being partners with them. The Beatles had always displayed a more sympathetic attitude to women in their songs than most other rock writers, but their personal behavior had often been at odds with these sentiments. Now their actions and sentiments began to seem more consistent as John, especially, began the process of being identified with a kind of early feminism.

"I've never seen a relationship that was as equal," said the comedian Dick Gregory later of John and Yoko. "They came together, they moved together. . . . He said, 'It's me and her. We are one.' He demanded that you not overlook her."

"There's never really been a couple to identify with before," said John. "That's our gimmick." In a long conversation with rock writer Richard Williams he talked about his hope "that the image of the person or artist as an individual should to some degree be replaced by an

acknowledgment of the power and joint personality of a male/female couple."

Not that the other three Beatles and their cohorts saw things that way at the time. It could be that John really believed that he could bring Yoko into the inner circle as he had brought in Stuart Sutcliffe almost a decade before. Or it may be that he saw Yoko as a wedge to liberate himself from a band he now found confining.

Whatever the thought, and it was probably both, the reality was that as soon as Yoko started showing up by his side all the time—at Beatles recording sessions, at Apple, at press conferences—all hell broke loose, causing seismic shifts in the group dynamic. "Yoko's presence burst the bubble that the Beatles had always lived within," said Barry Miles, Paul's friend.

"There was already a lot going against Yoko Ono when she walked into the goldfish bowl," said Richard DiLello, an American who worked at Apple. "She was overeducated, spoke several languages, was highly proficient in the culinary arts, and a writer of verse and creator of sculpture. She was well versed in history and a survivor of the New York avant-garde scrap race."

"It was an incredibly closed little cabalistic circle there," said David Dalton. "It was the most exclusive boys club in the world. Having Yoko in there was outrageous in that context."

"All new girlfriends don't like their boyfriend's old friends or cronies," added journalist Don Short. The equation ran both ways as Paul, particularly, felt an obligation to the abandoned Cynthia and continued to visit her and Julian—with one such trip inspiring the writing of "Hey Jude."

Not that Yoko took a lot of time to court the others. "I sort of went to bed with this guy that I liked and suddenly the next morning, I see these three guys standing there with resentful eyes," she once complained.

Yoko does not deserve the almost mythological charge that she broke up the Beatles. But it is clear that her sudden and constant presence in the recording studio and at John's side caused major disruptions. Some of these less than enthusiastic reactions were also fueled by the fact that John began using heroin around the time that Yoko ap-

peared, according to Yoko's unofficial biographer Jerry Hopkins and others.

Yoko also did not make things easier for the other three, at least as they saw it. The role of a Beatle wife or girlfriend had traditionally been to stay in the background and have nothing directly to do with the group's artistic product. Yoko was different. She began making suggestions for songs, asking why the beat always had to remain the same or telling the Beatles that they could, ahem, play better. "It was very difficult for a composer to be just sitting there, not making your own music," she explained.

"It simply became very difficult for me to write with Yoko sitting there," said Paul in turn. "If I had to think of a line, I started getting very nervous. I might want to say something like, 'I love you girl' but with Yoko watching, I always felt that I had to come out with something clever and avant-garde."

Though a rift was developing between the couple and the rest of the band, it wasn't totally personal. "We were never really that mean to them," Paul said. "We didn't accept Yoko totally but how many groups do you know who would?"

They didn't hate her, explained Derek Taylor. "But the reason he [John] thinks so is because we don't love her."

The irony is that despite John's giddy and triumphant descriptions of his new partnership, the art on both sides of the relationship suffered. "The creative rapport between John and Paul was extraordinary and to come between it was almost artistically criminal but I suspect Yoko never realized what she was doing, not at the time, anyway," said Ray Connolly. Besides, the relationship between John and Paul had already begun to fray before John met Yoko. In any event, by the time John began work in the studio that spring of 1968 on the songs he had written in India, he had little interest in collaborating with anyone in the band.

Even when John did work with the other Beatles, he now seemed more interested in putting Yoko's conceptual-type pieces on their album—like the collage of sounds entitled "Revolution 9"—than working on their songs. "She encouraged him to create her kind of art," said Jerry Hopkins.

"The old gang of mine was over the moment I met her," John said.

Their relationship thus marked the beginning of the end of the Beatles as symbols of collectivism during their era. "To get a relationship between two people is a start," said John, describing his connection to Yoko and its place in the world. "And then if we two can make it maybe we can make it with you. And from maybe us four—you and yours—we can make it with the next four," It was a lovely concept, but as critic Robert Christgau later put it, it was the end of the sixties when the image of a cooperative was replaced by that of a couple.

Ironically, most of Yoko's old friends in the conceptual art movement said her work was also never the same after she met John. "Her art did suffer because of her association with him," said Dan Richter. Under John's influence, Yoko spent far less time on her visual and performing art and more time making experimental music, which, in the eyes of many of her contemporaries, was the weakest part of her portfolio.

"They were a disaster for each other artistically," said Adrian Henri, a Liverpool poet and painter. "They brought out the narcissism in each other."

"With conceptual artists, their lives are their greatest art," said Dan Richter; John and Yoko each became, in Robert Christgau's words, a "professional celebrity." Soon, John was busy spending his time with Yoko planting acorns for peace, making experimental films (the first, focusing simply on John's smile, lasted almost an hour), and appearing onstage in a bag where they proceeded to do, well, nothing.

From books, unreleased recordings of banter in the studio, and interviews with witnesses, it's apparent that Yoko's presence grated the most on George Harrison, who had always looked up to John. To George's dismay, John often stopped coming into the studio when George was recording his own songs. Ringo, as usual, was more accepting.

Paul's reaction was more complicated. Like George, he was deeply hurt by John's implicit rejection of everything they had built as a group. Yet he desperately wanted to keep the Beatles together. Whereas two years earlier it had been John who couldn't possibly envision life beyond the band, now in mid-1968 it was Paul's turn to feel the same.

Paul was also very jealous of John's romance, according to friends

such as Maggie McGivern, a girlfriend of Paul's at the time (unbeknownst to the public). "John was in love and was happy," she said. "Paul wasn't happy at all." His own relationship with Jane Asher was crumbling. Paul and Jane had become publicly engaged at the end of 1967, but that marked the beginning of the end of their relationship. Paul still didn't approve of Jane's having a full-time career. Besides, acquaintances said Jane never liked a number of Paul's friends—especially the ones who joined him in his drug taking, of which she disapproved.

It was also inevitable that someone as clever as Jane would eventually catch on that the Beatles were hardly paragons of fidelity when they were apart from their wives or girlfriends. It has been reported that when she came home early from one acting tour in mid-1968 and found Paul with another woman, the relationship was over—though the public at the time wasn't told why.

For Paul, who seemed to panic at the thought of being without a girlfriend, the breakup with Jane was yet another blow at a time when he had both to deal with John and Yoko and to try (at least as he saw it) to keep the group going in the wake of Brian's death. "He was desperate to settle down," said Maggie McGivern. "He was terribly lost—he needed that foothold of security. He kept saying about the group, 'I feel I've done everything I can do. Where do we go from here?'"

Just as Yoko had been lurking on the edges of John's world for well over a year before they finally got together, Linda Eastman had been playing a similar role with Paul. Linda was a photographer from a well-to-do New York family. She and Paul had met when she came to London to shoot pictures for a book on rock and roll in the spring of '67. She got herself invited to the launch party for *Sgt. Pepper,* and during that visit went to Paul's house with him. Whatever happened then, nothing serious developed between them at that time.

Like Yoko with John, Linda didn't seem to be Paul's type. In the summer of 1968, when they got together permanently, she was a twenty-five-year-old American divorcée from Scarsdale with one child, the daughter of a prominent lawyer whose clients included a number of celebrated musicians such as Sammy Kaye and Tommy Dorsey. With her traditional upper-middle-class upbringing in the suburbs, she was,

wrote her friend David Dalton, "brought up to marry a successful executive." Like so many girlfriends of the Beatles, she had lost a parent; her mother had been killed in a plane crash when she was eighteen. She was also something of the black sheep of her family, with little interest in school or college. She had married a geology student while still a teenager, had a daughter, and moved to Arizona. "It just didn't last," was all she tended to tell even her close friends afterward.

"To this day," she told an interviewer much later, "nobody knows what or who I am. I don't even know what or who I am."

After several years, she left her husband and moved back to New York with her young daughter to begin a process of metamorphosis. She worked at *Town and Country* magazine in a rather menial job, until one day she somehow got herself into a boat party for the Rolling Stones. She immediately began flirting with Mick Jagger and taking pictures of the group. At that point, her friends didn't even know she considered herself anything more than the most amateur of photographers. She left with Jagger and came home that night at 4 a.m. ("I tried my best to get all the details and failed miserably," said one friend). From then on, she had found a new vocation and new role. "Linda was like a dog with a bone," said her friend Christina Berlin. "She was now determined to make photography her career."

She quickly became a fixture on the blossoming New York rock scene. "Those were the days," she later wrote, "when Jimi Hendrix would walk up to see me at my apartment and when Jim Morrison and I would go to Chinatown to eat. I can remember going to buy peanut butter with Janis Joplin for a late-night feast and traveling out on the subway with Jackson Browne."

"She was an attractive, sexy girl," said Berlin, but not in a conventional way. Her friends remembered her as a natural beauty who paid little attention to traditional aspects of appearance like clothes or cosmetics. She never seemed to wear makeup and always dressed casually and somewhat messily, often in khaki pants with a Lacoste polo shirt.

"She knew everybody," said another friend, Blair Sabol. "She was up all night—she went everywhere. Linda was like a publicist. She got you into anything. What a spirit! I would go with her every Friday night to

the Fillmore. She was always there, wearing her dirty jeans and smock and cowboy boots and carrying her camera—though it often didn't have any film in it."

"She had a lot of guts and her spirit was contagious," said Robin Richman, also a friend at the time. This was the sixties—a period of cultural and sexual freedom—and Linda was hardly alone in mixing freely with some of the best and brightest in her scene. Gossiping friends linked her, at various times, with Jim Morrison, Warren Beatty, and Mikhail Baryshnikov, among others. Not that her friends cared a whit. "That was the life then," said Blair Sabol. "She was not a groupie."

"You have to remember that in those times and in those circles," said Robin Richman, "everyone slept with everyone else."

In the sixties, said Pete Townshend of the Who, there were the people who had fun and the people who shagged them.

Regardless of what happened with Paul when Linda was in London in May 1967, it was a year before they saw each other again. When Paul was in New York in May 1968 to publicize Apple, she slipped him her number at a press conference and they got together again. The following month, they were reunited when Paul flew to Los Angeles on Apple business and asked her on the spur of the moment to join him.

By that time, of course, Yoko was publicly with John; Paul seemed determined to have his own partner to counter his comrade. "They [John and Yoko] were very strong together which left me out of the picture," he said later. He had a flirtation with another American girl that summer, Francie Schwartz, who later wrote a book about it. By August that was over and Paul phoned Linda to invite her to London. It was still only three months since John had struck off on his own with Yoko and less time than that since Jane and Paul had broken off their engagement. This was not a man who liked to be alone or one-upped by John.

Two months later, Linda told friends she was going to England to be with Paul. As with Yoko and John, the move stunned acquaintances on both sides of the relationship.

"To be honest, I was totally shocked," said Christina Berlin. "I didn't think it was going to last. It just seemed like another lark Linda had gotten herself into."

"I was surprised," said Blair Sabol. "To tell the truth, we were more into the Rolling Stones. Linda was more hard-edged than that; she was always cutting edge. John was her kind of guy. Paul McCartney? I thought she had sold out." Sabol and Linda's other New York friends were especially surprised when their formerly independent cohort emerged in subsequent press accounts from London as a kind of domestic goddess—utterly devoted to her boyfriend's needs.

Most of Paul's acquaintances were equally flabbergasted. "To us who had known Jane it was a surprise . . . ," said Hunter Davies, the group's biographer. "It seemed to us that Linda was a 'yes' girl, who was overdoing her adoration, clinging to him, hanging on every word. We couldn't see it lasting."

"I thought she was one very unusually obedient daughter who was completely controlled by her father, you know?" said Yoko around the time.

"The people at Apple didn't like me because of the way I dressed, because I was American, divorced and . . . unsure of myself in Paul's London world, and it came off like arrogance," Linda later told a friend.

Yet as with Yoko, the relationship made sense the longer one saw the couple together. Like Yoko, Linda was sophisticated—and in the Beatles' circle, one didn't meet many women like that. "She was incredibly dignified—a total equal," said Ray Connolly. "She was very self-contained and far more mature than the women commonly around the other Beatles—Yoko excepted. She was also one of the only ones in that whole circle who treated me—a journalist—as an equal."

"Linda kept him sane," said Peter Brown. "She was his anchor. He's a man who needs one."

What's more, Paul had always been drawn to families, and Linda provided an instant one with her young child. "She gave him a center in his life which he had never had," said Connolly. "She gave him a home. Paul was someone who hadn't had someone to make tea for him when he got home ever—he had to do it himself. He hungered after a family life and someone who would put that first." That sentiment revealed itself on the group's next album, as Paul recorded a number

of songs celebrating domestic life: "Ob-La-Di, Ob-La-Da" and "Martha My Dear."

Linda also gave Paul a partner and an advocate just as John now had. "She fought for him," said Maggie McGivern. Within a short time, a journalist wrote, "Paul's firm-minded . . . Linda . . . seems to have taken over as a kind of barrier between him and the rest of the world."

Once Linda was allied with Paul, as Yoko was with John, the women tended to spur their partners in opposite directions from one another, almost acting like lawyers in an ongoing dispute. Yoko made John kookier, at least in Paul's eyes, and certainly the couple's unconventional artistic activities together seemed to bolster his view. John thought Linda made Paul more "bourgeois," and there was evidence to support that too as Paul began to rail against the counterculture. ("None of that psychedelic shit," he told someone when they asked him how to paint a room at Apple headquarters.)

"They became like the Montagues and the Capulets," said Linda's friend David Dalton. "There was total rancor every day."

Besides, the two women—who theoretically could have considered themselves allies against the world—were like oil and water. Yoko saw herself as John's artistic equal; Linda envisioned a more supporting role as Paul's cushion against the world. "Linda and Yoko hated each other," Dalton said. "They were two people who set out to do two completely different things and both ended up with a Beatle."

One thing both women had in common, however, was that, by and large, the group's fans, as well as much of the rock press, disliked them. Typically, of course, rock stars had hung out with other glamorous pop culture figures. Yoko and Linda were different. Neither seemed to cultivate traditional glamour; Yoko came from the rarefied world of serious art.

"The fans didn't know what to make of Yoko," said Ida Langsam. "She was too weird, she wasn't cute, and they couldn't embrace her emotionally." Still, it was the English fans who gave her the hardest time. When John and Yoko released 365 balloons with cards over London in July 1968 with a request that the finders mail the cards back to them

with a message ("I declare these balloons high," intoned John as the launch occurred), they found, to their shock, that many were returned with racist comments about Yoko. The English press, too, turned on Yoko with a vengeance, including in their arsenal of invective constant racist references to her Asian background. One magazine called her "Yoko Hama" and "Okay yoni"—"yoni" being the word for vagina in the Kama Sutra.

As for Linda, "the fans never liked her either," said Langsam. "She, too, wasn't like the other women around them like Jane Asher or Pattie Boyd. She didn't fit in with their fashion sense with her unkempt hair and knee socks."

"Most of the girls . . . laughed at Linda to her face because they hated her so much," said one fan. "They also thought she was ugly. She had very large breasts; the girls would say within her hearing 'they bounce off her knees.' "

"People preferred Jane Asher," said Paul later. "Jane Asher fitted."

As Yoko, and then Linda, arrived on the Beatle scene to take up their places beside their men during that summer and fall of '68, the Beatles were trying to record an album of the numerous songs they had written in India. The studio sessions on what was to become known as the White Album were contentious from the start. The first song the group recorded—John's "Revolution"—was a problem for Paul from the get-go. Already displaying one new direction John was developing with Yoko, the song was far more timely and political than anything the Beatles had ever done, with its references to the political struggle in the streets and "Chairman Mao." (John, who hated to make decisions, could never decide whether you could count him "out" or "in" the struggle, which is why different verses and versions of the songs had him singing it different ways.)

Yet the overtly political nature of the song was precisely why Paul didn't want it to go out as the A side of a single. "If there was such a thing as a conservative rock star, Paul was it," said David Dalton.

Paul won the argument only when, three months later, he wrote one of his best songs, "Hey Jude," illustrating once again that what almost always drove him to the heights of creativity was conflict in his love life.

(This was before he had hooked up with Linda.) John's song was once again consigned to the B side, to his disappointment.

In retaliation, John soon vetoed Paul's attempts to have "Ob-La-Di, Ob-La-Da" released as a single. The song irritated the group endlessly as Paul insisted on reworking it dozens of times over a period of several weeks.

Soon after recording "Revolution," Lennon was at work with Yoko on the eight-plus-minute sound collage, "Revolution 9." (Knowing what his musical partner would think, John worked on much of it while Paul was visiting America with Linda.) Whether or not one agrees with Beatle analyst and author Ian MacDonald that it was one of the most important works the group ever recorded, the fact remains that "Revolution 9" was among the least popular or accessible pieces it ever released.

With Yoko constantly in the studio that fall, Linda began coming in too, and the group's last cloister against the world collapsed. Soon, George's and Ringo's wives began dropping by occasionally as well and the Beatles even began including them in recordings. Maureen and Yoko sang on "Bungalow Bill"; Pattie and Yoko joined in on "Birthday."

Increasingly John and Paul began working alone in separate studios. In June, George and Ringo left for America (where George appeared in a film with Ravi Shankar) and the recording went on without them—the first time this had ever happened. Meanwhile John's "Julia" was the first Beatle song he ever recorded without any of the others. Paul, too, did "Blackbird," "Mother Nature's Son," "Wild Honey Pie," and "Martha My Dear" as solo efforts, at least as far as the other Beatles were concerned. On some of the cuts he even included outside musicians. "I was always hurt when Paul would knock something off without involving us," John said later.

As for George, he was finally coming into his own as a songwriter the equal of his partners, especially now that they were no longer enjoying the benefit of each other's input. Ten years earlier, while walking near Woolton Church one day, Paul and John had decided to cut George out of the songwriting process. Paul remembered the discussion: "Without wanting to be too mean to George, should three of us write or would it be better to keep it simple? We decided we'd just keep to two of

us." The Beatles remained a tight collective unit—largely because writing songs didn't seem like such a big deal at the time—but when animosities arose later, George bitterly recalled that decision. Eventually, the decision not only affected George's position in the group but held back his songwriting ability.

Now things were changing. Yet George still faced enormous diffidence from John, Paul, and George Martin. "You'd have to do fifty-nine of Paul's songs before he'd even listen to one of yours," Harrison complained. Meanwhile for George's "While My Guitar Gently Weeps," John's playing was so uninspired that one account has it essentially being dubbed out of the final version. When the cut was finally released, the song featured Eric Clapton on lead, a product of the time George invited him into the studio to be his new compatriot—yet another sign that the group's ties were fraying.

The atmosphere in the studio soon turned so dark that it was practically all the Beatles' associates could talk about. When John and Ringo came in one day, "you could cut the atmosphere with a knife," one said. One engineer, Geoff Emerick, quit in the middle of the sessions—the victim of a tongue-lashing from John—and early that fall, though the news was kept from the public, Ringo walked out, convinced the band no longer appreciated him. The other three welcomed him back almost two weeks later, but not before they had recorded two songs—"Back in the USSR" and "Dear Prudence"—with Paul filling in on drums more than adequately.

Almost no one outside the inner circle knew of this discord, however. Though the new women surrounding the group were well publicized, the Beatles seemed to remain inviolate as a unit as far as the public was concerned. A cartoon movie of "Yellow Submarine," released in the summer of 1968, portrayed the group as the same happy zany foursome as always. In reality the Beatles had little to do with the film other than to write a few songs for it and make a short cameo appearance at the end; the movie had been planned at Brian's insistence to fulfill their three-film contract to United Artists and was coauthored by Erich Segal, the future author of Love Story. Yet when it was released the Beatles still benefited immensely. Yellow Submarine was a captivating

psychedelic fairy tale about Blue Meanies besieging the band in a magic world called Pepperland, and it captured the fantasist, childlike side of the zeitgeist perfectly.

Meanwhile the pairing of "Hey Jude" and "Revolution," released in late August 1968, still ranks among the most popular singles the group ever did. The Beatles' video of "Hey Jude"—with the group singing the endless coda surrounded by dozens of ordinary people—once again highlighted the collective nature of the counterculture they still purported to lead. (It was shown on *The Smothers Brothers Comedy Hour* on a Sunday night in the U.S.)

The new two-disc album released that fall, *The Beatles*—called colloquially the White Album because of its plain white cover—showed the Beatles near the top of their form despite all the problems recording it. It's true that in their urge to throw everything they had written onto vinyl (and to release two records rather than one, the better to get out from under their recording obligations), they included a number of unpolished songs beneath their standards (like "Wild Honey Pie" and "Why Don't We Do It in the Road"). And it's also true that the band didn't sound as coherent and collaborative as it had in the past. It was, said critic Lester Bangs, the first album "in the history of rock by four solo artists in one band."

Yet a lot of the undertaking still stands up as very good. Whether one agreed with later critical appraisals that the album was intended to display the range of influences on the Beatles—from Paul's send up of the Beach Boys ("Back in the USSR") to John's blues tribute ("Yer Blues")—or that it was a catalog of memories from their childhoods (as on John's "Cry Baby Cry" and tribute to his mother, "Julia"), the album signaled a departure from their three previous LPs. In reaction to what some saw as the overproduction of *Revolver* and *Sgt. Pepper*, the White Album had its roots in the simplicity of their experience in India. It was of a piece with other back-to-the-basics albums beginning to appear on the rock scene—Dylan's more acoustic *John Wesley Harding* and the Band's *Music from Big Pink*—and it marked on some level a musical attempt by the Beatles to move the counterculture away from the chaos into which it seemed to be heading and back to its simpler, more positive roots.

Like much of what the Beatles did, this, too, had its origins in England's past. Social critic Paul Berman later compared the sixties counterculture to the Romantic movement of Keats, Blake, and Wordsworth in the late eighteenth and early nineteenth centuries. Like its predecessor, the sixties revival of the Romantic impulse produced a similar critique of an overintellectualized industrial society and urged the young to return to simpler living pursuits that could reestablish a new authenticity.

The plain cover reflected this sentiment—another departure from *Pepper*—as did the enclosures within. Instead of cutout paper dolls of the band in elaborate uniform, buyers got four individual close-up pictures of each Beatle unshaven.

"The Beatles . . . have really led the whole revival movement," wrote Lenny Kaye in *Fusion* two years later. "Along with the rest of us, they seem to have become uncomfortable with the path the music has taken of late, stuck in theater seats, all full of Importance and Meaning."

Yet even as the Beatles labored to move in a new direction, they still seemed oddly disconnected to the larger culture. The world at large was turning darker, especially outside England. The spring before, the U.S. had witnessed the assassination of Martin Luther King Jr.—along with the subsequent rioting in many cities at the news of his death—and two months later the murder of Robert Kennedy. Over the summer, Soviet tanks crushed the Czech rebellion in Prague, while in the U.S., demonstrators and the Chicago police rioted and clashed during the Democratic convention. Black Panther leader Huey Newton was sentenced to fifteen years in prison for killing a policeman. Protests on college campuses escalated across the country, as students began seizing buildings.

Meanwhile, the November election in the U.S. produced a counterreaction, as eight years of Democratic liberalism were ended with Republican Richard Nixon's election as president. Even the formerly "untouchable" Beatles were ensnared in the counterreaction on both sides of the Atlantic, as John and Yoko were busted by the London police in October 1968 for drug possession.

As they quarreled among themselves, overseeing this world presented the Beatles with a new kind of challenge. In the end, they would no longer be up to it.

GROWING OLDER, LOSING FAITH

B|Y the end of 1968, the Beatle "family" was crumbling from within: As the four band members got older, the bonds they had created and needed as teenagers were being pulled apart by the demands and concerns of adulthood.

Meanwhile, as the sixties began to stumble into the seventies, it was quickly becoming apparent, to paraphrase William Butler Yeats, that the center of the counterculture was not holding for anyone. Unsurprisingly, given the way they were so thoroughly entangled with the spirit of their times, the Beatles couldn't make it work either.

"The Beatles' breakup could be seen as their final contribution to the creation of new trends," Mike Evans later wrote. "Dissolution, after all, was one of the keynotes of the forthcoming decade."

By the beginning of 1969, the counterculture was beginning to splinter and turn more fractious. It was not a dissolution that happened all at once. Instead, it was an accumulation of a number of events that led to a growing sense that the idealism of the past several years was dead. "The Winter of Despair" is what historian Todd Gitlin later called the era.

There had been hopeful signs indicating otherwise even during that year. In July 1969, the Rolling Stones—the new avatars of the rock coun-

terculture now that things had turned more fractious and the Beatles no longer gave public shows—held a free concert in Hyde Park that attracted the largest audience in England since VE Day. The next month, the Woodstock Festival was interpreted by the media and many others as a high point of the new culture, as hundreds of thousands of young people gathered peacefully for three days in the New York rain to listen to a panoply of rock groups.

In retrospect, however, Woodstock marked the sunset, rather than the dawn, of the Age of Aquarius. In December 1969, when the Stones performed at a similar festival at Altamont near San Francisco, the event disintegrated into violence: Numerous fights broke out and a spectator was killed.

The Beatles, who had once been at the core of the counterculture, were nowhere near any of these events that helped define the year. Yoko complained that "the only thing with the Beatles is that they changed it [the world] and then they stopped there—they weren't going on being revolutionaries." Yet she missed the point: Maybe she and John felt differently, but the type of cultural revolution the four Beatles together had once embodied as a group was no longer feasible.

In the U.S., "the tidal wave of moral outrage that had swept the country out of its lassitude of conscience was, by the end of the decade, breaking into driblets of petulant narcissism and mindless exhibitionism," wrote Charles Morris in *A Time of Passion,* his history of those years. Counterculture leaders talked openly of civil war. When students in the U.S. took over a building at Cornell University in the spring of 1969, they carried shotguns. As the Vietnam War wound on, demonstrations grew more violent. One branch of the radical student organization SDS issued a guide to what protesting demonstrators should wear: motorcycle jackets (to guard against police billy clubs); helmets (for the same); and a wet washcloth to protect against tear gas. In May 1969, one man was killed following a demonstration at Berkeley's People's Park, foreshadowing what would happen at Kent State the following year. In the fall of 1969, the Weathermen—a splinter faction of SDS—organized the "Days of Rage" in Chicago, which essentially meant trashing the downtown of the city through acts of wanton violence.

The new mood hardly comported with the Beatles' commitment to an exuberant vision of collectivism. To many, the band now seemed strangely irrelevant. "I learn that opinion has shifted against the Beatles," wrote the influential Robert Christgau when *Abbey Road* was released in the fall of '69. "Everyone is putting down *Abbey Road*. . . . One evening I change my mind and put it on. It gives me a headache."

"People had lost faith in the Beatles," Marianne Faithfull later wrote. "They seemed phony and hollow by this point."

The counterculture seemed to be turning sour in other ways. In Los Angeles, just days before Woodstock, actress Sharon Tate and others were brutally murdered by members of a hippie cult led by Charles Manson. He and his followers maintained that they received mysterious musical coded instructions to commit the murder. Despite the absurdity of their contentions, one could somehow understand if they had claimed that this message came from a Doors or Rolling Stones song. But the fact that Manson and his followers said it came from the Beatles' "Piggies" and "Helter Skelter" on the White Album ("Helter Skelter" by Paul no less!), showed how far some people were taking the Beatles out of any identifiable context. "What's 'Helter Skelter' got to do with knifing somebody?" John lamented.

The growing conservative backlash on both sides of the Atlantic (the Tories would win back power in the UK in the spring of 1970) also affected the Beatles and made it harder for them to function—though John and Yoko undoubtedly stoked the reaction against themselves by playing the role of provocateurs. Both John and George were arrested at different times for possession of marijuana. "For one of the Beatles to get busted was very serious because they were more or less used to being untouchable," said Derek Taylor. "Now things were going wrong." Because he was afraid Yoko might be deported if convicted, John pleaded guilty to a possession of marijuana charge against him; charges against her were dropped. That conviction, in turn, sparked years of visa problems for him.

Toward the end of the sixties, wild rumors also began circulating throughout the United States that Paul McCartney had died two years earlier in a car crash and been replaced by a look-alike. An elaborate set

of clues had supposedly been planted by the three surviving Beatles. For example, Paul's back faced the camera on the rear cover of *Sgt. Pepper;* the group sang in "A Day in the Life" of someone who "blew his mind out in a car"; and a new "Billy Shears" was welcomed into the band on the same album. Through the haze of drugs, the notion that "Paul is dead" was discussed incessantly and taken so seriously by fans that *Life* magazine eventually sent a representative to the UK to certify that Paul was alive.

The music business was changing too. Linda McCartney later told a writer friend, "There was a sourness. There were parasites moving in, there was friction. Everybody started getting hugely successful and with success came craziness, and any beautiful glow attracts a lot of ugly creatures."

The core of female fans who had originally looked to the Beatles for their first taste of feminism were older too and starting to move past them. By 1969, the emerging women's liberation movement was beginning to have widespread influence. Leaders such as Gloria Steinem were articulating a theory of empowerment far more clearly than the vague sentiments of a song such as "You're Gonna Lose That Girl." The yearning for community and freedom that had once been expressed in a collective scream could now be voiced in far more compelling ways at the ballot box and in the courts. Within a few years, mainstream feminists began militating for the Equal Rights Amendment in the United States.

Meanwhile, as the baby boom generation began to enter its twenties (the oldest were now twenty-three), many began to doubt their commitment to collectivism. As the sixties ended, these boomers began to head "back to the land" as farmers and craftsmen; go to graduate school; move into environmental or consumer-rights work; and slowly return to mainstream culture, where they brought many of their new ideas with them.

Without stretching the comparison too far, that became the story with the Beatles, too. All four were now in their mid to late twenties—older, even, than the oldest baby boomers who followed them. "They were totally exhausted," said Ray Connolly. "People forget the amount of work they did." Each was struggling with issues of adulthood and

commitment, which were hard to square with the wild, rebellious senti- ment of rock and roll. Between 1968 and 1970, Paul had his first child with Linda; Ringo and Maureen had their third child; and John and Yoko suffered the first of several miscarriages, this one in the third trimester.

"The Beatles are a democratic group of middle-aged teenagers," said John in 1969, shortly before he decided that his days of adolescence were finally over. The allure of Peter Pan notwithstanding, even English boys have to grow up sometime.

That's not the way people saw it at the time, of course, and that in- cludes most of the Beatles themselves, who viewed their breakup as in- evitable only with the hindsight of history. "We are afraid of their coming apart," wrote Jann Wenner of *Rolling Stone,* "because if they did, we might as well." Their dissolution was stormy and excruciating. "It was terrible, horrendous, not enjoyable at all," George said. They loved each other more than most couples do, and when they split it was more wrenching than most divorces.

Like the partners in a lot of marriages, John and Paul had fulfilled a deep need in each other when they first linked up as teens. Both shared a passion for rock and roll and both had lost their mothers. Paul found in John an outlet for his hidden anger and rebellion. As for the other half of the relationship, Chris Salewicz once wrote, "The strangely etoli- ated furious figure of John Lennon was mollified and calmed by the jaunty, ritualistic cheeriness of Paul McCartney. . . . There was some- thing strong, resilient, and durable about Paul, and he acted as an an- chor for John's indiscipline and barnstorming impatience, and as an antidote to his angry air of badly secreted pain."

The subsequent collaboration resulted in an incredible creative syn- ergy. Besides the music, the foursome was a family—always hugging each other and talking in code.

Yet in the end the differences won out—as they often do. Like a lot of couples, as all four got older the discrepancies became more striking than the similarities. "It had become a family thing," said Peter Brown. "They had been together since they were teenagers. If they had met later they would have had nothing in common." When Paul and John each

found a female mate who fulfilled his needs better than his collaborator, they turned away from one another. It wasn't so much "the women" who broke them up; it was the fact that after they met these women, the two leaders of the group realized they no longer needed the others as much, if at all.

"John's in love with Yoko and he's no longer in love with the three of us," said Paul.

Their personal issues inevitably became public. Like many couples splitting up, the Beatles fought a lot about money in their final year and a half, and those struggles have been described at length in several books. (When Paul sang about the group's troubles in "You Never Give Me Your Money," many of their fans—unaware of the deep splits now in the group—thought he was singing about a real divorce.) They all fought about the in-laws, though in this case the in-laws wanted to manage them. As with most couples, however, the money and the in-laws were really metaphors for something else. And they couldn't figure out what to do next—how to "get back," as the title of their next project indicated, what would prove to be ungettable.

Things really started spiraling downhill in the fall of '68 after the re-lease of the White Album. It was Paul's idea (acting yet again as the group's spark plug) that the Beatles needed to snap themselves out of their disunity by reestablishing touch with their fans and appearing live again. It was not an outlandish idea. Their video performance of "Hey Jude" in the fall of '68 had been viewed as a huge success. Moreover, both George and John had performed with others in the fall of '68 (John had played with a pickup group for the Rolling Stones' TV pro-duction *The Rolling Stones' Rock and Roll Circus;* George had jammed with friends in Los Angeles). Both had found they liked it.

What's more, all four Beatles knew they were increasingly isolated and the instinct of many leaders when things begin to go astray is to try to make contact with their followers. Politicians get back to their roots by holding "town meetings." Musicians do it by performing live.

The Beatles, however, were no longer capable of agreeing on any-thing; the collectivity and one-for-all mentality that had governed the group had dissipated. A plan to do several concerts at the end of 1968

collapsed because no one but Paul wanted to go back on stage immediately. Then Paul came up with the idea, in George Martin's words, to "record an album of new material and rehearse it, then perform it before a live audience for the very first time." John, in a now constant passive-aggressive mode, seemed to say yes; Ringo and George went along. The group made plans to film all the writing and rehearsal sessions, taking a page from Yoko's performance art playbook on the importance of revealing the lives of celebrities.

Because the cameras and tapes were rolling constantly, the disaster—eventually released as *Let It Be*—was well documented. Their changing physical appearance had always heralded shifts in the group, and now the four looked, for the most part, awful, with straggly hair (in John's case now down to his shoulders) and Paul no longer shaving. Instead of playing in a comfortable, familiar studio at night—their usual practice—they had to travel to Twickenham in the suburbs of London and keep banker's hours to meet filming requirements. Because they had just released a double album, they didn't have enough new material and spent most of the time jamming to old familiar ditties or working on half-composed numbers. Still, the sessions did produce two terrific singles from Paul, "Get Back" and "Let It Be."

Though the public learned of it only later, these sessions confirmed that the Beatles could no longer stand to be in the same room with one another. Constantly preoccupied with Yoko, and on and off a multitude of drugs as usual, John essentially became a dropout. "I just didn't give a shit," he said; for example, he asked if he could giggle during the guitar solo of "Let It Be." George grew sick of repeatedly being told by Paul how to play. He fought constantly, too, with John, walking out on the group midway through the sessions, at which point John calmly suggested that if George didn't return they could invite Eric Clapton to join them. When George did come back, he brought along musician Billy Preston, which at least had the effect of quashing the quarrels. "I'd like him in our band actually," said John of Preston, who had first met the group in Hamburg in the early sixties. "I'd like a fifth Beatle." But that was obviously never going to happen.

The four never could agree about a concert. There was talk of doing

one in a North African amphitheater at dawn, or on a cruise ship, and Yoko suggested—à la her own performance art—that they do the show in an empty auditorium for "the invisible nameless everybody in the world." But no one but Paul was really willing to travel, and John said that any fans on a cruise ship would be a "load of mental deficients."

When they finally just decided to go on the roof of Apple headquarters on stately Savile Row at lunchtime and play for an hour, George didn't even want to do that and agreed only at the last minute. Once they performed that lunchtime gig in late January '69—amid hundreds of awed and irritated businessmen and shoppers—they abandoned the filmed studio sessions. It would be more than a year before they had someone do the extensive editing work required to release the album.

Meanwhile the real world was taking a financial toll on the idealism of Apple—the "ultimate stoner's dream come true," according to one associate. Because the Beatles and their mates actually knew something about music, the Apple record label was having some success, having signed James Taylor, Mary Hopkin, and Badfinger. Much of the rest of the operation was a mess, however, and burning money faster than the Beatles could make it. The clothing store closed with losses; many of the other plans never got off the ground.

"Apple has, to a certain extent, been a haven for dropouts," said George. "The problem is some of our best friends are dropouts." The sole qualification to work at some Apple enterprises, maintained John's friend Pete Shotton, was that the employee had to like to smoke dope as much as the Beatles did. The offices on Savile Row attracted the marginalized visitors of the counterculture: a man with a formula for a pill that could make you whomever you wanted to be; or the protester who wanted to destroy dolls with napalm; or the dozen or so Hell's Angels George had invited to pay a visit on their way to straighten out the situation in Czechoslovakia; or Magic Alex, John's friend, who said he was inventing an electric paint that could light up. Richard DiLello, the American "in-house hippie," described the office's reception area as resembling "the waiting room at a VD clinic in Haight-Ashbury at the height of the acid madness of '67."

The office liquor bill was said to be six hundred pounds a month. It

was also said that caviar was kept at all times for Yoko, as well as premium wine for group lunches. The four band members were fractious and touchy: Paul was much more involved in the day-to-day office administration required of the four, but when John and Yoko came in, they countermanded many of his orders. Apple was essentially Paul's baby and, reflecting the discord of that time, as Peter Brown explained, "because it was Paul's, John felt he had to destroy it."

The Beatles realized they needed to fill the void that had been left by the death of their manager Brian Epstein in August 1967. But as might be expected at this point, they couldn't agree on a replacement. In late January 1969, as the whole *Let It Be* film-music project was dissipating, John asked American Allen Klein to look after his business affairs, and almost immediately Ringo and George threw in their lot with Klein too. The lone skeptic was Paul.

Klein was a short, squat, tough, wheeling-dealing New Yorker—"a junkyard dog who had fought his way to the top," in Dan Richter's words—who included among his clients the Rolling Stones. His reputation was murky; the Stones sued him and the Beatles would eventually get in the litigation line down the road.

But for now, John wanted him, and Ringo and George weren't going to follow Paul anywhere. To the junior members of the group, whatever the merits of Paul's arguments, he had become too bossy and too conventional.

"You shouldn't have to think about money," Klein said to them. "You should be able to say FYM—Fuck You, Money." John identified with Klein's rough edges and the fact that he, too, had been raised motherless. Klein was also among the few to treat John and Yoko as coequals, impressing her with promises to back her movies and art exhibitions. Most important, John told a friend, he needed someone like Klein to counter McCartney's advisers.

Paul's response to the group's financial confusion and troubles had been typical: He turned to family, asking help from Linda's father, Lee, who in turn recommended her brother, John, a lawyer. But the Kleins and Eastmans were New Yorkers from the opposite side of the tracks: They despised each other, splitting the band further. It's true the East-

mans were ultimately right about Klein; the other members of the band eventually ended up suing him. And it's also true that the Eastmans turned out to be savvy advisers as Paul grew to be one of the richest men in the history of show business.

But it's also true that there was no way the other three Beatles were going to let the young brother of Paul's new girlfriend become their chief financial adviser. For a while the Beatles ended up retaining both the Eastmans and Klein—an invitation to chaos if there ever was one. That didn't work out, as the opposing advisers clashed about almost everything, drawing yet another line in the sand that divided the group. In the first two months of 1969, as the group fought over Klein and finances, Paul learned that Linda was pregnant.

In the "official" story of the Beatles, Paul and Linda (despite their having lived together for less than six months) had been planning their marriage for some time. Yet Maggie McGivern had a somewhat different impression. "I saw him shortly before the wedding," she said. "He was so low, so depressed, so confused. He was in a terrible state—so scruffy looking that you'd think he was a vagrant. It was quite sad. He had lost direction—Apple was in shambles. He was a Catholic boy from Liverpool and quite a conformist as well. . . . When I saw him, he just cried and cried."

By this time, the splits in the group were so large, at least as far as Paul was concerned, that none of the other three Beatles attended his March 12, 1969, wedding in London. In May, the gap widened further when Paul refused to endorse a document signed by the other three naming Klein as their manager.

Still influenced by—and competitive with—his old mate, John was spurred by Paul's wedding into marrying Yoko. Only eight days after Paul's nuptials, John married Yoko in Gibraltar, at which point the couple headed to Amsterdam to stage the first of their infamous "bed-ins" for peace—another event straight out of Yoko's catalog of performance art. (Journalists had shown up expecting something X-rated but the two stayed in their pajamas the whole time regaling reporters with their political rhetoric.) John and Paul were still close enough professionally that within a month of John's wedding, they entered the studio together

to record John's "The Ballad of John and Yoko," which promptly became yet another source of controversy for mentioning the word "Christ" (which many radio stations edited out) and for John's declaration, "They're gonna crucify me."

Despite their quarrels through the first half of 1969, the Beatles kept working on joint projects more or less. They periodically went into the studio to record new songs, and by July 1969 they were back in the studio regularly to record a new album that few expected, *Abbey Road.*

As others later pointed out, *Abbey Road* was recorded in a shorter time period than any Beatles album since 1965; featured the Beatles harmonizing more than at any time since *Sgt. Pepper,* and marked the return of George Martin in a major role, which helped give the album its shape. It relied heavily on an innovative device—the Moog synthesizer. In the estimation of many, the record's two best songs came from George Harrison: "Something" and "Here Comes the Sun," the latter notable for the way its promise of a new dawn after a lonely winter caught the wearied sensibility of the counterculture.

Yet the album, as good as it was, seemed slightly out of kilter. George Harrison was onto something when he said later that the album "doesn't feel like the Beatles." After all, the recording process, as might be expected, had proven anything but peaceful: The four were rarely in the studio at the same time; in one notable incident, according to McCartney biographer Chris Salewicz, John headed to Paul's house and obliterated one of his mate's favorite paintings when McCartney failed to show up for a scheduled session. (Not that Lennon didn't refuse to show up himself much of the time now.) The unity was supplied electronically, mostly through dubbing, rather than the physical closeness that existed before.

The album also lacked coherence because it was a compromise: The first half of the record was a traditional album with separate unrelated songs, like what John wanted to release. Side two featured mostly a medley that Paul and George Martin favored, in a continuation of the thematic approach they had explored in *Sgt. Pepper.* Though John contributed several cuts, he didn't like the album as a whole (he thought it lacked authenticity) and called Paul's contributions music "for the grannies to dig" and not "real songs."

Because Lennon was preoccupied with his work with Yoko, his own musical work was scattershot; he missed a number of the sessions—both because of injuries suffered in a summer auto accident in Scotland with Yoko and because he still couldn't be bothered to come into Abbey Road when a song of George's was being recorded. He later said he appreciated having his "Come Together" released as a single so it would allow him to listen to one of his own songs without listening to the whole album.

The critical reaction to the album reinforced both George's sense that something was missing and John's that the Beatles had become too fabricated. Back to basics, after all, was still the order of the day in rock music. Ed Ward wrote in *Rolling Stone,* "The Beatles create a sound that could not possibly exist outside the studio." The Moog synthesizer, he added, "disembodies and artificializes their sound," and he called the album "complicated instead of complex." William Mann in the *London Times* echoed Ward's comments, predicting that *Abbey Road* would "be called gimmicky by people who want a record to sound exactly like a live performance." Unlike *Sgt. Pepper* or their earlier work, which had galvanized the entire British invasion, *Abbey Road* inspired few to imitate it. "Too contrived for the rock underground to copy, too complex for the bubblegum pop brigade to follow, the album influenced no one—except its main creator, Paul McCartney, who wasted years trying to re-create its effortless brilliance," wrote Peter Doggett. (Within a few years, of course, many rock musicians would use synthesizers and other studio "tricks" so that studio albums didn't sound live at all.)

The fans obviously didn't listen to these critics. *Abbey Road* was a huge seller at the time and remains the Beatles' biggest-selling album ever. Subsequently critics looked at this last album the Beatles recorded together and saw it as a farewell to their fans and an attack on "selfishness and self-gratification" through McCartney's medley which called for love once again to save the world. One critic even found that the separation of the instruments in the recording process symbolized the separation of the group. There was only one problem with some of these theories: According to George Martin, the Beatles didn't realize, at least

consciously, that they were recording their last album together when they worked on *Abbey Road* that summer.

In September 1969, the month the album was released, John raised the specter of a breakup. He told the other three, "I want a divorce. Just like the divorce I got from Cynthia." Yet he was persuaded by Allen Klein not to announce his plans to the public so Klein could negotiate better Beatles contracts and deliver the additional money he had promised them when they hired him.

Despite his declaration, it's unclear in retrospect how serious John really was about leaving. Both George and Ringo had walked out on the group in the past twelve months during recording sessions and had returned. "Everybody had tried to leave, so it was nothing new," said George. "Everybody was leaving for years."

Moreover, anyone who knew John understood that no matter what his immediate intentions were, he had a terrible time leaving *anything*, much less the band he had created almost fifteen years earlier and loved so much. "I never wanted the Beatles to be has-beens," John later said. "I wanted to kill the band while it was on top." But if the loquacious and outspoken John Lennon had really wanted to shut the group down permanently at this point, it's hard to believe he would have kept his mouth shut for over six months about his plans, no matter what Klein told him to do. Yet that's what he did.

In fact, the Beatles' public comments in the months that followed John's private announcement—including his own—more accurately indicate that they seemed to envision a loose relationship in which they would get together from time to time to record and spend the rest of their energy pursuing individual projects.

"The fact is now we have so much material and you have got to have outlets somewhere," said John. "There's just too much material to get on a Beatle album."

"By allowing each other to be each other," said George, "we can become the Beatles again." He told Don Short at another point, "We just can't stop being Beatles whatever we do. . . . It's all unity through diversity."

That loose arrangement seemed to suit three members of the band. John went off with Yoko to pursue their art together, engaging themselves in such projects as their "War Is Over" billboard campaign and funding political protesters. At the same time, George seemed content to link up with relatively minor groups like Delaney and Bonnie and become an occasional sideman. He also began work on his own album, while Ringo did the same with *Sentimental Journey,* a collection of old thirties and forties standbys he thought his mother would like. In the months after *Abbey Road,* three of the Beatles worked with another member of the band on these solo projects: George played on John's "Instant Karma"; Ringo joined in for the recording of John's "Cold Turkey"; and George and Ringo worked together on Ringo's "It Don't Come Easy," eventually released in 1971.

The odd one out was Paul, who was still the only one supporting the Eastmans in the conflict with Klein. In contrast to the other three, Paul was having terrible trouble envisioning life without the Beatles as a full-time unit. He responded to John's declaration about a divorce by going into an apparent depression. "I love them," he once said. "I really do." He retreated to his farm in Scotland with Linda and began drinking heavily. One trauma triggered memories of another: He compared this event to the death of his mother fourteen years earlier. "Truth is, I couldn't handle it for a while," he later said. "When my mother died I don't think my confidence suffered. It was a terrible blow but I didn't think it was my fault."

This was different: He responded, said Ray Connolly, "like someone had broken up his family"—and everyone knew what family meant to Paul. The more he thought about it, the worse he got. It became, Paul said, "like a deep kind of emptiness in my soul. It really made me very frightened. I thought, 'Oh God, it's gone, it's slipping from underneath me!' I felt like the bottom was falling out. . . . You sit at home, start boozing and you stop shaving."

Ultimately, "Lennon needed McCartney less than McCartney needed him," wrote Ian MacDonald. And Paul couldn't accept it.

Newly married and with a baby, Linda hadn't realized what she was getting herself into. "It was frightening beyond belief," she later said. As

Cynthia had done with John years earlier, Linda tried to pull Paul together. She helped persuade him to begin recording his own solo album, which, rather typically, he did by playing every instrument himself. Unlike the other three, however, he did so secretly, returning to Abbey Road and booking the studios under an assumed name.

Linda's family also moved into the breach. They were lawyers, so perhaps it's unsurprising that Paul eventually became convinced that his only proper recourse was to sue the other three Beatles.

In the meantime, the other three Beatles had given the old *Get Back/Let It Be* session tapes to producer Phil Spector in the hopes he could do something with the project. (John and George later used Spector as a producer on solo projects.) Spector's response was to do what he typically did as a producer, which was to introduce his "wall of sound"—adding strings and choirlike voices to some of the cuts. George Martin and Paul were horrified: "I would never put female voices on a Beatle record!" Paul said, forgetting, apparently, that they had done just that on the White Album.

"As far as I was concerned," Paul later said, "yeah, I would have liked the Beatles never to have broken up." But he did cast some key stones. Paul's songs throughout his career as a Beatle provide insight into how he viewed the threat of abandonment. John always expected to be deserted. In contrast, Paul's lyrics set him up as the one doing the leaving—following the sun or finding "Another Girl" if the first wouldn't treat him right. Life imitated art: Paul later commented that he couldn't "just let John control the situation and dump us as if we're the jilted girlfriends."

The other Beatles learned during that winter of 1970 that Paul was recording his own album. That was hardly a big deal: They all were doing similar projects. But Paul was apparently furious that the other three wanted him to delay the release of his solo effort, called simply, if not egotistically, *McCartney,* so as not to conflict with the release, finally, of the group's "Get Back" project album, now entitled *Let It Be.* The other three backed down. Yet that wasn't enough either. On April 9, 1970, Paul called John, who, with Yoko, was with Dr. Arthur Janov. It's believed that Paul informed John in that call that the release of *McCartney* would signal he was quitting the band.

The day after Paul's call to John, the headline of London's *Daily Mirror* read, "Paul Is Quitting the Beatles." Don Short reported that McCartney was releasing a statement, to be included with his upcoming album, in which he said, "I have no future plans to record or appear with the Beatles again."

Lennon was furious and called up *Melody Maker* magazine. "Paul hasn't left," he said. "I sacked him."

"I put out four albums last year," John told *Rolling Stone* the following month, referring to his mostly forgettable "performance art" albums with Yoko, "and I didn't say a fucking word about quitting."

Some supported Paul's decision. "He was very perceptive," said David Dalton, who was in and out of Apple working on the book to accompany the *Let It Be* album. "He saw Pompeii—the volcano erupting and the culture falling apart—and he figured he had to get out of there." This reading of the culture, of course, was in sharp contrast to that of John and Yoko, who had issued a statement at the end of 1969: "We believe that the last decade was the end of the old machine crumbling to pieces."

While Paul's "announcement" was front-page news in England, it got less attention in the United States, whose youth culture was preoccupied with other matters. On April 30, shortly after the *Daily Mirror* story, President Nixon announced an escalation of the Vietnam War, as the U.S. invaded next-door Cambodia. Four days later, four students were killed protesting the war at Kent State University in Ohio, and in reaction, what seemed like every university campus across the country shut down and went on strike.

The fact that the Beatles' breakup was not earth-shattering international news showed how much the Beatles had been eclipsed in their final years. Besides, most believed it wasn't permanent. There were few tears and even fewer wistful op-ed pieces wishing them farewell. Some disc jockeys talked about how the move was actually a plus—the public could now expect four times as many albums from the foursome as each did his own.

After Paul's announcement, there were scattered reports for the rest of the year speculating that the Beatles might be recording again. After

all, on the day the news had broken, Derek Taylor had said, "It must be temporary. There can be no breakup of these people." Don Short heard stories that one or two other musicians had been approached by George to replace Paul, if only temporarily. Yet John moved in to finish what Paul had started, giving a lengthy, iconoclastic interview to *Rolling Stone* that sought to demystify the legend of the group. He then ended the year with a solo album in which one song proclaimed, "I don't believe in Beatles. . . . The dream is over."

Yet most didn't consider the separation truly final until the last day of 1970, when Paul filed suit to dissolve the Beatles' partnership, claiming that the band no longer functioned as a group and that Allen Klein had mismanaged their financial affairs. The other three Beatles soon contested his action, and the band that had dominated so much of the world's attention in the sixties was officially no more.

"There was a sadness like there would be in a divorce with one's family because it's the end of what you've known," said one of their devoted Apple Scruff fans. But, she said, "it released you to get on with the rest of your life."

POSTSCRIPT

Beatles had expired. But that didn't stop their followers from spending the next decade until John Lennon's assassination on December 8, 1980, waiting for a resurrection.

For the next ten years after the breakup, there were constant rumors of potential reunions. (George Harrison complained that every time Paul wanted publicity, he planted a rumor the group was getting back together.) Promoters offered them millions to reunite, if only for one night. There was talk that all four might appear together for George's charity concert for Bangladesh in New York in the summer of '71, but only Ringo showed. Paul and John—together in New York for an evening in the mid-seventies—considered heading over to the set of *Saturday Night Live* when the show made a facetious offer of several thousand dollars for a reunion concert but decided against it.

Barriers to get the four together privately for business reasons proved insurmountable too. Once, when George, Ringo, and Paul gathered for a meeting in New York, John's new hometown, John refused to show, claiming the signs weren't favorable. Instead he sent over a balloon to the meeting place with the inscription "Listen to this balloon."

Though they retained a certain closeness given all that they had been through together (one of the first people Paul called when his father died was John), in public, at least, they quarreled, attacking each other in interviews and songs. The John Lennon Capulets and the Paul McCartney Montagues fought on as before, and for a while George

sniped at everyone, except for Ringo, of course, who was still everyone's best mate. There was something about the whole experience of being a Beatle, wrote journalist Mikal Gilmore, that left the four men at the heart of it "seeming wounded, haunted, even bitter."

"He hasn't been happy . . . since the old days," said Linda McCartney of her husband.

"John wanted love and when the Beatles split he lost a lot of love," said Cynthia, his former wife.

In fact, John himself had once predicted it might come to this. "This is different from anything that anybody imagines," he had said when the group was still together. "You don't go on from this. You do this and then you finish."

"It was always going to be impossible to top," said Paul.

Though each of the four Beatles produced a fair amount of music on his own after the breakup, very little of it reached the heights of what they had done together, proving again, if only unwittingly, that each needed the others to do his best work. The aura they had once projected as a foursome had now dissipated. Though it's hard to believe today, by 1980 the Beatles weren't even considered that big a deal in popular culture. Their time had come and gone. Few collectors were vying to accumulate their trinkets. "The group still sold a lot of records," said Tony Rotundo, a historian who teaches at Phillips Andover, "but they had ceased to be a cultural phenomenon."

What began to change everything was the death of John Lennon at the end of 1980. In his book *Dead Elvis*, Greil Marcus described how Elvis Presley became a cultural obsession after his death in 1977, "a figure made of echoes, not of facts." The legend grew, Marcus wrote, out of "art works, books, movies, dreams; sometimes more than anything cultural noise." "The King" became the patron saint of the Church of Elvis.

"Elvis didn't die," said his manager, Colonel Tom Parker. "The body did."

So it went with John beginning three years later. His legacy included the same literary tributes from the entourage, followed by the same bios (which even now continue), and the same creation of civic shrines (the Liverpool airport), the same cultural buzz, the same attention paid to

the surviving clan, and the same anniversary observances of the day he died. Because John's death also killed any lingering chance of the Beatles' reuniting, the group also began to go through a similar process of canonization. Though there continued to be talk that the three remaining members of the group might get together, everyone now knew that things could never be the same. "As far as I'm concerned," George said in his typically direct way, "there won't be a Beatles reunion as long as John Lennon remains dead"—a prediction that was broken in the nineties when the three surviving members reunited to record several songs for an *Anthology* series that, by and large, moved very few.

Over the years, the Beatles legend grew. The now ubiquitous presence of "oldies" stations helped spread the optimism and music to new generations. Apple—once planned as the model for a new kind of capitalism—became instead, in one critic's words, "a secretive and unsentimental business organization, marketing its priceless assets for all they're worth."

"I am the custodian of the graveyard," said Neil Aspinall, their old associate, now the managing director at Apple.

There was a way in which the Beatles now haunted the baby boomers, albeit in a positive fashion. Unlike other rock figures, such as Mick Jagger or Bob Dylan, the Beatles retired close to their peak. Frozen in time and memory, they never faded before our eyes. "If you are among those who let the Beatles' recordings in, or better, couldn't keep them at bay, and even if you seldom feel an urge to play them anymore, chances are they have remained a big part of you," wrote Gerald Marzorati. "[It was] that part of you that is impatient with seemingly reasonable limits, that is untroubled by and even sneakily satisfied with meaningless change for change's sake, that has never quite grasped the satisfactions of abidingness, fixity, yesterday. In the quieter precincts of the self, you are what they sounded like."

For their female fans—the ones who had discovered them and put them on the map—the Beatles served as a reminder of the heady days when anything seemed possible, long before anyone had been forced to confront a glass ceiling or try to balance work against family.

"They gave me such a feeling of happiness," said Bernadette O'Reilly, a fan from their early days. "They captured me as a girl and I'm

trapped forever. They put a spell on me that has never been broken. I don't know if I'd be the person I am today without them."

Behind the former Iron Curtain, the baby boomers paid the Beatles special homage. "I'm convinced the Beatles are partly responsible for the fall of communism," said Milos Forman, the film director. Pavel Palazchenko, the Soviet interpreter for Mikhail Gorbachev, agreed. "We knew their songs by heart," he told a writer about his generation's love of the Beatles. "They helped us create a world of our own, a world different from the dull and senseless ideological liturgy that increasingly reminded one of Stalinism. . . . The Beatles were our quiet way of rejecting 'the system' while conforming to most of its demands."

Yet there was more to it than all that. As the years passed, the band became a vehicle for the culture to remember what had seemed best about the sixties. Because of the excitement and possibilities the decade had once seemed to promise, it generated far more than its share of nostalgia—and controversy too.

"The reason the sixties still evoke such vehement reactions is because we're still fighting over what kind of a country and what kind of culture we're going to have," said Allen Matusow, a historian specializing in the sixties.

"Whatever was at issue in the music for its original fans remains at issue," wrote Francis Davis.

The spirit of the sixties absorbed the attention of the next generation as well. J. Bottum wrote about the "oddly constant nostalgia [that] runs through popular music . . . a sense of having somehow missed better times."

Over time, as the followers of the Beatles spent riches for baubles like an old George Harrison guitar after he died in 2001, or gathered in the thousands at annual conventions to pay homage to their saints and messiahs, their continued worship began to resemble a kind of religion. The group's songs became a kind of scripture; what they stood for became a creed.

It was all of a piece, of course, with what had happened before. When John Lennon had controversially compared the Beatles to Jesus way back in 1966, he was not the only one to do so. Surveying the

screaming and weeping mobs surrounding the group in San Francisco in 1964, one reporter wrote, "It could have been the Second Coming."

"Fans seemed to think the Beatles had magic healing powers," wrote Ivor Davis.

When John Lennon was honored on British television at the end of 1969, a critic wrote, "I must admit that John Lennon was the only person in all these [TV] programs with a gospel, a hope, and a belief."

It is not a novel notion that in an era when the appeal of certain types of conventional religion is fading, mass entertainment has rushed into the vacuum. "Celebrity is the religion of our consumer society," Judy and Fred Vermorel have written. "And fans are the mystical adepts of this religion who dramatize moods, fantasies and expectations we all share."

In his book *Life: The Movie*, Neal Gabler described how the forces of organized religion opposed the rise of pop culture "amusements"— reasoning correctly that the temporal "values of entertainment frequently vied with those of the church."

"When people say . . . that they feel they have a 'personal relationship' with a celebrity, they are invoking the same term that evangelists use to describe their relationship with God," he wrote.

The Beatles were neither the first nor the last pop culture celebrities to undergo this process of becoming divine. But no one else could compare to them. They were their own Trinity plus one. Their followers were fanatics, in the true sense of the word. Their muse was music, which has always been a key part of religion and unlike, say, the movies, is internalized in a way impossible with other genres.

The sixties counterculture that the New Testament Beatles embodied offered a kind of counterreligion, with its own music, festivals, and sacraments such as the use of marijuana. At the time, Harvey Cox, a scholar of religion, even described the hippies as the founders of a new theology. "It has its evangelists, its sacred grottoes, its exuberant converts," he wrote. Scholar Camille Paglia has written in a similar vein about the "evangelical fervor" in which this sixties "earth cult," as she described it, developed its own costumes, hymns, icons, holy texts, and

mystical traditions—many of which survive in some form and are still the subject of great debate.

"I thought they were saviors, so did a lot of people," said Derek Taylor after the Beatles broke up. "But we overestimated them. They were just ordinary human beings." But Taylor had the disadvantage of personally knowing the Fab Four. Those who didn't could still believe. Their fans today, said Paul's old friend Barry Miles, act as if the group continues to exist. But of course it does. As long as there is hope, communion, and optimism, there will always be a reason to believe in the Beatles. After all, as it reads in the scripture, "All you need is love."

SOURCES

A Beatles historian has no shortage of sources from which to choose. The key is finding the ones which are reliable decades after the events in question. The Beatles have become so mythologized over the years that episodes that never happened and words that were never spoken have become an accepted part of the story.

As much as I could, I tried to separate fact from fiction by relying on those who could be deemed most trustworthy. That's easier said than done: A researcher finds even the four Beatles giving conflicting accounts of many events, or of one Beatle telling the same story two or three different ways over the years.

My research took some divergent paths, encompassing not only the subject of the Beatles but a fair amount of social history about such topics as the evolution of male hairstyles, the prominence of drug use during the sixties, and sexual mores in England during World War II. As mentioned in the introduction, I found some of my best sources in unexpected places—teen magazines published during the sixties or oral histories located in Liverpool museums or the British Library. Being in England for a spell also was tremendously helpful in developing an appreciation of the unusual culture that gave rise to the band.

For starters, I conducted interviews myself with more than a hundred people. Those interviewed included everyone from Yoko Ono and Astrid Kirchherr, to members of the entourage such as Tony Barrow, to childhood friends such as Rod Davis, to journalists such as Ray Connolly and Chris Hutchins. Devoted fans of the group, such as Ida Langsam and former Apple Scruff Diane Hamblyn, were a big help too. To widen my scope, I also tried to talk to a number of authors and historians who had thought or written critically about the group in the past, such as Jon Savage, Ellen Willis, and Simon Frith.

Unlike some authors, I refused to interview anyone who wanted to be paid for an interview, on the ground that such a practice violates journalistic ethics.

The book and the numerous quotes it contains, of course, are based on much more than simply my own conversations with sources. Though the two surviving Beatles refused my requests for interviews, all four were never shy about talking to the press in their heyday and to selected interviewers since. Over the years, many of their friends and associates (some now dead) talked just as freely to writers and reporters as well. I relied heavily on those first-person accounts.

When I couldn't depend on a direct interview of some sort, I tried to find either contemporaneous accounts of the events in question or descriptions in books written by Beatles associates and observers writing close to the time, when memories were fresher. Accounts by journalists and photographers—who are, after all, in the business of observation—proved especially useful, beginning, obviously, with Hunter Davies's *The Beatles*, first published in the late sixties.

Finally, to a certain extent, I had to depend for information on some previous historical accounts of the group. By checking these works against reliable historical texts, one gets a sense of who can be trusted and who can't. These works run the gamut from Albert Goldman's biography of John Lennon—which I felt I could barely use at all—to books by respected English journalists such as Ray Connolly, who wrote a biography of John Lennon, and Chris Salewicz, whose *McCartney* still stands up very well almost twenty years after it was written. In the past several years, several British rock periodicals such as *Mojo* and *Q* (as well as the American publication *Goldmine*) have also published historical anthologies in magazine form about the Beatles that were well researched and written by some of the best rock writers in Britain such as John Harris and Johnny Black.

As I wrote the book, two prior works were very helpful in setting out the group's day-to-day workings: Mark Lewisohn's *The Complete Beatles Chronicle* and Barry Miles's *The Beatles Diary*. In addition, in chapter 1, I regularly consulted A. S. Rayl's *Beatles '64: A Hard Day's Night in America* and Bruce Spizer's *The Beatles Are Coming*. In chapter 11, *I Want to Take You Higher* was a valuable source as was Derek Taylor's *It Was Twenty Years Ago Today*. For chapter 14, Peter Doggett provided an excellent account of the recording of the group's final two albums, *Let It Be* and *Abbey Road*, that I also consulted regularly. I found no reason to quarrel with the generally accepted notion that the best critical accounts of the Beatles' music are found in Tim Riley's *Tell Me Why* and the late Ian MacDonald's *Revolution in the Head*. Allan Kozinn's *The Beatles* deserves mention too as the best short introduction to the group and its music.

I also want to note a couple of graduate theses that were useful, if only because these commonly don't receive much attention: Frontani's "The Beatles as Sign," Moorefield's "From the Illusion of Reality to the Reality of Illusion," Smith's "The Beatles as Act," and Kopp's "Linking Differences in Self-Directed Learning Competency to Dyadic Conflict," which was a lot more helpful and easier to follow than its title makes it sound.

What follows is a detailed list of sources categorized for easier reference.

A. INTERVIEWED OR CONSULTED DIRECTLY

My thanks again to all these individuals for the considerable time they spent helping me. There were five interviewees who asked to remain anonymous.

Arthur Aaron	Michael Elliot	Gibson Kemp
Violet Upton Ahmed	Geoffrey Ellis	Frances Kenn
Tony Allen	Ron Ellis	Randall Kennedy
Helen Anderson	Royston Ellis	Ian Kimmet
Bryan Barrett	Mike Evans	Astrid Kirchherr
Tony Barrow	Bernie Farrell	Shirley Klein
Dot Rhone Becker	Julie Felix	Al Kooper
John Belchem	Joe Flannery	Meyer Kupferman
David Bennion	Neil Foster	Ida S. Langsam
Christina Berlin	Simon Frith	Tony Lee
Roag Best	Philip Furia	Spencer Leigh
Tony Bramwell	Neal Gabler	Vic Lewis
Gerard Brennan	Steve Gebhardt	Michael Lydon
Mike Brocken	Erich Goode	Mary McCahey
Peter Brown	Brian Gresty	Allison McCracken
Vern Bullough	Jonathan Hague	Ray McFall
Julie Burchill	Diane Hamblyn	Maggie McGivern
Billy Butler	Charles Hamm	Thelma Pickles
Mike Byrne	Colin Hanton	McGough
Iris Caldwell	Lynne Harris	Phyllis McKenzie
Tony Carricker	Louise Harrison	David Magnus
Alan Clayson	Bill Harry	Ann Mason
Kevin Concannon	Jon Hendricks	Elaine Tyler May
Ray Connolly	Jerry Hopkins	Larry May
Frankie Connor	Matt Hurwitz	Albert Maysles
Jonathan Cott	Chris Hutchins	Louis Menand
Peter Curran	Chrissie Iles	Jim Miller
David Dalton	Virginia Ironside	Kate Millett
Lynn Davidman	Charles Iscove	Elliot Mintz
Hunter Davies	Maurice Isserman	Jon Murden
Rod Davis	Bruce Jenkins	Rod Murray
Peter Doggett	Michael Kazin	Marcy Lanza Oldham

Yoko Ono	Sheila Rowbotham	Steve Turner
Bernadette O'Reilly	Blair Sabol	Tony Tyler
Stanley Parkes	Chris Salewicz	Anthony Waine
Joanne Petersen	Jon Savage	Chris "Nigel" Walley
William Pobjoy	Frank Sellors	Hank Walters
Harry Prytherch	Don Short	Jacqueline Warwick
Sidney Pyzan	Roy Skeldon	Jeffrey Weeks
Irene Radclyffe	Keith Stroup	Nat Weiss
Diane Reverand	Doug Sulpy	Roy Wheeler
Simon Reynolds	Pauline Sutcliffe	Deborah Grove Wiener
Robin Richman	Geoff Taggart	Richard Williams
Dan Richter	Iain Taylor	Zoe Williams
Jill Richter	Joan Taylor	Ellen Willis
Tony Rotundo	Ted "Kingsize" Taylor	Bob Wooler

B. ORAL HISTORIES AND COLLECTIONS OF INTERVIEWS

Badman. *The Beatles Off the Record: Outrageous Opinions and Unrehearsed Interviews*. London: Omnibus Press, 2000.

The Beatles Anthology. San Francisco: Chronicle Books, 2000.

Gambaccini. *The McCartney Interviews: After the Break-Up*. London: Omnibus Press, 1996.

Geller, ed. by Wall. *The Brian Epstein Story*. London: Faber and Faber, 1999.

G. Giuliano and B. Giuliano. *The Lost Beatles Interviews*. London: Virgin, 1995.

———. *The Lost Lennon Interviews*. New York: Omnibus Press, 1998.

———. *Things We Said Today: Conversations with the Beatles*. Holbrook, MA: Adams Media, 1997.

Golson, ed. *The Playboy Interviews with John Lennon and Yoko Ono*. New York: Playboy Press, 1981.

Joseph. *Good Times: An Oral History of America in the 1960s*. New York: Charterhouse, 1973.

Leigh. *Speaking Words of Wisdom: Reflections on the Beatles*. Liverpool: Cavern City Books, 1991.

———. *Twist and Shout! Merseybeat, the Cavern, the Star-Club, and the Beatles*. Liverpool: Nirvana Books, 2004.

Leigh and Firminger. *Halfway to Paradise: Britpop, 1955–1962*. Folkestone, Eng.: Finbarr International, 1996.

McCabe and Schonfeld. *John Lennon: For the Record*. New York: Bantam, 1984.

Miles. *Paul McCartney: Many Years from Now*. New York: Henry Holt, 1997.

Miles, comp. *The Beatles in Their Own Words.* Edited by Marchbank. London: Omnibus Press, 1978.

Pritchard and Lysaght. *The Beatles: An Oral History.* New York: Hyperion, 1998.

The Rolling Stone Interviews 1967–1980. New York: St. Martin's, 1981.

Soderbergh. *Getting Away with It, or The Further Adventures of the Luckiest Bastard You Ever Saw.* New York: Faber and Faber, 2000.

Somach, Somach, and Gunn. *Ticket to Ride.* New York: William Morrow, 1989.

Sulpy and Schweighart. *Get Back: The Unauthorized Chronicle of the Beatles' Let It Be Disaster.* New York: St. Martin's, Griffin, 1999.

Wenner. *Lennon Remembers.* New York: Popular Library, 1971.

C. INTERVIEWS PUBLISHED IN ARTICLE FORM

Complete citations for books referenced in this section are listed in Sections D, E, F, and G.

THE BEATLES

Aldridge. "Beatles Not All That Turned On." In Eisen, *The Age of Rock.*

Everett. "Beatles Interview with Kenny Everett," 6/5/68. www.geocities.com/ ~beatleboy1/db6568.int.html.

"Interview with the Beatles on ITN-TV," 12/20/66. http://www.geocities.com/ ~beatleboy1/dbemi66.int.html.

Lister. "Radio Interview with the Beatles," 10/28/62. www.geocities.com/ ~beatleboy1/dbbts62.int.html.

Matthew. "Interview with John Lennon and Paul McCartney on *Top of the Pops,*" 3/20/67. www.geocities.com/~beatleboy1/db32067.int.html.

Shepherd. "The Playboy Interview with the Beatles." *Playboy,* 2/65.

Tate. "BBC Interview with the Beatles," 6/30/63. www.geocities.com/ ~beatleboy1/db73063.int.html.

PETE BEST

Hersey. "The Pete Best Interview," 1994. http://personal.nbnet.nb.ca/mccorp/ petebest1994.html.

HUNTER DAVIES

Barnes. "Hunter Davies in Conversation with Digger," 4/00. http://home.clara.net/ digger/sixties/hunter.htm.

ROD DAVIS

"An Interview with Rod Davis." www.fabfour.addr.com/rod.htm.

GEOFF EMERICK

Burack. "A Conversation with Geoff Emerick," 1997. http://macca-l.org/macca-l/macca-l.net/alixgeoff.htm.

MARIANNE FAITHFULL

Hoskyns. "The *Backpages* Interview: Marianne Faithfull." *Rock's Backpages*, 7/01. www.rockbackpages.com.

GEORGE HARRISON

Brown. "An Interview with George Harrison." *Rolling Stone*, 4/19/79.
Cashmere. "George Harrison Gets 'Undercover'—Interview," 1996. http://abbeyrd.best.vwh.net/harrison.htm.
DeCurtis. "Rolling Stone's Last Interview." In Editors of Rolling Stone, *Harrison*.
Glazer. "Interview with George Harrison." *Crawdaddy*, 2/77.
Murray. "Within Him and Without Them: Interview with George Harrison." London *Daily Telegraph*, 6/27/92.
"Unseen Interview with George Harrison." *Mojo*, 1997.
White. "A Portrait of the Artist." *Billboard*, 12/5/92.

BILL HARRY

Franklin. "A Conversation with Bill Harry." *World Beatles Forum*, 7/8/00.
"Reminiscences of Merseyside: An Interview with Bill Harry." In Okun, *Compleat Beatles*, vol. 1.

ARTHUR JANOV

J. Harris. "You Scream, I Scream: Interview with Arthur Janov." In *Mojo Special Edition: John Lennon.*

ASTRID KIRCHHERR

Digger. "An Interview with Astrid Kirchherr." www.retrosellers.com/features10.htm.

CYNTHIA LENNON

Leigh. "Convention Interview with Cynthia Lennon." *Good Day Sunshine*, 75 (1994).

McDermott. "An Interview with Cynthia Lennon." *Liverpool Echo*, 2/17/95.

"You Ask the Questions—Interview with Cynthia Lennon." London *Independent*, 7/7/99.

JOHN LENNON

"ATV Interview on 12/2/69 with John Lennon on *Man of the Decade*," 12/30/69. www.geocities.com/~beatleboy1/db12269.int.html.

Blackburn and Ali. "Power to the People." *Real Mole*, 3/8–3/22/71.

Cott. "*Rolling Stone* Interview with John Lennon." *Rolling Stone*, 11/23/68.

"John and Yoko Interview on David Frost on Saturday," 8/24/68. http://homepage.ntlworld.com/carousel/pob14.html.

"John and Yoko Interview on David Frost Show: What's Bagism," 6/14/69. http://homepage.ntlworld.com/carousel/pob00.html.

"John Lennon Interview: *Look*," 12/13/66. www.geocities.com/~beatleboy1/db121366.int.html.

Miles. "John Lennon/Yoko Ono Interview." In *Rock Backpages*, 9/69.

Robinson. "Our London Interview with John and Yoko." *Hit Parader*, 8/70.

Smith. "Interview with John and Yoko." *Hit Parader*, 2/72.

Turner. "Grapefruit Interview with John and Yoko," 7/71. http://homepage.ntlworld.com/carousel/pob10.html.

Yorke. "Interview with John Lennon, 6/69." On *Rockmine*, www.rockmine.music.co.uk/Rockmn.html.

RICHARD LESTER

Sakol. "Richard Lester Remembers." In Okun, *Compleat Beatles*, vol. 1.

Soderbergh. " 'George Was by Far the Best Actor of the Four of Them,' (Richard Lester Interview)." *Guardian*, 11/27/01.

MICHAEL LINDSAY-HOGG

DeYoung. "Michael Lindsay-Hogg—Father of the Music Video." In Goldmine Magazine, ed., *The Beatles Digest*, 1st ed.

ANDREW LOOG OLDHAM

Kubernik. "The *Backpages* Interview: Andrew Loog Oldham." *Rock Backpages,*
1/01.www.rocksbackpages.com.

PAUL MCCARTNEY

Bacon. "Paul McCartney—Meet the Beatle." *Bass Player,* 7–8/95.
Bonici. "Interview with Paul McCartney." *Music Express,* 4–5/82.
Garbarini. "Paul McCartney Interview." In Okun, *Compleat Beatles,* vol. 2.
"Interview with Paul and Linda McCartney." *Playboy,* 12/84.
"Interview with Paul McCartney." *CNN Larry King Live,* 6/12/01.
"Interview with Paul McCartney." *Life,* 11/7/69.
Lewisohn. "Introductory Interview with Paul McCartney." In Lewisohn, *The Beatles
Recording Sessions.*
Merryman. "Paul McCartney Talks About the Beatle Breakup and His New Life."
Life, 4/16/71.
"Paul McCartney Interview with David Frost," 12/27/67. www.geocities.com/
~beatleboy1/db122767.int.html.
"Paul McCartney Interview with Radio Luxembourg on White Album," 11/20/68.
www.geocities.com/~beatleboy1/db112068.int.html.
Salewicz. "Paul McCartney: An Innocent Man?" *Q,* 10/86.
Wilde. "McCartney: My Life in the Shadow of the Beatles." *Uncut,* 7/04.

GREIL MARCUS

Hargus. "Do Politics Rock? Interview with Greil Marcus," 6/97. www.furious.com/
perfect/marcus.html.
Vites. "Interview with Greil Marcus." *Jam,* www.interferenza.com/bcs/itgrailuk.htm.

GEORGE MARTIN

DeYoung. " 'They Were My Boys, the Greatest in the World' (Interview with George
Martin)." In Goldmine Magazine, ed., *The Beatles Digest,* 1st ed.
"Interview with George Martin." *Melody Maker,* 1/71. http://aboutthebeatles.com/
biography_georgemartin_mminterview.html.
Kozinn. "Interview with George Martin," 2/23/87. http://abbeyrd.best.vwh.net/
kozinn.htm.
Sakol. "George Martin Remembers." In Okun, *Compleat Beatles,* vol. 2.

Sexton. "George Martin: The *Billboard* Interview," *Billboard*. 4/11/98.

Sharp. "The Last Hurrah of the Fifth Beatle." In Goldmine Magazine, ed., *The Beatles Digest*, 2d ed.

SIMON NAPIER-BELL

Hoskyns. "What Simon Says: Simon Napier-Bell." *New Musical Express*, 1984. www.rocksbackpages.com.

YOKO ONO

Bracewell. "Yoko on Lennon." *London Sunday Telegraph*, 11/1/97.

Cook. "Yoko Ono Interview." *New Musical Express*. 2/11//84.

Denberg. "Interview with Yoko Ono." 4/15/00. www.instantkarma.com/yointerviewjody00.htm.

Gaar. "Yoko Ono Speaks About Her Ryodisk Reissues." In Goldmine Magazine, ed., *The Beatles Digest*, 1st ed.

Ingraham. "Unfinished Dialogue: Interview with Yoko Ono." In *Mojo Special Edition: John Lennon*.

"Interview with Yoko Ono." *CNN Larry King Live*, 12/4/99.

Marinucci. "The Transcript of a Phone Conversation with Yoko Ono," 1/19/98. http://abbeyrd.best.vwh.net/yoko.htm.

"Ono on Lennon." www.amazon.com/exec/obidos/tg/feature/-/3640/104-7593449-5672740.

FRANCIE SCHWARTZ

"The Beatles.about.com interview Francie Schwartz." http://oldies.about.com/b/a/2003_07_09.htm.

"An Interview with Francie Schwartz." http://abbeyrd.best.vwh.net/francie.htm.

WALTER SHENSON

Gaar. "Acting Naturally (Interview with Walter Shenson)." In Goldmine Magazine, ed., *The Beatles Digest*, 1st ed.

RINGO STARR

Wiener. "Conversation with Ringo." In Goldmine Magazine, ed., *The Beatles Digest*, 2d ed.

DEREK TAYLOR

Hieronimus. "Interview with Derek Taylor," 11/5/99. http://21stcenturyradio.com/
NP-8-25-99.1.html.

JURGEN VOLLMER

Sharp. "Jurgen Vollmer (Interview)." In Goldmine Magazine, ed., *The Beatles Digest*,
1st ed.

BOB WOOLER

Gaar. "I Am the DJ: An Interview with the Cavern's Bob Wooler." *Goldmine*, 11/8/96.
Leigh. "*Record Collector* Interview with Bob Wooler." *Record Collector*, 7/98.

D. PERSONAL REMINISCENCES BY THE BEATLES AND THEIR CIRCLE

Baird with Giuliano. *John Lennon My Brother*. New York: Henry Holt, 1988.
Barrow. *The Making of the Beatles' Magical Mystery Tour*. London: Omnibus Press,
1999.
Bedford. *Waiting for the Beatles: An Apple Scruffs Story*. Poole, Eng.: Blandford
Press, 1984.
Benson. *The Beatles in the Beginning*. Edinburgh: Mainstream Publishing, 1993.
P. Best and Doncaster. *Beatle! The Pete Best Story*. London: Plexus, 1985.
R. Best. *The Beatles: The True Beginnings*. Ipswich; Eng.: Spine Books, 2002.
Brown and Gaines. *The Love You Make: An Insider's Story of the Beatles*. New York:
McGraw-Hill, 1983.
Clayson and P. Sutcliffe. *Backbeat: Stuart Sutcliffe; The Lost Beatle*. London: Pan
Books, 1994.
DiLello. *The Longest Cocktail Party*. New York: Playboy, 1972.
Epstein. *A Cellarful of Noise*. New York: Doubleday, 1964.
Fawcett. *John Lennon: One Day at a Time*. New York: Grove Press, 1976.
Freeman. *The Beatles: A Private View*. London: Pyramid Books, 1990.
———. *Yesterday: Photographs of the Beatles*. London: Weidenfeld & Nicolson, 1983.
Gentle and Forsyth. *Johnny Gentle and the Beatles: First Ever Tour Scotland, 1960*.
Runcorn, Eng.: Merseyrock Publications, 1998.
Harrison. *I Me Mine*. New York: Simon & Schuster, 1980.
Hoffmann. *The Beatles Conquer America: The Photographic Record of Their First
American Tour*. London: Virgin Books, 1984.

Hogg. *The* Revolver *Sessions*. London: UFO Books, 1991.

Kirchherr and Voorman. *Hamburg Days*. Guildford, Eng.: Genesis Publications, 1999.

C. Lennon. *A Twist of Lennon*. Tiptree, Eng.: W. H. Allen, 1978.

J. Lennon. *In His Own Write and Spaniard in the Works*. London: Pimlico, 1997.

P. Lennon. *Daddy, Come Home: The True Story of John Lennon and His Father*. London: Angus & Robertson, 1990.

L. McCartney. *Sixties: Portrait of an Era*. London: Pyramid, 1992.

M. McCartney. *Remember: Recollections and Photographs of the Beatles*. New York: Henry Holt, 1992.

Martin with Hornsby. *All You Need Is Ears*. New York: St. Martin's, 1979.

Martin with Pearson. *Summer of Love: The Making of Sgt. Pepper*. London: Pan Books, 1995.

Mitchell with M. Munn. *All Our Loving: A Beatle Fan's Memoir*. London: Robson Books, 1988.

Saltzman. *The Beatles in Rishikesh*. New York: Penguin, 2000.

Schwartz. *Body Count*. San Francisco: Straight Arrow Books, 1972.

Seaman. *The Last Days of John Lennon: A Personal Memoir*. New York: Dell, 1991.

Shotton and Schaffner. *The Beatles, Lennon, and Me*. New York: Stein & Day, 1983.

P. Sutcliffe with D. Thompson. *The Beatles' Shadow: Stuart Sutcliffe and His Lonely Hearts Club*. London: Sidgwick & Jackson, 2001.

A. Taylor with Roberts. *Yesterday: The Beatles Remembered*. London: Sidgwick & Jackson, 1988.

D. Taylor. *As Time Goes By*. London: Abacus, 1973.

———. *Fifty Years Adrift*. Guildford, Eng.: Genesis Publications, 1985.

———. *It Was Twenty Years Ago Today: An Anniversary Celebration of 1967*. New York: Simon & Schuster, 1987.

Vollmer. *Rock 'n' Roll Times: The Style and Spirit of the Early Beatles and Their First Fans*. Woodstock, NY: Overlook, 1983.

Whitaker and M. Harrison. *The Unseen Beatles*. San Francisco: Collins, 1991.

Williams and P. Sutcliffe. *Stuart: The Life and Art of Stuart Sutcliffe*. Guildford, Eng.: Genesis Publications, 1996.

E. COMPILATIONS ABOUT THE BEATLES

The Beatles: Band of the Century. Q Magazine Collector's Limited Edition, 2000.

The Beatles: The Complete Story. NME Originals, 2002.

"Beatle Symposium." *Stereo Review*, 2/73.

Catone. *As I Write This Letter: An American Generation Remembers the Beatles*. Ann Arbor, MI: Greenfield Books, 1982.

Cording, Jankowski-Smith, and Laino, eds. *In My Life: Encounters with the Beatles.* New York: Fromm International Publishing, 1998.

Cott and Doudna, eds. *The Ballad of John and Yoko.* New York: Doubleday, 1982.

A. Davis. *The Beatles Files.* Godalming, Eng.: Bramley Books, 1998.

E. Davis, ed. *The Beatles Book.* New York: Cowles, 1968.

Days of Beatlemania: April 1, 1962, to December 31, 1964. Mojo Limited Edition, 2002.

Days of Revolution, The Beatles' Final Years—January 1, 1968, to September 27, 1970. Mojo Limited Edition, 2003.

Editors of Rolling Stone. *Harrison.* New York: Simon & Schuster, 2002.

Evans. *The Beatles Literary Anthology.* London: Plexus, 2004.

Goldmine Magazine, ed., *The Beatles Digest.* 1st edition. Iola, WI: Krause Publications, 2000.

———. *The Beatles Digest.* 2nd edition Iola, WI: Krause Publications, 2002.

Harry, ed. *Mersey Beat: The Beginnings of the Beatles.* New York: Omnibus Press, 1977.

Inglis, ed. *The Beatles, Popular Music, and Society: A Thousand Voices.* New York: St. Martin's, 2000.

Mojo Special Edition: John Lennon: His Life, His Music, His People, His Legacy, Swinging London. NME Originals, 2003.

Neises, ed. *The Beatles Reader.* Ann Arbor, MI: Pierian Press, 1984.

Okun, ed. *The Compleat Beatles.* Vol. 1, *1962–1966.* New York: Delilah Communications / ATV Music Publications / Bantam Books, 1981.

———. *The Compleat Beatles.* Vol. 2, *1966–70.* New York: Delilah Communications / ATV Music Publications / Bantam Books, 1981.

1000 Days That Shook the World: The Psychedelic Beatles—April 1, 1965, to December 26, 1967. Mojo Limited Edition, 2002.

Reising, ed. *Every Sound There Is: The Beatles' Revolver and the Transformation of Rock and Roll.* Aldershot, Ashgate, Eng.: 2002.

Thomson and Gutman, eds. *The Lennon Companion: Twenty-five Years of Comment.* New York: Schirmer Books, 1987.

F. BOOKS AND DISSERTATIONS ABOUT THE BEATLES AND THEIR CIRCLE

Badman. *The Beatles After the Breakup, 1970–2000: A Day-by-Day Diary.* London: Omnibus Press, 1999.

Baker. *The Beatles Down Under: The 1964 Australian and New Zealand Tour.* Lane End, Aust.: Magnum, 1996.

Benson. *Paul McCartney: Behind the Myth.* London: Victor Gollancz, 1992.

Braun. *Love Me Do: The Beatles' Progress.* Middlesex, Eng.: Penguin, 1964.

Campbell and Murphy. *Things We Said Today: The Complete Lyrics and a Concordance to the Beatles' Songs, 1962–1970*. Ann Arbor, MI: Pierian Press, 1980.

Carr. *Beatles at the Movies*. New York: Harper Perennial, 1996.

Clayson. *The Quiet One: A Life of George Harrison*. London: Sanctuary Publishing, 1996.

————. *Ringo Starr: Straight Man or Joker*. New York: Paragon House, 1992.

Coleman. *Lennon*. New York: McGraw-Hill, 1984.

————. *The Man Who Made the Beatles: An Intimate Biography of Brian Epstein*. New York: McGraw-Hill, 1989.

————. *McCartney Yesterday . . . and Today*. London: Boxtree, 1995.

Concannon. "Yoko Ono's *Cut Piece* (1964): A Reconsideration." Ph.D. diss., Virginia Commonwealth University, 1998.

Connolly. *John Lennon: 1940–1980*. London: Fontana, 1981.

H. Davies. *The Beatles*. New York: McGraw-Hill, 1978.

————. *The Quarrymen*. London: Omnibus Press, 2001.

Doggett. *Let It Be/Abbey Road*. New York: Schirmer Books, 1998.

Dowling. *Beatlesongs*. New York: Simon & Schuster, 1989.

DuNoyer. *We All Shine On: The Stories Behind Every John Lennon Song, 1970–1980*. New York: HarperPerennial, 1997.

A. Elliott. *The Mourning of John Lennon*. Berkeley: University of California Press, 1999.

Evans. *The Art of the Beatles*. London: Anthony Blond, 1984.

W. Everett. *The Beatles as Musicians: The Quarry Men Through Rubber Soul*. Oxford: Oxford University Press, 2001.

————. *The Beatles as Musicians: Revolver Through the Anthology*. New York: Oxford University Press, 1999.

Fields. *Linda McCartney: A Portrait*. Los Angeles: Renaissance Books, 2000.

Flippo. *Yesterday: The Unauthorized Biography of Paul McCartney*. New York: Doubleday, 1988.

Frontani. "The Beatles as Sign: Their Transformation from Moptops to Granscian Intellectuals." Ph.D. diss., Ohio University, 1998.

Giuliano, G. *Dark Horse*. New York: Dutton, 1990.

Goldman. *The Lives of John Lennon*. New York: William Morrow, 1988.

Goldsmith. *The Beatles Come to America*. Hoboken, NJ: John Wiley, 2004.

Harry. *The Encyclopedia of Beatles People*. London: Blandford, 1997.

————. *The Paul McCartney Encyclopedia*. London: Virgin Books, 2002.

————. *The Ultimate Beatles Encyclopedia*. New York: Hyperion, 1993.

Hertsgaard. *A Day in the Life: The Music and Artistry of the Beatles*. New York: Delacorte Press, 1995.

Herzogengrath and Hansen. *John Lennon: Drawings, Performances, Films*. London: Thames & Hudson, 1995.

Hopkins. *Yoko Ono*. New York: Macmillan, 1986.

Hutchins and Thompson. *Elvis Meets the Beatles*. London: Smith Gryphon, 1994.

Kopp. "Linking Differences in Self-Directed Learning Competency to Dyadic Conflict: An Instrumental Case Study of the Leadership Dyad of John Lennon and Paul McCartney." Ph.D. diss., Adriam Dominican School of Education of Barry University, Florida, 2001.

Kozinn. *The Beatles*. London: Phaidon Press, 1995.

Leigh. *The Best of Fellas: The Story of Bob Wooler*. Liverpool: Drivegreen Publications, 2002.

Lewisohn. *The Beatles Recording Sessions: The Official Abbey Road Session Notes, 1962–1970*. New York: Harmony Books, 1988.

———. *The Complete Beatles Chronicle*. London: Hamlyn, 1992.

McCabe and Schonfeld. *Apple to the Core*. New York: Pocket Books, 1972.

MacDonald. *Revolution in the Head: The Beatles Records and the Sixties*. London: Pimlico, 1998.

McKeen. *The Beatles: A Bio-Bibliography*. New York: Greenwood Press, 1989.

McKinney. *Magic Circles: The Beatles in Dream and History*. Cambridge, MA: Harvard University Press, 2003.

Magnus. *All You Need Is Love: The Beatles Dress Rehearsal*. Chorley, Lancashire, Eng.: Tracks, 1997.

Miles. *The Beatles Diary*. Vol. 1, *The Beatles Years*. London: Omnibus Press, 2001.

Neaverson. *The Beatles Movies*. London: Cassell, 1997.

Norman. *Shout! The Beatles in Their Generation*. New York: Simon & Schuster, 1981.

O'Donnell. *The Day John Met Paul*. New York: Hall of Fame Books, 1994.

Parkinson. *The Beatles Book*. London: Hutchinson, 1964.

Rayl. *Beatles '64: A Hard Day's Night in America*. New York: Doubleday, 1989.

Riley. *Tell Me Why: The Beatles: Album by Album, Song by Song, the Sixties and After*. Cambridge, MA: Da Capo Press, 2002.

Robertson. *The Art and Music of John Lennon*. New York: Citadel Press, 1993.

Robertson and Humphries. *The Beatles: The Complete Guide to Their Music*. London: Omnibus Press, 2004.

Salewicz. *McCartney*. New York: St. Martin's, 1986.

Schaffner. *The Beatles Forever*. New York: McGraw-Hill, 1977.

Semmel. "The Pepperland Perspective: A Study in the Rhetorical Vision of the Beatles." Ph.D. diss., Bowling Green State University, Ohio, 1980.

Shepherd. *The True Story of the Beatles*. London: Beat Publications, 1964.

Shevey. *The Other Side of Lennon*. London: Sidgwick & Jackson, 1990.

L. Smith. "The Beatles as Act: A Study of Control in a Musical Group." Ph.D. diss., University of Illinois at Urbana-Champaign, 1970.

Spizer. *The Beatles Are Coming: The Birth of Beatlemania in America*. New Orleans: 498 Productions, 2003.

Stokes. *The Beatles*. London: Omnibus Press, 1981.

Sullivan. *The Beatles with Lacan: Rock 'n' Roll as Requiem for the Modern Age*. New York: Peter Lang, 1995.

Terry, ed. *Here, There, and Everywhere: The First International Beatles Bibliography, 1962–1982*. Ann Arbor, MI: Pierian Press, 1985.

Tremlett. *The Paul McCartney Story*. New York: Popular Library, 1977.

Turner. *A Hard Day's Write: The Stories Behind Every Beatles Song*. London: Carlton, 2000.

20 Forthlin Road (A National Trust pamphlet handed out at the site).

Wiener. *Come Together: John Lennon in His Time*. New York: Random House, 1984.

Yule. *Richard Lester and the Beatles*. New York: Primus, 1994.

G. GENERAL WORKS

Aberbach. *Surviving Trauma: Loss, Literature, and Psychoanalysis*. New Haven, CT: Yale University Press, 1989.

Ackroyd. *Albion: The Origins of the English Imagination*. London: Chatto & Windus, 2002.

———. *Dressing Up: Transvestitism and Drag, the History of an Obsession*. London: Thames & Hudson, 1979.

Adam. *A Woman's Place, 1910–1975*. New York: W.W. Norton, 1977.

Adams. *Dandies and Desert Saints: Styles of Victorian Masculinity*. Ithaca, NY: Cornell University Press, 1995.

Aldgate, Chapman, and Marwick, eds. *Windows on the Sixties: Exploring Key Texts of Media and Culture*. London: I.B. Tauris, 2000.

Allyn. *Make Love Not War: The Sexual Revolution; An Unfettered History*. Boston: Little, Brown, 2000.

Altman. *The Homosexualization of America, the Americanization of the Homosexual*. New York: St. Martin's 1982.

Altschuler. *All Shook Up: How Rock 'n' Roll Changed America*. Oxford: Oxford University Press, 2003.

Anderson. *The Movement and the Sixties*. New York: Oxford University Press, 1995.

Anson. *Gone Crazy and Back Again: The Rise and Fall of the Rolling Stone Generation*. Garden City, NY: Doubleday, 1981.

Appleford. *The Rolling Stones It's Only Rock 'n' Roll: The Stories Behind Every Song*. London: Carlton Books, 1997.

Aughton. *Liverpool: A People's History*. Preston, Eng.: Carnegie Press, 1990.

Aya and Miller, eds. *The New American Revolution.* New York: Free Press, 1971.

D. Bailey and Evans. *Goodbye Baby and Amen: A Saraband for the Sixties.* New York: Coward-McCann, 1969.

Baker and Stanley. *Hello Sailor! The Hidden History of Gay Life at Sea.* London: Longman, 2003.

Balfour. *Rock Wives: The Hard Times and Good Lives of the Wives, Girlfriends, and Groupies of Rock and Roll.* New York: Beech Tree Books, 1986.

Bayles. *Hole in Our Soul: The Loss of Beauty and Meaning in American Popular Music.* New York: Free Press, 1994.

Bayton. *Frock Rock: Women Performing Popular Music.* Oxford: Oxford University Press, 1998.

Belchem. *Merseypride: Essays in Liverpool Exceptionalism.* Liverpool: Liverpool University Press, 2000.

Bell-Metereau. *Hollywood Androgyny.* New York: Columbia University Press, 1993.

Belz. *The Story of Rock.* New York: Harper Colophon 1969.

Berman. *A Tale of Two Utopias: The Political Journey of the Generation of 1968.* New York: W.W. Norton, 1996.

Betrock. *Girl Groups: The Story of a Sound.* New York: Delilah Books, 1982.

Binda, ed. *America's Musical Pulse: Popular Music in Twentieth-Century Society.* Westport, CT: Greenwood Press, 1992.

C. Black. *Cilla Black: What's It All About.* London: Ebury Press, 2003.

Bloom and Breines, eds. *"Takin' It to the Streets": A Sixties Reader.* New York: Oxford University Press, 2003.

Bogdanor and Skidelsky, eds. *The Age of Affluence, 1951–1964.* London: Macmillan, 1970.

Bolt. *The Women's Movements in the United States and Britain from the 1790s to the 1920s.* Amherst: University of Massachusetts Press, 1993.

Bolt. *Feminist Ferment: "The Woman Question" in the USA and England from the 1790s to the 1920s.* London: UCL Press, 1995.

Booker. *The Neophiliacs.* London: Fontana / Collins, 1970.

Booth. *American Popular Music: A Reference Guide.* Westport, CT: Greenwood Press, 1983.

Bowen. *A Gallery to Play To: The Story of the Mersey Poets.* Exeter, Eng.: Stride, 1999.

Bracewell. *England Is Mine: Pop Life in Albion from Wilde to Goldie.* London: Flamingo, 1998.

Braunstein and Doyle, eds. *Imagine Nation: The American Counterculture of the 1960s and '70s.* New York: Routledge, 2002.

Braybon and Summerfield. *Out of the Cage: Women's Experiences in Two World Wars.* London: Pandora Press, 1987.

Bret. *George Formby: A Troubled Genius.* London: Robson Books, 1999.

Bristow. *Effeminate England: Homoerotic Writing After 1885*. New York: Columbia University Press, 1995.

Bronson. *The* Billboard *Book of Number One Hits*. New York: Billboard Publications, 1985.

Bruley. *Women in Britain Since 1900*. New York: Macmillan, 1999.

Bryer. *The History of Hair: Fashion and Fantasy down the Ages*. Wappinger Falls, NY: Philip Wilson Publishers, 2000.

Bufwack and Oermann. *Finding Her Voice: The Saga of Women in Country Music*. New York: Crown, 1993.

Bullough and Bullough. *Cross Dressing, Sex, and Gender*. Philadelphia: University of Pennsylvania Press, 1993.

Burchill. *Girls on Film*. New York: Pantheon, 1986.

Burg. *Sodomy and the Pirate Tradition: English Sea Rovers in the Seventeenth-Century Caribbean*. New York: New York University Press, 1995.

Buruma. *Anglomania: A European Love Affair*. New York: Random House, 1998.

Carpenter. *A Great, Silly Grin: The British Satire Boom of the 1960s*. New York: Public Affairs, 2002.

Caute. *The Year of the Barricades: A Journey Through 1968*. New York: Harper & Row, 1998.

Chambers. *Urban Rhythms: Pop Music and Popular Culture*. New York: St. Martin's, 1985.

Chandler. *Liverpool and Literature*. Liverpool: Rondo Publications, 1974.

Channon. *Portrait of Liverpool*. London: Robert Hale, 1972.

Chapple and Garofolo. *Rock 'n' Roll Is Here to Pay: The History and Politics of the Music Industry*. Chicago: Nelson-Hall, 1977.

Christgau. *Any Old Way You Choose It: Rock and Other Pop Music, 1967–1973*. Baltimore: Penguin, 1973.

———. *Grown Up All Wrong: Seventy-five Great Rock and Pop Artists from Vaudeville to Techno*. Cambridge, MA: Harvard University Press, 1998.

Clarke. *The Rise and Fall of Popular Music*. New York: St. Martin's, 1995.

Cleaver. *Soul on Ice*. New York: McGraw-Hill, 1967.

Cohen. *Rock Culture in Liverpool*. Oxford: Clarendon Press, 1991.

Cohn. *Awopbopaloobop Alopbamboom: Pop from the Beginning*. London: Minerva, 1996.

Connolly. *Stardust Memories: Talking About My Generation*. London: Pavilion, 1983.

———, ed. *In the Sixties*. London: Pavilion, 1995.

Conrad. *Modern Times, Modern Places*. New York: Knopf, 1999.

Cooper. *Hair: Sex, Society, and Symbolism*. London: Aldus Books, 1971.

Corson. *Fashions in Hair: The First Five Thousand Years*. New York: Hastings House, 1965.

Costello. *Love, Sex, and War: Changing Values, 1939–45*. London: Collins, 1985.

Crawford. *America's Musical Life: A History*. New York: W.W. Norton, 2001.

Cullen. *Born in the U.S.A.: Bruce Springsteen and the American Tradition*. New York: HarperCollins, 1997.

Curtis. *Rock Eras: Interpretations of Music and Society, 1954–1984*. Bowling Green, OH: Bowling Green University Popular Press, 1987.

Daniel. *Lost Revolutions: The South in the 1950s*. Chapel Hill: University of North Carolina Press, 2000.

Davidman. *Motherloss*. Berkeley: University of California Press, 2000.

P. Davies. *Arthur Ballard: Liverpool Artist and Teacher*. Abertillery, Eng.: Old Bakehouse Publications, 1996.

DeCurtis and Henke, eds. *The Rolling Stone Illustrated History of Rock and Roll: The Definitive History of the Most Important Artists and Their Music*. New York: Random House, 1992.

D'Emilio. *Sexual Politics, Sexual Communities: The Making of a Homosexual Minority in the United States, 1940–1970*. Chicago: University of Chicago Press, 1983.

Dever. *Death and the Mother from Dickens to Freud: Victorian Fiction and the Anxiety of Origins*. Cambridge: Cambridge University Press, 1998.

Dewe. *The Skiffle Craze*. Aberystwyth, Wales: Planet, 1998.

Dickerson. *Women on Top: The Quiet Revolution That's Rocking the Music Industry*. New York: Billboard Books, 1998.

Dickstein. *Gates of Eden: American Culture in the Sixties*. Cambridge, MA.: Harvard University Press, 1997.

Douglas. *Where the Girls Are: Growing Up Female with the Mass Media*. New York: Times Books, 1994.

Dudley, ed. *The 1960s*. San Diego: Greenhaven Press, 2000.

Dunnan. *The Amy Vanderbilt Complete Book of Etiquette: Fiftieth Anniversary Edition*. New York: Doubleday, 1995.

Du Noyer. *Liverpool: Wondrous Place Music from Cavern to Cream*. London: Virgin Books, 2002.

Eck. *A New Religious America: How a "Christian Country" Has Become the World's Most Religiously Diverse Nation*. San Francisco: HarperCollins, 2002.

Edelman. *Motherless Daughters: The Legacy of Loss*. Reading, MA: Addison-Wesley, 1994.

Ehrenreich. *The Hearts of Men: American Dreams and the Flight from Commitment*. Garden City, NY: Anchor Press, 1983.

Ehrenreich, Hess, and Jacobs. *Remaking Love: The Feminization of Sex*. Garden City, NY: Anchor Press / Doubleday, 1986.

Eilberg-Schwartz and W. Doniger. *Off with Her Head! The Denial of Women's Identity in Myth, Religion, and Culture*. Berkeley: University of California Press, 1995.

Eisen, ed. *The Age of Rock: Sounds of the American Cultural Revolution*. New York: Vintage Books, 1969.

Ennis. *The Seventh Stream: The Emergence of Rock 'n' Roll in American Popular Music*. Hanover, NH: Wesleyan University Press, 1992.

L. Evans. *Women, Sex, and Rock 'n' Roll: In Their Own Words*. London: Pandora, 1994.

P. Everett. *You'll Never Be Sixteen Again: An Illustrated History of the British Teenager*. London: BBC Publications, 1986.

Faithfull with Dalton. *Faithfull*. London: Penguin, 1994.

Farber. *The Age of Great Dreams: America in the 1960s*. New York: Hill & Wang, 1994.

———, ed. *The Sixties: From Memory to History*. Chapel Hill: University of North Carolina Press, 1994.

Farber and B. Bailey. *The Columbia Guide to America in the 1960s*. New York: Columbia University Press, 2001.

Farnes. *The Goons: The Story*. London: Virgin, 1997.

Farrell. *Collaborative Circles: Friendship Dynamics and Creative Work*. Chicago: University of Chicago Press, 2001.

Fasteau. *The Male Machine*. New York: McGraw-Hill, 1974.

Ferris. *Sex and the British: A Twentieth-Century History*. London: Michael Joseph, 1993.

Fischer. *Albion's Seed: Four British Folkways in America*. New York: Oxford University Press, 1989.

Fisher and K. Davis, eds. *Negotiating at the Margins: The Gendered Discourses of Power and Resistance*. New Brunswick, NJ: Rutgers University Press, 1993.

Fletcher. *Gender, Sex, and Subordination in England, 1500–1800*. New Haven, CT: Yale University Press, 1995.

Fong-Torres, ed. *The Rolling Stone Rock 'n' Roll Reader*. New York: Bantam Books, 1974.

Forte. *The American Popular Ballad of the Golden Era, 1924–1950*. Princeton, NJ: Princeton University Press, 1995.

Fox. *The Personality of Britain: Its Influence on Inhabitant and Invader in Prehistoric and Early Historic Times*. Cardiff: National Museum of Wales, 1959.

Frank. *The Conquest of Cool: Business Culture, Counterculture, and the Rise of Hip Consumerism*. Chicago: University of Chicago Press, 1997.

Friedlander. *Rock and Roll: A Social History*. Boulder, CO: Westview Press, 1996.

Frith. *Sound Effects: Youth, Leisure, and the Politics of Rock 'n' Roll*. New York: Pantheon, 1981.

Frith and Goodwin, eds. *On Record: Rock, Pop, and the Written Word*. New York: Pantheon, 1990.

Frith and Horne. *Art into Pop*. London: Methuen, 1987.

Frith, Straw, and Street, eds. *The Cambridge Companion to Pop and Rock.* Cambridge: Cambridge University Press, 2001.

Furia. *The Poets of Tin Pan Alley.* New York: Oxford University Press, 1990.

Gaar. *She's a Rebel: The History of Women in Rock and Roll.* Seattle: Seal Press, 1992.

Gabler. *Life: The Movie: How Entertainment Conquered Reality.* New York: Vintage Books, 1998.

Gaines. *Heroes and Villains: The True Story of the Beach Boys.* New York: Da Capo Press, 1995.

Garber. *Vested Interests: Cross-Dressing and Cultural Anxiety.* New York: Routledge, 1992.

Gardiner. *From the Bomb to the Beatles.* London: Collins & Brown, 1999.

Giles. *Women, Identity, and Private Life in Britain, 1900–1950.* New York: St. Martin's, 1995.

Gill. *Queer Noises: Male and Female Homosexuality in Twentieth-Century Music.* Minneapolis: University of Minnesota Press, 1995.

Gillett. *The Sound of the City: The Rise of Rock 'n' Roll.* New York: Dell, 1970.

Gillis. *For Better, for Worse: British Marriages, 1600 to the Present.* New York: Oxford University Press, 1985.

Gilmore. *Night Beat: A Shadow History of Rock and Roll.* New York: Doubleday, 1998.

Gitlin. *The Sixties: Years of Hope, Days of Rage.* New York: Bantam, 1987.

Gladwell. *The Tipping Point: How Little Things Can Make a Big Difference.* Boston: Little, Brown, 2000.

Goldman. *Freakshow.* New York: Atheneum, 1971.

Goldstein, ed. *The Poetry of Rock.* New York: Bantam, 1969.

Gorer. *Exploring English Character.* New York: Criterion, 1955.

Gosling. *Personal Copy: A Memoir of the Sixties.* London: Faber & Faber, 1980.

Grant. *Sexing the Millennium: Women and the Sexual Revolution.* New York: Grove Press, 1994.

Green. *All Dressed Up: The Sixties and the Counter-Culture.* London: Jonathan Cape, 1998.

———. *It: Sex Since the Sixties.* London: Secker & Warburg, 1993.

Gunther. *Media Days.* Guildford, Eng.: Genesis Publications, 2000.

Hajdu. *Positively Fourth Street: The Lives and Times of Joan Baez, Bob Dylan, Mimi Baez Farina, and Richard Farina.* New York: North Point Press/Farrar Straus Giroux, 2001.

Hall. *Sex, Gender, and Social Change in Britain Since 1880.* New York: St. Martin's, 2000.

Hamburger. *Liszt.* Budapest: Corvina, 1987.

Hamilton. *The ABC-CLIO Companion to the 1960s Counterculture in America.* Santa Barbara: ABC-CLIO, 1997.

Hamm. *Yesterdays: Popular Song in America*. New York: W.W. Norton, 1983.

Hammond. *Love Between Men in English Literature*. New York: Macmillan, 1996.

Haskell and Hanhardt. *Yoko Ono, Arias and Objects*. Salt Lake City: Peregrine Smith Books, 1991.

Haste. *Rules of Desire: Sex in Britain; World War I to the Present*. London: Chatto & Windus, 1992.

Heilbrun. *Toward a Recognition of Androgyny*. New York: Knopf, 1973.

Henke and Puterbaugh. *I Want to Take You Higher: The Psychedelic Era, 1965–1969*. San Francisco: Chronicle Books, 1997.

Heron, ed. *Truth, Dare, or Promise: Girls Growing Up in the Fifties*. London: Virago, 1985.

Hewison. *Too Much: Art and Society in the Sixties, 1960–75*. London: Methuen, 1986.

Heylin. *Dylan: Behind the Shades*. London: Penguin, 1991.

Hickman. *The Sexual Century*. London: Carlton, 1999.

Higgins. *Heterosexual Dictatorship: Male Homosexuality in Postwar Britain*. London: Fourth Estate, 1996.

Hodgson. *America in Our Time*. New York: Vintage Books, 1978.

———. *More Equal Than Others: America from Nixon to the New Century*. Princeton, NJ: Princeton University Press, 2004.

Holloway, ed. *The Daily Telegraph, The Fifties: A Unique Chronicle of the Decade*. London: Simon & Schuster, 1991.

Horner and Swiss, eds. *Key Terms in Popular Music and Culture*. Malden, MA: Blackwell Publishers, 1999.

Horwitz. "Persona and Spectacle in the Films of Elvis Presley and the Beatles." Ph.D. diss., University of California at Los Angeles, 1990.

Hoskyns. *Beneath the Diamond Sky: Haight-Ashbury, 1965–1970*. New York: Simon & Schuster, 1997.

Hutchison. *High Sixties: The Summers of Riot and Love*. Edinburgh: Mainstream Publishing, 1992.

Hyde. *The Other Love: An Historical and Contemporary Survey of Homosexuality in Britain*. London: Heinemann, 1970.

Iles and Ono. *Yoko Ono: Have You Seen the Horizon Lately?* Oxford: Museum of Modern Art, 1997.

Ingham. *Men: The Male Myth Exposed*. London: Century Publishing, 1984.

Isserman and Kazin. *America Divided: The Civil War of the 1960s*. New York: Oxford University Press, 2000.

Jacobs and Landau. *The New Radicals: A Report with Documents*. New York: Vintage Books, 1966.

Jenkins, ed. *The Children's Culture Reader*. New York: New York University Press, 1998.

K. Jones. *Accent on Privilege: English Identities and Anglophilia in the U.S.* Philadelphia: Temple University Press, 2001.

L. Jones. *Great Expectations: America and the Baby Boom Generation.* New York: Ballantine, 1980.

Kaiser. *1968 in America: Music, Politics, Chaos, Counterculture, and the Shaping of a Generation.* New York: Weidenfeld & Getty, 1988.

Kasson. *Houdini, Tarzan, and the Perfect Man: The White Male Body and the Challenge of Modernity in America.* New York: Hill & Wang, 2001.

Keil. *Urban Blues.* Chicago: University of Chicago Press, 1966.

Kelly. *The Beatle Myth: The British Invasion of American Popular Music, 1956–1969.* Jefferson, NC: McFarland & Company, 1991.

Kent. *Making Peace: The Reconstruction of Gender in Interwar Britain.* Princeton, NJ: Princeton University Press, 1993.

G. Kimball, ed. *Women's Culture: The Women's Renaissance of the Seventies.* Metuchen, NJ: Scarecrow Press, 1981.

R. Kimball. *The Long March: How the Cultural Revolution of the 1960s Changed America.* San Francisco: Encounter Books, 2000.

Kirk. *A Boy Called Mary: Kris Kirk's Greatest Hits.* Brighton: Millivres Books, 1999.

Koestenbaum. *Double Talk: The Erotics of Male Literary Collaboration.* New York: Routledge, 1989.

Kureishi and Savage, eds. *The Faber Book of Pop.* London: Faber & Faber, 1995.

Kurlansky. *1968: The Year That Rocked the World.* New York: Ballantine Books, 2004.

Laing. *The Sound of Our Time.* Chicago: Quadrangle Books, 1970.

Landau. *It's Too Late to Stop Now: A Rock and Roll Journal.* San Francisco: Straight Arrow Press, 1972.

Lant. *Blackout: Reinventing Women for Wartime British Cinema.* Princeton, NJ: Princeton University Press, 1991.

Lapham. *The Wish for Kings: Democracy at Bay.* New York: Grove Press, 1993.

Lee. *Folksong and Music Hall.* London: Routledge, 1982.

Leech. *Youthquake: The Growth of a Counterculture Through Two Decades.* London: Sheldon Press, 1973.

Leigh. *Baby That Is Rock and Roll: American Pop, 1954–1963.* Folkestone, Eng.: Finbarr International, 2001.

———. *Brother, Can You Spare a Rhyme? 100 Years of Hit Songwriting.* Southport, Eng.: Spencer Leigh, 2000.

———. *Let's Go Down the Cavern: The Story of Liverpool's Merseybeat.* London: Vermilion, 1984.

Leuchtenberg. *A Troubled Feast: American Society Since 1945.* Rev. ed. Boston: Little, Brown, 1979.

Levin. *The Pendulum Years: Britain and the Sixties.* London: Jonathan Cape, 1970.

Levy. *Ready, Steady, Go! Swinging London and the Invention of Cool*. London: Fourth Estate, 2002.

Lewis, ed. *The Adoring Audience: Fan Culture and Popular Media*. London: Routledge, 1992.

Lipsitz. *Time Passages: Collective Memory and American Popular Culture*. Minneapolis: University of Minnesota Press, 1990.

Longmate. *How We Lived Then: A History of Everyday Life During the Second World War*. London: Hutchinson, 1971.

Lucie-Smith, ed. *The Liverpool Scene*. London: Donald Carroll, 1967.

Lurie. *The Language of Clothes*. New York: Random House, 1981.

Lydon and Mandel. *Boogie Lightning: How Music Became Electric*. New York: Da Capo Press, 1980.

Lyons. *New Left, New Right, and the Legacy of the Sixties*. Philadelphia: Temple University Press, 1996.

McAleer. *Hit Parade Heroes: British Beat Before the Beatles*. London: Hamlyn, 1993.

McClary. *Feminine Endings: Music, Gender, and Sexuality*. Minneapolis: University of Minnesota Press, 1991.

McClelland and Scher. *Postwar German Culture: An Anthology*. New York: Dutton, 1974.

McDevitt. *Skiffle: The Definitive Inside Story*. London: Robson Books, 1997.

Macedo, ed. *Reassessing the Sixties: Debating the Political and Cultural Legacy*. New York: W.W. Norton, 1997.

Maitland, ed. *Very Heaven: Looking Back at the 1960s*. London: Virago, 1988.

Makower. *Boom: Talkin' About Our Generation*. Chicago: Tilden Press, 1985.

Maltby. *Popular Culture in the Twentieth Century*. London: Grange Books, 1994.

Mangan and Walvin, eds. *Manliness and Morality: Middle-Class Masculinity in Britain and America, 1800–1940*. New York: St. Martin's, 1987.

Marcus. *Dead Elvis: A Chronicle of a Cultural Obsession*. New York: Doubleday, 1991.

———. *Mystery Train: Images of America in Rock 'n' Roll Music*. New York: Dutton, 1982.

———. *Ranters and Crowd Pleasers: Punk in Rock Music, 1977–82*. New York: Anchor, 1993.

Margolis. *The Last Innocent Year: America in 1964*. New York: William Morrow, 1999.

Marsh. *Before I Get Old: The Story of the Who*. New York: St. Martin's, 1983.

———. *The Heart of Rock and Soul: The 1001 Greatest Singles Ever Made*. New York: New American Library, 1989.

Marsh and Swenson, eds. *The New Rolling Stone Record Guide*. New York: Random House, 1983.

Martin. *Avant Rock: Experimental Music from the Beatles to Bjork*. Chicago: Open Court, 2002.

Marwick. *British Society Since 1945*. London: Penguin, 2003.

———. *The Sixties: Cultural Revolution in Britain, France, Italy, and the United States, c. 1958–c. 1974*. Oxford: Oxford University Press, 1998.

Masters. *The Swinging Sixties*. London: Constable, 1985.

Matusow. *The Unraveling of America*. New York: Harper & Row, 1984.

L. May, ed. *Recasting America: Culture and Politics in the Age of Cold War*. Chicago: University of Chicago Press, 1989.

Maynard. *Looking Back: A Chronicle of Growing Up Old in the Sixties*. Garden City, NY: Doubleday, 1973.

Mellers. *Angels of the Night: Popular Female Singers of Our Time*. Oxford: Basil Blackwell, 1986.

———. *Twilight of the Gods: The Music of the Beatles*. New York: Viking, 1973.

Melly. *Revolt into Style: The Pop Arts*. New York: Anchor, 1971.

B. Miles. *In the Sixties*. London: Pimlico, 2003.

G. Miles. *English Humour for Beginners*. London: Andre Deutsch, 1980.

J. Miller. *Flowers in the Dustbin: The Rise of Rock and Roll, 1947–1977*. New York: Simon & Schuster, 1999.

M. Miller. *Boxed In: The Culture of TV*. Evanston, IL.: Northwestern University Press, 1988.

T. Miller. *The Hippies and American Values*. Knoxville: University of Tennessee Press, 1991.

Moorefield. "From the Illusion of Reality to the Reality of Illusion: The Changing Role of the Producer in the Pop Recording Studio." Ph.D. diss., Princeton University, 2001.

Moorhouse. *Britain in the Sixties: The Other England*. Baltimore: Penguin, 1964.

E. Morgan. *The Sixties Experience: Hard Lessons About Modern America*. Philadelphia: Temple University Press, 1991.

K. Morgan. *Britain Since 1945: The People's Peace*. Oxford: Oxford University Press, 2001.

Morris. *A Time of Passion: America, 1960–1980*. New York: Penguin, 1986.

Mosse. *Nationalism and Sexuality: Middle-Class Morality and Sexual Norms in Modern Europe*. Madison: University of Wisconsin Press, 1985.

Murray. *Crosstown Traffic: Jimi Hendrix and the Post-War Rock 'n' Roll Revolution*. New York: St. Martin's, 1989.

———. *Shots from the Hip*. London: Penguin, 1991.

Nanry, ed. *American Music: From Storyville to Woodstock*. New Brunswick, NJ: Transaction Books, 1972.

Napier-Bell. *Black Vinyl White Powder*. London: Ebury Press, 2002.

———. *You Don't Have to Say You Love Me*. London: Ebury Press, 1998.

Nasaw. *Going Out: The Rise and Fall of Public Amusements.* New York: Basic Books, 1993.

Nehring. *Flowers in the Dustbin: Culture, Anarchy, and Postwar England.* Ann Arbor: University of Michigan Press, 1993.

Neville. *Hippie Hippie Shake: The Dreams, the Trips, the Trials, the Love-ins, the Screw-ups . . . the Sixties.* London: Bloomsbury, 1995.

Norman. *The Road Goes On Forever: Portraits from a Journey Through Contemporary Music.* London: Elm Tree Books, 1982.

Nuttall. *Bomb Culture.* London: Paladin, 1970.

O'Brien. *She Bop: The Definitive History of Women in Rock, Pop, and Soul.* New York: Penguin, 1996.

Obst, ed. *The Sixties: The Decade Remembered Now by the People Who Lived It Then.* New York: Rolling Stone / Random House, 1977.

Oldham. *Stoned: A Memoir of London in the 1960s.* New York: St. Martin's, 2000.

O'Neill, ed. *The Woman Movement: Feminism in the United States and England.* Chicago: Quadrangle Books, 1971.

Paglia. *Sex, Art, and American Culture: Essays.* New York: Vintage, 1992.

———. *Sexual Personae: Art and Decadence from Nefertiti to Emily Dickinson.* New Haven, CT: Yale University Press, 1990.

———. *Vamps and Tramps: New Essays.* New York: Vintage, 1994.

Palladino. *Teenagers: An American History.* New York: Basic Books, 1996.

R. Palmer. *Rock and Roll: An Unruly History.* New York: Harmony, 1995.

T. Palmer. *All You Need Is Love: The Story of Popular Music.* New York: Grossman, 1976.

———. *Born Under a Bad Sign.* London: William Kimber, 1970.

Pavletich. *Rock-a-Bye Baby.* Garden City, NY: Doubleday, 1980.

Paxman. *The English: Portrait of a People.* London: Penguin 1999.

Perenyi. *Liszt: The Artist as Romantic Hero.* Boston: Little, Brown, 1974.

Pilcher. *Women of Their Time: Generation, Gender Issues, and Feminism.* Aldershot, Eng.: Ashgate, 1998.

Pinchbeck. *Breaking Open the Head: A Psychedelic Journey into the Heart of Contemporary Shamanism.* New York: Broadway, 2002.

Porter and Hall. *The Facts of Life: The Creation of Sexual Knowledge in Britain.* New Haven, CT: Yale University Press, 1995.

Pountain and Robins. *Cool Rules: Anatomy of an Attitude.* London: Reaktion Books, 2000.

Prendergrast. *The Ambient Century: From Mahler to Trance—the Evolution of Sound in the Electronic Age.* London: Bloomsbury, 2000.

Pressley. *The Best of Times: Growing Up in Britain in the 1950s.* London: Michael O'Mara, 1999.

Radner and Luckett, eds. *Swinging Single: Representing Sexuality in the 1960s.* Minneapolis: University of Minnesota Press, 1999.

Raymond, ed. *Sexual Politics and Popular Culture.* Bowling Green, OH: Bowling Green State University Press, 1990.

Rediker. *Between the Devil and the Deep Blue Sea: Merchant Seamen, Pirates, and the Anglo-American Maritime World, 1700–1750.* Cambridge: Cambridge University Press, 1987.

Reilly. *The 1960s.* Westport, CT: Greenwood Press, 2003.

Reynolds and Press. *The Sex Revolts: Gender, Rebellion, and Rock 'n' Roll.* Cambridge, MA: Harvard University Press, 1995.

Rogan. *Starmakers and Svengalis.* London: Futura, 1988.

Rolling Stone Editors. *The Age of Paranoia.* New York: Pocket, 1972.

Roper and Tosh. *Manful Assertions: Masculinities in Britain Since 1800.* London: Routledge, 1991.

Rorabaugh. *Kennedy and the Promise of the Sixties.* Cambridge: Cambridge University Press, 2002.

Rosen. *The World Split Open: How the Modern Women's Movement Changed America.* New York: Viking, 2000.

Roszak. *The Making of a Counter Culture: Reflections on the Technocratic Society and Its Youthful Opposition.* Garden City, NY: Anchor, 1969.

Rotundo. *American Manhood: Transformations in Masculinity from the Revolution to the Modern Era.* New York: Basic Books, 1993.

Rowbotham. *A Century of Women: The History of Women in Britain and the United States.* New York: Viking, 1997.

Ryback. *Rock Around the Bloc: A History of Rock Music in Eastern Europe and the Soviet Union.* New York: Oxford University Press, 1990.

Sale. *SDS.* New York: Vintage, 1974.

Savage. *Time Travel from the Sex Pistols to Nirvana: Pop Media and Sexuality, 1977–96.* London: Vintage, 1997.

Sayres. Stephanson, Aronowitz, and Jameson. *The Sixties Without Apology.* Minneapolis: University of Minnesota Press, 1984.

Schickel. *Intimate Strangers: The Culture of Celebrity.* Garden City, NY: Doubleday, 1985.

Schneider and Rockhill. *John F. Kennedy Talks to Young People.* New York: Hawthorn, 1968.

Selvin. *Summer of Love: The Inside Story of LSD, Rock and Roll, Free Love, and High Times in the Wild West.* New York: Dutton, 1994.

Senelick. *The Changing Room: Sex, Drag, and Theatre.* London: Routledge, 2000.

Shapiro. *Waiting for the Man: The Story of Drugs and Popular Music.* London: Helter Skelter Publishing, 1999.

Showalter. *Hystories: Hysterical Epidemics and Modern Media*. New York: Columbia University Press, 1997.

———. *Sexual Anarchy: Gender and Culture at Fin de Siecle*. New York: Viking, 1990.

Simon. *Hair: Public, Political, Extremely Personal*. New York: St. Martin's, 2000.

J. Smith. *Off the Record: An Oral History of Popular Music*. London: Pan Books, 1990.

P. Smith, ed. *The Queer Sixties*. New York: Routledge, 1999.

Southall. *Abbey Road: The Story of the World's Most Famous Recording Studio*. Cambridge: Patrick Stephens, 1982.

Spector with Waldron. *Be My Baby: How I Survived Mascara, Miniskirts, and Madness, or My Life as a Fabulous Ronette*. New York: Harmony, 1990.

Spencer. *It Was Thirty Years Ago Today*. London: Bloomsbury, 1994.

Springhall. *Coming of Age: Adolescence in Britain, 1860–1960*. Dublin: Gill and MacMillan, 1986.

Stark. *Glued to the Set: The Sixty Television Shows and Events That Made Us Who We Are Today*. New York: Free Press, 1997.

Steigerwald. *The Sixties and the End of Modern America*. New York: St. Martin's, 1995.

Stephens. *Anti-Disciplinary Protest: Sixties Radicalism and Postmodernism*. Cambridge: Cambridge University Press, 1998.

J. Stern and M. Stern. *Sixties People*. New York: Knopf, 1990.

Stevens. *Storming Heaven: LSD and the American Dream*. New York: Atlantic Monthly Press, 1987.

Steward and Garratt. *Signed, Sealed, and Delivered: True-Life Stories of Women in Pop*. Boston: South End Press, 1984.

Strauss and Howe. *Generations: The History of America's Future, 1584 to 2069*. New York: William Morrow, 1991.

Swiss, Sloop, and Herman, eds. *Mapping the Beat: Popular Music and Contemporary Theory*. Malden, MA: Blackwell Publishers, 1998.

Tarrant. *Ready Steady Go! Growing Up in the Fifties and Sixties*. London: Hamlyn, 1994.

Thaden. *The Maternal Voice in Victorian Fiction: Rewriting the Patriarchal Family*. New York: Garland Publishing, 1997.

Theado, ed. *The Beats: A Literary Reference*. New York: Carroll & Graf, 2001.

Thomson and Gutman, eds. *The Dylan Companion*. New York: Da Capo Press, 2000.

Trumbach. *Sex and the Gender Revolution*. Vol. 1, *Heterosexuality and the Third Gender in Enlightenment London*. Chicago: University of Chicago Press, 1998.

Twiggy. *Twiggy: An Autobiography*. London: Hart-Davis, MacGibbon, 1975.

Tynan. *Tynan Right and Left: Plays, Films, People, Places, and Events*. New York: Atheneum, 1967.

Umansky. *Motherhood Reconceived: Feminism and the Legacies of the Sixties*. New York: New York University Press, 1996.

Van Der Mewe. *Origins of the Popular Style: The Antecedents of Twentieth-Century Popular Music*. Oxford: Clarendon Press, 1989.

Vermorel and Vermorel. *Starlust: The Secret Fantasies of Fans*. London: Comet Books, 1985.

Waksman. *Instruments of Desire: The Electric Guitar and the Shaping of Musical Experience*. Cambridge, MA: Harvard University Press, 1999.

Walker. *Crossovers: Art into Pop/Pop into Art*. London: Comedia Books, 2002.

Walser. *Running with the Devil: Power, Gender, and Madness in Heavy Metal Music*. Hanover, NH: Wesleyan University Press, 1993.

Ward, Stokes, and Tucker. *Rock of Ages: The Rolling Stone History of Rock and Roll*. New York: Rolling Stone Press, 1986.

Watson. *A Terrible Beauty: A History of the People and Ideas that Shaped the Modern Mind*. London: Weidenfeld & Nicolson, 2000.

Weeks. *Sex, Politics, and Society: The Regulation of Sexuality Since 1800*. London: Longman, 1981.

Weight. *Patriots: National Identity in Britain, 1940–2000*. London: Pan Books, 2003.

Wheen. *The Sixties: A Fresh Look at the Decade of Change*. London: Century Publications, 1982.

Whitcomb. *Rock Odyssey: A Musician's Chronicle of the Sixties*. New York: Dolphin Books, 1983.

White, ed. *Lost in Music: Culture, Style, and the Musical Event*. London: Routledge, 1987.

Willis-Pitts. *Liverpool, the Fifth Beatle; An African-American Odyssey*. Littleton, CO: Amozen Press, 2000.

Wolfe. *The Electric Kool-Aid Acid Test*. New York: Farrar, Straus & Giroux, 1976.

Woodfored. *The History of Vanity*. New York: St. Martin's Press, 1992.

Young. *King James and the History of Homosexuality*. New York: New York University Press, 2000.

H. ARTICLES

Complete citations for books referenced in this section are listed in Sections D, E, F, and G.

Abbott. "It's Been a Fab Forty Years for Fans of Rock's Greatest Band." Knight Ridder / Tribune News Service, 12/3/03.

Agajanian. " 'Nothing Like Any Previous Musical, British or American': The Beatles' Film *A Hard Day's Night*," in Aldgate et al., *Windows on the Sixties*.

Alden. "Wild-Eyed Mobs Pursue Beatles: Dozen Girls Injured Here in Fervent Demonstrations." *New York Times,* 2/13/64.

Allan. "A Fab Sister Goes Home Again." *Indianapolis Star and News,* 3/8/98.

Alstrand. "The Evolution of Rock Bass Playing McCartney Style." http://abbeyrd.best.vwh.net/paulbass.htm.

Amis. "Lennon—From Beatle to Househusband." *Observer,* 12/14/80, in Thomson and Gutman, *The Lennon Companion.*

Anderson and Cocks. "Pop Goes the Culture: A National Knack for the Quick, the Vivid, the Exuberant." *Time,* 2/16/86.

"Anecdote—John Lennon—Pudding Bowls." www.anecdotage.com/index.php?aid=8084.

Aronowitz. "The Beatles." www.bigmagic.com/pages/blackj/column16.htm.

———. "The Beatles: Music's Gold Bugs." *Saturday Evening Post,* 3/64.

———. "A Family Album," in Eisen, *The Age of Rock.*

———. "Let's 'Ave a Larf." *Blacklisted Journalist,* 10/1/95.

Ascher-Walsh. "With a Little Help from Their Friend." *Entertainment Weekly,* 4/22/94.

Asthana. "Heard the One About Scouse Comics? Well Soon You Will." *Observer,* 9/14/03.

Badman. "Aussie Rulers!" in *Days of Beatlemania,* Mojo Limited Edition.

———. " 'Long Live Ze King,' " in *1000 Days,* Mojo Limited Edition.

———. "Recording Give Peace a Chance," in *Days of Revolution,* Mojo Limited Edition.

———. "Universal Love," in *1000 Days,* Mojo Limited Edition.

Bailey. "Sexual Revolution(s)," in Farber and Bailey, *Columbia Guide to America.*

Bainbridge. "Across the Mersey." *The Times Magazine* (London), 8/18/01.

———. "Sixties: Where We Went Wrong." *Guardian,* 3/18/93.

Ball. "Popular Music," in Farber and Bailey, *Columbia Guide to America.*

Bamigboye. "Why I Still Believe in Yesterday." *Daily Mail,* 4/1/94.

Bangs. "The Beatles' Moralizing Was Insipid and Self-Righteous," in *Beatle Symposium,* Stereo Review.

———. "The British Invasion," in DeCurtis and Henke, *Rolling Stone Illustrated History.*

———. "Musical Innovations," in Okun, *Compleat Beatles,* vol. 2.

Bannister. "The Beatle Who Became a Man: *Revolver* and George Harrison's Metamorphosis," in Reising, ed., *Every Sound.*

Barker. "The Beatles' Liverpool." *Washington Post,* 12/29/85.

Barrow. "Cruel, Yes, but Lennon Could Be So Vulnerable." *Daily Mail,* 2/16/98.

———. "Paul and John Were Two Huge Talents Ready to Explode," *Daily Mail,* 2/17/98.

———. "The Willing Girls Who Were a Headache for the Beatles." *Daily Mail,* 2/18/98.

Bart. "Keeper of the Beatles." *New York Times,* 9/5/65.

Baxter. "Eyewitness to a Revolution." *Daily Post* (Liverpool), 8/10/01.

———. "Farewell to the Father of Merseybeat." *Daily Post* (Liverpool), 2/19/02.

"A Beatle Named Ringo." *Mersey Beat,* 9/3/64, in Harry, *Mersey Beat.*

"Beatles Are Blamed by Agnew." *The Times* (London), 9/15/70.

"Beatles Are 'Helpful,' Prince Philip Thinks." *New York Times,* 2/26/64.

"Beatles as a World Commodity." *Billboard,* 2/15/64.

"The Beatles Beat a Retreat from Fans in Cleveland." *New York Times,* 8/16/66.

"Beatles End Separation." *New York Times,* 11/16/66.

"Beatles Greeted by Riot at Paris Sports Palace." *New York Times,* 6/21/65.

"Beatles Head Merseyside Tops." *Mersey Beat,* 10/18/62, in Harry, *Mersey Beat.*

"Beatles Record at E.M.I." *Mersey Beat,* 9/20/62, in Harry, *Mersey Beat.*

"Beatles Top 500." *Rolling Stone Daily.* www.rollingstone.com, 11/18/03.

Bell. "Sensibility in the Sixties." *Commentary,* 6/71.

Berdichevsky. "The Sixties Revisited." *Contemporary Review,* 4/99.

Berio. "Comments on Rock." *Nuova Rivista Musicale Italiana* 5–6/67, in Thomson and Gutman, *The Lennon Companion.*

Betts. "From the Other Shore, Beatlemania." www.britannia.com/travel/betts/m2.html.

Bicat. "Fifties Children: Sixties People," in Bognador et al., *The Age of Affluence.*

J. Black. "The Book of the Film of the Mug," in *The Beatles: Band of Century, Q.*

———. "The Eggman Cometh," in *1000 Days,* Mojo Limited Edition.

———. "Enter Allen Klein," in *Days of Revolution,* Mojo Limited Edition.

———. "Going, Going, Gone," in *1000 Days,* Mojo Limited Edition.

———. "The Gong Show," in *The Beatles: Band of Century, Q.*

———. "M. M. Yogi Esq., AKA Sexy Sadie," in *The Beatles: Band of Century, Q.*

———. "Nice Package!" in *Days of Beatlemania,* Mojo Limited Edition.

———. "Roll Up, Roll Up for the Mystery Tour," in *1000 Days,* Mojo Limited Edition.

———. "Scaling the Toppermost," in *Mojo Special Edition: John Lennon.*

———. "Scandal!" in *The Beatles: Band of Century, Q.*

———. "A Slice of History," in *Days of Revolution,* Mojo Limited Edition.

———. "A Tale of Two Cities," in *Days of Beatlemania,* Mojo Limited Edition.

Bottum. "Soundtracking of America." *Atlantic Monthly,* 3/00.

Boyd. "Column for 16 Magazine." *16,* 4/65.

———. "Column for 16 Magazine." *16,* 5/65.

Bracewell. "Give Yoko a Chance." *Guardian,* 1/20/96.

Bradby. "Do-Talk and Don't Talk: The Division of the Subject in Girl-Group Music," in Frith and Goodwin, *On Record.*

Bragg. "Go Lonnie Go." *Guardian,* 6/21/04.

Bramwell. "Suddenly Drugs and Girls Meant Nothing." *Mail on Sunday,* 3/14/99.

Braunstein. "Forever Young: Insurgent Youth and the Sixties Culture of Rejuvenation," in Brownstein and Doyle, *Imagine Nation.*

Bridges and Denisoff. "Changing Courtship Patterns in the Popular Song: Horton and Carey Revisited." *Popular Music and Society* 10 (1986).

Brocken. "Some Other Guys: Some Theories About Signification: Beatles Cover Versions." *Popular Music and Society* (Winter 1996).

Brook. "George Was My First Love." *Mail on Sunday,* 12/02/01.

Brown and Woods. "John Lennon: The Forgotten Family Album." *The Sunday Times* (London), 9/22/96.

Burchill. "Books: According to Paul." *Guardian,* 10/2/97.

Burn. "Such Nice Boys." *Guardian,* 4/12/97.

Burns. "The Myth of the Beatles." *86 South Atlantic Quarterly* (Spring 1987).

———. "Trends in Lyrics in the Annual Top Twenty Songs in the United States, 1963–1972." *Popular Music and Society* 9, no. 1 (1983).

Brown. "Dark Side of the Cake Maker." *Daily Telegraph,* 9/30/96.

Caldwell. "All Things Must Pass." *Weekly Standard,* 11/30/01.

Caldwell and Tarloff. "Posts on *The Beatles Anthology.*" *Slate,* 10/9–10/11/00.

Carey. "Changing Courtship Patterns in the Popular Song." *American Journal of Sociology* 74 (1969).

Carr. "Perhaps One in Five of McCartney's Songs Is Memorable on Any Other Level Than Hummability," in *Beatle Symposium,* Stereo Review.

Casey. "The Silver Beatles." *Mersey Beat,* 6/20/63, in Harry, *Mersey Beat.*

Chasins. "High-Brows vs. No-Brows." *McCall's,* 9/65.

"Chicago Flips Wig; Beatles and Otherwise." *Billboard,* 2/15/64.

Christgau. "Chuck Berry," in DeCurtis and Henke, *Rolling Stone Illustrated History.*

———. "Double Fantasy: Portrait of a Relationship," in Cott and Doudna, *Ballad.*

———. "Pop Before Rock." *Salon,* 10/27/00.

———. "The Rolling Stones," in DeCurtis and Henke, *Rolling Stone Illustrated History.*

———. "Symbolic Comrades." *Village Voice,* 1/14–1/20/81, in Thomson and Gutman, *The Lennon Companion.*

Clayson. "Backbites." *Independent,* 3/4/95.

A. Clayson. "Express Yourself," in *1000 Days,* Mojo Limited Edition.

———. "George Releases the Wonderwall Soundtrack," in *Days of Revolution,* Mojo Limited Edition.

———. "Ringo Records Sentimental Journey," in *Days of Revolution,* Mojo Limited Edition.

———. "Starr Turn," in *Days of Beatlemania,* Mojo Limited Edition.

Clayton-Lea. "The Serenity in Being Saved from a 'Mundane Sort of Life.' " *Irish Times*, 12/01/01.

Cleave. "The Gospel According to Paul." *Evening Standard*, 8/26/93.

———. "How Does a Beatle Live? John Lennon Lives Like This." *Evening Standard*, 3/4/66, in Thomson and Gutman, *The Lennon Companion*.

———. "Music Was His Religion: He Would Play the Guitar for Hours on End." *Evening Standard*, 11/30/01.

———. "My Friend John, the Ghost at the Feast." *Daily Telegraph*, 11/18/95.

———. "Why the Beatles Create All That Frenzy." *Evening Standard*, 2/2/63.

———. "With Thanks, George, from Me to You." *Evening Standard*, 3/13/98.

Coates. "Revolution Now? Rock and the Political Potential of Gender," in Swiss et al., *Mapping the Beat*.

Cohen. "New Slant on the Sixties." *New York Times*, 6/13/98.

Colt. "The Summer of '63." *Life*, 6/93.

Compton. "McCartney or Lennon? Beatle Myths and the Composing of the Lennon-McCartney Songs." *Journal of Popular Culture* 22, no. 2 (1988).

Connolly. "All Our Loving." *Daily Mail*, 4/25/98.

———. "Are John Lennon's Sons Right to Lay Bare Their Father's Legend?" *Daily Mail*, 5/26/98.

———. "Did the Beatles Really Need to Break Up?" *Daily Mail*, 4/1/00.

———. "The Gospel According to Johnny Dean." *Telegraph Magazine*, 9/4/93.

———. "The Greatest Story Ever Told?" *Daily Mail*, 4/3/00.

———. "Happy Behind the Garden Wall." *Daily Mail*, 12/31/99.

———. "How British Pop Once Cast a Spell." *Daily Telegraph*, 4/16/94.

———. "How Linda Won Over the Critics." *Daily Mail*, 4/28/98.

———. "Let It Be, Paul." *Daily Mail*, 5/17/01.

———. "My Return to the Cavern." *Daily Mail*, 12/11/99.

———. "The Reluctant Beatle." *Daily Mail*, 12/1/01.

———. "Ringo Revealed." *Daily Mail*, 9/4/00.

———. "The True Emptiness in John Lennon's Life." *Daily Mail*, 8/26/98.

———. "Why Them? Why Then?" *Daily Telegraph*, 11/18/95.

———. "The World Gently Weeps." *Courier Mail* (Queensland), 12/01/01.

G. Cook and Mercer. "From Me to You: Austerity to Profligacy in the Language of the Beatles," in Inglis, *The Beatles, Popular Music, and Society*.

W. Cook. "Hamburg: Here, There, and Everywhere." *Guardian*, 4/27/02.

Cooper. "Looking Back in Anger," in Bogdanor and Skidelksy, *The Age of Affluence*.

Coppage. "I Still Believe in the Beatles," in *Beatle Symposium*, Stereo Review.

Corliss. "Becoming the Beatles." *Time*, 12/19/94.

Cott. "Buddy Holly," in DeCurtis and Henke, *Rolling Stone Illustrated History*.

———. "John Lennon: How He Became Who He Was," in Cott and Doudna, *Ballad*.

Critchley. "An Interest in All Things British." *The Times* (London), 11/21/69.

Cushley. "The Beatles' Promotional Videos," in *Days of Revolution,* Mojo Limited Edition.

———. "Dream On!" in *1000 Days,* Mojo Limited Edition.

———. "In His Life," in *Days of Beatlemania,* Mojo Limited Edition.

Cutner, Griffin, Cameron, and Waters. "The Beatles." *Life,* 2/84.

Dallos. "Beatles Strike Serious Note in Press Talk." *New York Times,* 8/23/66.

D. Dalton. "Linda McCartney: How Rock 'n' Roll Saved Our Lives." *Gadfly,* 8/98.

———. "My Walk-on in the Life of George." *Gadfly,* 1/3/02.

———. "Once Upon a Beatle." *Gadfly,* 5/14/01.

———. "Wings: On the Wings of a Beatle." *Gadfly,* 2001.

S. Dalton. "Revolution Rock." *Vox,* 6/93.

Danto. "Life in Fluxus." *Nation,* 12/18/00.

E. Davies. "Psychological Characteristics of Beatle Mania." *Journal of the History of Ideas* 30, no. 2 (April–June 1969).

H. Davies. "Complex Character of the Quiet Beatle Who Inspired Creativity." *Express,* 12/01/01.

———. "Introduction to Updated Edition of the Bestselling Authorized Biography," in H. Davies, *The Beatles* (London: Cassell Illustrated, 2004).

———. "It Was an Instant Attraction but John Did Not Make Love for a Year." *Daily Mail,* 11/22/97.

———. "Paperback Writer," in *1000 Days,* Mojo Limited Edition.

———. "Paul Started It All," *Beatles Monthly Book,* vol. 60, 7/68.

———. "We Still Love Them, Yeah, Yeah, Yeah . . ." *Express,* 11/14/00.

———. "When Paul Brought Linda to Our House." *Independent,* 3/11/94.

E. Davis. "On with the Show, Good Health to You," in Davis, *The Beatles Book.*

F. Davis. "In His Own Jukebox." *Atlantic Monthly,* 10/94.

———. "Napoleon in Rags." *Atlantic Monthly,* 5/99.

I. Davis. "Get Back." *Los Angeles Magazine,* 8/94.

Dean. "Paul Talks About." *Beatles Monthly Book,* vol. 46, 5/67.

———. "When Did You Switch On?" *Beatles Monthly Book,* vol. 69, 4/69.

———. "When Did You Switch On?" *Beatles Monthly Book,* vol. 70, 5/69.

Deignan. Review of *Life: The Movie. World and I,* 6/99.

Delingpole. Review of *Black Vinyl White Powder. Sunday Telegraph,* 3/25/01.

DeMain. "Closing the Apple Shop," in *Days of Revolution,* Mojo Limited Edition.

———. "Meat Is Murder," in *1000 Days,* Mojo Limited Edition.

"Despite Rumors of Split, Beatles Cut a Big Melon." *New York Times,* 11/16/66.

Dewhurst. "The Day of the Beatles." *Guardian,* 4/15/70.

Dickson. "She Can Work It Out." *Independent,* 5/29/99.

DiMartino. "Hitsville USA," in *Days of Beatlemania,* Mojo Limited Edition.

———. "John and Yoko Get Naked," in *Days of Revolution*, Mojo Limited Edition.

———. "Matchstick Men," in *1000 Days*, Mojo Limited Edition.

Doggett. "Empire Building," in *Days of Beatlemania*, Mojo Limited Edition.

———. "Fight to the Finish," in *Days of Revolution*, Mojo Limited Edition.

———. "Meet the Parent," in *Days of Beatlemania*, Mojo Limited Edition.

———. "The Other Half," in *1000 Days*, Mojo Limited Edition.

Dolan. "Midnight in the Oasis." www.trancenet.org/personal/dolan/midnight.shtml.

Donegan. "Another Bite of the Apple." *Guardian*, 11/21/95.

Donovan. "Afterword," in *Days of Revolution*, Mojo Limited Edition.

M. Doyle. "Debating the Counterculture: Ecstasy and Anxiety over the Hip Alternative," in Farber and Bailey, *Columbia Guide to America*.

T. Doyle. "The Long Unwinding Road," in *The Beatles: Band of Century*, Q.

———. "A Meditation on the White Album," in *The Beatles: Band of Century*, Q.

DuNoyer, "Across the Universe," in *Days of Beatlemania*, Mojo Limited Edition.

———. "Best of the Beatles," in *The Beatles: Band of Century*, Q.

———. "McCartney/Lennon," in *The Beatles: Band of Century*, Q.

———. "Meet the Wife." *Q*, 4/95.

———. "Mr. Brian Epstein," in *The Beatles: Band of Century*, Q.

"East German Commies Surrender to Beatles; Battle Was Lost Anyway." *Variety*, 4/6/66.

Edelstein. "The Fifth Beatle: Revisiting the Antic Music Richard Lester Made with *A Hard Day's Night*." *Slate*, 12/6/00.

Eden. "Thanks, Goodnight," in *1000 Days*, Mojo Limited Edition.

Eder. "Guys Named Cliff, Tommy, Adam, and Billy," in Goldmine Magazine, *The Beatles Digest*, 1st ed.

———. "Parlophone Records: The Starting Point for the Beatles' Invasion," in Goldmine Magazine, *The Beatles Digest*, 1st ed.

Ehrenhalt. "Talking 'Bout His Generation: Paul Berman Reconsiders 1968." *Slate*, 8/13/96.

Ellen. "The Complete Picture," in *1000 Days*, Mojo Limited Edition.

———. "Eins, Zwei, Drei, Vier," in *The Beatles: Band of Century*, Q.

———. "A Good Yeah!" in *Days of Beatlemania*, Mojo Limited Edition.

M. Elliot. "The Curse of Glory." *Newsweek*, 10/23/95.

Ellis. "Yes, Sir: The Legacy of Zeppo Marx." *Journal of Popular Culture*, 8/03.

Engelhardt. "Talking 'Bout a Revolution." *Nation*, 12/13/99.

Epstein. "Anglophilia, American Style." *American Scholar* 66, Summer 1997.

Espiner. "The *Guardian* Profile: George Martin." *Guardian*, 6/30/01.

———. "Sounds and Vision." *Guardian*, 6/29/01.

Estabrook. "The Beatles Have Landed." *Dartmouth Online*, 2/6/04. www.thedartmouth.com/article.php?aid=2004020605010.

Mal Evans. "Beatles in India." *Beatles Monthly Book,* vol. 58, 5/68.

Mal Evans and Aspinall. "Magical Mystery Tour." *Beatles Monthly Book,* vol. 53, 12/67.

———. "Mal and Neil Tell You How 'All You Need Is Love' Was Recorded." *Beatles Monthly Book,* vol. 49, 8/67.

Mike Evans. "The Arty Teddy Boy," in Thomson and Gutman, *The Lennon Companion.*

Everett. "Beatles' Dinner Party." *Beatles Monthly Book,* vol. 48, 7/67.

———. "Detroit and Memphis: The Soul of *Revolver,*" in Reising, *Every Sound.*

Faggen. "New York City Crawling with Beatlemania." *Billboard,* 2/15/64.

Fair. "Profile in Courreges." *New York Times,* 2/24/02.

Faithfull. "We Love You," in *1000 Days,* Mojo Limited Edition.

"Fame? It's Enough to Make His Guitar Weep," *Sunday Times,* 11/19/00.

Farber. "The Intoxicated State / Illegal Ration: Drugs in the Sixties Counterculture," in Brownstein and Doyle, *Imagine Nation.*

———. "Introduction," in Farber, *The Sixties from Memory.*

———. "The Sixties Legacy: The Destructive Generation or 'Years of Hope?' " in Farber and Bailey, *Columbia Guide to America.*

Fearon. "Suicide or Murder?" *New York Post,* 4/11/00.

Feeney. "Elvis Movies." *American Scholar,* 70 (Winter 2001).

Fitzgerald. "Lennon-McCartney and the Early British Invasion, 1964–66," in Inglis, *The Beatles, Popular Music, and Society.*

———. "Lennon-McCartney and the 'Middle Eight.' " *Popular Music and Society* 20, no. 4 (1996).

———. "Songwriters in the U.S. Top Forty, 1963–1966." *Popular Music and Society* 21, no. 4 (1997).

Flans. "The Fab 4/4," in Goldmine Magazine, *The Beatles Digest,* 1st ed.

Fleischer. "Down the Rabbit Hole," in Davis, *The Beatles Book.*

"For Lenin, Read Lennon." *Guardian,* 11/18/00.

Fox. "Not A Second Time," in Cording et al., *In My Life.*

Freund. "Still Fab: The Beatles and Their Timeless Influence," *Reason,* 6/2001.

Fricke. "Abbey Road," in *Days of Revolution,* Mojo Limited Edition.

———. "Best in Show," in *Days of Beatlemania,* Mojo Limited Edition.

———. "The Holy War," in *1000 Days,* Mojo Limited Edition.

———. "Something About George Harrison," in Okun, *Compleat Beatles,* vol. 2.

Frith. "John Lennon: My Brilliant Career." *New York Rocker,* 3/81.

———. "1967: The Year It All Came Together." *History of Rock* 1 (1981). www.rocksbackpages.com.

———. "Rock and the Politics of Memory," in Sayres et al. *The Sixties Without Apology.*

———. "Why Do Songs Have Words?" in White, *Lost in Music.*

Frith and McRobbie. "Rock and Sexuality," in Frith and Goodwin, *On Record.*

Gaar. "Acting Naturally," in Goldmine Magazine, *The Beatles Digest,* 1st ed.

———. "The Beatles in Hamburg," in Goldmine Magazine, *The Beatles Digest,* 1st ed.

———. "The Long and Winding Road: The Making of the Beatles' Video Anthology," in Goldmine Magazine, *The Beatles Digest,* 1st ed.

———. "A Year in the Life: The Beatles in 1967," in Goldmine Magazine, *The Beatles Digest,* 1st ed.

———. "Yoko Ono: A Spoken-Word Discography," in Goldmine Magazine, *The Beatles Digest,* 1st ed.

Gabler. "Male Bonding." *Modern Maturity,* 1–2/00.

———. "The People's Prince: What JFK Jr. Meant to America." *New Republic,* 8/9/99.

M. Gardner. "The Explosion Heard Round the World." *Christian Science Monitor,* 5/25/04.

P. Gardner. "3,000 Fans Greet British Beatles." *New York Times,* 2/8/64.

Garfield. "An Apple a Day Keeps the Lawyers in Pay." *Independent,* 3/4/90.

Garner. "Greatest Love of All." *Sunday Herald Sun* (Melbourne), 2/2/00.

———. "The Man Who Loved the Beatles." *Daily Mail,* 11/6/99.

———. "Why Sixties Girls Fell for the Scouse Spell." *Daily Telegraph,* 11/18/95.

Garratt. "Teenage Dreams," in Frith and Goodwin, *On Record.*

Geisler. "A Ruined Life: Why There Is No Place in Our Future for the Culture of the 1960s." *American Enterprise,* 5–6/97.

"George Harrison." *Economist,* 12/8/01.

"George's Secret Love Child." *Daily Star,* 12/7/01.

Gilham. "Who Introduced John Lennon to Marijuana in the Sixties?" *Observer,* 9/10/00.

Gill. "Car Sick Blues," in *1000 Days,* Mojo Limited Edition.

———. "Hate Is Too Small a Word." *Spectator,* 8/14/99.

Gilmore. "The Mystery Inside George," in Editors of Rolling Stone, *Harrison.*

Gipp. "Party Lights: Utopic Desire and the Girl Group Sound," in Raymond, *Sexual Politics.*

Gladwell. "Group Think." *New Yorker,* 12/2/02.

Glancey. "What John Saw in Yoko." *Independent,* 1/24/96.

Glass. "Remembering George Harrison." *New York Times,* 12/9/01.

Gleason. "Like a Rolling Stone." American Scholar (Autumn 1967), reprinted in Davis, *The Beatles Book.*

Gold. "The Act You've Known for All These Years: The Beatles and *Sgt. Pepper,*" 1974. www.rocksbackpages.com.

Goldstein. "Are the Beatles Waning?" *New York Times,* 12/31/67, in Davis, *The Beatles Book.*

————. "I Blew My Cool Through the *New York Times*." *Village Voice*, 7/20/67, in Davis, *The Beatles Book*.

————. "*Sgt. Pepper* . . . Was Dazzling but Ultimately Fraudulent," in *Beatle Symposium*, Stereo Review.

Gopnik. "Carry That Weight." *New Yorker*, 5/1/95.

————. "The Invention of Oscar Wilde." *New Yorker*, 5/18/98.

Grace. "Beatles Forever." *Report Newsmagazine*, 1/1/01.

Grant. "My Beloved Liverpool." *Guardian*, 6/5/03.

Greckel. "Rock and Nineteenth-Century Romanticism: Social and Cultural Parallels." *Journal of Musicological Research* 3 (1979).

Green. "*Sgt. Pepper*: A Day in the Life 1967." *St. Petersburg Times*, 6/1/87.

Greenfield. "They Changed Rock, Which Changed the Culture, Which Changed Us." *New York Times Magazine*, 2/16/75.

Gritten. "First Among Beatles." *Daily Telegraph*, 3/12/94.

Gross. "John Lennon: A Shorn Beatle Tries It on His Own." *Look*, 12/13/66.

Guralnick. "Elvis Presley," in DeCurtis and Henke, *Rolling Stone Illustrated History*.

Hajdu. "Hustling Elvis." *New York Review of Books*, 10/9/03.

Hall. "Scene and Heard." *Mersey Beat*, 7/23/64, in Harry, *Mersey Beat*.

Hamm. "Rock 'n' Roll in a Very Strange Society." *Popular Music* 5 (1987).

Hammond. "Body Count." www.geocities.com/hammodotcom/beathoven/body.htm.

————. "The Harrisong." www.geocities.com/hammodotcom/beathoven/harrisx.htm.

————. "McCartney Swings." www.geocities.com/hammodotcom/beathoven/mcswings.htm.

————. "Revolution 9." www.geocities.com/hammodotcom/beathoven/r911.htm.

Hannah. "How Different from the Cavern Days." *Beatles Monthly Book*, vol. 8, 3/64.

Harding. "The Dream Is Over: Lennon in Search of Himself." *Guardian*, 12/21/00.

————. "The Dream Is Over Part II." *Guardian*, 12/21/00.

Hardy. "He's My Secret Beatle Love Child." *Daily Mail*, 5/31/97.

Harlow. "Myth of Linda McCartney's Sex Claims Exposed." *The Sunday Times* (London), 3/19/00.

Harrington. "The Beatles' Helping 'Hand.'" *Washington Post*, 2/16/04.

————. "The Birth of Beatlemania; 25 Years Ago Today, That Sullivan Show." *Washington Post*, 2/9/89.

————. "It Was 20 Years Ago Today . . ." *Washington Post*, 5/31/87.

J. Harris. "All You Need Is Normality." *Independent*, 2/2/00.

————. "At the Crossroad," in *The Beatles: Band of Century*, Q.

————. "Band on the Run," in *The Beatles: Band of Century*, Q.

————. "Banding Together," in *1000 Days*, Mojo Limited Edition.

————. "Bittersweet Sympathy," in *The Beatles: Band of Century*, Q.

————. "Cruel Britannia," in *Days of Revolution*, Mojo Limited Edition.

————. "I Just Believe in Me," in *Mojo Special Edition: John Lennon*.

————. "I'm Still Standing." *Guardian*, 6/11/04.

————. "Lady Madonna," in *Days of Revolution*, Mojo Limited Edition.

————. "Let It Be," in *Days of Revolution*, Mojo Limited Edition.

————. "Poll Position," in *Days of Beatlemania*, Mojo Limited Edition.

————. "Snapper's Delight," in *Days of Beatlemania*, Mojo Limited Edition.

————. "Syntax Man," in *Days of Beatlemania*, Mojo Limited Edition.

————. "Unpeeled," in *The Beatles: Band of Century*, Q.

————. "You Scream, I Scream," in *1000 Days*, Mojo Limited Edition.

P. Harris. "I Am the Sister John Lennon Never Knew." *Daily Mail*, 8/25/98.

"Harrison's First Guitar Sold at Auction." Associated Press, 11/21/03.

B. Harry. "How Motown Fell for Detroit," in Goldmine Magazine, *The Beatles Digest*, 1st ed.

————. "My Mate John Was a Rebel, a Joker, a Livewire, and a Genius . . . Then Yoko Came Along and Changed All of That." *Daily Mail*, 12/3/00.

————. "They Hate You If You're Clever," in *Mojo Special Edition: John Lennon*.

V. Harry. "Mersey Roundabout." *Mersey Beat*, 3/22/62, in Harry, *Mersey Beat*.

Hartman. "Meeting the Beatles." http://abbeyrd.best.vwh.net/story.htm.

Hasted. "Starting Over." *Independent*, 6/24/97.

"He Helped Found the Beatles, Defined Their Style, Died Young." *Independent*, 10/31/01.

Helen and Elliott. "Lennon's Poison-Pen Letter to Paul." *The Sunday Times* (London), 8/05/01.

Heller. "Moll of Kintyre." *Vanity Fair*, 10/92.

Hennessey. "Roll Credits," in *Mojo Special Edition: John Lennon*.

Henry. "The Man Who Put the Beat in the Beatles." *Observer*, 8/2/98.

Hentoff. "I Read the News Today, Oh Boy." *Ramparts*, 11/67, in Davis, *The Beatles Book*.

————. "They May Well Have Surprised Even Themselves," in *Beatle Symposium*, Stereo Review.

Hershberg. "Just Who Did Smash Communism?" *Washington Post*, 6/27/04.

Hibbert. "Britain Invades the World: Mid-Sixties British Music." *History of Rock* 35 (1982) www.rocksbackpages.com.

Hilton. "Ono, Yoko's Got a New Show." *Independent*, 12/7/97.

Hinckley. "A to Z of the Beatles in New York." *New York Daily News*, 11/19/95.

————. "Fab Four Revved Radio Rivalries." *New York Daily News*, 2/9/04.

Hines. "Their First Visit to Hamburg Part One." *Beatles Monthly Book*, vol. 36, 7/66.

Hoberman. "The Films of John and Yoko," in Cott and Doudna, *Ballad*.

Hodson. "Bob Dylan's Stories About Men," in Thomson and Gutman, *The Dylan Companion*.

Hoffman. "Rock and Roll and JFK: A Study of Thematic Changes in Rock and Roll Lyrics Since the Assassination of John F. Kennedy." *Popular Music and Society* 10, no. 2 (1985).

Hogan. "Carry That Weight." *Observer*, 3/9/03.

Hoge. "The House That Can't Forget a Boy with a Guitar." *New York Times*, 5/6/03.

"Honors: Furor over Beatles." *New York Times*, 6/20/65.

Hornby. "Rock of Ages." *New York Times*, 5/21/04.

Horsburgh. "When He Was Fab." *People Weekly*, 12/17/01.

Horton. "Quotes Stand the Test of Time." *Bath Chronicle*, 2/20/99.

Hudson. "The Rivals." *Daily Mail*, 9/27/97.

Hull. "The Sound and Vision of Psychedelia." *Creem*, 1/81.

Humphries. "The Fans Hated Her for Catching a Beatle." *Daily Mail*, 4/20/98.

———. "The Last Beatle Single, Let It Be," in *Days of Revolution*, Mojo Limited Edition.

———. "Picture Perfect," in *1000 Days*, Mojo Limited Edition.

Hunt. "Fantasy Island," in *1000 Days*, Mojo Limited Edition.

———. "From Me to Yule," in *Days of Beatlemania*, Mojo Limited Edition.

———. "Hey Jude," in *Days of Revolution*, Mojo Limited Edition.

Hurn. "Lights, Camera, Action!" in *Days of Beatlemania*, Mojo Limited Edition.

Hutchins. "The Virgin Star Who Captivated a Beatle." *Daily Mail*, 11/18/94.

Hyett. "Waiting on the Beatles," in Cording et al., *In My Life*.

Ingham. "Dear John," in *Days of Beatlemania*, Mojo Limited Edition.

———. "John and Yoko Get Married," in *Days of Revolution*, Mojo Limited Edition.

———. "A Slight Hitch," in *Days of Beatlemania*, Mojo Limited Edition.

Inglis. " 'The Beatles Are Coming!' Conjecture and Conviction in the Myth of Kennedy, America, and the Beatles." *Popular Music and Society* 24, no. 2 (Summer 2000).

———. "Conformity, Status, and Innovation: The Accumulation and Utilization of Idiosyncrasy Credits in the Career of the Beatles." *Popular Music and Society* 19, no. 3 (1995).

———. "Synergies and Reciprocities: The Dynamics of Musical and Professional Interaction Between the Beatles and Bob Dylan." *Popular Music and Society* 20, no. 4 (Winter 1996).

———. "Variations on a Theme." *International Review of the Aesthetics and Sociology of Music* 28 (1997).

Irvin. "The Death of Brian," in *1000 Days*, Mojo Limited Edition.

———. "Different Strokes," in *1000 Days*, Mojo Limited Edition.

———. "Get It Better: The Story of Let It Be . . . Naked." *Mojo*, 2003.

———. "Into Tomorrow," in *1000 Days*, Mojo Limited Edition.

———. "Killer in Manila," in *1000 Days*, Mojo Limited Edition.

———. "Paul Quits the Beatles," in *Days of Revolution*, Mojo Limited Edition.

———. "The Premiere of *Yellow Submarine*," in *Days of Revolution*, Mojo Limited Edition.

"Israel Bans Beatles." *New York Times*, 3/18/64.

" 'I've Thrown Away Thirty Songs,' Says George." *Beatles Monthly Book*, vol. 39, 10/66.

Jackson. "The Model of Hipness." *Sunday Telegraph*, 5/12/96.

K. Jackson. "Rimbaud IV." *Independent*, 9/16/94.

Jahn. "The Beatles: Magical Mystery Tour." *Saturday Review*, 12/67.

James. "In the Studio." *Beatles Monthly Book*, vol. 74, 9/69.

———. "Lennon and McCartney (Songwriters) Ltd." *Beatles Monthly Book*, vol. 2, 9/63.

———. "Why Did They Grow Moustaches?" *Beatles Monthly Book*, vol. 46, 5/67.

———. "Why the Beatles?" *Beatles Monthly Book*, vol. 8, 3/64.

Jays. "The Original Italian Stallion." *Observer*, 11/2/03.

Jenkins. "The Sensuous Child," in Jenkins, *The Children's Culture Reader*.

Johansson. "The Harmonic Language of the Beatles." STM-Online, vol. 2 (1999). musik.uu.se/ssm/stmonline/vol_2-1/KGJO/.

"John Acquires Stuart Painting." *Mersey Beat*, 11/12/64 in Harry, *Mersey Beat*.

"John Lennon." *Mersey Beat*, 12/5/63, in Harry, *Mersey Beat*.

"John Lennon." www.twicefiz.com/52/page4162.htm.

"John Lennon—A Message to Merseyside." *Mersey Beat*, 6/20/63, in Harry, *Mersey Beat*.

"John Lennon and Yoko Ono." *People Weekly*, 2/12/96.

"John's Homes." http://homepage.ntlworld.com/carousel/pob40.html.

Johnson. "They Saw Her Standing There," *People Weekly*, 5/16/94.

Jones. "He Loved Me, Yeah Yeah Yeah." *Daily Mail*, 10/11/97.

———. "Paul Wanted to Control Every Move." *Daily Mail*, 10/13/97.

J. Jones. "Meeting Yoko Ono," in Thomson and Gutman, *The Lennon Companion*.

N. Jones. "The Maharishi and the Meaning of *Sgt. Pepper*," in Editors of Rolling Stone, *Harrison*.

Joyce. "The Man Who Gave Away the Beatles." *Toronto Globe and Mail*, 9/5/92.

Judis. "The Spirit of '68: What Really Caused the Sixties." *New Republic*, 8/31/98.

Kael. "Metamorphosis of the Beatles." *New Yorker*, 11/30/68, in Thomson and Gutman, *The Lennon Companion*.

A. Kahn. "Altered States," in *Days of Beatlemania*, Mojo Limited Edition.

———. "Eric Clapton Guests on 'While My Guitar Gently Weeps,' " in *Days of Revolution*, Mojo Limited Edition.

T. Kahn. "Ten Reasons the Beatles Still Matter." *Boston Globe*, 11/5/95.

Kane. "Beatles over America," in *Days of Beatlemania*, Mojo Limited Edition.

Kaplan. "Teen Spirit: What Was So Important About the Beatles' Appearances on *The Ed Sullivan Show*?" *Slate*, 2/6/04.

Karwowski. "Fifty Years of British Popular Culture." *Contemporary Review*, 11/02.

Kaye. "The Beatles Instrumentality," in Okun, *Compleat Beatles*, vol. 1.

———. "Carry That Weight: Music in the Sixties." *Fusion*, 1/20/70.

Keightly. "Reconsidering Rock," in Thomson and Gutman, *The Lennon Companion*.

Kempton. "The Beatles," in Eisen, *The Age of Rock*.

Kidel. "Poetry You Could Dance To." *Times Literary Supplement*, 9/7/01.

Kimmelman. "Yoko Ono: Painter, Sculptor, Musician, Muse." *New York Times*, 10/27/00.

Kingston. "The Wedding Album." *National Post*, 8/31/00.

Kirchherr. "The Last Word," in *Days of Beatlemania*, Mojo Limited Edition.

Kirk. "In Tokyo," in Cott and Doudna, *Ballad*.

Kozinn. "All You Need Is Transcripts." *New York Times*, 12/25/98.

———. "The Beatles' Producer, Still with Stories to Tell." *New York Times*, 6/17/03.

———. "Looking for the Real John Lennon." *New York Times*, 12/7/00.

———. "Re: A Musical Vindication for Pete Best." www.beatlesagain.com/breflib/petekozn.html.

———. "They Came, They Saw, They Conquered." *New York Times*, 2/6/04.

Kroll. "The Beatles' Breakthrough in the Sixties Was the Most Thrilling Creative Surge in the History of Pop Culture." *Newsweek*. Posted at www.geocities.com/SunsetStrip/Palms/6797/article5.html.

Kureishi. "Boys Like Us." *Guardian*, 11/2/02.

Lacayo. "Linda McCartney's Sixties." *People Weekly*, 11/9/92.

Lahr. "The Beatles Considered." *New Republic*, 12/2/81.

———. "Introduction to *Up Against It*," in Thomson and Gutman, *The Lennon Companion*.

D. Laing and Valentine. "George Harrison." *Manchester Guardian Weekly*, 12/12/01.

R. D. Laing. "They Sought Without Finding." *Rolling Stone*, 2/16/84.

Landau. "Rock 1970—It's Too Late to Stop Now," in Nanry, *American Music*.

Larkin. "Fighting the Fab." *Observer*, 10/9/83.

"LBJ Ignored As N.Y. Crowds Chase Beatles." *Billboard*, 2/15/64.

Leary. "Thank God for the Beatles," in Davis *The Beatles Book*.

Lee. "Real Lives: The Icing Maiden." *Guardian*, 4/9/97.

Lees. "Beatles, Op. 15." *High Fidelity*, 8/68.

Leider. " 'He's Too Foreign.' " *Guardian*, 9/20/03.

Leigh. "The Axe Files," in *Days of Beatlemania*, Mojo Limited Edition.

———. "John Returns His MBE," in *Days of Revolution*, Mojo Limited Edition.

———. "Obituary: Bob Wooler." *Independent*, 2/9/02.

———. "Obituary: Lord Woodbine." *Independent*, 7/7/00.

Lennon. "Beatle John Lennon—His Life Story / Horoscope / Future Plans." *Mirabelle*, 10/12/63.

"Lennon Not to Play Christ." *The Times* (London), 12/5/69.

Leonard. "Lennon Energized High Art with Pop." *New York Times*, 12/14/80.

Leslie. "Before the Beatles' First LP." *Spectator*, 12/15/01.

Levin. "The Day Father Killed Himself." *Daily Mail*, 2/27/98.

Levine. "The Gendered Grammar of Ancient Mediterranean Hair," in Eilberg-Schwartz, *Off with Her Head*.

Lewis. "The Beatles in 1961." *Beatles Monthly Book*, vol. 28, 11/65.

R. Lewis. "Love You, Yeah Yeah Yeah." *Los Angeles Times*, 1/31/04.

Lewisohn. "The Day of Reckoning," in *Days of Beatlemania*, Mojo Limited Edition.

———. "Going for a Song," in *Days of Revolution*, Mojo Limited Edition.

———. "Going Overground," in *Days of Beatlemania*, Mojo Limited Edition.

———. "High Times," in *1000 Days*, Mojo Limited Edition.

———. "I Wanna Be Your Fan," in *Days of Beatlemania*, Mojo Limited Edition.

———. "The Release of Something," in *Days of Revolution*, Mojo Limited Edition.

Lipsitz. "Who'll Stop the Rain? Youth Culture, Rock 'n' Roll and Social Crises," in Farber, *The Sixties from Memory*.

Loder. "The Beatles: The Rock Musicians." *Time*, 6/8/98.

Lowe. "Number 1 with a Bullet," in *The Beatles: Band of Century*, Q.

———. *"Revolver,"* in *The Beatles: Band of Century*, Q.

Lydon. "Lennon and McCartney: Songwriters." Unpublished research file for *Newsweek*, 3/66. www.rocksbackpages.com.

———. "Monterey Pops! An International Pop Festival." Unpublished for *Newsweek*, 6/20/67. www.rockbackpages.com.

———. "When the Beatles Arrived in America." *Yale Daily News*, 2/20/64.

Lyng. "Money (It's Not What I Want)." *Sunday Tribune*, 8/26/01.

Lyon. "More on the Beatles Textual Problem." *Journal of Popular Culture* 4 (1970).

P. McCartney. "Hamburg." *Mersey Beat*, 9/20/62 in Harry, *Mersey Beat*.

McConnell. "Rock and the Politics of Frivolity." *Massachusetts Review* 12 (1971).

I. MacDonald. "Focus: George Harrrison." *Independent on Sunday*, 12/2/01.

———. "Genius and After." *Independent*, 10/28/95.

———. "A Perfect Match," in *Days of Beatlemania*, Mojo Limited Edition.

———. "The Psychedelic Experience," in *1000 Days*, Mojo Limited Edition.

———. "The White Album," in *Days of Revolution*, Mojo Limited Edition.

K. MacDonald and Kaufman. " 'Tomorrow Never Knows': The Contribution of George Martin and His Production Team to the Beatles' New Sound," in Reising, *Every Sound*.

McGrath. "The Plastic Ono Band Play Live in Toronto," in *Days of Revolution*, Mojo Limited Edition.

Maconie. "The Lonesome Death of Brian Epstein," in *The Beatles: Band of Century, Q.*

———. "Na Na Na, Na-Na Na Na," in *The Beatles: Band of Century, Q.*

"The Man Who Discovered the Beatles." *Mersey Beat,* 6/20/63, in Harry, *Mersey Beat.*

Mann. "Beatles Revive Hopes of Progress in Pop Music." *The Times* (London), 5/29/67, in Thomson and Gutman, *The Lennon Companion.*

———. "The New Beatles Album." *The Times* (London), 11/22/68, in Thomson and Gutman, *The Lennon Companion.*

———. "Those Inventive Beatles." *The Times* (London), 12/5/69.

———. "What Songs the Beatles Sang." *The Times* (London), 12/27/63, in Thomson and Gutman, *The Lennon Companion.*

Marcus. "Backbeat." *Artforum,* 3/94.

———. "The Beatles," in DeCurtis and Henke, *Rolling Stone Illustrated History.*

———. "George Harrison Was Not a Brilliant Musician. But That's Beside the Point." *Guardian,* 12/3/01.

———. "The Girl Groups," in DeCurtis and Henke, *Rolling Stone Illustrated History.*

———. "Real Life Top 10: Special All-Beatles Edition!" *Salon,* 2/22/00.

———. "A Virtuoso Would Have Destroyed the Beatles." *Guardian,* 12/3/01.

Margolis. "Former Beatle Sutcliffe's Sister Disputes Account in 'Backbeat.'" *Pittsburgh Post-Gazette,* 5/13/01.

———. "Why I'm Convinced that John Lennon Murdered My Brother." *Mail on Sunday,* 9/17/00.

Marowitz. "The Beatles' Home Movie." *Village Voice,* 1/4/68, in Thomson and Gutman, *The Lennon Companion.*

Marsh. "Power and Intimacy," in Okun, *Compleat Beatles,* vol. 1.

Marshall. "Taking the Beatles Seriously: Problems of Text." *Journal of Popular Culture* 3 (1969).

Marzorati. "Something New." *New York Times Magazine,* 11/19/00.

———. "Sounds." *New York Times Magazine,* 12/5/99.

———. "The Way We Live Now." *New York Times Magazine,* 11/19/00.

———. "Where Have You Gone, Sgt. Pepper?" *New York Times,* 9/5/99.

Maslin. Review of *The Colonel. New York Times,* 7/19/03.

E. May. "Explosive Issues: Sex, Women, and the Bomb," in May, *Recasting America.*

Maycock. "The Battle Of Grosvenor Square." *Independent,* 3/17/98.

Mellers. "Infantilism." *New Statesman,* 10/27/72, in Thomson and Gutman, *The Lennon Companion.*

———. "New Music in a New World," in Eisen, *The Age of Rock.*

Melly. "John Lennon." Punch, 12/17/80, in Thomson and Gutman, *The Lennon Companion.*

Menand. "Don't Think Twice: Why We Won't Miss the 1980s." *New Republic,* 10/9/89.

———. "Life in the Stone Age: Checks, Drugs, and Rock 'n' roll." *New Republic*, 1/7/91.

———. "Lives of the Saints." *New Republic*, 10/31/88.

———. Review of *In the New World: Growing Up with America*. *New Republic*, 4/18/88.

———. Review of *Yesterday: The Unauthorized Biography of Paul McCartney*. *New Republic*, 10/31/88.

———. "The Triumph of Vulgarity." *New Republic*, 3/23/87.

———. "When They Were Fab." *New Yorker*, 10/16–10/23/00.

Mendelsohn. "Only Very Rarely Did They Deserve Credit as Innovators," in *Beatle Symposium*, Stereo Review.

Michaelis. "Rereading Sgt. Pepper's Words." *American Scholar* 74 (Autumn 2002).

Miles. "Brimful of Asher," in *Days of Beatlemania*, Mojo Limited Edition.

———. "Dazed and Infused: The Summer of Love." *Vox*, 8/92.

———. "Going Underground," in *1000 Days*, Mojo Limited Edition.

———. "The Launch of Apple Records," in *Days of Revolution*, Mojo Limited Edition.

———. "Nemesis!" in *Mojo Special Edition: John Lennon*.

———. "Your Move, Yoko!" in *1000 Days*, Mojo Limited Edition.

Miller. "The Beach Boys," in DeCurtis and Henke, *Rolling Stone Illustrated History*.

Molenda. "Divine Light: George Harrison's Fab Life of Innovation and Exploration." *Guitar Player*, 3/02.

Mooney. "Popular Music Since the 1920s: The Significance of Shifting Taste." *American Quarterly* 20 (1968).

———. "Rock as an Historical Phenomenon." *Popular Music and Society* 1 (1972).

Moore. "The Brilliant Career of Sgt. Pepper," in Aldgate et al., *Windows on the Sixties*.

Morris. "In Liverpool," in Cott and Doudna, *Ballad*.

Morris. Legrand, and Sexton. "Meeting the Beatles: Feb. 7, 1964; Fab Four Takes U.S. by Storm." *Billboard*, 2/7/04.

Morrison. "The Sound of the Sixties." *Times Literary Supplement*, 5/15/81.

Muncie. "The Beatles and the Spectacle of Youth," in Inglis, *The Beatles, Popular Music, and Society*.

Murray. "All Aboard the Magic Bus," in *1000 Days*, Mojo Limited Edition.

———. "The Beatles: 1—Does the Fabs 'Best Of' Add Up?" Mojo, 12/2000.

———. "Focus: The McCartney Marriage." *Observer*, 7/29/01.

———. "Four on Film," in *Days of Beatlemania*, Mojo Limited Edition.

———. "Talking About Revolution," in *1000 Days*, Mojo Limited Edition.

———. "Why the Fab Four Are Still with Us." *Evening Standard*, 12/05/01.

———. "Why We Still Want a Piece of Lennon." *Daily Telegraph*, 10/7/00.

"My Magic Moment." *Stoke Sentinel*, 8/3/98.

Naughton. "Agnew Assails Songs and Films That Promote a 'Drug Culture.'" *New York Times*, 9/15/70.

Neal. "A Different Bag," in Davis, ed. *The Beatles Book.*

"New Nanny." *Beatles Monthly Book*, vol. 44, 3/67.

Noden, "The Lone Star," in *1000 Days*, Mojo Limited Edition.

———. "The Long and Winding Road," in *Days of Revolution*, Mojo Limited Edition.

———. "'Paul Is Dead,'" in *Days of Revolution*, Mojo Limited Edition.

Norman. "The Beatles: Break-up and Beyond." *Daily Mail*, 2/1/95.

———. "The Beatles: Break-up and Beyond." *Daily Mail*, 2/2/95.

———. "The Bourgeois Beatle." *Asia Africa Intelligence Wire*, 4/3/03.

———. "The Day the Beatles Were Born." *Daily Mail*, 10/23/93.

———. "A Hard Day's Flight." *The Sunday Times Magazine* (London), 9/2/01.

———. "He Was the Greatest Rock Star in the World, but Now All John Wanted to Do Was Stay at Home and Bake Bread." *Daily Mail*, 1/31/95.

———. "How Sex Destroyed the Beatles." *Daily Mail*, 1/30/95.

———. "Lennon Offered Love and Peace to the World—but Never to the Son He Cast Aside." *Daily Mail*, 2/12/01.

———. "The Lonely Hearts' Club Band." *The Sunday Times* (London), 10/8/00.

———. "McCartney the Manipulator." *Daily Mail*, 2/10/01.

———. "Phantom of Fab Four." *Mercury* (Australia), 7/19/03.

———. "Revealed: How Joe Flannery's Mother Inspired a Sixties Legend." *Daily Mail*, 7/30/94.

———. "Sweet George." *The Sunday Times* (London), 12/02/01.

———. "The Unknown Beatle About to Become a Star Thirty Years After His Death." *Mail on Sunday*, 8/1/93.

———. "When Love Was All You'd Need." *The Times* (London), 5/30/87.

Norris and Caldwell. Posts on *Flowers in the Dustbin. Slate*, 8/16/99–8/19/99. http://slate.msn.com/id/2000103/entry/1003439/.

"Notes and Queries." *Guardian*, 8/29/02.

O'Brien. "Seven Years in the Life." *New York Review of Books*, 7/19/01.

O'Connell. "We All Live on a House on Wimpole Street." *The Times* (London), 4/18/98.

O'Gorman. "Love Unlimited," in *Days of Beatlemania*, Mojo Limited Edition.

———. "Recording the White Album," in *Days of Revolution*, Mojo Limited Edition.

———. "Strange Fruit," in *1000 Days*, Mojo Limited Edition.

———. "'Take 137!'" in *1000 Days*, Mojo Limited Edition.

O'Grady. "*Rubber Soul* and the Social Dance Tradition." *Ethnomusicology* 32, no. 1, 1/79, reprinted in Thomson and Gutman, *The Lennon Companion.*

Okun. "To (Be)atles or Not to Be(atles)," in Okun, *Compleat Beatles*, vol. 1.

Oldham. "A Day in the Life." *Guardian*, 4/6/01.

———. "Foreword," in *Days of Beatlemania*, Mojo Limited Edition.

O'Mahony. "The End of an Era." *Beatles Monthly Book,* vol. 77, 12/69.

"One Last Question," in *1000 Days,* Mojo Limited Edition.

"The Other Beatle." *Mersey Beat,* 8/1/63, in Harry, *Mersey Beat.*

Page. "It Looks as Though They're Here to Stay." *Washington Post,* 1/31/01.

Paglia. "Cults and Cosmic Consciousness: Religious Vision in the American 1960s." *Arion,* vol. 10 (Winter 2003).

R. Palmer. "The Other Half of the Sky: The Songs of Yoko Ono," in Cott and Doudna, *Ballad.*

T. Palmer. "Born Under a Bad Sign," in Evans, *The Beatles Literary Anthology.*

Pam. "First Person: When It Was '64." *Los Angeles Times,* 11/30/00.

Panfile. "Boys Will Be Girl Group or the Johnettes: The Beatles and the Girl Group Sound." *Soundscapes* 2 (9/99).

———. "Soul of a Clean Machine: Paul McCartney's Compositions in the Beatles Years (1960–1969)." www.vex.net/~paulmac/beatles/btt/soul.htm.

"Paul McCartney Predicts Breakup of Beatles Soon." *New York Times,* 1/23/67.

Paytress. " 'Helter Skelter' and the Manson Murders," in *Days of Revolution,* Mojo Limited Edition.

———. "Passage to India," in *Days of Revolution,* Mojo Limited Edition.

———. "Pleased to Meet You," in *Days of Beatlemania,* Mojo Limited Edition.

———. "Revolution 9," in *Days of Revolution,* Mojo Limited Edition.

Pekacz. "Did Rock Smash the Wall? The Role of Rock in Political Transition." *Popular Music* 13 (1994).

Perrick. "Lennon's Literary Lunch," in Thomson and Gutman, *The Lennon Companion.*

Peters. "Sweet Jane Puts Some Spice in Her Life." *Evening Standard,* 10/28/92.

Peterson. "Why 1955? Explaining the Advent of Rock Music." *Popular Music* 9 (1990).

Petty. "Decline of a Rock Genius." *The Times* (London), 9/29/00.

Peyser. "The Music of Sound, or the Beatles and the Beatless," in Eisen, *The Age of Rock.*

Platts. "The Songs the Beatles Gave Away," in Goldmine Magazine, *The Beatles Digest,* 1st ed.

Poirier. "Learning from the Beatles." *Partisan Review* (Fall 1967), in Eisen, *The Age of Rock.*

Price. "Sources of American Styles in the Music of the Beatles." *American Music* 15, no. 2 (Summer 1997): 208.

Protzman. "Rendered Mersey." *Washington Post,* 11/30/97.

Pyle. "Elvis Presley and the Western Performing Artist's Unrecognized Role as Social and Self-Healer: Issues of Transformation and Addiction." *Popular Music and Society* 13, no. 4 (1989).

Quinault. "Britain 1950." *History Today,* April 2001.

Rabkin. "Feminism: Where the Spirit of the Sixties Lives On," in Macedo, *Reassessing the Sixties.*

Radosh. "Take What You Need." *New Republic,* 6/18/01.

Radwan. "A Generic Approach to Rock Film." *Popular Music and Society* 20, no. 2 (1996).

Reade. "If Being a Beatle Killed John Lennon in One Explosive Split Second, It Was Slowly Eating at George Harrison's Soul for Thirty Years." *Mirror,* 12/01/01.

"Reds Rap Beatles." *Christian Science Monitor,* 8/12/65.

Reich-Silber. "Hello, Goodbye," in Cording et al., *In My Life.*

Reinhart. "In Person and on the Air," in Goldmine Magazine, *The Beatles Digest,* 1st ed.

Reising. "*Revolver* and the Birth of Psychedelic Sound," in Reising, *Every Sound.*

Remnick. "Birthday Boy." *New Yorker,* 5/14/01.

"Result of *Revolver* Poll." *Beatles Monthly Book,* vol. 40, 11/66.

Reynolds. "Big Time." *Guardian,* 6/5/63.

Rich. "Growing Up with the Beatles." *New York Times,* 12/14/80.

Richards. "Passing for the Love of Women: Manly Love and Victorian Society," in Mangan and Walvin, *Manliness and Morality.*

Richards. "Through the Eye of the Beholder." *Independent,* 5/5/94.

Rickey. "Rockfilm, Rollfilm," in DeCurtis and Henke, *Rolling Stone Illustrated History.*

Riley. "Rock History Meets the Beatles." *Millennium Pop* (Winter 1995).

Rimmer. "I Killed the Mother of John Lennon and Changed the Course of History." *Sunday Mirror,* 2/22/98.

"Ringo Accolades: Part One." http://groups.google.com/ groups?q=ringo+driving+on+three+wheels&hl=en&lr=&ie=UTF-8&selm=B5D1FFE9.8B1C%25uburoi%40rochester.rr.com&rnum=1.

Robbins. "Remember Those Fabulous Seventies? A Musical Stroll from Woodstock to Punk Rock." *Trouser Press,* 1/80.

J. Robertson. "The End of the Beginning," in *1000 Days,* Mojo Limited Edition.

———. "The End of the Road," in *Days of Revolution,* Mojo Limited Edition.

———. "Renaissance Man," in *Mojo Special Edition: John Lennon.*

P. Robertson. "Re: Backbeat Question—Stu's Death." www.getback.org/ breflib/studead.html.

Robins. "When Rock Became Art." *Newsday,* 5/24/87.

Robinson. "Conversations with Lennon." *Vanity Fair,* 11/01.

Robson. "In Search of the Fab Four's Enduring Legend." *Express,* 4/8/00.

Rockwell. "For $325, a Chance to Assess the Legacy of the Beatles." *New York Times,* 10/24/82, in Thomson and Gutman, *The Lennon Companion.*

———. "Introduction," in Okun, *Compleat Beatles*, vol. 1.

———. "Rock and Avant-Garde: John and Yoko's Record Collaborations," in Cott and Doudna, *Ballad.*

Rodriguez. "The Not-So-Fab-Four." *Montreal Gazette*, 2/27/00.

Rollins. "He Loves You (Yeah, Yeah, Yeah)," in Cording et al. *In My Life.*

Rorem. "The Music of the Beatles." *New York Review of Books*, 1/18/68, in Thomson and Gutman, *The Lennon Companion.*

C. Rose. "The Blank Generation—How Rock Moved from Political Opposition to Sheer Nihilism." *History of Rock* 51 (1982). www.rocksbackpages.com.

———. "The Dilemmas of Sex and Romance in Fifties Rock." *History of Rock* 12 (1982). www.rocksbackpages.com.

———. "How Music Changed the Look of American Youth." *History of Rock* 44 (1982). www.rocksbackpages.com.

L. Rose. "Long Gone John: Lennon and the Revelations." *Boston Phoenix*, 12/10/85, in Thomson and Gutman, *The Lennon Companion.*

Rosenberg. "Taking Popular Culture Seriously: The Beatles." *Journal of Popular Culture* 4 (1970).

Rothstein. "Critic's Notebook: Rude Awakening from Sixties Dreams." *New York Times*, 5/1/97.

Rotondi and Obrecht. "The Genius of John Lennon: In His Own Write." *Guitar Player*, 9/94.

Rotundo. "Boy Culture," in Jenkins, *The Children's Culture Reader.*

Rowley. "Is *Sgt. Pepper's* the Best Rock Album Ever?" Rockmine Archives, www.rockmine.music.co.uk.

———. "Sgt. Pepper's Facts." Rockmine Archives, www.rockmine.music.co.uk.

———. "Strawberry Fields Forever." Rockmine Archives, www.rockmine.music.co.uk.

Roxon. "Why Not a Beatle Museum in Times Square?" in *Beatle Symposium*, Stereo Review.

Rush. "Video Prophets Who Foretold Today's Innovations." *New York Times*, 10/14/01.

Safanov. "You Say You Want a Revolution." *History Today*, 8/03.

Saki. "Good vs. Bad." http://www.recmusicbeatles.com/public/files/saki/lyrics.html.

———. "Let's Talk About Lewisohn/MacDonald/Hertsgaard." www.recmusicbeatles.com/public/files/saki/saki-macdonald.html.

———. "Re: Early Critics of the Fabs (Repost)." www.recmusicbeatles.com/public/files/saki/lyricism.html.

———. "Re: George Martin's Contribution." www.recmusicbeatles.com/public/files/saki/gmartin.html.

Saltzman. "The Beatles . . . Were the First Poets of Technological Culture," in *Beatle Symposium*, Stereo Review.

Sammons. "Standing in the Shadows." *Daily Post* (Liverpool), 11/15/01.

Samuels. "Dead Beatles for Christmas." *Slate,* 12/20/02.

Sandall. "Joint Honours," in *1000 Days,* Mojo Limited Edition.

———. "Soundtrack of Their Lives," in *Days of Beatlemania,* Mojo Limited Edition.

Sarris. "A Hard Day's Night." *Village Voice,* 8/27/64, in Thomson and Gutman, *The Lennon Companion.*

Savage. "Anarchy in the V&A." *Artforum International,* 2/95.

———. "The Beatles: The Outtakes." *Mojo,* 11/95.

———. "The Fifth Beatle." *Gadfly,* 6/99.

———. "How Brian Epstein Fell Victim to Drugs and the Pressures of Being a Secret Homosexual." *Guardian,* 12/18/98.

———. "John Lennon: Imagine." *Mojo,* 4/00.

———. "Love Him Tender, Love Him True." *Mojo,* 12/94.

———. "Private on Parade," in *1000 Days,* Mojo Limited Edition.

———. "Young Lovers: Sixties Pop TV." *Face,* 3/82.

Schaffner. "Transformations," in Okun, *Compleat Beatles,* vol. 2.

Scheurer. "The Beatles, the Brill Building, and the Persistence of Tin Pan Alley in the Age of Rock." *Popular Music and Society* 20, no. 4 (1996).

Schiff. "The Tradition of the Oldie." *Atlantic Monthly,* 3/01.

Schneider. "The Nowhere Man and Mother Nature's Son." *Anthropoetics* 4, no. 2 (Fall 1998–Winter 1999).

Schuberk. "Beginning of the End," in Goldmine Magazine, *The Beatles Digest,* 1st ed.

Segal. "The Booted Beatle." *Washington Post,* 6/4/03.

———. "*Hard Day's Night:* Well-Aged Wit." *Washington Post,* 12/8/00.

Sexton. "The Beatles." *Billboard,* 11/20/99.

Shabecoff. "Beatles Winning in East Germany." *New York Times,* 4/17/66.

Shapiro. "The Big Apple," in *1000 Days,* Mojo Limited Edition.

Sharp. "The Last Hurrah of the Fifth Beatle," in Goldmine Magazine, *The Beatles Digest,* 2d ed.

Shaw. "Brill Building Pop," in DeCurtis and Henke, *Rolling Stone Illustrated History.*

———. "Leader of the Pack: Teen Dreams and Tragedy in Girl Group Rock." *History of Rock* 29 (1982). www.rocksbackpages.com.

———. "The Singer or the Song." *History of Rock* (1982). www.rocksbackpages.com.

Shepherd. "He's a Sensitive Soul." *Beatles Monthly Book,* vol. 69, 4/69.

———. "A Tale of Four Beatles, Part VI." *Beatles Monthly Book,* vol. 7, 2/64.

Shepherd and Dean. "Behind the Spotlight." *Beatles Monthly Book,* vol. 13, 8/64.

———. "Behind the Spotlight." *Beatles Monthly Book,* vol. 16, 11/64.

———. "Behind the Spotlight: Two Years Ago." *Beatles Monthly Book,* vol. 30, 1/66.

Shillingshaw. "Give Us a Kiss: Queer Codes, Male Partnering, and the Beatles," in Smith, ed., *The Queer Sixties.*

Shuster. "McCartney Breaks Off with Beatles." *New York Times*, 4/11/70.

Sierz. "Joking Aside . . ." *New Statesman and Society*, 10/20/95.

Silverton. "Elvis, Homoeroticism, and 'Jailhouse Rock.'" *Observer*, 8/10/97.

Simmons. "Apple Corps." *Request* (1996).

Simon. "Celebrating Birth of Beatlemania." *Boston Globe*, 2/5/04.

Sloan. "You Say You Want a Revolution," in Cording et al. *In My Life*.

Alan Smith. "At a Recording Session with the Beatles." *Mersey Beat*, 1/3/63, in Harry, *Mersey Beat*.

———. "Liverpool Audiences Are Great, Says Cliff." *Mersey Beat*, 11/1/62, in Harry, *Mersey Beat*.

———. "London Beat." *Mersey Beat*, 11/15/62, in Harry, *Mersey Beat*.

Andrew Smith. "In the Sixties, Yoko Ono Married John Lennon." *Observer*, 11/4/01.

G. Smith. "The Beatles' Straight Man." *New Yorker*, 11/20/95.

———. "The Sixth Beatle," in *The Beatles: Band of Century*, Q.

J. Smith. "I'm Trying to Make Julian Feel That John Did Love Him, Even If He Can't Tell Him Anymore." *Daily Express*, 7/25/00.

Smith and Coren. "We Still Wanna Hold Your Hand." *The Times* (London), 11/29/95.

Snow. "And Now My Life Has Changed," in *Mojo Special Edition: John Lennon*.

———. "Backbeat: A Bit of a Slap and a Wig." *Q*, 5/94.

———. "George Harrison, 1943–2001." *Rock's Backpages*, 11/01.

"South Africa Radio Ban on Records." *The Times* (London), 8/9/66.

"Soviet Critic Asserts the Beatles Are Out of Tune with the Times." *New York Times*, 12/4/68.

N. Spencer. "Eastern Rising," in *1000 Days*, Mojo Limited Edition.

———. "Some Product," in *Days of Beatlemania*, Mojo Limited Edition.

T. Spencer. "A Design for Life," in *Days of Beatlemania*, Mojo Limited Edition.

Stafford. "I'd Love . . . to Tu . . . r . . . r . . . n You On," in Davis, *The Beatles Book*.

B. Stanley. "Girls with Guitars." *The Times* (London), 6/25/04.

———. "The Quality of Mersey Unrestrained." *The Times* (London), 8/12/03.

———. "Riding So High," in *1000 Days*, Mojo Limited Edition.

Stansell. "The Fashion of the Christ." *New Republic*, 3/4/04.

Steinem. "Beatle with a Future." *Cosmopolitan*, 12/64, in Thomson and Gutman, *The Lennon Companion*.

Stephens. "Cultural Outlaws, Political Organizers." *Australian Humanities Review*, 5/98.

Stonehouse. "Review: For Eight Years, Alistair Taylor's Was the Fab Four's Mr. Fixit," *Sunday Express*, 12/02/01.

Strawberry Walrus Web site. "The Meeting." www.strawberrywalrus.com/firstmeeting.html.

Street-Porter. "Like All Good Comedy, the Goons Mirrored the Social Mores of Their Day but It Was No Golden Era." *Independent on Sunday,* 4/15/01.

Sturges. "Baby You Can Buy My Car." *Independent,* 3/16/97.

H. Sullivan. "Paul, John, and Broad Street." *Popular Music* 6 (1987).

J. Sullivan. "Beatles' *Sgt. Pepper* Isn't Greatest." *San Francisco Chronicle,* 3/3/02.

M. Sullivan. " 'More Popular Than Jesus': The Beatles and the Religious Far Right." *Popular Music* 6 (1987).

Pauline Sutcliffe. "Isolation: Sutcliffe, Epstein, Lennon, and Loss," in Thomson and Gutman, *The Lennon Companion.*

———. "My Brother the Forgotten Beatle and How He Was Killed by John Lennon." *Daily Mail,* 10/27/01.

Phil Sutcliffe. "The Dream Is Over," in *Mojo Special Edition: John Lennon.*

———. "Fancy That!" in *1000 Days,* Mojo Limited Edition.

———. "We Mean It, Ma'am!" in *Days of Beatlemania,* Mojo Limited Edition.

Sweeting. "Let It Be—Again." *Guardian,* 10/18/95.

———. "Rock Solid." *Guardian,* 5/17/96.

"Talking with Linda McCartney." *People Weekly,* 11/9/92.

Tamm. "Beyond Strawberry Fields: Lennon's Later Style," in Thomson and Gutman, *The Lennon Companion.*

A. Taylor, "George; He Mostly Hated Being a Beatle." *Independent,* 10/28/95.

———. "Secret Truth About the Beatles." *Sunday Mercury,* 9/9/01.

———. "There Was Only One Woman for My Friend Paul . . . and It Wasn't Linda." *Mail on Sunday,* 9/23/01.

Thompson. "McCartney Wanted Nothing More Than to Hold Her Hand . . . but Then He Betrayed Her." *Daily Mail,* 12/3/94.

D. Thompson. "The Beatles Meet the Loog," in Goldmine Magazine, *The Beatles Digest,* 1st ed.

———. "Linda McCartney," in Goldmine Magazine, *The Beatles Digest,* 1st ed.

Tiger. "Why, It Was Fun! (America's Response to the Beatles)." *Rolling Stone,* 2/16/84.

Tillekens. "A Flood of Fat-Sevenths," in Reising, *Every Sound.*

———. "The Sound of the Beatles." www.icce.rug.nl~/soundscapes/VOLUME01/The_sound_of_the_Beatles.html.

"The *Times* Diary: Shake-Up." *The Times* (London), 7/1/76.

Titova. "McCartney Plays for Fifty Thousand in Russia." Associated Press, 6/20/04.

Tobler. "George Martin: From Comedy Records to Rock Classics." *History of Rock* 32 (1982). www.rocksbackpages.com.

Torgoff. "Don't Pass This Boy By: Ringo and the Beatles," in Okun, *Compleat Beatles,* vol. 1.

Townshend. "I Know That It's a Dream," in *Mojo Special Edition: John Lennon.*

"Triumphant Return!" *Beatles Monthly Book,* vol. 37, 8/66.

Trust. "A Music Publisher's Perspective," in Okun, *Compleat Beatles,* vol. 1.

Turner. "One Pair of Eyes." *Beatles Monthly Book,* vol. 75, 10/69.

———. "Sgt. Pepper's Lonely Hearts Club Band," in *The Beatles: Band of Century,* Q.

———. "Timeless Illustrious Past: Why the Beatles Are Still Big Business." *Wiener Zeitung,* 6/99.

"TV Top Medium for Launching New Platters." *Variety,* 11/24/54.

"Two Beatle Fans Paroled," *New York Times,* 8/26/66.

Tynan. "Help!" in Evans, *The Beatles Literary Anthology.*

Vance. "An Uninterrupted Five-Year Stretch of Genius," in *Beatle Symposium,* Stereo Review.

Waine. "The Beatles in Hamburg." *Lancaster Comment,* 3/11/82.

Ward. "How the DIY Sounds of Skiffle Still Inspire Today." *Guardian,* 9/6/03.

Warwick. "I'm Eleanor Rigby: Female Identity and *Revolver,*" in Reising, *Every Sound.*

———. "You're Going to Lose That Girl: The Beatles and the Girl Groups." Unpublished paper.

Waters. "Sister's Act Hits Wrong Note." *Sunday Herald,* 11/18/01.

Weinstein. "Rock Is Youth / Youth Is Rock," in Binda, *America's Musical Pulse.*

Weisberg. Review of *The Heart of Rock and Soul: The 1001 Greatest Singles Ever Made. Washington Monthly,* 12/89.

Welch. "Obituary: George Harrison." *Independent,* 12/1/01.

Wells. "The British Invasion of American Popular Music: What Is It and Who Pays?" *Popular Music and Society* 11 (1987).

———. "Images of Popular Music Artists: Do Male and Female Audiences Have Different Views?" *Popular Music and Society* 12, no. 3 (1988).

Wenner. "The Ballad of John and Yoko," in Isles and Ono, *Yoko Ono.*

———. "One Guy Standing There Shouting 'I'm Leaving,' " in Cott and Doudna, *Ballad.*

West and Martindale. "Creative Trends in the Content of Beatles Lyrics." *Popular Music and Society* 20, no. 4 (1996).

"What Happened in America." *Beatles Monthly Book,* vol. 9, 4/64.

Whissell. "Traditional and Emotional Stylometric Analysis of the Songs of Beatles Paul McCartney and John Lennon." *Computers and the Humanities* 30 (1996).

Whitaker. "Here, There, and Everywhere," in *1000 Days,* Mojo Limited Edition.

Whitely. "Little Red Rooster v. the Honky Tonk Woman," in Swiss et al., *Mapping the Beat.*

———. " 'Love Is All and Love Is Everyone,' " in Reising, *Every Sound.*

———. "Repressive Representations," in Swiss et al., *Mapping the Beat.*

Widmer. "You Say You Want a Revolution: From Bertolucci to the Beatles, 1968 Is Back," *Slate,* 3/9/04.

A. Wiener. "Who Was the Real Fifth Beatle?" in Goldmine Magazine, *The Beatles Digest*, 1st ed.

———. "Why the Beatles?" http://abbeyrd.best.vwh.net/wiener.htm.

J. Wiener. "Pop and Avant-Garde: The Case of John and Yoko." *Popular Music and Society* 22, no. 1 (Spring 1998).

———. Review of *Acid Rock: A Flashback. Nation*, 2/26/01.

P. Williams. "Eyewitness," in *The Beatles: Band of Century, Q*.

———. "The Golden Road: A Report on San Francisco." *Crawdaddy*, 6/67.

———. "John and Yoko Record 'Give Peace a Chance.'" *Q*, 11/95.

———. "The Stones: It Wasn't Only Rock 'n' Roll (and I Liked It)." *Crawdaddy*, 11/74.

R. Williams. "Derek Taylor: Obituary." *Mojo*, 11/97.

———. "The Immaculate Inception," in *Days of Beatlemania*, Mojo Limited Edition.

———. "The Paul Perplex: A British Commentary," in Williams, *Giants of Rock Music*. Reprinted in *Rock Backpages*. www.rocksbackpages.com.

———. "Stretching the Boundaries," in *1000 Days*, Mojo Limited Edition.

Wilson. "2,900-Voice Chorus Joins the Beatles: Audience Shrieks and Bays and Ululates." *New York Times*, 2/13/64.

E. Wilson. "Deviancy, Dress, and Desire," in Fisher, *Negotiating at the Margins*.

L. Wilson. "Billy Preston Joins the Beatles," in *Days of Revolution*, Mojo Limited Edition.

———. "Jim'll Fix It," in *Days of Beatlemania*, Mojo Limited Edition.

Wingfield. "When Hamburg's Style Mistress Told the Beatles to Get Black." *Australian*, 10/15/99.

"WMCA Bans New Single, Ballad by Beatle Lennon." *New York Times*, 5/24/69.

Wolfe. "Beatles! More Than Just a Word to the Wild." *New York Herald Tribune*, 2/8/64.

———. "A Highbrow Under All That Hair?" *Book Week*, 5/3/64, in Thomson and Gutman, *The Lennon Companion*.

Wolmuth. "Flower Power Revisited." *People*, 6/22/87.

Wood. "John Lennon's School Days." *New Society*, 6/27/68, in Thomson and Gutman, *The Lennon Companion*.

Woodall. "John, Yoko, and the Whole Beatles Thing." *Age* (Melbourne), 1/25/97.

———. "When John Met Yoko." *Telegraph Magazine*, 11/2/96.

Woods. "'It's Amazing We're Still Alive.'" *Daily Telegraph*, 3/17/99.

Wooler. "John, Paul, George, and Pete . . ." *Mersey Beat*, 3/22/62, in Harry, *Mersey Beat*.

———. "Sounding Off About . . . The Girls!" *Mersey Beat*, 10/5/61, in Harry, *Mersey Beat*.

———. "Well Now—Dig This!" *Mersey Beat*, 8/31/61, in Harry, *Mersey Beat*.

"Yeah, Yeah, Yeah (Personal Accounts of the Beatles)." *Rolling Stone*, 2/16/84.

"Yellow Submarine," in *Days of Revolution,* Mojo Limited Edition.

"Yesterday: A Sixties Hit Is the World's Most Frequently Recorded Song." *People,*
 2/6/84.

Yoakum. "The Man Who Killed Paul McCartney." www.rocksbackpages.com.

Yorke. "Bedding In for Peace: John and Yoko in Canada." *Rolling Stone,* 6/28/69.

———. "Gently Weeping." *Sunday Herald Sun,* 12/2/01.

"Young John." *Beatles Monthly Book,* vol. 25, 8/65.

"Young Paul." *Beatles Monthly Book,* vol. 27, 10/65.

Zacharek. "Beatles—Magical History Tour." *Newsday,* 12/9/00.

———. "Between the Beatles' Flashy Suits. . . ." *Salon,* 1/12/00.

I. VIDEO AND AUDIO RECORDINGS

All You Need Is Cash. BBC Radio, 1995.

Apple Scruffs. BBC Radio, 1996.

The Beatles: Across the Universe. BBC Radio 2.

The Beatles Anthology. Apple Corps Limited, 1996.

The Beatles: The First U.S. Visit. Maysles Films, 1991.

Beatle Wives: The E! True Hollywood Story. Aired 2/22/99.

The Compleat Beatles. Delilah Films, 1982.

George on George. BBC Radio 4/Above the Title Productions, 2004.

It Was Twenty Years Ago Today. Granada Television, 1987.

McCartney on McCartney. BBC Radio 1 Documentary, 1989.

The Making of Sgt. Pepper. A Really Useful Group, 1992.

Nothing's Going to Change My World; Part 1: "Baby You're a Rich Man." BBC Radio 4.

ACKNOWLEDGMENTS

I owe thanks to a lot of people for their considerable help with this book. In Liverpool, Spencer Leigh was an indispensable guide to sources and all things musical; thanks, too, to Brian Gresty for giving me my first taste of the city and to Helen Anderson and Alan Clayson for their early assistance. The project never would have gotten off the ground without the substantial aid and support of my able agent, Nat Sobel. At HarperCollins, I benefited from the skillful support of Diane Reverand and then editor Henry Ferris and his assistant, Peter Hubbard; thanks, too, to my copy editor, Adam Goldberger. As I wrote the book, I had the good fortune to receive the copious feedback of two good friends who happen to be great historians, Alex McNeil and Tony Rotundo. I have undoubtedly made mistakes, but there would have been a good many more had it not been for the heroic fact-checking efforts of Susanna Stossel and my wife, Sarah Wald. Finally, a special thanks to Sarah, who, in addition to her considerable academic credentials, is a rock and roller at heart. As I went along, she read every word countless times, answered continual questions about the meaning of lyrics, feminism, and 1960s fashion, and even agreed to move to England with the family so the project could be properly researched. With this, as with everything else, I could never have come close to doing it without her.

INDEX